Sculpture by Picasso

WERNER SPIES Sculpture by Picasso

WITH A CATALOGUE OF THE WORKS

HARRY N. ABRAMS, INC., PUBLISHERS,
NEW YORK

Translated from the German *Picasso: das plastische Werk*
by J. Maxwell Brownjohn

English translation © 1971 by Thames and Hudson Ltd., London
© 1971 by Verlag Gerd Hatje, Stuttgart

Standard Book Number: 8109-0394-6
Library of Congress Catalogue Card Number: 76-149857
All rights reserved. No part of the contents of this book may be
reproduced without the written permission of the publishers
Harry N. Abrams, Incorporated, New York
Printed in Switzerland
Picture reproduction rights © 1971 by SPADEM, Paris, and
Cosmopress, Geneva

For Daniel-Henry Kahnweiler

Contents

Preface

Until a few years ago, Picasso's sculptural work was one of the best guarded secrets in twentieth-century art. Picasso has retained possession of almost all his own sculptures. Very many pieces are still unica, and no systematic editions have ever been made. There are, for instance, no examples outside Picasso's own collection of the magnificent group of iron sculptures which originated from 1929 onwards and already enjoy a legendary status in the development of twentieth-century art.

Public attention was first drawn to Picasso the sculptor by the Paris, London and New York retrospectives of 1966–67. Made possible by the artist's willingness to lend his work, they bore witness to a line of artistic development which, in quality and quantity, well deserves to be ranged alongside his paintings and drawings.

Although publications on Picasso have never overlooked this aspect of his work entirely, no general account of his sculptures has ever been produced before. Daniel-Henry Kahnweiler was the first to draw attention to the continuity of Picasso's sculptural development. This was in 1949, in his introduction to an album of photographs by Brassaï. Many hitherto unknown pieces have come to light since then.

Until now, the conception of Picasso as a sculptor has necessarily proceeded from the assumption that his sculptural activity has been restricted to a few major phases in his work: Cubist constructions in the synthetic period, iron sculptures and modelled pieces produced at Boisgeloup in the late 1920s and early 1930s, material collages in the 1940s, and ceramics from 1948 onwards. Quite apart from such quantitatively rich periods, however, Picasso's other work is accompanied, with an impressive autonomy, by individual pieces which exemplify the nature of his quest, his *recherche*. We repeatedly find that it is just such individual pieces which, in their divergence from Picasso's serial mode of working, help to resolve problems of composition.

Picasso's sculptural work is in no way inferior, either in variety or in significance, to the remainder of his output. He has influenced his century profoundly, not only as a painter but also as a modeller and constructor of three-dimensional works. I have attempted to trace the stages in this development.

The original idea for this book came from Daniel-Henry Kahnweiler and Gerd Hatje. Kahnweiler, to whom I am indebted for numerous suggestions, was the first to draw attention to Picasso's sculptural work in a publication. Picasso himself looked through my material at Mougins and supplied me with

information which helped to clarify a number of important points. He also permitted me to take photographs in his magnificent sculpture gallery there. We are thus able to supplement Brassaï's historic photographs and the more recent ones taken on the occasion of the Paris, London and New York exhibitions with a few plates which conjure up the exciting setting in which Picasso's sculpture is seen to best advantage.

I should also like to express my gratitude for conversations with Brassaï, André Chastel, Douglas Cooper, Edward Fry, Roberta González, Carola Giedion-Welcker, Werner Hofmann, Max Imdahl, Maurice Jadot, Louise and Michel Leiris, Roland Penrose, Hélène Parmelin, Edouard Pignon, Lionel Prejger and Christian Zervos.

A very special word of thanks must go to the late Karl Kaspar, who devoted himself to this project with such unflagging energy and wholehearted concentration until his untimely death. Only the tireless editorial help of Ruth Wurster has made it possible to carry this publication through, and to incorporate a catalogue of Picasso's sculptural work. Gert Hatje has given me all the support and assistance I could have wished for, both as a critical reader and as an enthusiastic maker of books.

Page references in the text refer to the plate sections; all other works catalogued are illustrated on pp. 273-300.

Early bronzes

BEGINNINGS

Although we have little firm information about the role played by sculpture in Picasso's childhood and adolescence, he was fascinated from the outset by modes of expression which lay beyond the realm of painting and drawing. As a child he was good at cutting animals and figures out of paper with scissors. Jaime Sabartés reports that he took an interest in handicraft techniques. At Barcelona he painted in a studio in the Calle des Escudillers Blancs. There was a corset-maker's establishment in the same building, and Picasso used to amuse himself by inserting eyes in corsets with the tools of the trade.[1] His delight in things manual was later to lead to many novel techniques and media of expression which had a basis in 'non-art'.[2] During his early days at art school in Barcelona, Picasso often worked at the studio of his friend Cardona, who used to model small figurines which were cast in bronze and sold as knick-knacks.

One of Picasso's first friends in Paris was the Catalan sculptor Carlo Mani y Roig, who had moved to the French capital in 1893. In 1906 he left Paris and worked on the figurative decoration of Antoni Gaudí's church of La Sagrada Familia in Barcelona. At Mani's studio, Picasso was able to see a sculpture, *The Degenerates,* which represented two human figures seated on a rock with their heads – as in Rodin's *Thinker* – inclined forwards.

The only major piece of information about this early period comes from Picasso himself. He has told me that as a child he modelled – to quote his own words – 'thousands of crib figures', but that all these were destroyed. He recalled these crib figures when, in the course of examining photographs and sculptures, we came across the small bronze entitled *Seated Woman* (p. 29).

This is the earliest Picasso sculpture known to us. It exemplifies a pattern from which the artist was to diverge only in very rare instances: like almost all Picasso's sculptural works, it is an individual piece. Groups are extremely rare, or have been assembled subsequently. Again, the climate in which *Seated Woman* exists (i.e. the free space enclosing the sculpture) seems to compress it into a single block. Speaking of Picasso's hunched figures, the Spanish art historian Alejandro Cirici-Pellicer enunciates a law of form, that of 'maximum contact', and draws attention to a certain affinity with the Romanesque murals of Catalonia. In this connection, he quotes an exclamation which Picasso is said to have made when confronted by the frescoes from Santa María de Tahull in the Museo de Arte de Cataluña in Barcelona: '*Regarde ! Voici qui est mien !*' (Look! This is something that's mine!)[3]

This stylistic principle, in which volumes are condensed into as compact a mass as possible, played an important part in Picasso's entire output from 1902 onwards. Before that, his pictures aimed at a linear-outlined, two-dimensional frontal view in which the gesture of the hand fulfilled a graphic, animating role. This 'massification' occurred in painting as soon as Picasso abandoned Impressionist surface-treatment, with its individual juxtaposed brush-strokes, and freed himself from the impetus of Art Nouveau, which subordinated body and drawing to a melodious linear flow.

These observations supply pointers to the date of *Seated Woman,* hitherto in doubt. The sculpture must have originated after Picasso awoke to the corporeality of his figures. The compact, block-like structure is incompatible with the years 1899 or 1900, nor does it accord with the seated figures of the Madrid period of 1901.[4] Picasso himself at first told me that *Seated Woman* dated from 1901;[5] but when I quoted *Streetwalkers in a Bar,* done in Barcelona in 1902, as a point of stylistic comparison, he confirmed this. We may thus regard the Barcelona 1902 dating as having been corroborated.

It is in this period that we first encounter a new mode of composition which was to govern a whole series of works. Picasso began to activate impressionistic surfaces. Masses become furrowed with shadows, and ridges appear at the meeting-place of light and dark areas. These no longer, as in Impressionism, melt into each other but are contraposed in the form of discrete units. This mode of composition recalls the folds of drapery in medieval sculpture, which encase figures in an autonomous design. Not only do Picasso's 1902 paintings often involve the *Seated Woman* motif; several pictures done in Barcelona in the same year exhibit the same type as this particular sculpture.[6] It is possible that modelling had inspired Picasso to represent new aspects of corporeality in his paintings as well. It is also conceivable that the pictures of the Barcelona period, with their initial two-dimensional monochromy, had prompted him to seek new effects in a strong emphasis on plasticity, something which was to be revived in 1906 during the Gosol period. Viewed in this light, this small sculpture is characteristic of Picasso's early desire to couple the expressive properties of the face with those of the body.

Picasso's early bronzes have been rather summarily classified as Rodinesque, attention being drawn to an impressionistic treatment of surfaces which permits light to bite into them. No such thing can be detected in this particular bronze, which stands in direct opposition to Rodin. This applies, first, to the absolute tranquillity that resides in the figure. No plastic form seeks to escape the confines of the block; the figure seems to be wrought from a single mass rather than modelled outwards into space. All thematic and technical dissimilarities apart, it is more reminiscent of the plastic solutions which Maillol – as opposed to Rodin – was to introduce into sculpture: the statuesque, solid mass, its plump corporeality replete with inner tension.

Following *Seated Woman* come two more bronzes: *Blind Singer* (p. 31) and *Head of Picador with Broken Nose* (p. 30), both done in Barcelona in 1903. Both are essentially masks, vehicles of physiognomical deformation. Whereas *Seated Woman* was designed to be viewed from various angles, Picasso here confines himself to two visual aspects only, full-face and profile. The profile view aims at a linear arrangement: cheeks and temples vanish behind the continuing line of forehead, nose, mouth and chin.

12

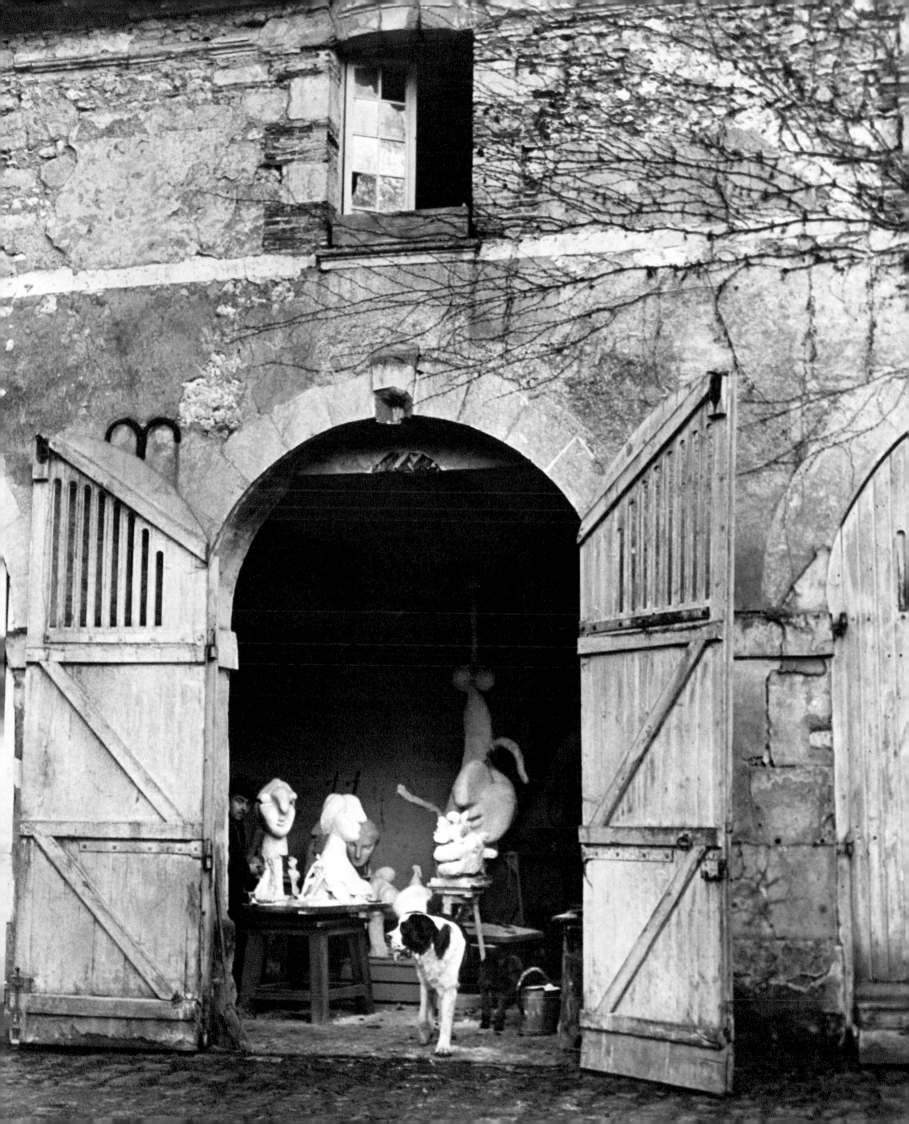

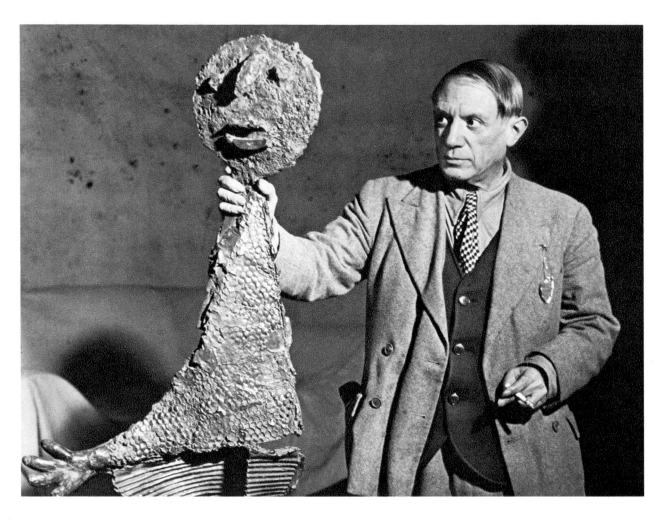

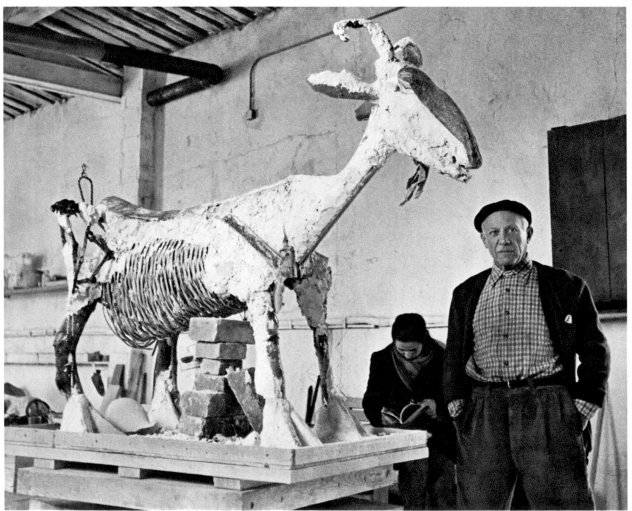

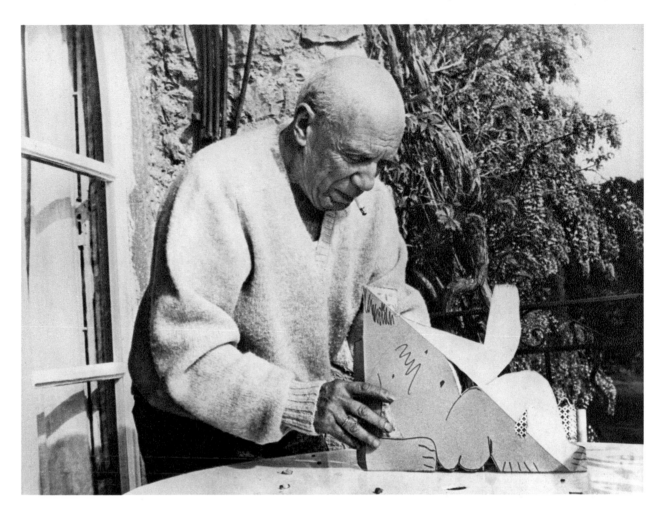

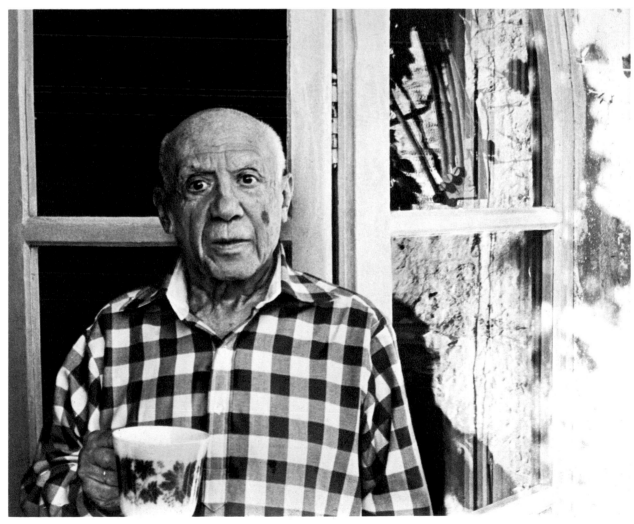

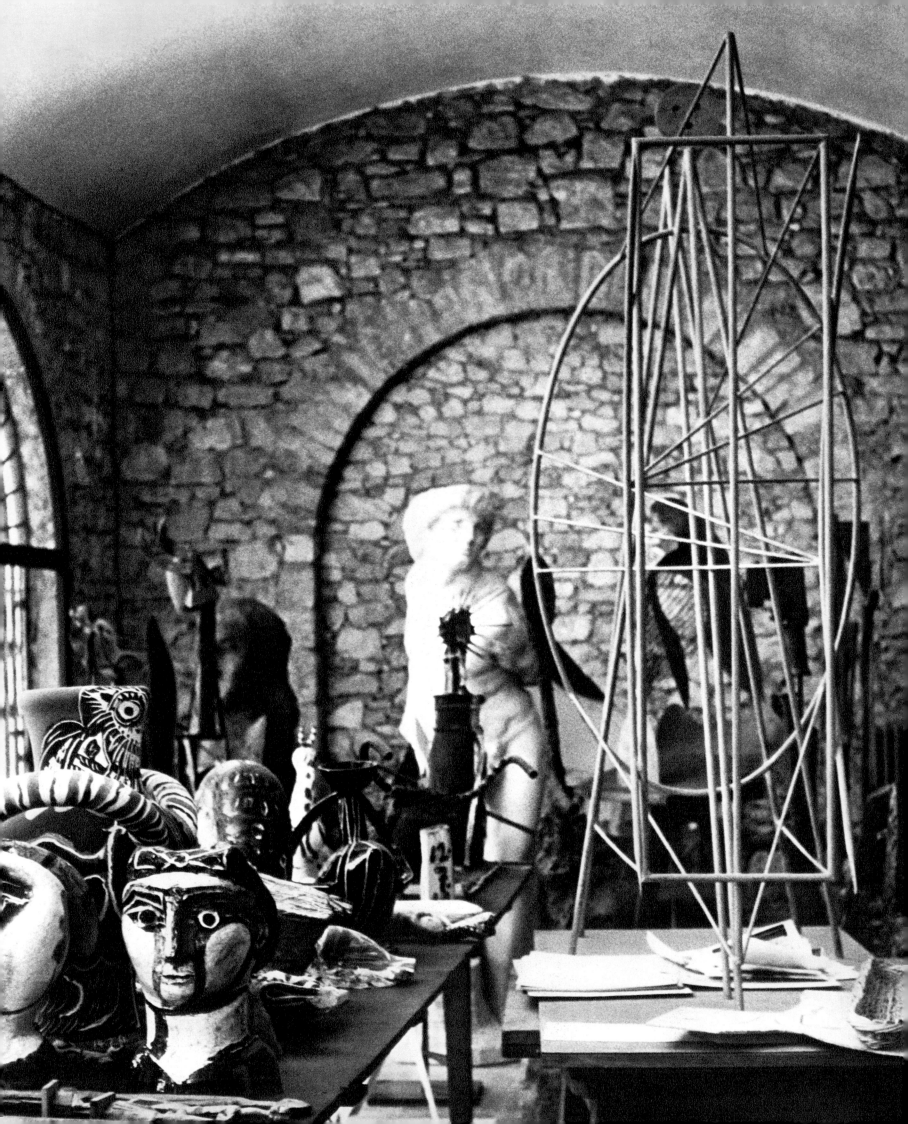

In the full-face view of *Blind Singer,* the mass-space contrast undergoes expressive development. Eye-sockets and open mouth are inserted as formally equal units. This gives the face an almost abstract structure: the hollow eyes seem to rhyme with the hollow mouth – an emotive formula.[7] The bronze is entirely smooth in this instance, probably so as to invest the emptiness of the eye-sockets and mouth with stronger plastic impact. Picasso long adhered to this motif, which played a part in the preliminary sketches for *The Peasants* in 1906.[8] It gave him a chance to codify psychological representation and to substitute a cipher for an anecdotal individual image.

The second mask, *Head of Picador with Broken Nose,* also has recourse to an expressive *topos*.[9] The motif first occurs in Picasso's work in a drawing apparently influenced by Gauguin.[10] It remains an open question whether this mask was a sort of homage to Gauguin, whom Picasso greatly admired at this period and who influenced him in numerous ways. Gauguin's *Self-portrait with Broken Nose* and Daniel de Monfreid's woodcut *Gauguin with Broken Nose* were certainly known to Picasso, who proceeded, for his part, to elevate irregularity of nasal configuration into a structural element of the face. The 'broken nose' motif leads to asymmetry in plastic structure. Its irregular formation becomes structurally perceptible in the remainder of the face: the right temple is more broadly reproduced than the left. Developing this irregularity, Picasso covers the mask with vigorous surface effects. This is where one could most aptly speak of Rodin's influence, not merely because of the treatment of the bronze but also because of Picasso's choice of an expressionism uncharacteristic of the remainder of his work.[11]

The 'broken nose' motif is one of the numerous physical abnormalities (or, rather, deviations from the norm) by means of which Picasso introduced new formal relationships into his work. In this early phase he used natural, anatomically credible deformation in order to provide the distortion which interested him in its own right. It was not until some years later that he freed himself from this logical basis for distortion and treated the body as a freely available inventory of autonomous forms and structures. During the Cubist period this inventory was introduced into every work, regardless of theme. Only sporadic allusions to reality invest these abstract shapes with objective meaning. Picasso's works were increasingly to be governed by what Kahnweiler terms primal lines (*Urlinien*).

The next two works, *The Jester* (p. 35) and *Head of a Woman* (pp. 32–33), came into being in 1905; *The Jester* is signed and dated. The contention that Picasso's earlier sculpture is impressionistic and influenced by Rodin was generally based on these two busts. Like *Seated Woman* and *Blind Singer, The Jester* is closely related to Picasso's painting and drawing. In 1905, the juncture when Picasso finally leaves the world of the Blue Period, his theme of isolation takes root in a new context: the fairground. This imbues the social motif with scenic colouring. Properties make their appearance – a stage-set, or the animal that accompanies the mountebank. The isolation of the individual is overlaid by an artificial relationship: his appearance on stage before the public. Picasso resorts to disguise. *The Jester* is an outstanding example of this. The account we possess of how this work originated amounts to a description of a process of alienation during which Max Jacob's portrait turned into a symbol. 'Picasso started on it one evening after a visit to the

circus with Max Jacob. The clay at first took on the features of his friend – naturally, as it were – but when he resumed work next day only the lower portion of the face retained a trace of the initial resemblance. He added a fool's cap, whereupon the head changed its personality.'[12]

The figure crowned with the fool's cap occurs in Picasso's paintings around the middle of the Rose Period. As a first example,[13] Christian Zervos cites an *Ex-libris for Guillaume Apollinaire* of 1905. This depicts a feasting king,[14] whose features are those of Apollinaire, of whom Picasso produced a drawing in the same year.[15] In the sculpture he converted the crown into a fool's cap.[16] He was less interested in the inherent symbolism of the cap than in the formal possibility of crowning the head with a strongly proportioned shape. That Picasso inserted this shape for its own sake is apparent from the fact that he used it in his pictures, not as a means of characterizing a figure, but as an accessory which imparts formal information; he was primarily attracted by the geometrical shape of the cap, a large triangle encompassed by smaller, lower-lying triangles.[17]

Here, in *The Jester,* he has translated this into sculpture. The account of how the sculpture came into being clearly discloses the process: the cap was added to the head by means of a collage-like procedure. The rich silhouette invests the bust with powerful plasticity. Plastic volumes emerge strongly here for the first time – a problem which Picasso, fortified by his experience of Cubism, was systematically to resolve in the 1909 *Head of a Woman* (pp. 42–43). The rest of the head is covered with a slight but consistent roughened modulation.[18]

In the *Head of a Woman* of 1905 (pp. 32–33) Picasso again made his point of departure a portrait, this time a likeness of Alice Derain. The surface treatment is quieter than in *The Jester* and the features are less vigorously worked. Small irregularities of surface are here confined to a few physiognomical irregularities: relative to the axis formed by the eyes and the bridge of the nose, the mouth is offset to the right. Looking at the averted head from the right, so that forehead, mouth and nose are seen slightly in profile, we find that this irregularity becomes subordinate to the overall view.[19]

The ironic *Jester* (or king) still adheres to the full-face scheme. The *Head of a Woman* (*Alice Derain*) contains an additional tendency which transcends the representational: the turn of the head gives the sculpture a faintly elegiac note which betrays the lingering influence of Symbolism. Medardo Rosso and Constantin Brancusi produced similar representations, in which the theme of sleep or suffering is used as an occasion for enrichment of form. This elegiac, passive attitude is characteristic of a whole contemporary style.

The next two works – *Head of a Woman* (*Fernande*) and *Woman Arranging her Hair* (pp. 36, 37) – are in contrast to their predecessors to the extent that they interpret volume in a different way: in *Fernande* the head was for the first time represented as a large voluminous mass of compact plasticity; *Woman Arranging her Hair* was to remain Picasso's largest modelled work for many years to come (until the bronzes of the Boisgeloup period).

Enlargement of format is important because by giving a viewer standing at an equal distance fields of vision which differ from those afforded by small pieces, Picasso obtains a different expressive effect. Particular importance attaches to this later on, in the Boisgeloup heads: the time required

for perception increases, and, in order to comprehend these heads in their entirety, we have to examine them longer and more exhaustively. Comparing them with the *Jeannette* heads of Matisse, we feel that, despite their non-realistic mode of representation, they preserve real dimensions. The bulky *Fernande* head itself discloses this circumstance. It is deliberately modelled so that the beholder receives differing plastic and tactile information from the two halves of the face. This heralds a creative principle – antithesis between two halves of a work – which was destined a few months later to be crystallized in the grandiloquent *non finito* of *Les Demoiselles d'Avignon*. The eyes and hair of the *Fernande* sculpture are only lightly worked; the left side of the head remains more amorphous than the right. On the left, the almond-shaped eye is only lightly incised into the smooth skin, which is covered with a fine, porous, reticular structure and stands out against the rougher surround. The head's startling impact derives from the strong contrast between the vigorously modelled nose-and-mouth section and the peripheral zones, which almost evaporate into shapelessness. Here, importance is assumed by the contrast between a plastic volume whose first impression is one of strength and clarity and a surface treatment which extends to the most delicate engraving – a feature which recalls the sculptures of Medardo Rosso.[20] Treatment of volume, with which Rosso dispensed, nevertheless plays a prominent role in Picasso's work. Here, for the first time, one can make express reference to a sculptural period in Picasso's work as a whole.[21] Even before Rodin, Rosso had systematically tried to dissolve sculptural volume so as to render visible the light that strikes it. In the celebrated group entitled *Conversation in a Garden* (1893), mass is dematerialized by light. Volume becomes diffused and loses all independent power of expression. The Impressionist mode here finds concrete, three-dimensional application.

RETREAT FROM PSYCHOLOGY: GOSOL

Picasso's visit to Holland in 1905 was important for the new direction which his work now took. He brought back several pictures in which his dialectical struggle with the corporeality of his models becomes unmistakable. He was to revert to this problem in the following year, during a stay of several months in Gosol, a Spanish mountain village near Andorra. Both *Head of a Woman (Fernande)* and *Woman Arranging her Hair* (pp. 36–37) belong within the ambit of this group of works. It is therefore probable that they were done in 1906, either during the months prior to his departure for Gosol or after his return, not in 1905 as previously assumed. At Gosol Picasso systematized the plastic tendency in his pictures. While there, he composed ochre landscapes with figures of diminished corporeality standing out strongly against them. His point of departure appears to have been the drawings and paintings of nudes (derived from Cézanne's *Large Male Bather*) which he produced at Paris in 1905–06, before he left for Gosol. The sculptural theme of the Greek *kouros* is manifest in them: the motif of the frontal stride is adopted from nude figures dating from the sixth century BC. The *Carnet catalan*, the Gosol sketchbook, contains one sketch for a sculpture. It shows three nude female figures (the Three Graces?) frontally arranged upon a plinth.

Even before he left Paris, however, Picasso had already grappled with several major themes on which he continued to work in Spain. Principal among them was *Woman Arranging her Hair,* a subject of central importance because in it, for the first time, he renounced psychological interpretation in favour of non-psychological representation.

The transition from the Blue to the Rose Period, and, ultimately, to the period which embraces the pictures painted during the trip to Holland, paves the way for this abandonment of the psychological. The tragic mood wanes during the Rose Period, and there is an incidence of themes which stress the playful, physical element. It was during his stay in Holland that Picasso discovered corporeality pure and simple. Thematic status is acquired by gestures which express virtually nothing about the human psyche or its social predicament. *Woman Arranging her Hair* (p. 37) is just such a motif – one in which a natural gesture devoid of any psychological foundation becomes self-sufficient. Exceptionally, *Woman Arranging her Hair* embodies a dynamic motif; but, in general, Picasso's treatment of figures prior to the painting *The Dance* (1925) is basically static.

The woman at her *toilette* constitutes a central theme in Degas's figurative paintings; Picasso does not, however, appear to have taken his cue from Degas. Impressionism had by this time become regarded as too peripheral.[22] Another source of inspiration seems more likely; and Ingres's *Turkish Bath* was publicly shown for the first time at the Salon d'Automne of 1905.[23] Enthusiasm for the Ingres exhibition was great.[24] The Ingres spell, detectable in the whole of Picasso's subsequent output, can first be verified in the works created late in 1905. The encounter with the *Turkish Bath* almost certainly had a decisive influence on Matisse's composition *La Joie de vivre;* it was also crucial to Picasso's figurative and compositional style.[25] Picasso's work enables us to trace, progressively, the stages in his dialogue with Ingres: from the borrowing of individual motifs – among them, in modified form, that of *Woman Arranging her Hair* – to the adoption of complete structural schemata which are concerned not only with numerous details in the *Turkish Bath* but also with its conception of space.[26] It is certain that this picture was one of the factors which stimulated Picasso to work on *Les Demoiselles d'Avignon* a year later.

However, influences of this kind are never to be read verbatim in Picasso's work. On the contrary, he unhesitatingly reworks and intensifies the expressive potentialities inherent in a particular motif.[27] Familiarity with Ingres enabled Picasso wholly to overcome the mood of the Blue and Rose Periods. Ingres helped him to progress from the emotionally stressed, psychologically exaggerated fact to sheer physical representation: choreographic movements, groping hands, the melodious music of the body which denotes nothing beyond itself. Ingres's *Turkish Bath,* an encyclopaedia of the nude, also prompted him to concentrate on nude studies for some months.

In *Woman Arranging her Hair,* originally a ceramic, smooth and serene areas are contrasted with animated and undulating areas. In contradistinction to *Head of a Woman (Fernande),* however, there is an absence of the contrast between softly modelled volume and sharply incised drawing. The material is used without harshness, in the manner of Art Nouveau ceramics. Picasso produced this sculpture in the studio of the Spanish ceramist Paco Durio, who lived in Paris. Picasso did not collaborate with Durio, although he did spend

much time with him: a fact which has yet to be explored.[28] Paco Durio was important to Picasso as a communicator of Gauguin's world of imagery, if for no other reason. He had been a friend of Gauguin's and owned several originals by him. His own works are strongly imbued with the decorative spirit that reigned at the turn of the century. His influence, if he had any, is most probably discernible in Picasso's treatment of hair in *Woman Arranging her Hair*. Flowing tresses are a central theme in Art Nouveau because they give scope for countless variations and numerous stylistic and thematic permutations (fire, water).

In contrast to most of Picasso's earlier works, this sculpture seems to be worked from a single visual angle. One indication of this is that the drawings which accompany the work almost all tackle the composition from the same side, so that the knees run leftwards and the right thigh combines with the beginning of the right upper arm to form a silhouette-like boundary. This accounts for the radical neglect of all sections which lie outside this field of vision. What also seems to legitimize this particular vantage-point is that the theme of the sculpture – combing – becomes clearly visible from there alone. If the line of vision is shifted too far to the left, the theme remains obscure. Preparatory work for the sculpture exists in the shape of various drawings made after Picasso's return from Gosol.[29]

One more ceramic sculpture, *Head of a Man* (*cat. 9*), originated in Paco Durio's studio. Picasso brought some sketches for it from Gosol. He told me that, as in *Woman Arranging her Hair,* he began with preliminary drawings and then translated them into sculpture. These are the only cases known to me in which the sketch-sculpture relationship can be verbally authenticated. In other instances, drawing and modelled sculpture follow one another by turns. Picasso has stated categorically that in this case the drawing preceded the sculpture.

EXOTIC INFLUENCES AND 'LES DEMOISELLES'

For all their diverse treatment of material and lack of clear distinction between full plasticity and relief, the sculptures which trace Picasso's artistic development in the Blue, Rose and Gosol periods may be classified as a single group of works. They were part of an output, already exceptional in its quantity, whose centre of gravity clearly lay in the realm of painting and drawing. By contrast, the works comprising a second group, which came into being between autumn 1906 and 1909, pose new questions hitherto unknown in European sculpture. In this respect, they are on a par with Picasso's work as a painter and draughtsman.

In Paris in the winter of 1906–07, Picasso produced a further sculpture for which the preparatory work had been done at Gosol: *Head of a Woman* (p. 40).[30] This mask-like object is the sculptural consequence of a radical transition in Picasso's pictorial and graphic work from a portrait-like conception of the head to a form of expressive stylization. It clearly illustrated Picasso's interest in the simple plastic relationships to which he had devoted himself at Gosol.[31] A certain sculptural coarsening of means, together with a concentration on block-like, distinct, even brutal masses, can also be found a little later in the works which Picasso fashioned directly from wood.

The relief *Head of a Woman* (*cat. 8*) dates from 1906. The original, as Picasso confirms, was worked in copper. This was Picasso's very first work in metal.

The first woodcuts also occur in this period. The relationship between the woodcut *Bust of a Young Woman* and the copper relief *Head of a Woman* is conspicuous. The development of this motif, too, can be observed in sketches done at Gosol,[32] because the same elongated facial type occurs in the preliminary drawings for *The Peasants*.[33]

This relief abandons the realistic, portrait-like treatment of the Gosol period. The nose is two-dimensionally incorporated, *in profile,* in a three-dimensional full-face representation. This detail is not new; Picasso had already developed it in other works in preceding months. What is new is the jutting mouth and ridged lips, which suggest a non-European source of inspiration. We are led to wonder how much influence had been exerted on Picasso by non-European art. In the case of this relief the answer is plain: Picasso was familiar with Gauguin's reliefs in wood through Paco Durio and Vollard, and in 1906 a large commemorative Gauguin exhibition was held in Paris, one of the works shown being his carved relief *Soyez amoureux*. Picasso undoubtedly borrowed his stippling technique from this composition, although Gauguin's relief is entirely covered by the system of dots whereas Picasso restricts it to the background.[34]

The detection of an affinity between works by Picasso and works which are either of exotic origin or – as in Gauguin's case – draw upon the formal richness of exotic works will not take us very far unless we relate it to the general process of assimilation in Picasso's work. There are no direct borrowings. In *Les Demoiselles d'Avignon,* for example, the African structural element enters into a general context for which Picasso himself had prepared the ground in a whole series of works: that of an all-embracing system of reality-extension which encompasses distortion, stylization and spatial compression. Far from occurring as a theme in its own right – as in Gauguin, for example – exoticism is adapted to the artist's own ends.[35]

This would seem to be a crucial point, because Matisse was the only artist apart from Picasso who managed to assimilate the principles of African sculpture in this way. One has only to compare works by Picasso and Matisse with the 'African' sculptures of artists such as Ernst Ludwig Kirchner or Karl Schmidt-Rottluff to confirm the accuracy of this statement. Carl Einstein wrote of the naive adoption of exotic elements by the Brücke painters: 'Exoticism intoxicated the Saxon primitives for lack of optical imagination.'

The discovery of African and Oceanic art occurred – as far as modern European artistic sensibility is concerned – in the years 1905–06. It can be attributed to Matisse. Picasso himself has denied seeing any African sculptures before he produced *Les Demoiselles d'Avignon,* but there is a conflict of evidence on this point. Gertrude Stein asserted that Matisse brought Picasso into contact with African art in autumn 1906, a statement which Matisse himself confirmed. Picasso told Christian Zervos that it was Iberian sculpture that he had in mind while working on *Les Demoiselles d'Avignon;* but we must assume today that Picasso was in fact acquainted with African art as well. This is indicated not only by sketches of the period but also by numerous statements on the part of his friends.[36]

Robert Goldwater was the first to conduct a critical inquiry into Picasso's relationship with African sculpture.[37] His basic assumption is that Picasso was exclusively concerned with the formal aspects of primitive works. He has

discovered some highly interesting points of comparison between Picasso's painting and the wooden masks and sculptures of the Dan (Ivory Coast) and the metal-studded figures of the Bakota (Gabon). Jean Laude pursues this inquiry in detail. His account of Egyptian, Iberian and African influences on Picasso's early work likewise culminates in an assertion that Picasso never copied a specific exemplar but developed stylistic elements which appealed to him. He was unaffected by the art-historical or ethnological significance of these works: 'In discovering Iberian and African art, Picasso discovered works whose significance was entirely unknown, both to him and his period.'[38]

Figure (p. 39), produced in Paris in 1907, is a crude wooden sculpture which might have been hewn with an axe. Picasso has stated that he regards it as unfinished. This carries the ring of conviction, especially when one compares it with smaller wooden sculptures of the same period, which, although totem-like in appearance, are more thoroughly worked (*cat. 15–18, 20–21*). The left side of the wooden block is almost untouched. The transition from torso to head and thigh is treated quite summarily. Here Picasso for the first time enlists colour in the interests of formal definition. White and red painting renders it easier to make out the structure.

Goldwater writes: 'His few sculptures in wood of 1907, although clearly under some primitivizing inspiration, give no evidence of specific stylistic sources.' Commenting on the use of paint, he goes on: 'Primitive sculpture quite naturally employs colour to enhance, or even simply to produce, any desired plastic effect, just as it can add modelled clay to a carved core of wood.'

This figure seems most nearly to recall the Tahitian *tiki* figures which Gauguin reproduced in his paintings and sculptures.[39] A Picasso drawing of 1907 bears a striking resemblance to the crude, chunky style of these sculptures.[40] The drawing is of a woman, twice repeated on the same sheet. The geometrical shape which characterizes the arm in the sculpture recurs in the drawing. This shows that Picasso can at any time make use of a formal unit independent of content. We here grasp something of the method which was later to govern all his works: the interchangeability of the elements of his formal alphabet.[41]

We are also acquainted with a head and two masks from the years 1907 and 1908 (pp. 40, 41, 44). *Head of a Woman* (p. 40) is undoubtedly earlier than the other two pieces. The surface of this perfectly serene and symmetrical bronze is smooth. The sculpture is preserved from the divisive impact of light, which serves merely to evoke two-dimensional reflections and does not break the metal into an uneven play of surfaces. The sculpture presents a wholly objectivized appearance – a formative ideal found in many contemporary works which reacted against Rodin, Rosso or Bourdelle. The protruding lips and the head, which is reduced to essentials, recall the expressive reduction which is present in the wooden sculptures. The schematic treatment of the almond-shaped eyes, from which the eyeball projects with slight convexity, has already been encountered in the *Head of a Woman (Fernande)*. The same schematization of the eyes occurs in the paintings and sketches of the Negro Period which paved the way for *Les Demoiselles d'Avignon*. Comparing this bulky and compact shape with the carved sculptures, we can see that Picasso was quick to assimilate the influence of primitive art. The conspicuous exoticisms of the wooden sculptures are fully integrated in the *Head of a Woman* of

1906–07. For the first time, Picasso obtains a sculptural representation in which dependence on received patterns and an interest in autonomous, compositionally abstract formative media counterbalance one another. Picasso has added physiognomical features more vigorously in this head than ever before, as a comparison with Rodin's *Large Head of Iris* shows. Fundamentally, in their bulky and unified outline and in their proportions, the two works exhibit startling parallels (even the shape of the mouth is similar); but the difference between Rodin's style, which subordinated all other elements to a consistent and lively play of light and shade, and Picasso's style, which aims at plastic separation, becomes clearly apparent here. Analytical elements emerge in Picasso's work with ever-increasing clarity. The *Mask* of 1907 (p. 41) pursues the same line, although its surface is not so highly polished. We are here given a foretaste of the autonomization of elements which was to culminate in the 1909 *Head of a Woman* (pp. 42–43), the chief example of Picasso's Cubist sculpture. This likewise employs simple schematization of features, a mode of treatment which we encounter in Picasso's paintings of the same period.

Mask of a Woman (p. 44), a bronze of 1908 cast from a terracotta, precludes any further talk of simplification or symmetry. It is a type of face which occurs in preliminary works for *Les Demoiselles d'Avignon*.[42] In *Mask of a Woman* we have a sort of sculptural model for the picture – one which, for all its sketchiness and deformation, leaves the real plastic values of the face unimpaired.[43]

The small bronze *Seated Woman* of 1908 (*cat. 23*) has its counterpart in the painting *Nude in a Wood*.[44] It is the first sculpture which seems to be constructed out of an interplay between void and mass; it transposes into a new medium what Picasso manages to achieve in a whole series of pictures: volumes which reach out into space and which, in turn, cause space to penetrate the sculpture. The intensive apposition of advancing and receding forms paves the way for a sculptural *construction* which takes the place of a soft modelling productive of transitions. In the celebrated female head of 1909, the evolutionary process leading to sculptural construction is complete and has replaced modelling altogether.

In other respects, *Seated Woman* recalls a *Seated Mother* of 1911 by Alexander Archipenko. There is a correspondence in the attitude of the head and the dynamic motif of the body, although Archipenko almost entirely geometricizes his theme. Picasso's *Seated Woman* also finds an echo in *The Lovers,* a relief by Raymond Duchamp-Villon. In both works, individual plastic masses emerge from the depths. A section of thigh, belly or breast inflates itself and protrudes, tightly constricted, from the ground of the relief. Matisse also applies the principle whereby solids and voids are contrasted and accentuated. In *Nude from Behind I,* 1909, the projecting mass is tightly constricted, and this treatment of material still appears to be objectively motivated; contrast is effected by means of muscular, anatomically accurate 'parcels'. In *Nude from Behind II, c.* 1913–14, and *Nude from Behind III, c.* 1914, this antithesis between fullness and neutral flatness undergoes a treatment which is independent of anatomical considerations.

If we were to look at Picasso's early sculptures in isolation, away from the context of his whole output, our imaginative faculty could scarcely keep pace with the evolutionary process through which his sculpture passed during those years. Picasso does not, like Matisse, build up his sculptural work along-

side and independent of his work as a painter, but seems from the very outset to reject the traditional division. This essential characteristic of Picasso's artistic nature prompted him to evolve a whole series of methods, techniques and shapes whose message reposes not only in the form in which they have crystallized themselves but also in the ideological role which they play in the history of twentieth-century art. Collage, construction and material assemblage have introduced into the art of our century a dialogue with reality which bears upon the reality of art itself. There are always new facts which sculpture seeks to represent; and it is also important to exploit a style or a technique, and then have done with it. Again and again, Picasso abruptly drops one form of activity and – something which is particularly noticeable in the realm of sculpture – takes a rest. Resumption almost always coincides with the discovery of new material potentialities.

THE CONTEXT OF THE EARLY SCULPTURES

Without overstating their importance, one may safely say that the early sculptural works pose major issues – all the more so because they occur only sporadically in Picasso's early work as a whole. It was not until later that his sculptural activities genuinely came to occupy the same place as his painting and drawing. Sculpture remains the exception in Picasso's early work, quite in contrast to that of Matisse, who produced over thirty sculptures in the period 1900–12. In Picasso's case, sculptures occur only where a general problem of form is involved. It is thus essential to relate these pieces to the whole of his contemporary work.

Until 1909, Picasso's sculptural activity came within the scope of a fundamental aesthetic debate. Sculpture participated in the systematic dissection of content. It was, because of the triviality of its own thematic content, a positive stimulus to withdrawal from the expressive, narrative phase, a withdrawal that became more perceptible with every passing month. Analysis of Picasso's increasing indifference to theme is essential to any understanding of the ensuing Cubist period. Only such an indifference can render the problems of form comprehensible. Picasso's recourse to Cubism might be construed as the direct result of an overproduction which had led him, in the thematic domain, close to a literary content which defied formal expression altogether.

The path to pure form was, in a certain sense, harder for Picasso than for the members of the contemporary French avant-garde, who dealt almost exclusively with the problems posed by Impressionism, a style that had abolished iconographic richness in favour of the representation of visual facts. This distinction is illustrated by a comparison between Picasso's development and that of Matisse. Symbolist painting and the literary themes of Ibsen and Hauptmann preoccupied Picasso for a considerable period. Curiously enough, his initial temporary liberation from literary themes was effected by an encounter with the work of Toulouse-Lautrec. This brought Picasso into contact with colour and, beyond it, with a thematic approach less fiercely socio-critical than that of Steinlen or Nonell. What makes Picasso's development so exciting is that it had to overcome not one particular style (Impressionism, Divisionism), as the Fauves had, but a plurality of styles and themes; he hailed from Barcelona, from a still solid and wide-ranging academic tradition.

Against the backcloth of this reduction of content, Picasso's work endows the quest for an objective quality with new meaning. Instead of inquiring into theme, we would do better to inquire into motif, into the scope for plastic variation which a motif permits. Groups of motifs take shape very early on: not set-pieces but thematically linked groups, objective juxtapositions of people, isolated figures, groups whose relationships are to the ultimate degree formal (front and back, positive and negative). Many two-figure groups are thus, in reality, juxtapositions of one and the same figure. The Gosol period, which we must today rank with the Blue and Rose Periods, is notable for the way in which this new mode of composition, which presents image and reflection to our gaze within the same pictorial unit, is systematically contrasted with the sentimental confrontations (lovers, wretched and solitary individuals) of earlier years. The items of information conveyed signify different formal states, not new contents; there is an obvious analogy with sculpture in the round, which presents the beholder with successive fields of vision as he walks round it. This was the beginning of *figuration complète,* a mode of composition which was – in Cubism – to result in the enumeration of a maximum of formal elements. Picasso was here preparing to concentrate different optical impressions, comprehensible only from different angles, in a static picture or relief. His sculptural work was thenceforward to be governed by this innovation.

THE CUBIST 'HEAD OF A WOMAN'

The first work to introduce a radically new mode of composition into Picasso's sculpture was the 1909 *Head of a Woman* (pp. 42–43). In this, the sculptural volume is made up of discrete formal units, approximately equal in magnitude.[45] Numerous drawings and paintings for this head exist. These were begun in spring 1909 and developed, during a visit to Horta de San Juan, into the high degree of formal disintegration which is evident in the sculpture. The treatment of light and shade is systematized into a strict rhythm: light zone, dark zone, light, shade. Moreover, some problems involved here were soon to constitute the early Cubist world of imagery: convex masses are negatively represented as concave recesses. The forms employed are rich in alternative interpretations: one and the same formal unit can signify different things according to the position it occupies in the work; the position – hair, forehead, cheek, neck – assigns the message. The basic shape of the head remains intact.[46]

The increased significative range afforded by these interchangeable formal units becomes apparent in a painted still-life which uses, to denote apples and pears, shapes that in another work signify breasts and hair.[47] Ambiguity of content prevails. If one wished to compile a dictionary of these early Cubist shapes, one could enter the symbols hair, breast and fruit under the heading 'rounded forms'. One formal unit can express a variety of symbols. During the analytical phase of Cubism Picasso elevated the 'rhyming' of related shapes within a single work into a genuine creative principle. Knowledge of the various structural relationships in which the same shape can assume different meanings enriches our aesthetic experience. What appears to be an abstraction of reality is, fundamentally, a subtle process which occurs on the objective plane. Picasso's work was never to lose this bias towards reality.

In this *Head of a Woman* he has adhered to a structural principle in representing the face and the hair: a balance between volume and void. The most important sections – eye-sockets, nose, lips – are permitted to retain their realistic concave or convex relationship to the adjacent formal units. Only in the case of forehead, cheeks and neck are convex areas reproduced as concavities. But the elements which comprise this head are not restricted to the use of formal units. Movement is conveyed in the region of the neck and throat: this takes the form of a torsion effected by elongated ridges arranged fan-wise which contrasts the head with other units of mass – ridged protuberances. The contrast between the flaccid, guttate units which constitute the hair and the upward-thrusting ridges which characterize the twisted neck sets up an autonomous rhythm: the heavy, symmetrically arranged hair meets the dynamic thrust of the ridges that run counter to it.

The 1909 *Head of a Woman* is the major work by Picasso which can be termed a Cubist sculpture. Although Picasso himself reverted to a fully plastic style of modelling only once more during his Cubist period (in *The Glass of Absinthe*, 1914, p. 49), *Head of a Woman* inspired a whole sculptural genre.[48] Roger de la Fresnaye, Raymond Duchamp-Villon, Alexander Archipenko, Juan Gris, Henri Laurens, Jacques Lipchitz and Umberto Boccioni adopted Picasso's additive technique of accumulating formal particles.[49] A number of works by contemporaries hark back to *Head of a Woman,* among them Boccioni's *Convex and Concave Abstraction of a Head* (1912),[50] Otto Freundlich's *Head* (1910), Boccioni's *Antigrazioso* (1911), and Naum Gabo's *Head* (1916). Boccioni's interpretation in *Convex and Concave Abstraction of a Head* looks more dynamic because of its dissolution of individual masses and, in a certain sense, more expressive because it accentuates facial features; an expressive treatment of the face was precisely what Picasso sought to avoid. The transformation essayed by Gabo in his *Head* goes farther than Picasso's 1909 *Head of a Woman* because it radicalizes the 'constructional' technique that had been evolved by Braque and Picasso in the interim. Gabo dispenses with the representation of mass: this he conveys by a framework of discs in which there is an interpenetration of exterior and interior. Mass emerges as a linear field of force.[51] Gabo uses interpenetration in a manner which Picasso had already achieved in his sheet-metal and paper constructions.

With the 1909 *Head of a Woman,* Picasso had brought sculpture a new freedom which it could derive neither from the boldest development of Rodin's disintegration of form nor even from the most radical concentration on Maillol's formal symbols. This work is as important in the history of sculpture as *Les Demoiselles d'Avignon* in that of painting.

What applies to the development of so-called Cubist sculpture, as it took place under Picasso's influence, applies equally to the painting of the same period: from a certain point onwards, there was an independent and parallel development of Cubism as such, which diverged from the works of Picasso and Braque. The works of other artists belong to a different category because they sought to resolve problems which Picasso and Braque had excluded from the reckoning: those of psychological representation. This seems to be the real aesthetic frontier of the Cubist system. Instead of regarding Cubism as a total language which relates form and content, contemporary artists used Cubist dissection simply as a plastic medium for the message of content.

The 1909 *Head of a Woman* remains a work apart. It is a sculptural synthesis of Picasso's ideas on formal analysis, in which the tendencies towards the consolidation and the disintegration of form are in balance. Picasso's pictures, like those of Braque, soon afterwards abandoned the mode of composition which leaves a firm plastic core intact. The next phase, synthetic Cubism, is unplastic. Particles of space and volume are replaced by two-dimensional patterns and dynamic lines; the transition to spatial depth no longer occurs by successive stages. Foreground and middleground are removed from each other in the form of layers of relief.

During the intermediate phase, in which painted portraits predominate, Picasso increasingly dispenses with separation into concrete and discernible formal units. The interplay of facets arouses no haptic ideas in the beholder. Having previously rooted his analysis of form in firm and recognizable spatial relationships, Picasso now encourages us to 'read' his work with the aid of thematic stimuli. We identify a portrait with the help of allusions: a lock of hair, a moustache, a pipe. This is a decisive reaction against Cézanne's pictorial approach, on which previous works had been based. In these paintings, identification of pictorial content is no longer facilitated by overall structure; instead, a representation is made legible by thematic details which carry scant formal weight. Moustache and pipe – additively superimposed on a consistently faceted structure – help us to elucidate an initially indecipherable text.

This also changes our attitude towards the work itself. Previously recognizable *in toto* by means of a single visual process, this now calls for a radically different mode of reading. As long as we lack the key to a work, its objective content remains hidden from us. The concept of 'reading', in Cubism and in Picasso's work in general, presupposes that the beholder is a knowledgeable and experienced partner; and the way of reading must adapt to cover new modes of interpretation. This is the context in which we should view all the inventions in Cubist technique which Picasso and Braque introduced in the course of the next two or three years: construction, collage, and *papier collé*. All of them are techniques which alter the concept of reading, a term which defines a continuous activity. The work postulates a mode of reading adequate to itself.

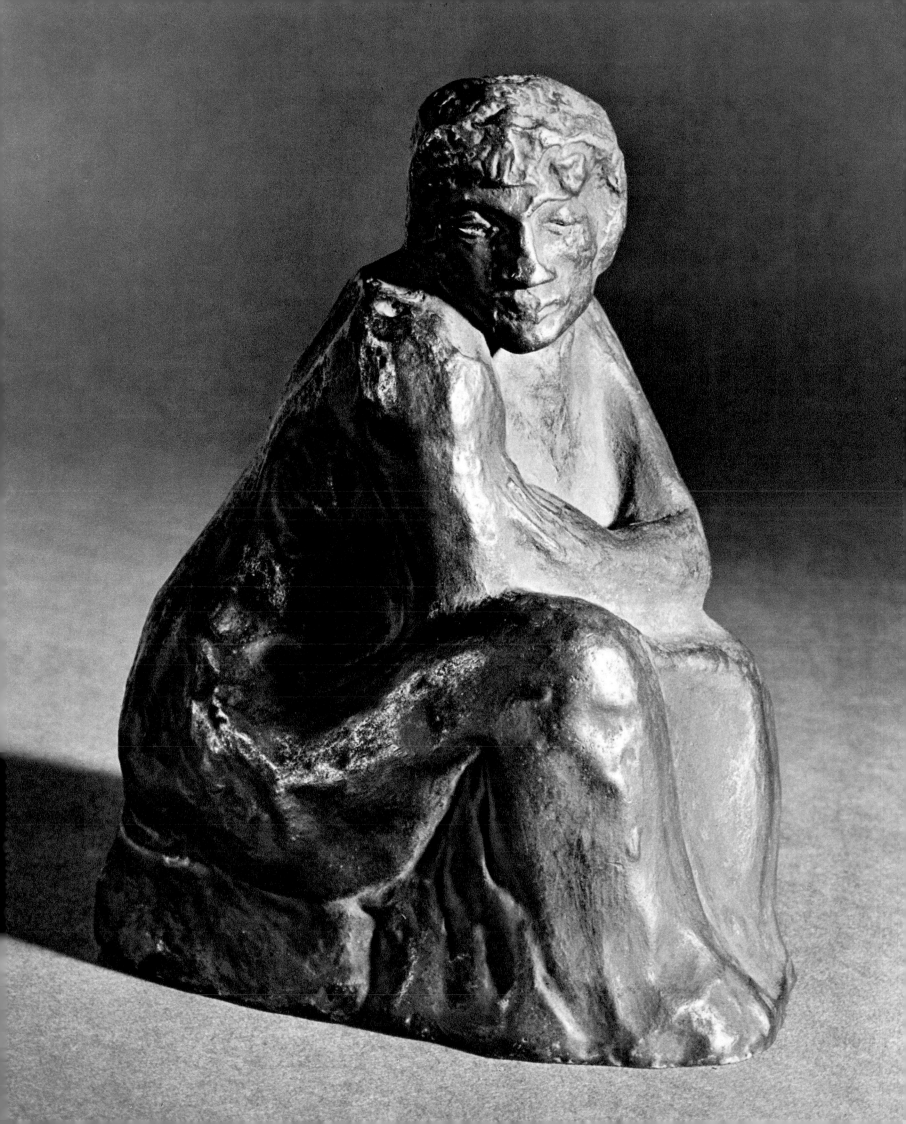

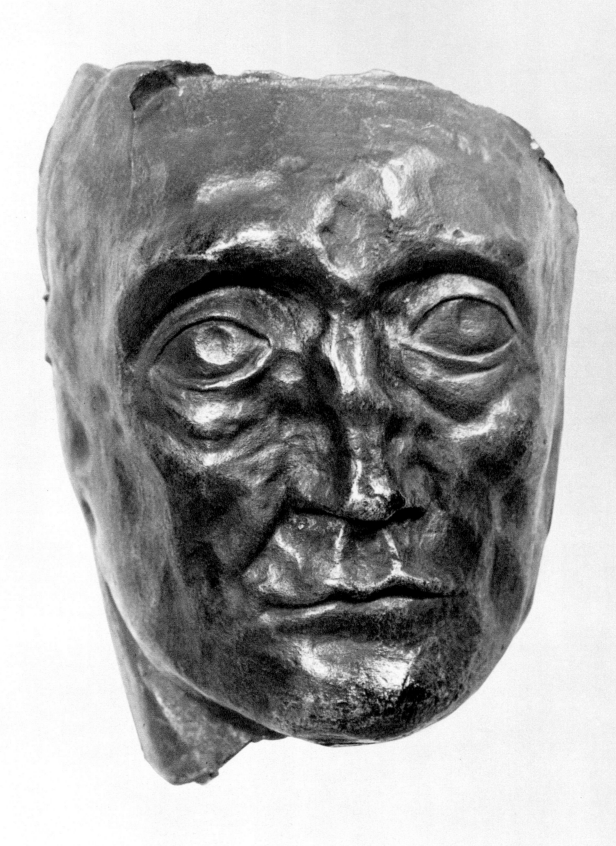

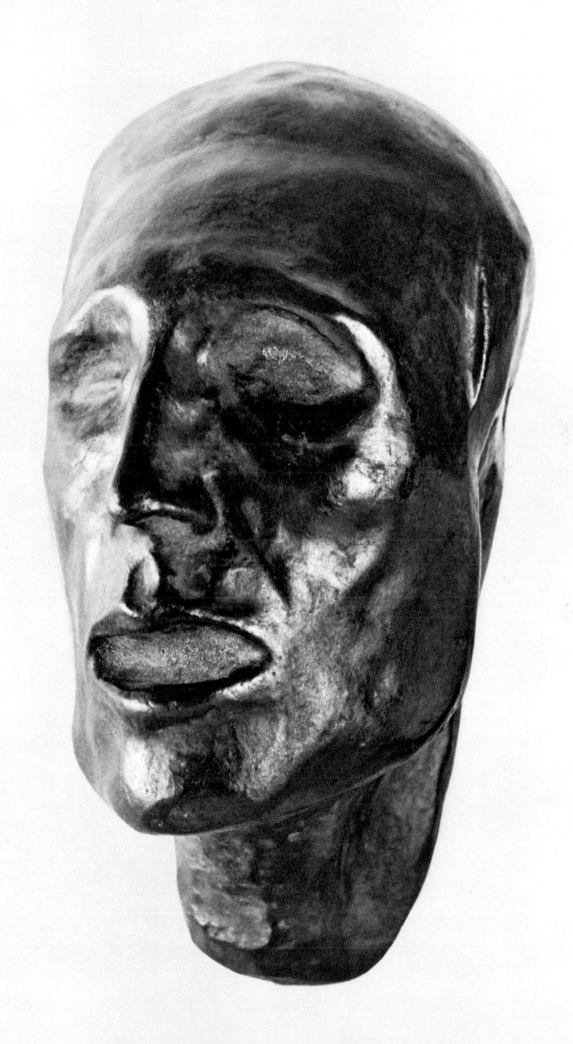

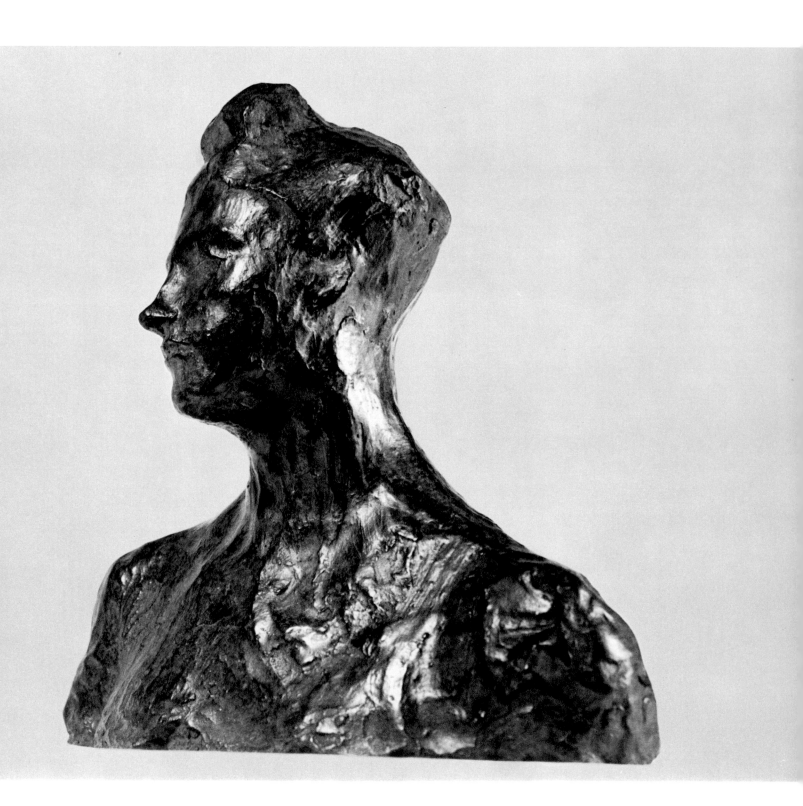

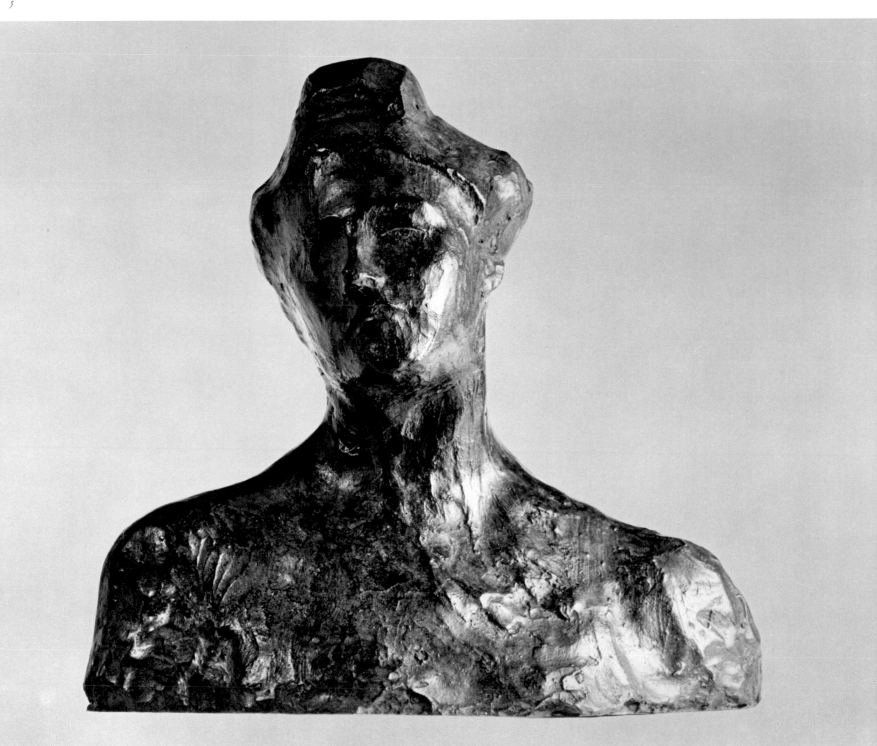

4 ▷

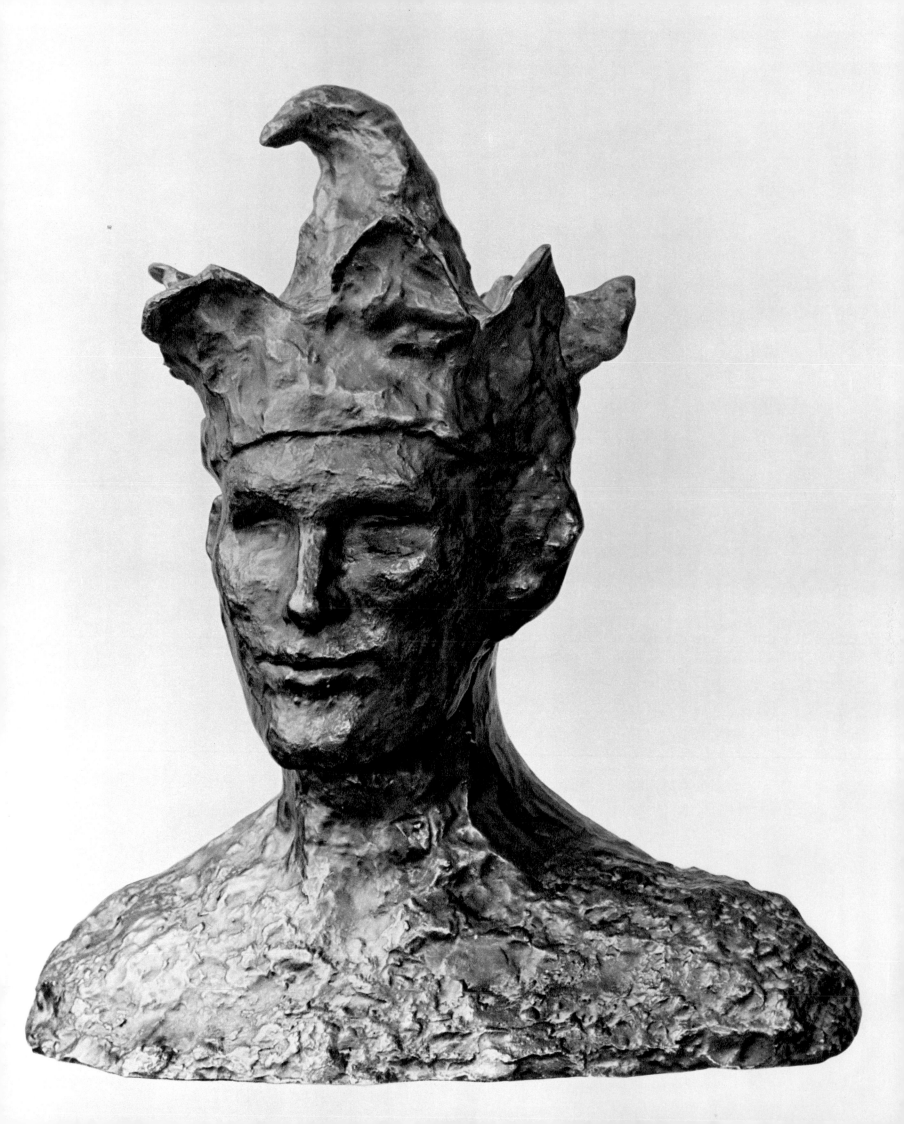

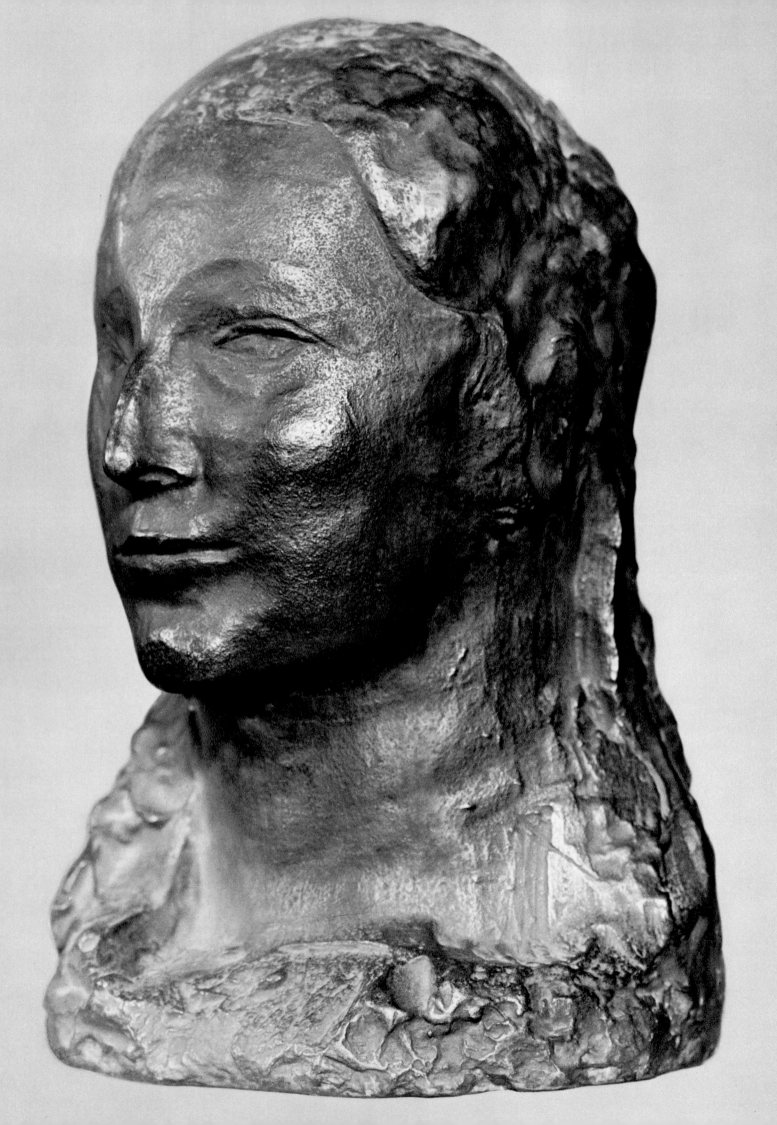

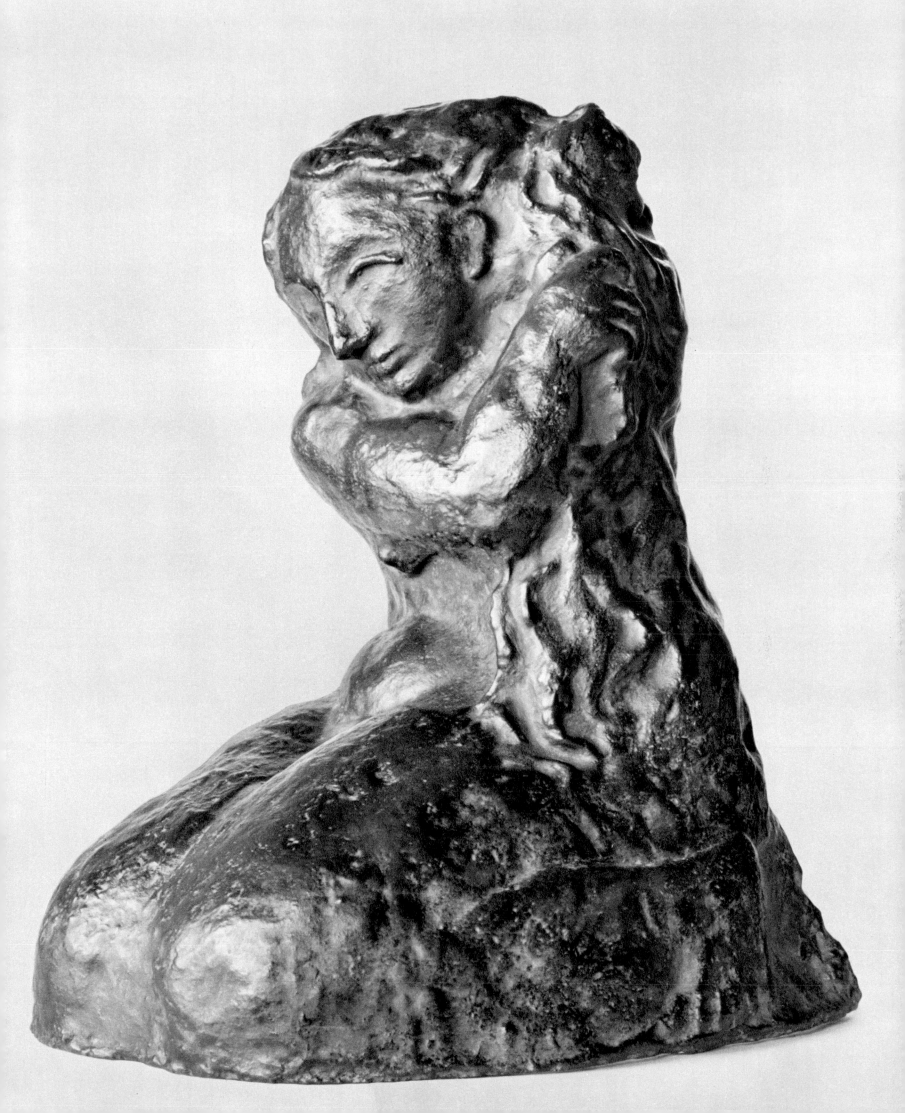

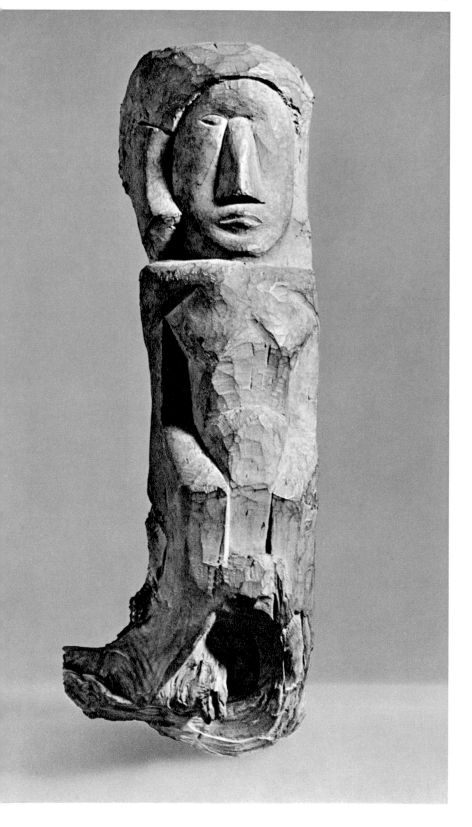

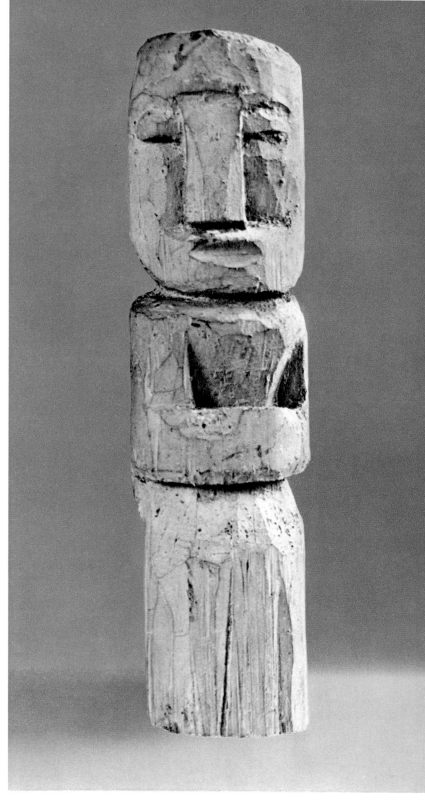

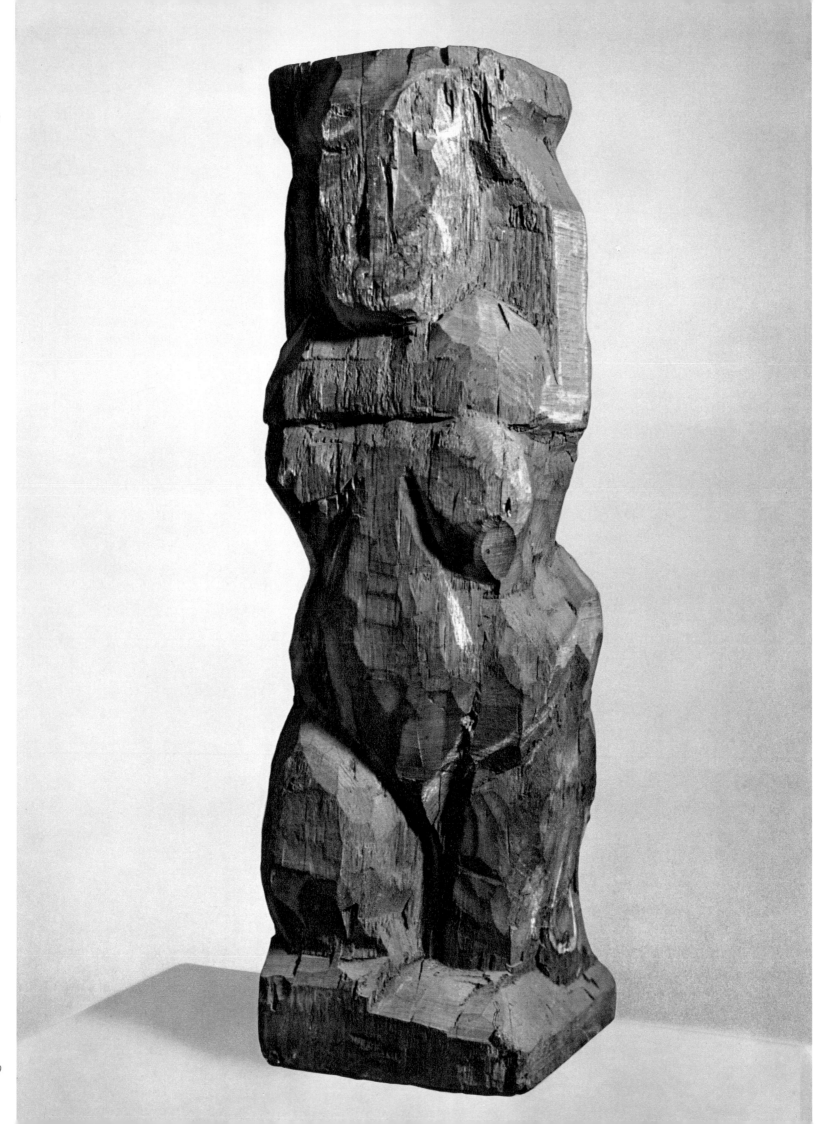

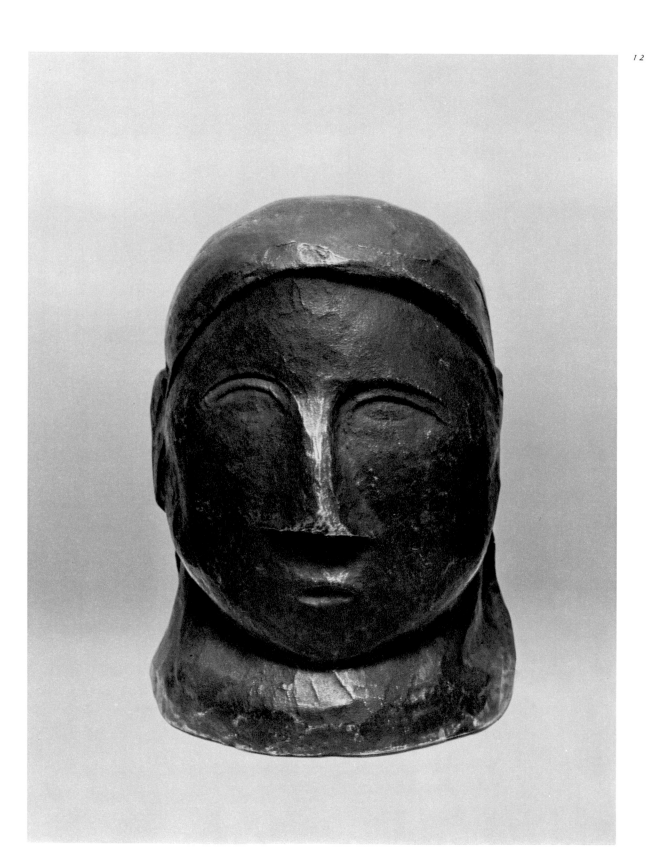

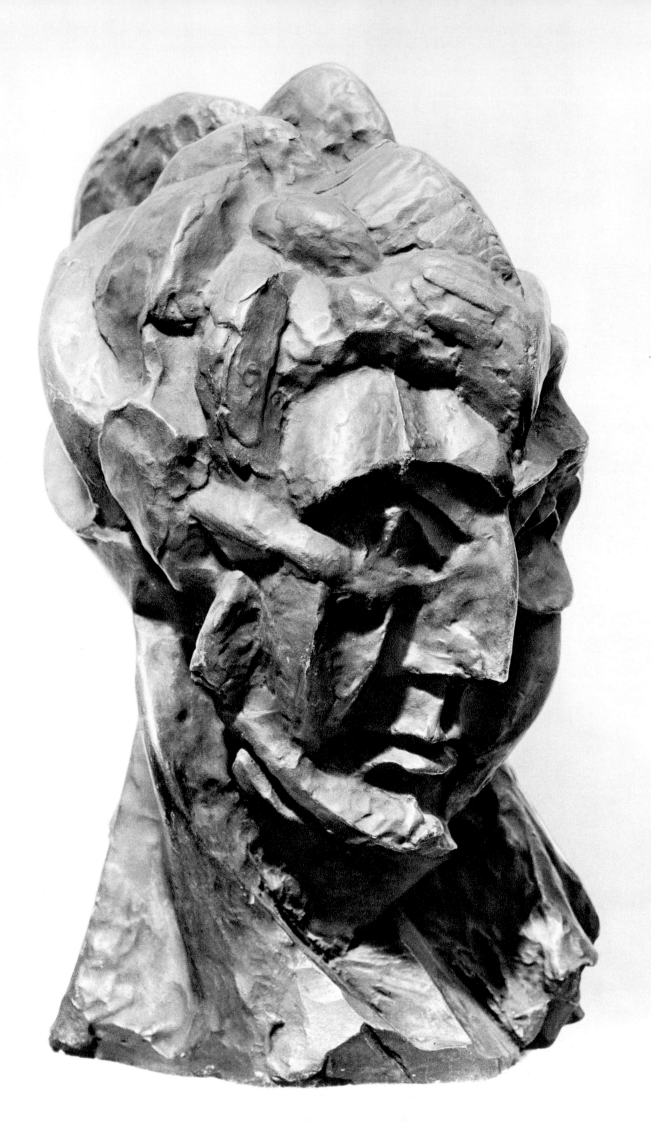

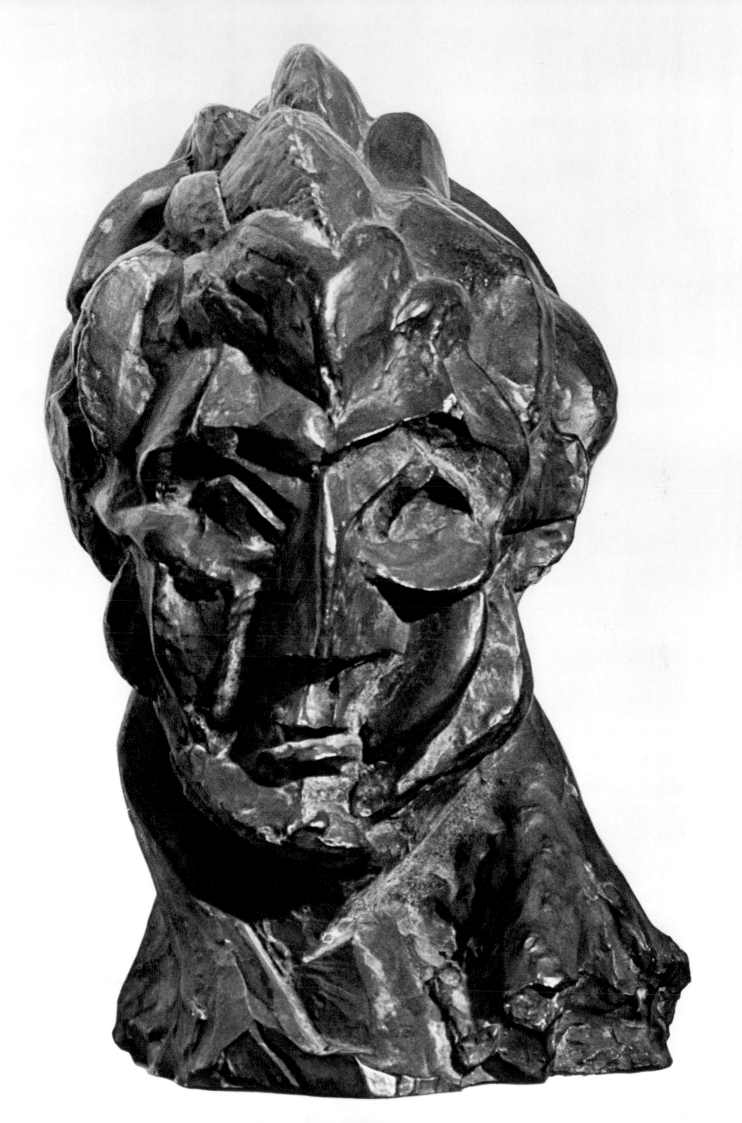

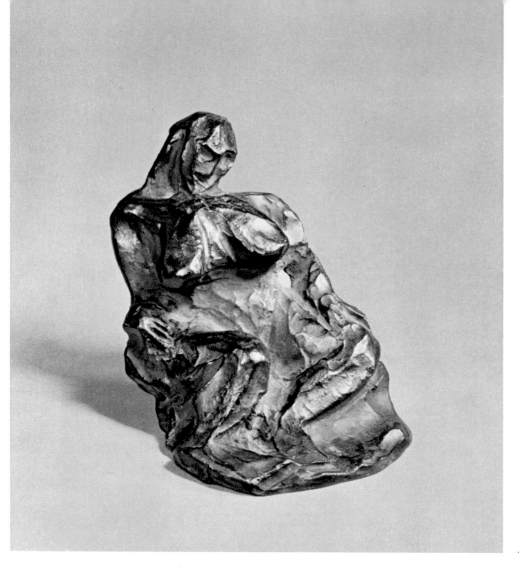

23

22

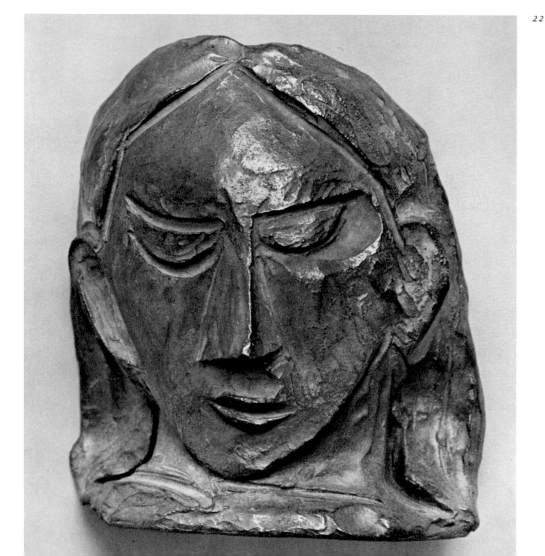

Constructions

PAPIER COLLÉ

Papier collé, the use of pasted paper as part of a painted composition, is one of the crucial aesthetic innovations of the twentieth century and the germ-cell of all techniques which transcend the divide between painting and sculpture. It first appeared in 1912; there are many written accounts of the circumstances surrounding this invention, and of Braque's role in its genesis.[52] At about the same time Braque produced a number of three-dimensional paper constructions in the Hôtel Roma, rue Caulaincourt; none has survived. Not so with Picasso. His 'constructions', in various materials, of which we possess examples dating from 1912 and 1913, display an astonishing degree of variety (*cat. 28–35,* pp. 57–60). They might be described as spatial sketches of ideas of which no equally succinct account exists in his contemporary work as a painter. Nowhere in his paintings or drawings does Picasso confine himself to so relatively simple a representation of a musical instrument as in his 1912 construction *Guitar* (p. 58), if only because a three-dimensional construction can spell out the spatial relationships which in a picture would have to be *represented*. Executed in a single material and unpainted, this sheet-metal construction does, fundamentally, already belong to the synthetic phase of Cubism, which no longer tackles spatial problems by trying to imitate modelling but solves them by the superimposition and juxtaposition of surfaces. Thus, in this construction, the very deep, richly contrasted plastic shape formed by the sound-box and sound-hole is left to be modelled by light, and an unsculptural conception of space, like a stage-set, is produced by superimposed planes. The unique formal quality of this work depends on the antithesis between clearly discernible planes and dark and diffused shadows.

Kahnweiler, who tends to play down the influence of African sculpture on Picasso's work, associates this composition with a Wobe sculpture from Nigeria which was then in the artist's possession. This sculpture, in which eyes, nose and mouth project from a flat plane in the form of circular or oblong shapes, left its mark upon a number of paintings produced over the same few months. In these, face and limbs are no longer represented by means of the faceted formal units of analytical Cubism; instead, a symbol is introduced for each portion of the face and body. Picasso no longer geometricizes an organic structure but assembles a body out of separate parts. However, he never borrows verbatim. In the *Guitar,* for instance, he combines the borrowed elements with the convex-concave dialectic of a single form. The sound-hole of the guitar, fashioned out of a section of stovepipe, is at once a hole and a cylinder. There are, nevertheless, certain indications that we

must construe this sound-hole in its original function. In the first place, this work is a relief, not a sculpture in the round: the cylinder is supposed to be seen in such a way that it disappears. In negating the cylinder by viewing it frontally, because its true form is only visible from an oblique angle which does not do justice to the work, we re-create the sound hole.

Picasso's preoccupation with the musical-instrument motif remained limited to sculpture. This is not refuted by the existence of three contemporary photographs showing a paper version of the *Guitar* together with a number of drawings.[53] These are merely complementary to the construction they accompany and may well be subsequent to it; in any case they are hardly drawings in the accepted sense at all. In translating a three-dimensional composition, Picasso very rarely uses hatching or shading; in general he conveys sculptural volume by using a medium which itself transcends the limitations of two-dimensional representation: *papier collé*. Because of the difference in material, the pasted shape stands out spatially from the two-dimensional drawing.

The distinction between sculpture and painting in the works of this period is thus a fluid one. Picasso himself at first made no categorical distinction between painting and construction. What is certain is that, having pictorially and graphically overcome the uniform flatness of pictures by means of analytical Cubist fragmentation of forms, Picasso now set out to transcend it materially as well. The fictive plane of the painted picture and the drawn drawing had hitherto survived intact. Picasso and Braque now made an assault on the medium itself, as we can see from a glance at Picasso's materials and grounds. His mixed techniques are manifold: *papier collé* supplemented by drawing; *papier collé* supplemented by oil-painting; *papier collé* mounted on cardboard; drawing, *papier collé*, sawdust; oil, sand, drawing and *papier collé* on cardboard; oil and pasted fragments of cloth; oil and plaster; painted wood and metal.

All the three-dimensional constructions, with all their enormous influence on twentieth-century sculpture, are thus rooted in painting; they owe their existence to a criticism of the pictorial. They have very little in common with his previous, modelled sculpture, beyond the fact that they are the product of an additive process. The introduction of such revolutionary materials as sheet metal, paper and wire was quite as significant a step in sculpture as that of pasted paper was in painting. In both instances Picasso transplanted into art foreign bodies, materials which lay beyond the bounds of painting and sculpture. An assembled or constructed work was founded on new creative principles. Materials acquired primary importance. The nature of representation in the traditional sense was negated: in place of a stylized and controlled representation of reality, the artist had to create a new reality. The whole technical style of the early twentieth century seemed to legitimize this. The objective and visible no longer constituted a barrier. Reality began to transcend that which was objectively comprehensible.

THE ANTHROPOMORPHIC MUSICAL INSTRUMENT

Braque was the first to introduce musical instruments into a Cubist composition, in 1908. To ascribe this to his passion for music – at a juncture when every thematic innovation had a formal motive – would be unduly superficial.

In winter of the same year, Picasso turned to the same motif in his *Woman with Mandoline*.[54] He uses the mandoline because of its formal analogies with the human body, so that woman and instrument coalesce into a single overall shape. This occurred at a time when Picasso was increasingly restricting himself to very simple objective allusions. The notion 'female body' is, as it were, accommodated in the shape of the musical instrument. An interrelationship comes into being between instrument and anthropomorphic structure. Picasso has confirmed this interpretation in conversation with me; he denies any thematic interest in the musical instrument itself. 'I know nothing of music,' were his actual words.

In his later works we constantly encounter representations of the human body which are just as ambivalent as are these Cubist musical instruments.[55] And here we already apprehend the thematic and formal flexibility in Picasso's work which was to replace Cubist dissection during the 1920s and 1930s. The integration of two themes in a single shape does not, however, signify metamorphosis: it is not designed to change a reality but to underline a formal relationship which is aesthetically ascertainable.

These constructions vary widely in character. They run the gamut from high relief to bas-relief. In the *Violin* of 1913 (p. 57), for example, a box-shaped centrepiece projects slightly from the ground within the sound-box only. The instrument's other plastic relationships are represented by painted surfaces pasted one on top of the other. The architectural conception of these works, to which attention has often been drawn, is not the whole story: architectonics, understood in the Constructivist sense, presupposes a certain indifference towards material. This is true in the case of the *Guitar* of 1912 (p. 58), because the aim here is quite clearly to interpret a shape, render it three-dimensionally comprehensible, and create from it a materially neutral model. In other cases, materials are employed not only structurally but, above all, as autonomous elements of form: the pre-shaped, turned piece of wood in *Violin and Bottle on a Table* (1915–16, p. 64) is rendered alien by a new representational context. Here, too, the aesthetic experience is founded on the ambiguity of a shape. Permutation within the work does not here occur between two levels of meaning, as it does in the picture *Woman with Mandoline* of 1908, but between a non-artistic object and its novel artistic use.

Boccioni, too, in his *Technical Manifesto of Futurist Sculpture,* calls for a wider range of sculptural materials: glass, cardboard, iron, cement, hair, leather, cloth, mirror-glass and electric light.[56] Archipenko likewise speculates on new working materials. Nevertheless, the mode of use which Boccioni illustrates in *Head+House+Light* and *Fusion of a Head and a Window* (1912) differs from that of Picasso, who is not so interested as Boccioni in the inherent expressiveness of materials. Shapes and objects attract him more. The contrast between the non-artistic reality of a structural element (scraps of paper, turned pieces of wood) and the status which this can assume in a work of art is more important to him than the idea of the 'poetry of modern civilization' which underlies Futurism. In citing iron, cement, mirror-glass and electric light in his *Manifesto,* Boccioni is referring less to their structural potentialities than to their modern cultural content.

The year 1914 brought a fundamental change in Picasso's style. The individual motif of a composition once more acquires greater weight. The objects

that are put together in his pictures become separately identifiable. They are pictures which display varying centres of gravity. The space between objects once more becomes a conventional interval: the continuous, interwoven structure is abandoned in favour of more dominant parts, in pictures for which Alfred H. Barr has suggested the designation 'Rococo Cubism'.[57] A new polychromy assumes importance in this stage of Cubism. It is inseparable from segmentation of the pictorial area because the colour is not unified or continuous: it does not seek to subordinate the representation to a single colour or harmonize it. Contrasts of colour and form now play a more important role than does analytical Cubism's pursuit of harmony through monochromy and formal units.

REALITY AND REFLECTION: 'THE GLASS OF ABSINTHE'

Seen against this background, particular importance accrues to one sculpture which – like the *Head of a Woman* of 1909 and the constructions of 1912 onwards – fundamentally widened the scope of sculptural potentialities: *The Glass of Absinthe* of 1914 (p. 49). In reality, this work ought to be referred to in the plural because the six casts from a wax model were variously painted; one cast is coated with brown sand. Here, for the first time, Picasso supplies us with a cycle of variations. The process of variation is restricted to painting, but the resulting differences of emphasis are so marked as to give the impression that variations in form are involved as well. The paint stresses first one element, then another, establishing a succession of new formal correspondences. Viewed thus, *The Glass of Absinthe* is closely allied to synthetic Cubism, which not only introduces stronger colouring but organizes and simplifies a picture with the aid of colour.

This work has hitherto been considered too narrowly in relation to its formal content – to the simultaneous representation of open and closed volumes. Its crucial novelty does not lie there, however, because we constantly encounter this interpenetration in Picasso's pictures. The glass is a favourite motif of his. Glass and bottle, with their transparency and immanent optical refractions, are a manifest stimulus to analytical dissolutions and extensions of form. The distortion and ambivalence of visual experience is a natural constituent of these antitheses. The glass is one of the major themes in Cubism, and in a wider sense than many have assumed hitherto. Barr includes in the 'iconography of Cubism' all shapes which were ready to hand in the studio. As we have already shown in the case of musical instruments, we must recognize these objects principally in their role as sources of dynamic form. All have a formal, not an iconographic, significance, which resides in their simplicity and associability.

What is new in *The Glass of Absinthe* is the manner in which Picasso here links an art object with reality. The celebrated spoon which is introduced into all six examples as a real object represents the vital additive. As early as 1912, Picasso had gummed a piece of oilcloth to a picture, where it occupied the space reserved for a table. Just as the piece of oilcloth served to represent reality by entering the fictive domain of the picture, so the spoon is confined to its own reality. A piece of banal reality is thus integrated in a work of art. Reference to reality comes into being on three levels: a *representation* signifying the glass, a *reality* termed 'spoon', and an *imitation* of a lump of sugar. Picasso

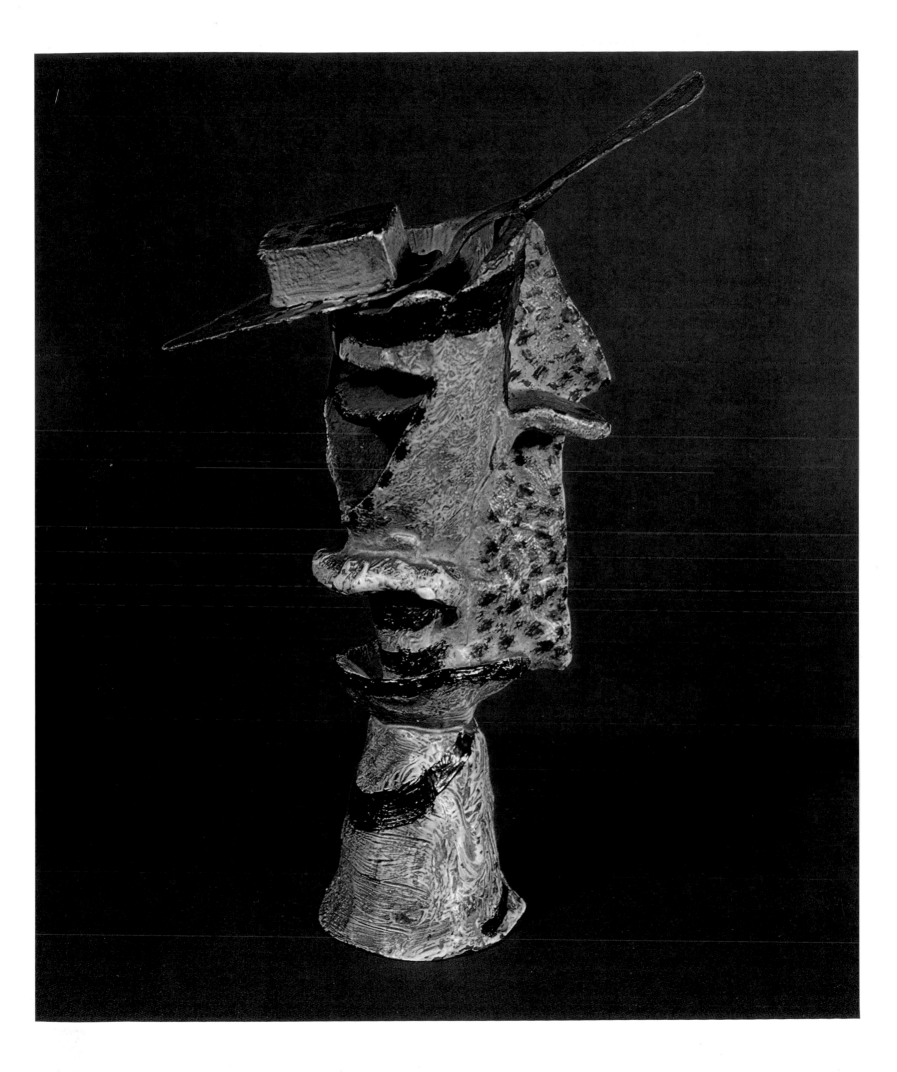

has confirmed this aim in the course of conversation. He was conscious of this mutual discrimination between object and style: 'I was interested in the relationship of the real spoon to the modelled glass – in their mutual impact.'

The use of the spoon has been related to the Readymades of Marcel Duchamp, who used them to question the validity of traditional art. The problem in Picasso's case is more complicated. He is not concerned with calling art into question. Duchamp simply picks out an object – mechanically, as it were – from a multitude of items in a store and sets it up as an art object; Picasso deliberately procures the object he needs for his picture just as he purchases paints, canvas and frame. A found object which is promoted to the rank of a work of art, unaltered save by its presentation, does not occur anywhere in Picasso's work. Either his choice is deliberate – so that the object is chosen for its shape and integrated in an artistic context extrinsic to it – or he takes the found object and promptly modifies it. The contrast he creates is fascinating and rich in tension: fragmented, sculpturally reflected form adjoins a form that is real and unreflected. Interaction results. A new plane is established on which reality and art combine to form a new unit; the object takes on a new significance in art. This is the greatest revolution that has occurred in twentieth-century sculpture.

Here lies the starting-point of all the countless methods which the artists of our century have applied in producing works from given ingredients. The blend of representation and reality (not realism) is a creative means of elevating the problem of style, which had always been dependent on the artist's consciousness, to another plane.

Picasso's *The Glass of Absinthe* was, in fact, destined to contribute more than any other work to the extension of techniques and forms. As an excerpt from reality, the absinthe-spoon is novel only in the context of a work which aims at representation, not at the illusion of reality. Degas's celebrated figure of a fourteen-year-old ballerina (1880), which is dressed in a bodice and tutu, likewise introduces the real. The contrast between bronze and cloth is important, of course; but the real clothing fundamentally serves to intensify the reality of the theme and is illusionist in aim.

J. K. Huysmans has drawn attention to the 'method of the old Spanish masters', who used to clothe sculptures in order to evoke extreme and startling realism. Although a Spaniard, Picasso never made use of such methods, which the Surrealists, later exploited; Picasso's assemblages and material pictures relate to real objects, not to surreal states of mind.

The process of reading things into a given shape, a process which employs form as a projection-screen for mental images, conflicts with Picasso's aesthetic approach. When, speaking of *The Glass of Absinthe,* I drew his attention to a school of thought which construes the glass as a face and the absinthe-spoon with its superimposed sugar-lump as a cap, he vigorously rejected the idea and told me that he had never intended such an interpretation. To Picasso, *The Glass of Absinthe* remains identical with its ostensible significance – a fact which seems to me to have a crucial bearing on his artistic self-comprehension. He looks upon reality itself, the theme of the individual representation, as a given factor which permits him further to explore the universal ramifications of a form. It is against the background of this realism – in the philosophical sense of the assertion that there is no absolute reality, crystallized once and

for all – that Picasso pursues his development of reality. He would like his works to be construed not as stylistic paraphrases but as a continuation of the creative process. His dictum 'One must invent new inventions' seems to me to typify this. It means that, in art, an object can run the gamut between recognizability and unrecognizability. Nevertheless, a shape always – however many points of departure it may afford our interpretative insight – remains nominally linked to a specific reality. The interpretation of *The Glass of Absinthe* as a head worried Picasso because he had created a precise object, not a shape which would admit of metamorphosis. The reality-principle in his art would be placed in doubt by an alternative designation of this kind. And Picasso seems to insist on such realism: even where deformation of a model is carried to extremes of grotesque complexity, the basic and unmistakable elements of that model preserve their recognizability.

He produced only two fully sculptural works during these years: *Head of a Woman* (pp. 42–43), which stands on the threshold of Cubism, and *The Glass of Absinthe*. The former still confronts us with a head of regular proportions; the latter materializes the perennial Cubist preoccupation which has been defined as 'a maximum of experience of the object'. Our knowledge of any object is moulded by our static vision. A maximum of objective experience can be conveyed to us only by an object which rotates on all its axes, in other words, by the sort of kinetic perception which obliterates form. The concept of time is eradicated from the works of Picasso and Braque; Picasso does not aim at the continuous, rotating perception of the Futurists, but at a form of perception which combines numerous spatially discrete objective aspects. Unlike Boccioni's *Development of a Bottle in Space, The Glass of Absinthe* gives no hint whatsoever of a whirling, rotating movement. Indeed, Picasso has quashed any such interpretation from the outset by placing the spoon in a firmly established relationship to the glass. It functions like a magnetic needle, as it were, enabling the beholder to orient himself because it is firmly rooted in its spatiality. The spoon is not merely an objective addition calculated to define an absinthe-glass by means of its accessories; in its linear, symbolic contrast to the plastic body, it fulfils the function which in pictures is assumed by overlapping lines. This is where we most keenly apprehend the different nature of Duchamp's Readymades, which either simply present real objects or render them alien by irrational juxtapositions.

STILL-LIFES

Surveying the series of constructions which Picasso produced in 1914 and the years that followed, one is struck by the way in which contouring of individual objects becomes more strongly perceptible. Earlier, in the initial synthetic phase of Cubism, it was almost impossible to distinguish an object from its ground; now, objects often fall back on their own formal boundaries. These are not necessarily the natural boundaries of the object itself. *The Glass of Absinthe,* Picasso's first fully sculptural projection of a Cubist subject, demonstrates this: its boundaries are the new and compact outlines of a freshly constituted reality. Where the first constructions tend to produce a framework, the later ones additionally contain a new plastic density by virtue of their choice of materials, notably wood. Although Picasso seldom reverted during these

years to his experience of borrowing excerpts from reality (spoon, turned piece of wood), the adoption of ready-shaped parts was particularly instrumental in determining the climate in which his work now proceeded.

The first constructions, fashioned out of paper and sheet metal, still convey an entirely free treatment of materials; from now on, however, Picasso seems to question the form of his material more closely and, for example, to compose a construction around a piece of wood which excites his interest. In addition, most of the works that originated during this period are coloured, coloration frequently being determined by the colour of, say, the piece of wood that is being used.

In *Violin and Bottle on a Table* (1915–16, p. 64), the anthracite-coloured, turned element provides a point of departure for the chromatic harmonization of its setting. Picasso adapts the part-forms which together signify 'bottle' to the found piece of wood with its anthracite colouring. Only the base of the bottle itself, in conformity with visual experience, is reproduced in opaque black: these works are not actually oriented towards local coloration, but the chromatic contrasts that occur in them transpose the chromatic and tonal relationships of reality. In isolated cases, Picasso also adopts the colour of the object in question. In *The Packet of Tobacco* (1921, p. 68), for example, the white-and-blue is a quotation from reality which every Frenchman would associate with a real packet of tobacco. Several of these works obliterate the boundary between relief and picture. Objects stand out in the manner of a relief, whereas the intervening space is painted – further evidence of the separation of objective reality from pictorial area. In *Glass, Pipe and Playing-card* (1914, p. 62), the objects of the title project from the ground of the picture. Finally, there is also *Glass, Newspaper and Die* (*cat. 42*), another example of the plastic detachment of objects from the pictorial ground.[58]

Painting, as we have said, plays an important role in the sculptures cited above, but Picasso resorted to colour later than, say, Delaunay or the Futurists. This statement must be more closely defined. The Blue and Rose Periods demonstrate the sensitivity with which Picasso could employ colour. In Cubism, he fundamentally remains true to the colour-treatment which was initiated in the Blue and Rose Periods. If it were not for the considerable formal difference between these two periods and Cubism, one might in a certain sense speak of a Grey-Brown Period. True colourism and chromatic tones are alien to Cubism; Picasso's colours do not attain to any independent activity of a visually stimulating nature. His use of colouring is unlike that of Delaunay, who systematically enlisted colour-relationships for purposes of composition.

At first sight, the patches of colour which Picasso distributes over his compositions seem to awaken Neo-Impressionist echoes; and these undoubtedly have a part to play. The use of individual colour particles is, however, accompanied by that of systematic formal units.

From 1913 onwards, Picasso builds into his painting a system of chromatic and formal irreducibles which are used with increasing freedom and independence in relation to subject. There develops a whole inventory of patterns and stereotypes. Here, too, Picasso proceeds deductively, deriving themes from patterns in such a way that they continue to retain a thematic residue. One constantly recurring pattern in his painting, that of parallel lines, is developed from the strings of a musical instrument. Wavy lines patently represent hair;[59]

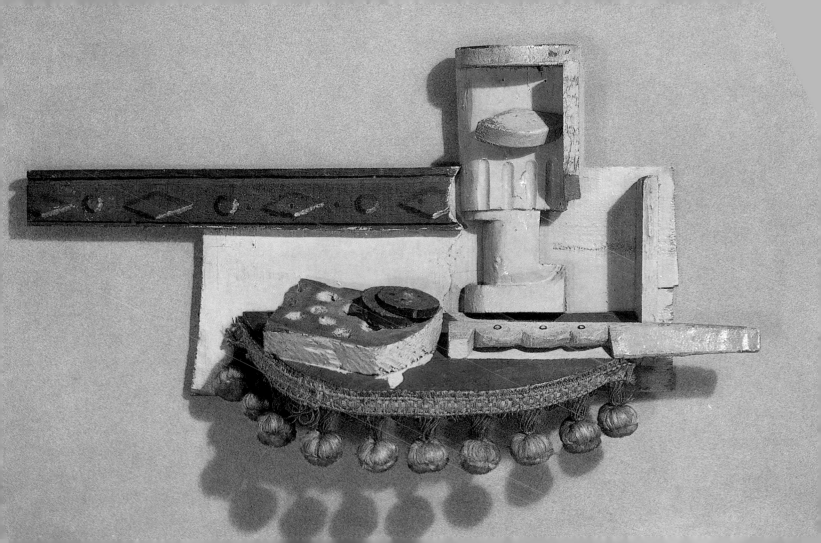

lozenges are immediately associated with Picasso's old harlequin theme[60] or hark back to representations of Chianti bottles; isolated dots originally occur as the spots on dice; and so on. Picasso's formal memory is so strong that it tolerates no non-objective shape, no shape that is unsustained by a reality of some kind.

The shapes which Picasso uses in the wooden constructions are very simple. The richest of the compositions put together out of wooden elements is the *Still-life* (p. 53) of 1914. This exemplifies a mode of composition which Picasso had not employed since his Cézannesque period of 1910, but on which Juan Gris was systematically basing his compositions of the same period: the elevated angle of vision. Having hitherto superimposed parallel objects in his pictures, Picasso here resorts to a form of perspective: the forward part of the table is folded down.[61] In contrast to *Glass, Pipe and Playing-card* (p. 62), the whole composition is plastically executed. The rhyming system which Picasso had pioneered, and which Juan Gris had systematized, here attains its supreme fulfilment.

Correspondences can be discovered everywhere in the *Still-life*. Batten and glass are as long as table section and knife. The knife is as long as the distance between its handle and the mouth of the glass. The knife and the batten form parallel movements tending in opposite directions. The tassels on the tablecloth pick up the serrations in the handle of the knife. The round shape inside the glass, which defines the level of its liquid content, is reiterated by the slices of sausage. The artistic theme is brought down to earth in an unprecedented manner: the glass is formally interpreted and promoted to a formal representation, but the sausage and cheese appear in direct imitation. This creates a stronger impact than the introduction of new materials called for by Boccioni and Archipenko. The plastic representation is a manifest assault on the fine-art theme. Although Picasso had already employed such motifs in a few pictures,[62] the incongruity becomes particularly noticeable here, not least because the ironically banal theme is treated with technical means which are almost ostentatiously derived from the golden section. This contradiction between form and theme was recognized by the Surrealists.[63]

These materialized still-lifes are important because they helped to break up the rigid grammar of Cubism. Although the same process of dissolution occurred in the realm of painting, its import to that of sculpture was greater because there the fictive plane of the picture was abandoned and a realm of new objects came into being.

Picasso made few sculptures in the interval between the wood collages of 1913–14 and the end of the 1920s (when he carried out a large-scale sculptural programme for the first time). He did, nevertheless, produce one or two works which heralded new sculptural ideas. Particularly noteworthy are two 1914 pieces (*cat. 52–53*) constructed of thin sheet metal.[64] In these, in contrast to the earlier sheet-metal constructions in which Picasso confined himself to the use of flat planes or simple circular shapes (as in *Guitar* of 1912), the metal is bent in such a way as to produce a strong plastic effect. Picasso was to readopt this technique in a long series of metal works in later years. The sheet-metal constructions of the 1920s show that Picasso very early anticipated not only the geometricizing trend in Constructivist sculpture but also the more complex tendency in which spatial factors are taken into account.

Further variations were introduced by a series of guitars and violins executed in wood or sheet iron, most of them painted. *Guitar* of 1924 (p. 66) takes the form of a relief with a strongly dynamic outline. The upper side of the sound-box is painted in white on the background. This white is intended to activate the painted shape and pull it into the foreground in its capacity as a surface area. The alternation between convex and concave in the undulating section which rounds off the base of the guitar is a palpable imitation of the gloss on a polished guitar. A surface-effect – the representation of a gleaming surface – is here expressed in plastic terms. That this mode of representation conveys volume as well as surface texture is apparent when we examine the way in which Léger employs this same undulating shape in certain pictures where the wavy line of the hair and its gloss are simultaneously expressed by the same pattern of lines.

The wavy line remains ambivalent: it suggests both a shape and a material quality. Picasso always differed from the creative intentions of the Constructivists in this respect.[65] He was never to employ material for the sake of its manifest, concrete properties – in its capacity as metal, wood, or glass. In his eyes, a working material possesses no absolute plastic value. That is why he has never hesitated to alienate or neutralize the materiality of his assemblages by casting them in bronze.

RETURN TO THE FIGURE

Representations of the human form were for many years absent from Picasso's sculpture. The last of his early figurative pieces, the *Head of a Woman,* dates back to 1909. The same applies, in a certain sense, to his painting and drawing. There, too, Picasso increasingly resorted to structures which admitted of no psychological interpretation. The Cubist portrait of Kahnweiler was the end of the line. Only a few details enable one to identify the subject. Figurative works recur during the First World War; but Picasso then reverts to a mode of representation which employs technical resources dating from the pre-Cubist period. The realistic portraits of his friends and family take no account of the Cubist language of form.

To say that the Kahnweiler portrait was the end of the line merits explanation. We have repeatedly seen that the development of Picasso's new formal language (which genuinely represented a new *language,* not merely a new style) came into being at the expense of the individual characterization of objects and physiognomies. One important feature of the new pictorial language, the permutational system which presupposes the interchangeability of basic shapes, is incompatible with the strong differentiation which is the basic prerequisite of portraiture. Undifferentiated representation is characteristic of Cubism, which presents ideal constructions approximating to objects and human figures, but no more. A glance at the imitators of Picasso and Braque clearly reveals that true Cubism is a world of expression more than a mere style. The identifiable portraits, or identifiable physiognomic representations, which the imitators of Cubism essayed, present no acceptable solutions. Picasso's portrait of Kahnweiler exemplifies the issue of the Cubist portrait at its most extreme; it is a non-physiognomic portrait in which recognition depends upon incidentals.

In one instance, however, Picasso enlisted the Cubist world of forms in the making of a precise psychological statement: the rigid *Manager* figures for the ballet *Parade,* which was produced for Diaghilev in 1917 in collaboration with Cocteau and Satie (*cat. 59, 60*). These huge superstructures, which were worn by the performers, might be described as Cubist dance-masks. Picasso translates problems of synthetic, chromatically accentuated Cubism into three-dimensional and figurative terms: superimposed, staggered pictorial planes become plastic and assume a spatial interpretation. From a formal point of view, this appears to be an innovation in Picasso's work. The Cubist constructions had until now stopped short at relief; although three-dimensionally composed, they aimed at pictorial crystallization. The beholder was assigned a particular angle of vision from which the pictorial relief became comprehensible. In the *Manager* figures, Picasso relinquishes this crystallization in favour of free spatial mobility.

Cubism had, in itself, introduced multiple aspects of an object into static representations designed to be viewed from one angle only. In the analytical phase of Cubism, shimmering splinters of an object served to represent it in such a way that a static position yielded the sum total of 'multi-visual' vision. Three-dimensional treatment of such works would have been pleonastic. Even in the later synthetic phase, Cubism lent itself only to relief-like plastic execution: the pictorial background from which the various facets projected was absolutely essential. The *Manager* figures are starkly simplified compositions in which elements of sculpture in the round (the cylinder) occur; but even these figures are incapable of movement in the true sense because they are designed in the manner of reliefs.

Picasso mitigates this dilemma by providing his dance-masks with vivid and contrasting coloration. The actual movement of a figure on the stage gives rise to a chromatic interplay which supplies information transcending the 'multiple aspect' of a static Cubist work of art. There emerges, too, an element of irony which is absent in other Cubist works: for the first time, Picasso attaches psychological meaning to the Cubist method. Cubist dissection of form is used to create a socio-political bogy. The mechanical rigidity of the figures becomes psychologically interpretable.

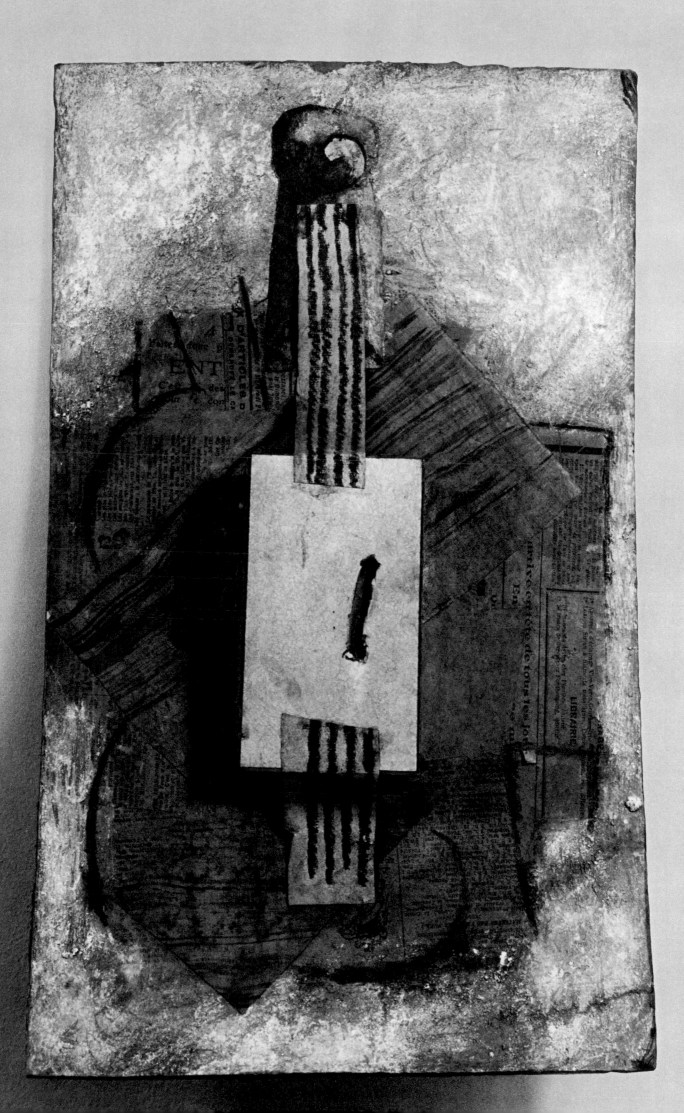

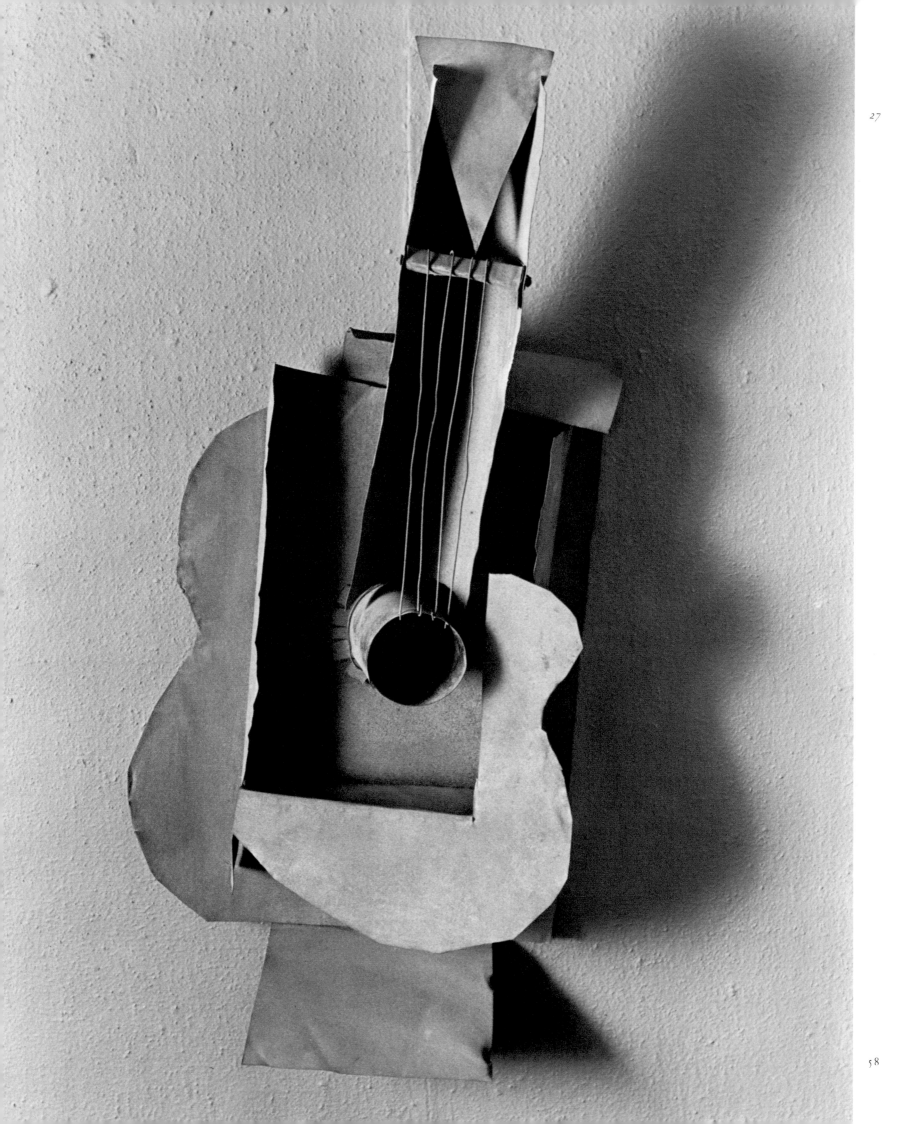

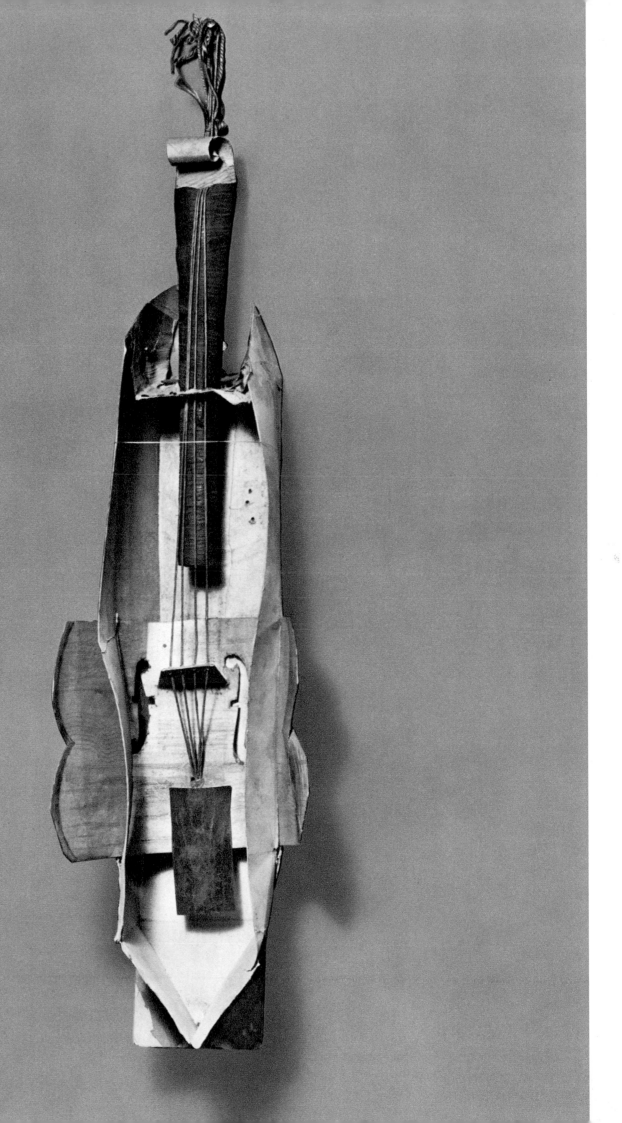

33

48

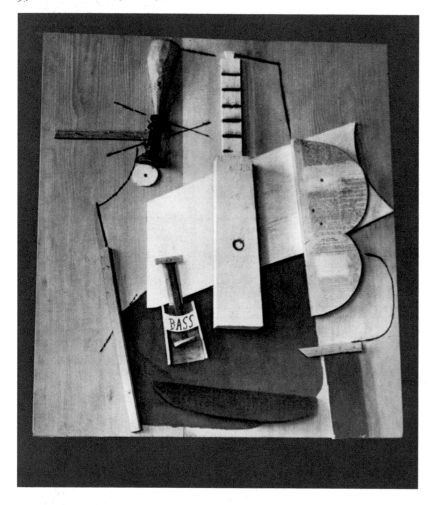

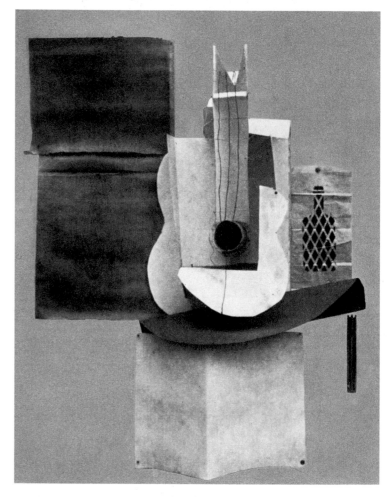

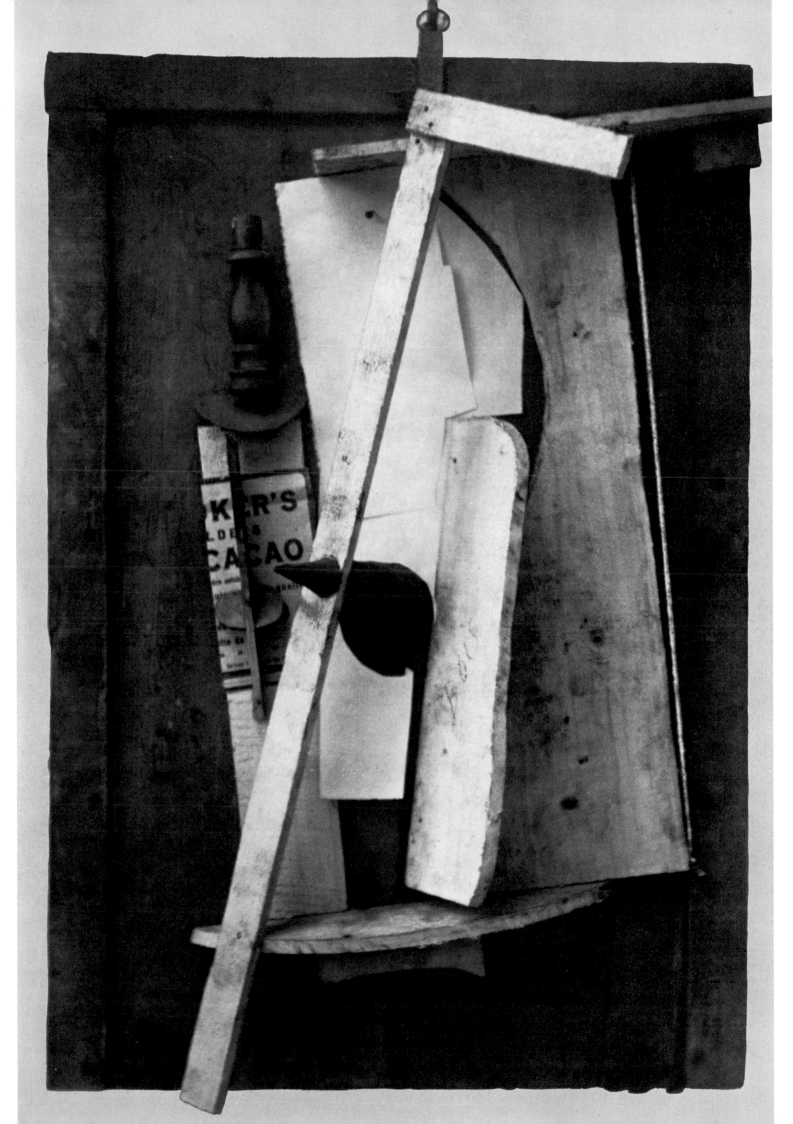

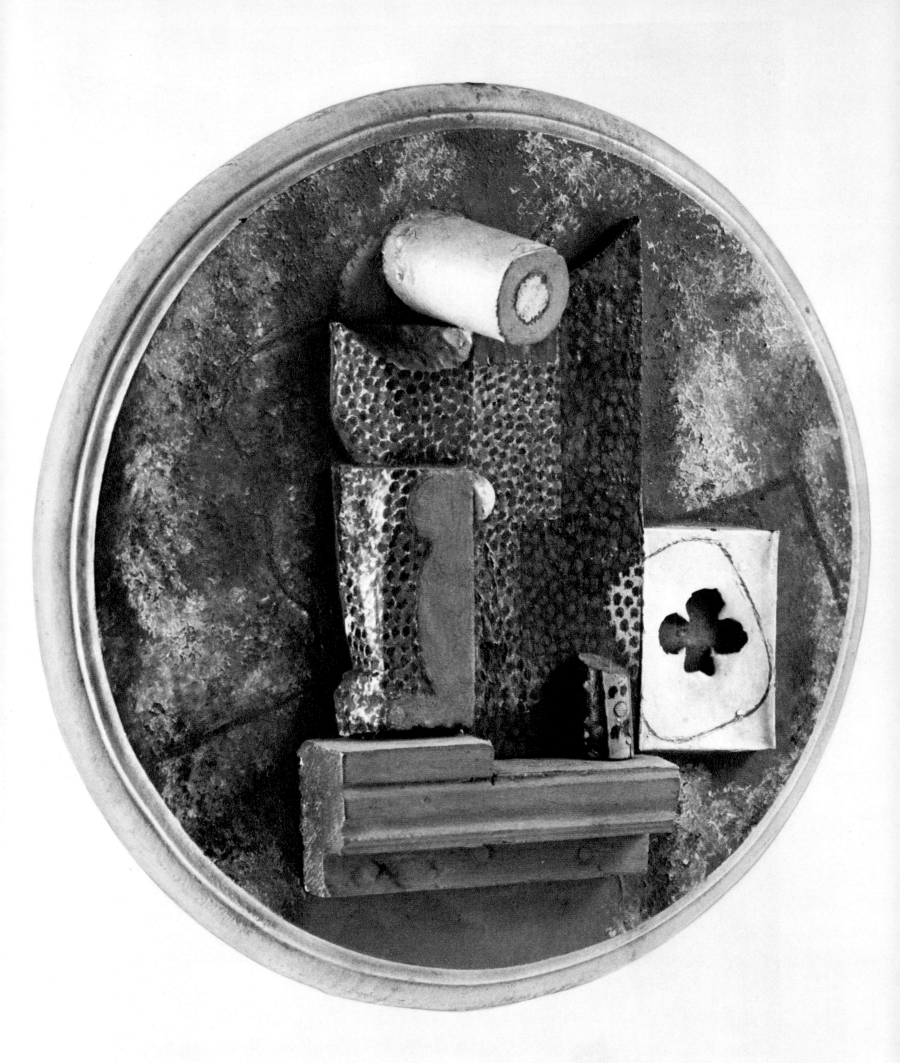

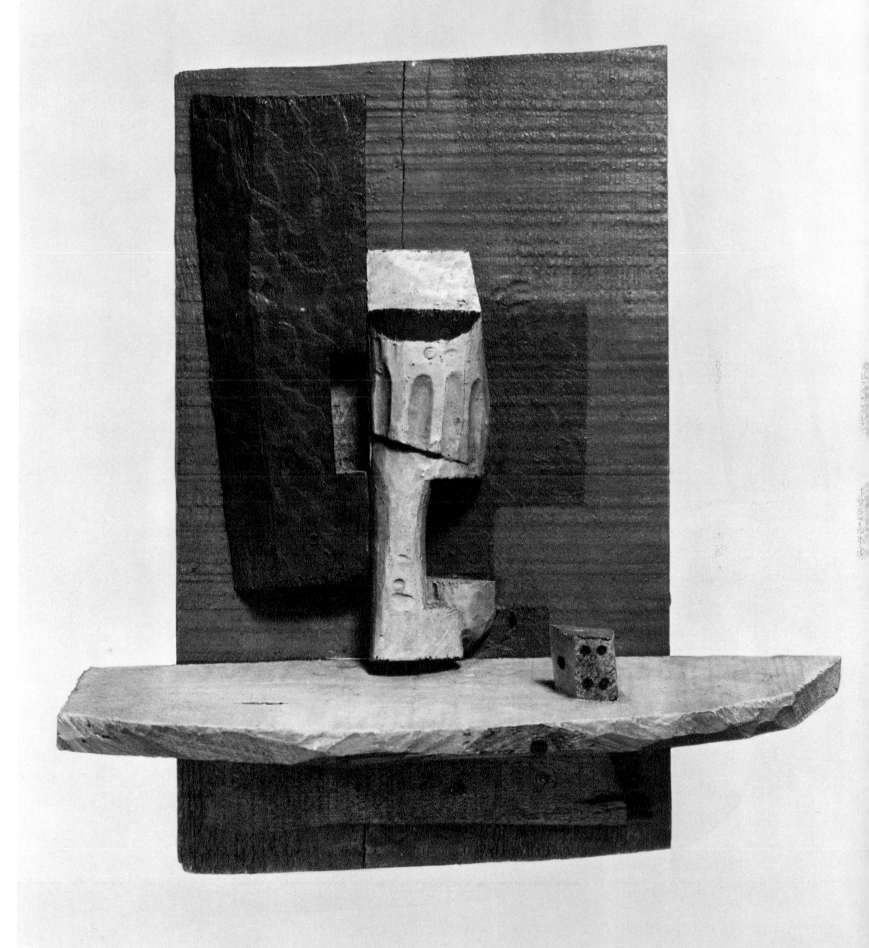

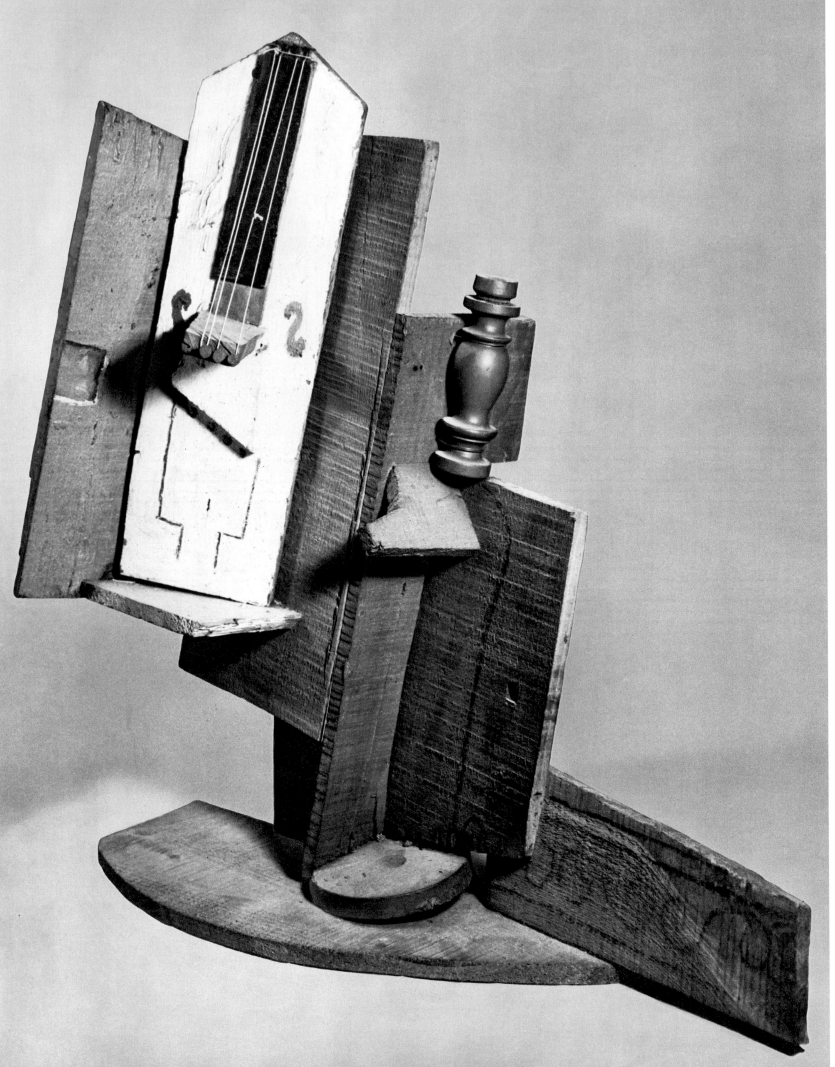

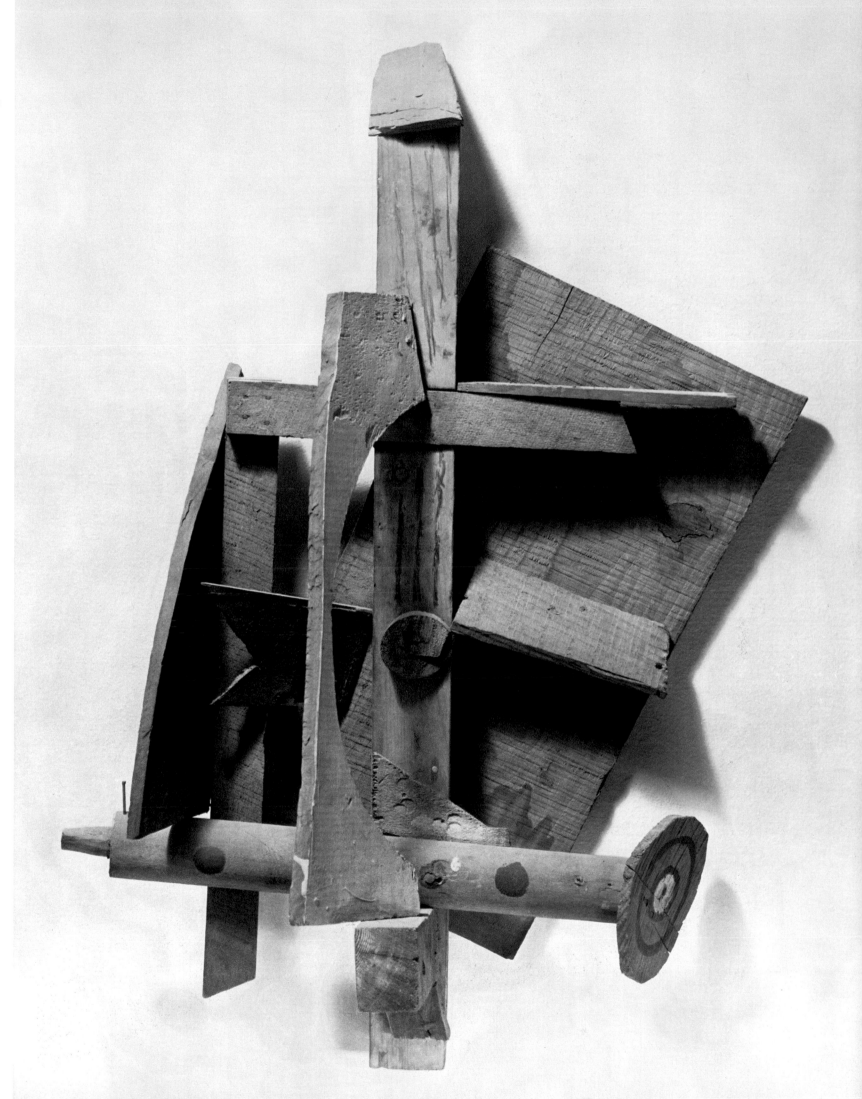

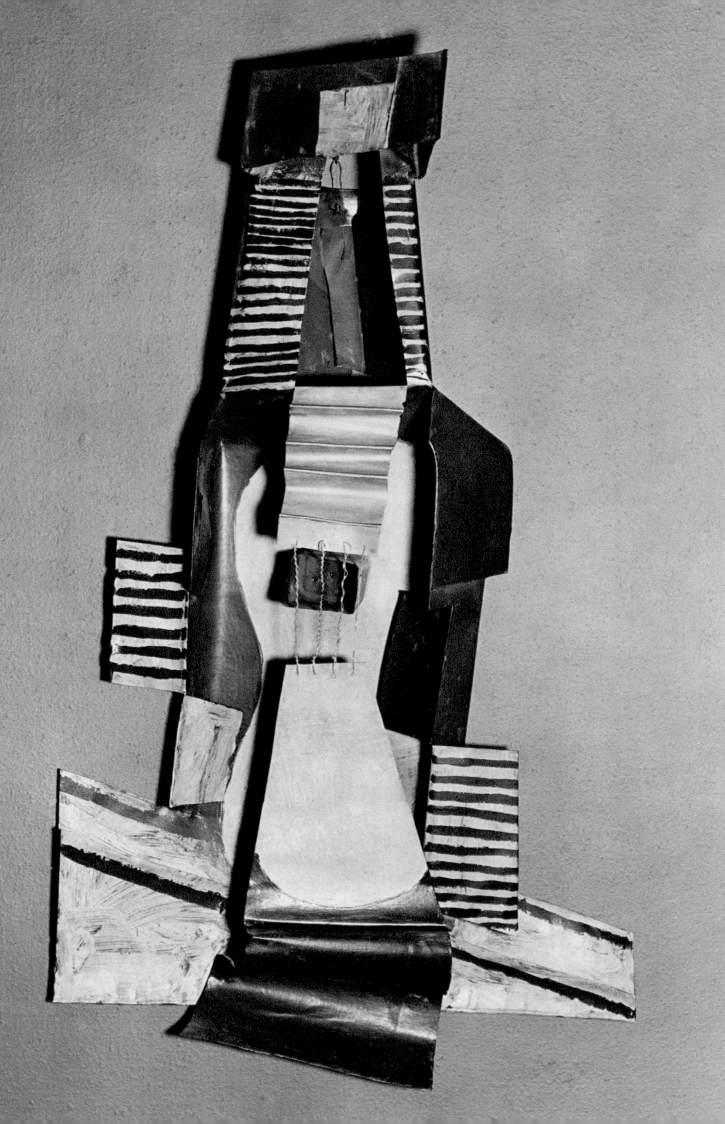

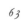

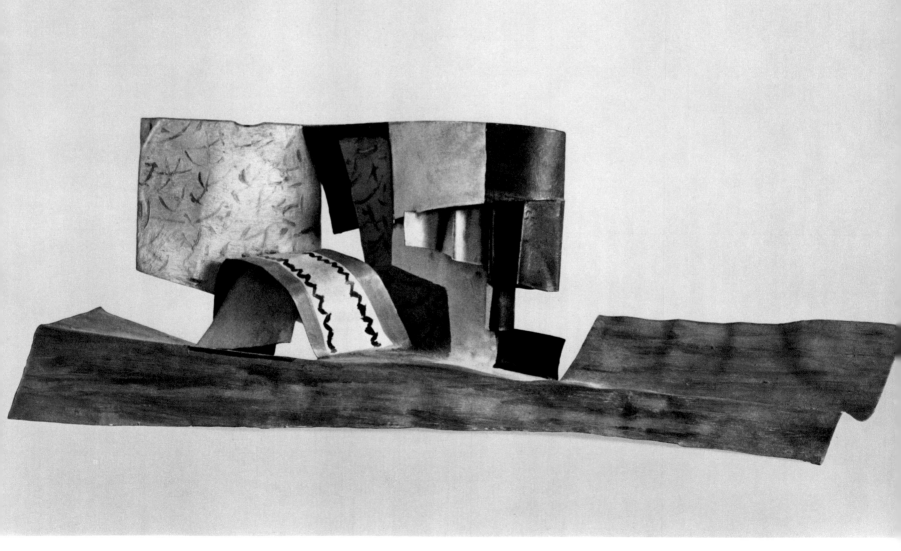

CHAPTER 3

From drawing to sculpture

POTENTIAL SCULPTURE

During the 1920s, two new and contrasting modes of sculptural expression
made their appearance. Both were developed in numerous drawings, graphics
and paintings. The term most applicable to these works is 'potential
sculpture': Picasso designed them with an eye to realization in monumental
terms but did not carry them out. All that survive are a few small models.
Kahnweiler's suggested designation for the first group is 'space-drawing'
(*dessin dans l'espace*). The second, which many writers associate with Surrealism,
has been described by Barr as 'metamorphic sculpture'.[66] Both potentialities,
Constructivist dematerialization in the space-drawings and organic tumescence
in the metamorphic sculptures, had been brought into play at an early stage in
Picasso's work.

The first traces of space-drawing occur in 1912, at the period when Picasso
was emerging from the analytical phase of Cubism and adopting a Con-
structivist approach to the object of representation. The use of wires in his
Guitars is an early technical indication of this.[67]

More studies exist for wire constructions than for any other single sculptural
problem ever tackled by Picasso. Common to them all is the exclusive use of
straight and circular elements, the circles being perspectively reproduced in
the drawings as ellipses.

Line became increasingly autonomous during these years, and not only
in sketches and drawings. In his pictures, Picasso frequently dissociates
outline and colour. Colour occurs as a free-floating plane from which a portion
is excised by the drawing. Picasso makes increasing use of a graphism which
confines itself entirely to linear effect. In addition to a neutral Constructivist
linear technique, in which only straight lines and smooth curves are employed,
we find a linear treatment of a freer though abstract kind.

The drawings *At the Circus,* of 1920, might – in comparison with the space
drawings – be called relief drawings.[68] They could be executed in wire on a
plane surface: the line unfolds in an unbroken two-dimensional flow. The
same principle plays a part in the stage designs for the ballet *Mercure* (1924).
These clearly illustrate both tendencies inherent in wire drawing: the freely
rhythmic and the Constructivist-geometrical. Also in this context belong the
numerous sketches of 1924, some of which were used in 1931 as illustrations
for Balzac's *Le Chef-d'œuvre inconnu*. Although these do not evoke a sense of
volume, the knots formed at linear intersections correspond to the soldered
joints in wire models. These divisive space-knots give rhythm to our vision
and correspond to the articulation of human limbs. The appeal of these works

consists to a large extent in this logical, traceable juxtaposition of enclosed areas.[69]

An important stage in the development of Picasso's wire constructions arrived with the sculpture *Head* (p. 80), which he produced in 1928. The symbols for eyes, nose and mouth are arbitrarily varied and juxtaposed within a basic 'head' shape. *Head* exemplifies the greatest simplification and abstraction attainable in this coupling of symbols. It also typifies Picasso's new figurative style, numerous examples of which can be found in his contemporary painting. The process of sculptural development can be directly traced in a series of dated sketches for this work.[70] In two drawings Picasso goes farther than in the sculpture, disregarding the suggestion of plastic volume and reducing the shape to a pure outline.[71] Having at first essayed variations of the face in terms of linear elements, he abandoned this intricate activity, which was too differentiated and rich in contrast for a wire construction, and turned in his studies to anthropomorphic wire skeletons.[72]

Picasso later varied this technique. Brassaï notes in his diary for 1943: 'Picasso disappeared and came back holding a small slab of wood on which stood an astonishing and audacious line-construction; the pieces of wood were attached to each other with tiny beads of modelling clay. I wanted to photograph it, but Picasso said there were still some elements missing; he wants to complete this matchstick sculpture first.'

Of the sculptures which were eventually carried out, *Wire Construction* of 1928/29 (p. 79) is a prime example of a wholly balanced composition in which zones of emptiness and density do not impinge too strongly. The basic shape remains intact from every angle of vision. Another contributory factor is the contrasting strength of the wire used: the vertical supporting sections are made of thicker wire than the horizontal. The second *Wire Construction* (p. 78), which dates from the same year, and for which an accurate preliminary drawing exists,[73] displays greater compression. The relationships between the figure and its spatial boundaries are not so clear. The centre of the composition receives stronger emphasis. The drawing goes farther than its sculptural realization; in it, the lines are so closely drawn that the centre acquires an almost concrete density.[74]

These works, whose spatial articulation is entirely reduced to lines, are in contrast to the sketches for metamorphic sculptures, in which Picasso works with solid volumes. This second mode of expression, which testifies to a renewed delight in plastic mass, also undergoes development in countless paintings and drawings. Solid volume-varying motifs occur first in 1927. Together with a second innovation, which the huge picture *The Dance* of 1925 first introduced into painting, they characterize an entirely new orientation in Picasso's work; one is inseparable from the other. In *The Dance,* the rudiments of rhythm already inherent in the contrasting figure-movements of *Les Demoiselles d'Avignon* are presented with the force of a manifesto: Picasso creates a suggestion of movement by contrasting rigidity with gesture.[75] Movement, which had hitherto found scant use in Cubism as a stimulus to the creative process, here produces a novel extension of form. Picasso introduces abstract shapes to dynamic effect: wavy lines, circles, folds, kinks, curves. Quite as important as this conceptual suggestion of movement, which is in radical contrast to the empirical dynamism of the

Study for a Wire Construction
Dinard 3 August 1928
Pen · 11⅜ × 6⅞ (30 × 22)

Futurists, is his new mode of distortion. Geometrical in his early Cubist works, it now becomes organic: elongation, expansion, extension – all of them formal changes which conjure up organic associations. At the same time, Picasso aspires to unity of form. Additive form, subject to a Constructivist modification in which each stage in the additive process could be followed, now gave way to a formal summation which laid emphasis on totality. The concept of metamorphosis, which is often quoted as a distinguishing feature of these works, provided no apt description of the technique employed because, fundamentally, an item of content remains strictly identical with itself. The nature of this form of distortion cannot be fully understood by anyone who fails to grasp that, behind the transformation, the semantic statement (head, breast, legs) remains intact. It is this alone that endows Picasso's new figurative style with its pre-Surrealist significance.[76]

DESIGNS FOR MONUMENTAL WORKS

Picasso's activities in the field of plastic volume and space-drawing were concurrent. This applies not only to the sketches for sculptures which he produced from 1927 onwards but also to his drawings and paintings proper, in which both tendencies run parallel. The earliest designs for a fully sculptural monument were made at Cannes in summer 1927. The theme – a woman opening a beach-hut with a key – is introduced by twenty charcoal drawings.[77] The hatching which Picasso inserted in the drawings helps to convey fully-rounded cylindrical and balloon-shaped masses. The bulky, hypertrophic representation of physical volumes, and the continuous horizontal line of the shore, are all foreshadowed in a series of works done between 1920 and 1923.[78] Foremost among those which are further developed in these sketches are *The Run* of 1922 and *On the Beach* of 1923.

These sketches contain all the wealth of movement that is present in *The Dance*. Only one was translated into sculpture: the *Figure of a Woman* of 1928 (p. 77). This bronze differs from the drawings in its massive attachment to the ground. Its solidity recalls contemporary works by Henri Laurens, but its gravitational disposition of form is even stronger. The soft, lumpy shapes from which Picasso constructs his sketches splay out as they descend. Wherever a shape conflicts with gravity and tapers towards the base, this thrust is checked.[79] The natural canon of the body, with its immanent synthesis of supporting and supported parts, is here surrendered in favour of a surreal conception.

There is a magnificent originality in the contrast between full, well-rounded sections and emptiness, between tapering shapes and broad doughy masses. Comparing the work with the drawings which prepare and accompany it, one is struck by the extent to which Picasso concentrates in his sculpture on the contrast between full form and void. This creates an equilibrium, a certain classical harmony between portions of the anatomy which are, in themselves, disproportionate. Viewing the sculpture, we relate the solid portions to those that are void and open. Half of it permits space to penetrate by way of two superimposed arches, the other half contraposes space and compactness.

A third series of sketches, done in Paris and Dinard during 1928, finally produced a sort of synthesis of the two themes of space-drawing and metamorphic sculpture. The stiff supporting framework and vertical Constructivist thrust derive from the space-drawings; the solid cladding of the framework and the individual shape anchored to and overlapping it derive from the organic distortions of metamorphic sculpture. The subsequent influence of these unrealized designs for large-scale monuments can be detected in a series of sculptures which Picasso produced at Boisgeloup some years later.

Picasso was for many years to interest himself in sculpturally conceived figures and groups of figures anchored firmly to the pictorial area. He often reverts in his pictures to solid architectural compositions of this kind. The spatial problems to be mastered are occasionally reminiscent of those presented by Pittura Metafisica, notably in Giorgio de Chirico's paintings. The creation of a 'place' in which figures are related to each other became a widespread artistic theme in the 1930s. This architectonically conceived anchoring-in-space is also a feature of some of Alberto Giacometti's major sculptures.

GONZÁLEZ AND METAL ASSEMBLAGE

The space-drawings gave rise to a series of metal assemblages which came into being from 1929 onwards with the technical assistance of the Spanish sculptor Julio González.[80] Picasso had met González during his early days in Paris, but the two men had lost touch over the years. In 1928, Picasso contacted González again. He wrote him a letter (Roberta González collection, dated 14 May 1928) condoling with him on the death of his mother. González at that time had his studio at 11 rue de Médéah, where he remained until 1935. Picasso visited him there and became interested in metalwork. His frequent visits to González's studio are attested by a series of notes in

Study for a Metal Sculpture
Paris 20 March 1928
Pen · 10 ³/₈ × 14 ¹/₈ (26 · 5 × 35 · 5)

which he announces his arrival. One such letter, dated 3 July 1931, contains an apology: 'I couldn't go to the studio this morning.' When Picasso increasingly withdrew to Boisgeloup from 1931 onwards so as to be able to work in his spacious studio there, González followed him. At Boisgeloup the two men often worked in the local village smithy. Picasso began by trying to make paper drawings of the shapes which he wanted cut out of sheet metal, but soon abandoned this practice and drew his shapes on the metal itself. He was full of admiration for González's manual dexterity. 'You work the metal like a pat of butter!' he once exclaimed.

The importance of the Picasso-González collaboration was not limited to the period around 1930. González introduced Picasso to metalwork techniques to which the latter reverted in later years. On the other hand, it scarcely seems tenable to claim that González also influenced Picasso stylistically. González was alerted to new artistic possibilities during his collaboration with Picasso, and Picasso told me that González one day asked his permission to work in the same manner as himself, an idea which Picasso naturally encouraged. It is evident from *Woman in Garden* (p. 81), the first and largest sculpture which Picasso produced with González's assistance, that Picasso had already developed its main formal aspects before he started to work with González. The essential basis of these metal constructions had been laid in his Cubist constructions and in *The Glass of Absinthe* (p. 49).

González's great technical skill as a smith and welder enabled Picasso to improvise larger compositions; but Picasso did not confine himself to supplying models, nor did he leave the development of specific working ideas to González's initiative: the works themselves were always produced in collaboration with his friend. *Woman in Garden* is an outstanding example of this. Everything about this assemblage seems to conflict with professional metalworker's practice. Individual parts are visibly jointed, and there is a deliberate avoidance of technical perfection. The very charm of the work reposes in its parodistic use of techniques, in its dilettantism. González, who was soon to continue working in the constructional style inspired by Picasso, himself furnishes evidence of this: his own works aim at far greater technical precision. Picasso's comment while we were studying one product of their collaboration – 'We had a good laugh when we were doing that' – indicates that the collaboration was a real one. González himself, in his unpublished manuscript 'Picasso et les cathédrales', lays strong emphasis on Picasso's share in the technical execution of these works. Referring to *Woman in Garden,* González observes: 'His hammer alone was enough for him to try to execute his monument to Apollinaire.' Picasso's enduring interest in technique would have precluded any collaboration in which his role was limited to design.

In many respects, *Woman in Garden* is a sculptural counterpart of *The Dance* (1925). In the painting Picasso had used a painter's techniques to tackle the representation of exploded bodies in space; this idea is even more drastically intensified in the sculpture. The physical framework is defined only by a few ambiguous formal quotations on the female body, which is much pierced. Many details, as for example the hair, emerge more strongly. The parallel strips of metal signifying hair bear a relationship to works produced years earlier.[81] Part of the substructure – the left half of the sculpture – can be found literally prefigured in drawings.[82] Indeed, one drawing which was done in April 1928

actually anticipates the entire composition.[83] The leaf shape, a favourite motif in pictures of the period, has its natural exemplar in the philodendron which adorned the Paris apartment in the rue de la Boétie.[84] An abundance of individual elements can be similarly identified in the remainder of the work. However, the novel feature of the sculptural synthesis produced by these individual motifs is its material, tactile richness. The varied techniques employed (the back of the head is of wrought iron, other parts are welded, still others bolted together) and the diversity of the pieces of metal that compose the sculpture, some of them used as found and others trimmed to shape, combine to make total perception difficult for the beholder. Here, far more than in the Cubist constructions, the material is permitted a voice of its own. No attempt has been made to conceal its diversity and the multiplicity of techniques employed, nor to camouflage the numerous joints and welds. The blacksmith's technique itself, in its crudest possible guise, is integrated in the work – an early form of *art brut,* and more radical than any other contemporary example.

The ensuing works, which are smaller in scale, make an impression less strong than the one just described. The reasons for this are twofold: either Picasso resorts to larger formal elements of equal status, as in *Head* (1931, p. 84), or he overpaints the welded composition a uniform white, as in *Head of a Woman* (p. 85).[85] *Woman in Garden* (p. 81) is the finest example of a transparency-sculpture in which certain stereotypes – hair, leaves, parts of the body – are overlaid by an anti-Constructivist use of Constructivist material.

Picasso has produced few such works in metal, but each embodies a fundamentally different point of departure and introduces a different technical and iconographic theme. *Figure of a Woman* (p. 83) has none of the supple, plant-like composition of *Woman in Garden.* It is a strictly rhythmic structure in which individual structural elements are contraposed. This obtains a maximum of movement and volume within a vertical format.[86]

The vertical line predominates. The skeletal structure of the figure is further emphasized by the 'dressing' which Picasso added to this sculpture. A photograph taken by Brassaï in Picasso's Paris apartment shows that the artist had suspended a number of objects from the framework (p. 82). Picasso: 'I hung up objects as one hangs one's hat.' This entirely alienates the original mode of reading. The small inclined head becomes an arm which dangles an aeroplane, and the figure itself becomes elongated. On the heron-like neck Picasso mounts a small doll which, in its new context, is construed as the head. The Constructivist composition vanishes beneath its fancy-dress. The costumed work recalls the *Objet Dad' Art* produced by Max Ernst in Cologne in 1919.

In the *Head* of 1931 (p. 84), Cubist constructions are evoked by the frontality of the composition and the suggestion of volume assigned to the two-dimensional face and the concave shape mounted in front of it. The uniform coat of white paint applied to *Head of a Woman* (p. 85) of the same year shows that Picasso was not here concerned with material fetishism and did his best to diminish the inherent message of the diverse elements employed; he preserves only the structure.[87] This is an interesting sculptural parallel with Max Ernst's frottages; the structures inherent in a particular object acquire virtual independence of that object and emerge as a free creative medium in which the original objective meaning dwindles to a mere resonance. In *Head of a Woman* we almost forget that the volume of the head consists of two opposed colanders

Woman · Cannes 1927
Wash · 23¹/₂ × 23¹/₈ (60 × 59)

or salad-strainers, and that the hair has been concocted out of nails and bed-springs. This sculpture – unlike *Woman in Garden,* for example – did not take shape in a freely parodistic manner. Picasso did not base it on random pieces of material which happened to be available. He told me that it suddenly occurred to him to construct the back of the head out of colanders. 'I said to González, go and get some colanders. And he brought back two brand-new ones.' For the rest, he synthesizes disparate motifs. Eyes, nose and mouth, together with the protruding semicircular wire shape which conveys volume, hark back to Picasso's wire sculptures. Similar reductions of corporeality to graphic elements can already be found in drawings dating from 1928.

In almost all the Picasso sculptures which have grown out of combinations of materials, the original significance of an object survives as an underlying echo. A dual activity is enforced on the beholder. He has, first, to construe the formal symbol within the context of a work, and, secondly, to recognize the inherent meaning – transcended in the work itself – of the alien element which has been employed in it. The *déjà vu* effect, and the usurpation of the structural context by the foreign body, combine to produce a new tension which is experienced on the sculptural plane. In these assemblages, for the first time, the artist tackles a sculptural problem to which no allusions can be found in his contemporary paintings and drawings. In all these works, Picasso's sculpture begins to divorce itself from his work as a painter and draughtsman. It may be stated, in general, that themes connected with the technique of assemblage – the integration of found objects in a work – remain autonomous and confined to sculpture. (As for Picasso's freely modelled sculpture, on the other hand, references to nearly all of it can be found in the

remainder of his work.) Also autonomous are the works based on a Constructivist treatment of material, that is to say, works in which found material is used as a medium not incorporated as a form. This becomes evident in the following group of works.

RELIEFS AND CARVED FIGURINES

In 1930, at Juan-les-Pins on the Côte d'Azur, Picasso produced a series of reliefs for which he employed a diversity of materials and found objects (*cat. 75–78,* pp. 86, 90). Toy boats, gloves, straw, twigs, roots, pieces of wood, nails, a fragment of palm-frond – items of this kind are supplemented by cardboard cut-outs bent into shallow reliefs and representing heads. Here, Picasso hit upon the idea of masking the collage effect by coating the entire composition with a fine layer of sand.[88] His previous sculptural works had been distinguished by their clear spatial relationships, most individual shapes being crisply outlined; but here he created an imperceptible transition between ground, shallow relief and high relief. A slightly later group (pp. 92–93, *cat. 117*) embraces compositions which employ a maximum of amorphous and nondescript materials;[89] the 1930 works, by contrast, divide up the relief area more strongly and allow many compositional elements to attain greater prominence.[90]

In 1932, Picasso produced a further relief (p. 91), in which he incorporated a butterfly and a leaf; but this time he refrained from disguising the substance of his ingredients with a homogeneous coating. This relief seems positively to contrast its organic excerpts from reality – finished parts not requiring interpretation – with artistic reality.

At about the same period, in 1931, there also came into being a number of statuettes (pp. 94–96; *cat. 86–88, 92–98, 100–01*) carved from small pieces of wood which came to hand in Picasso's studio. These display interesting affinities with African and Etruscan art.[91] In these carvings, Picasso surrenders himself to the initiative of the material[92] – in fact, their stylistic character reposes in the very contribution made by the refractory nature of the medium.

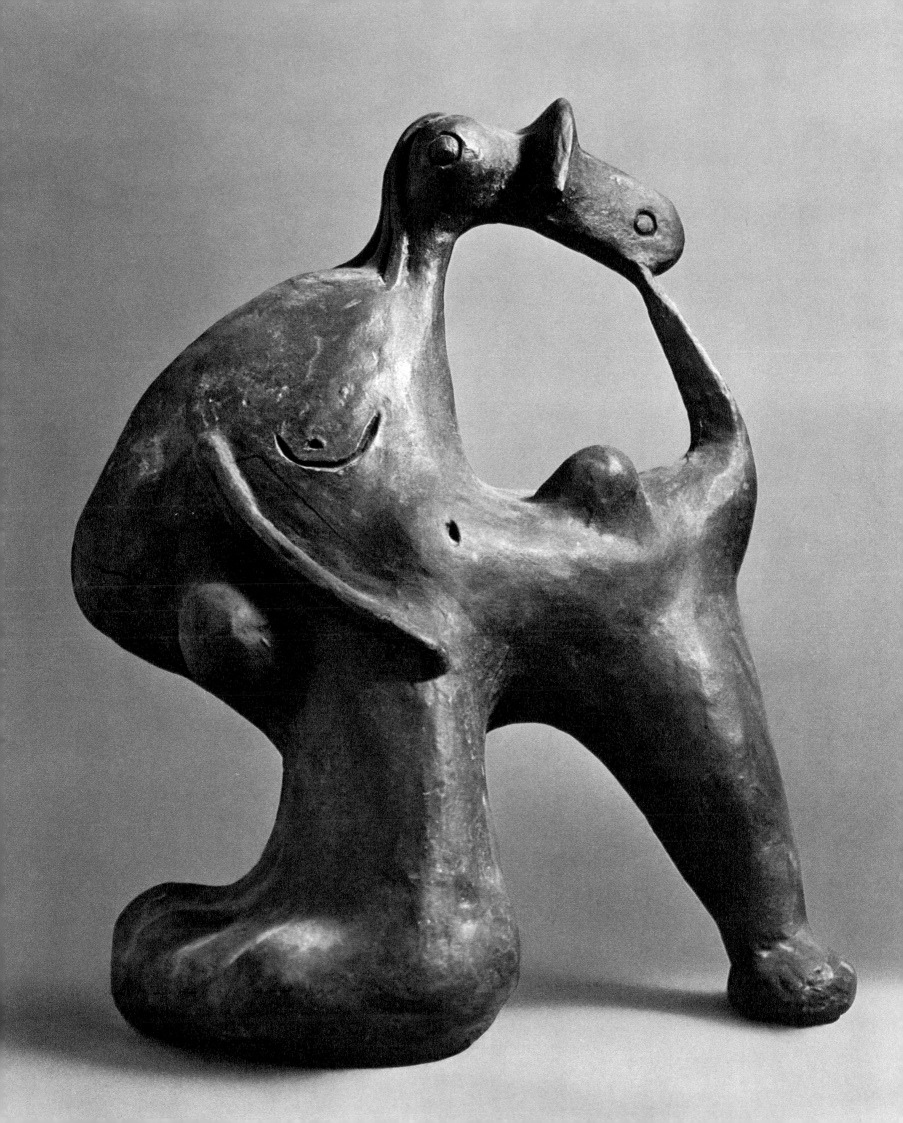

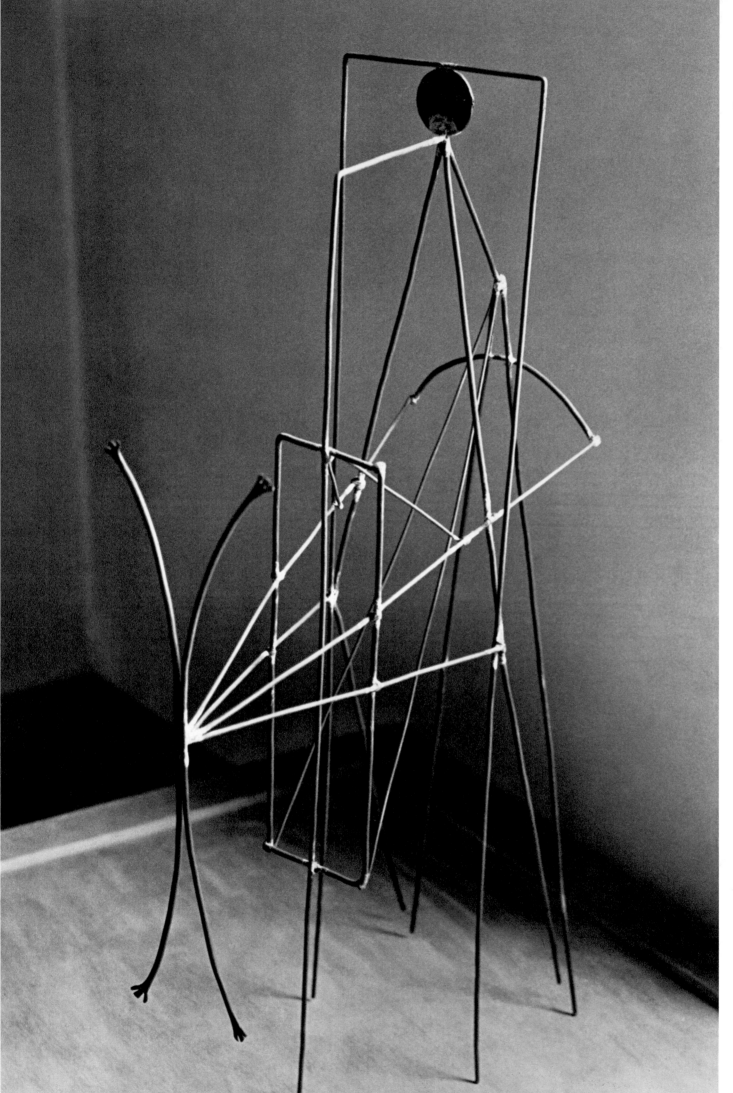

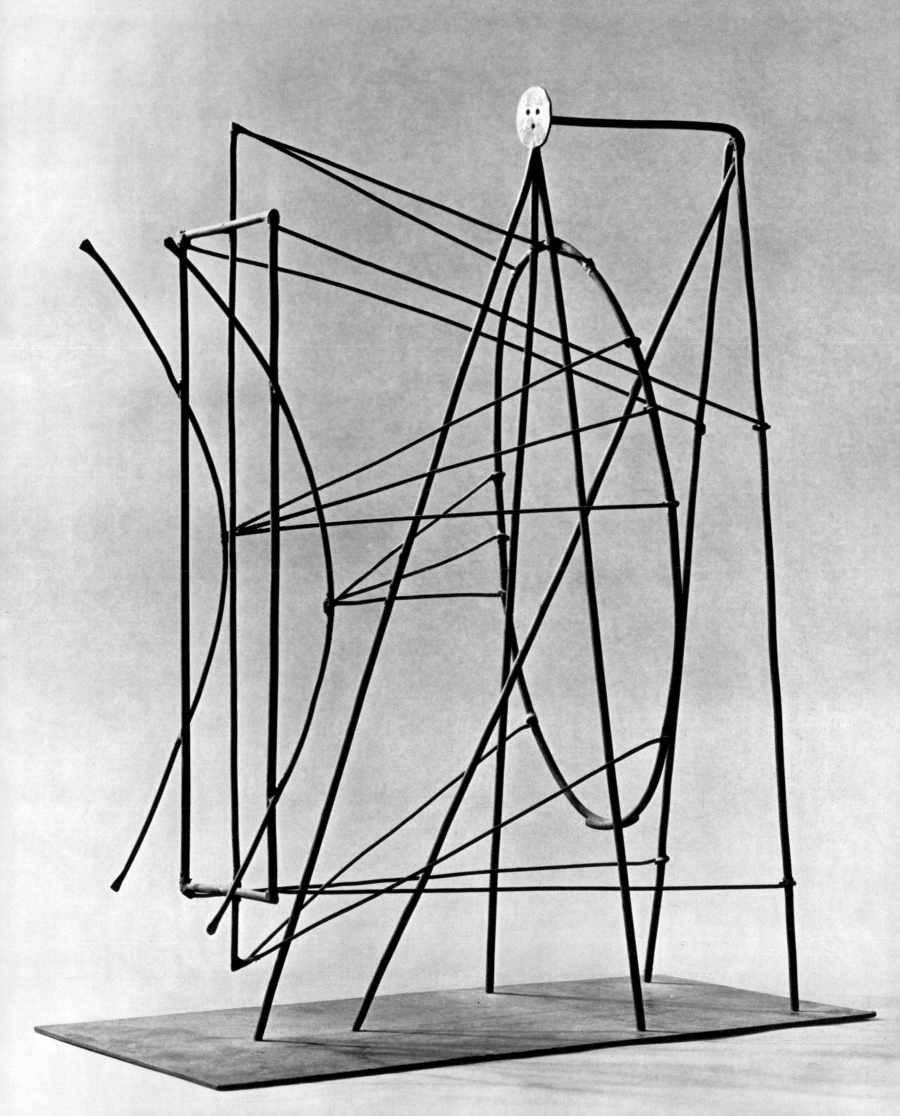

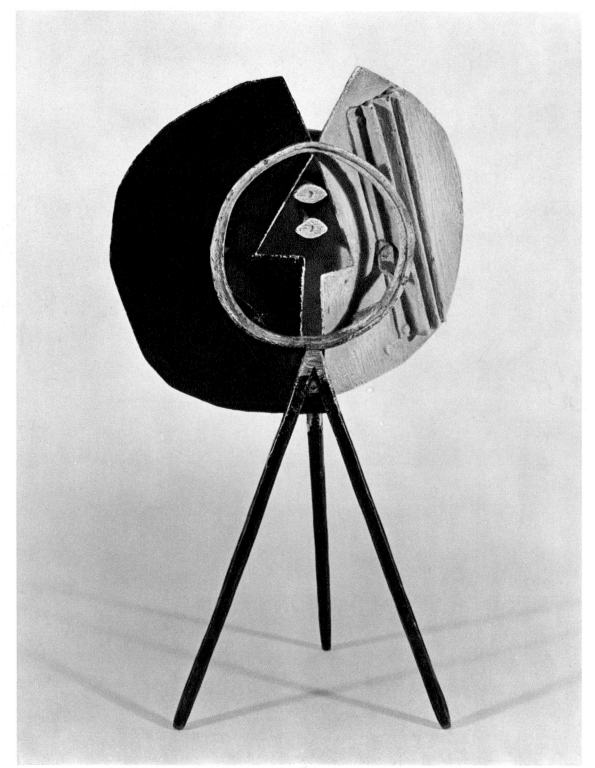

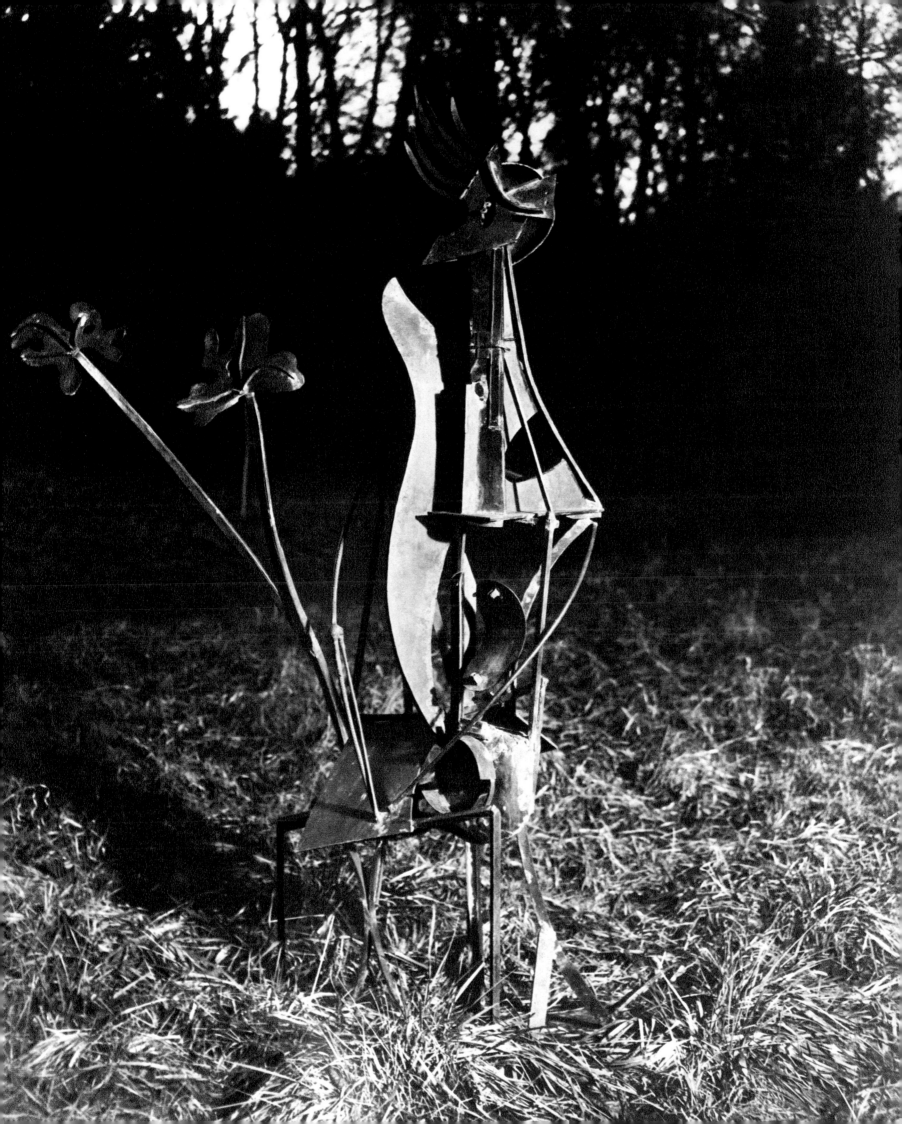

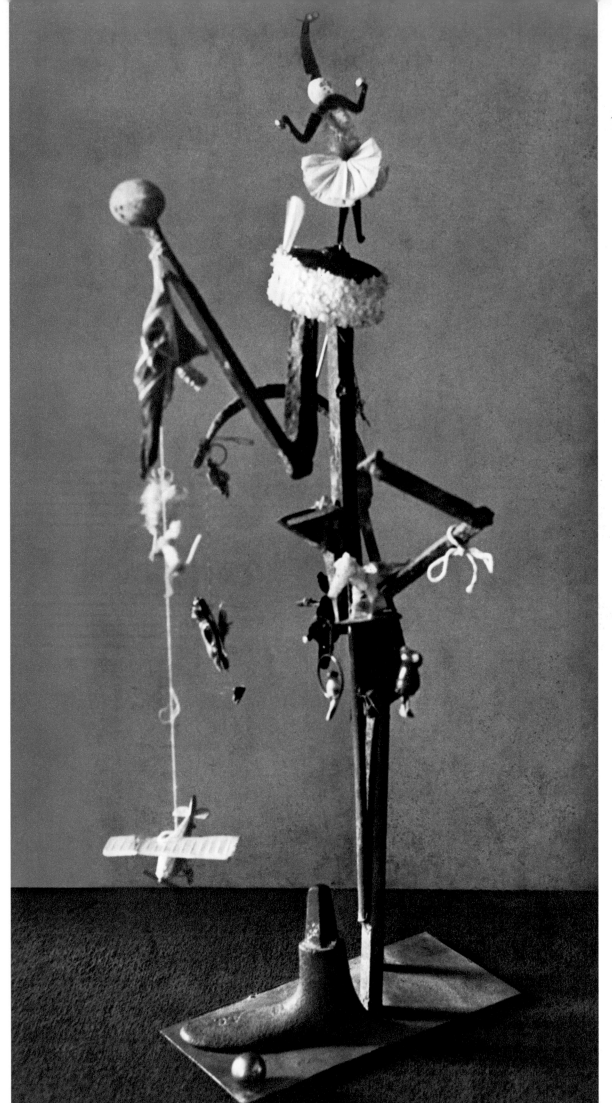

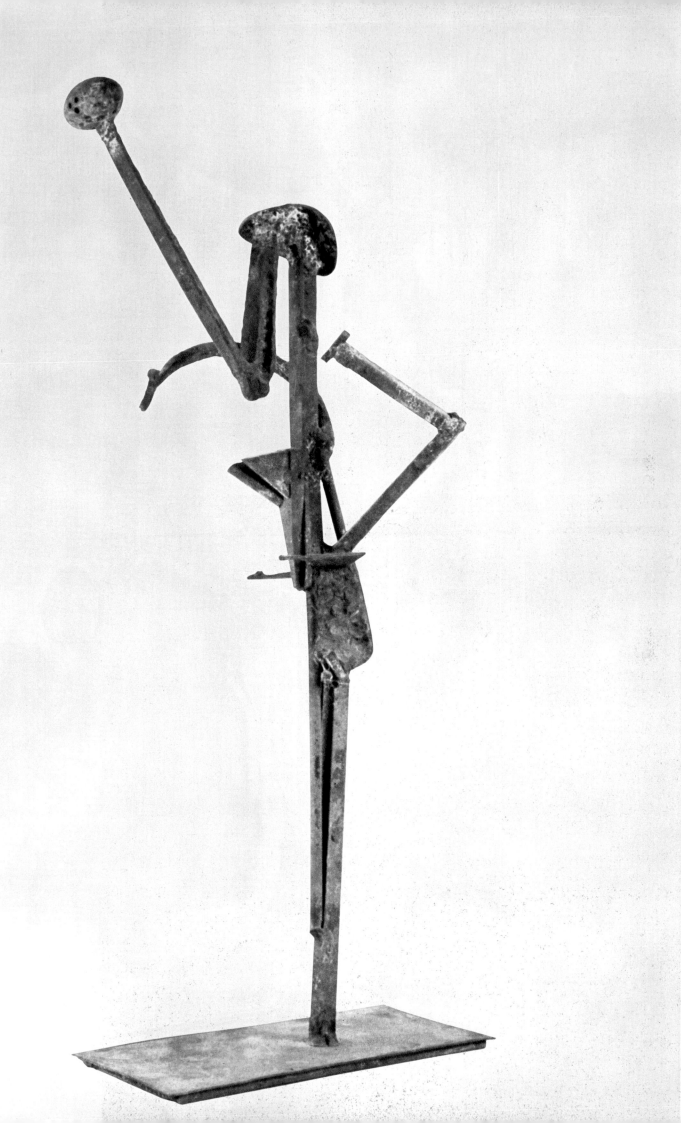

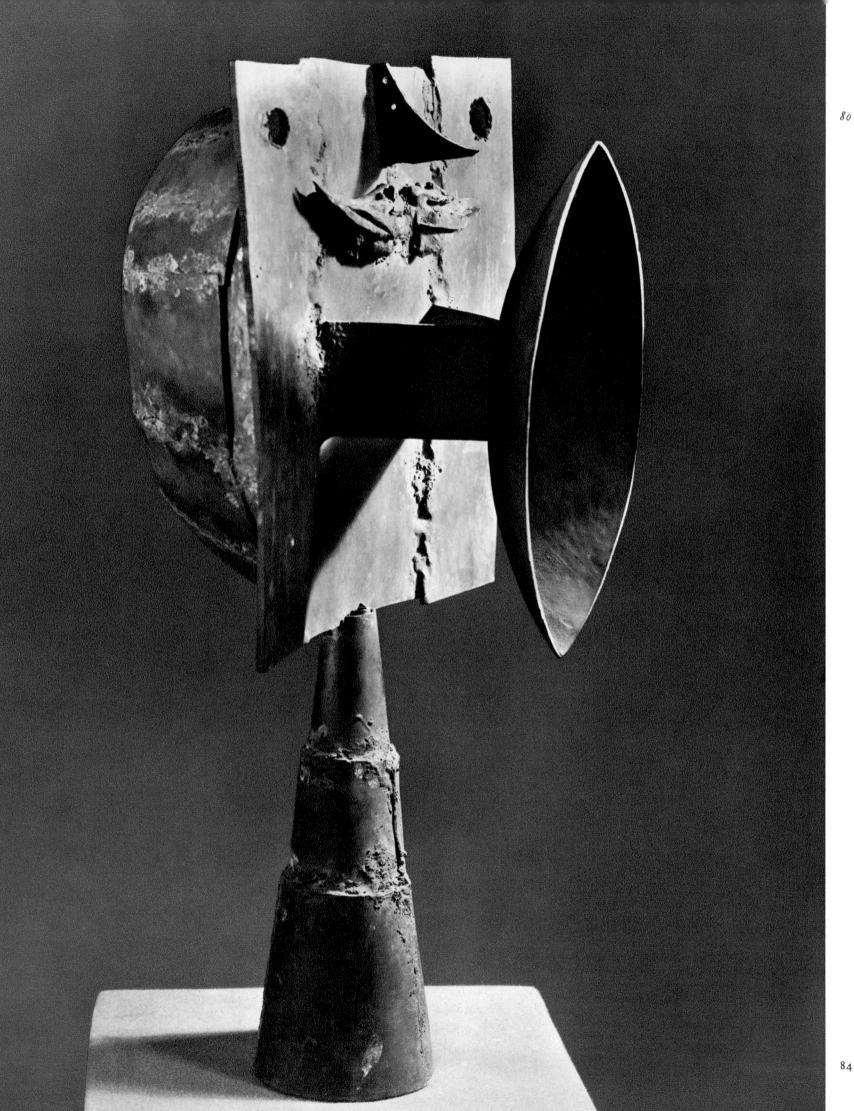

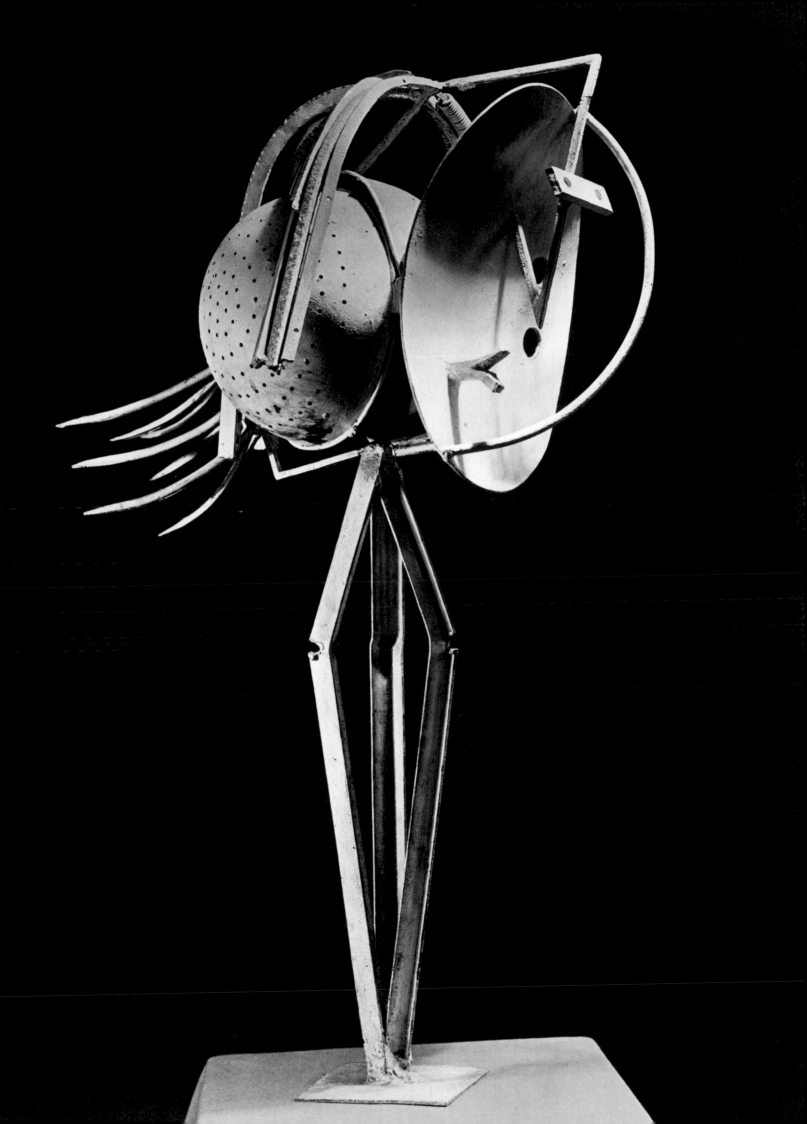

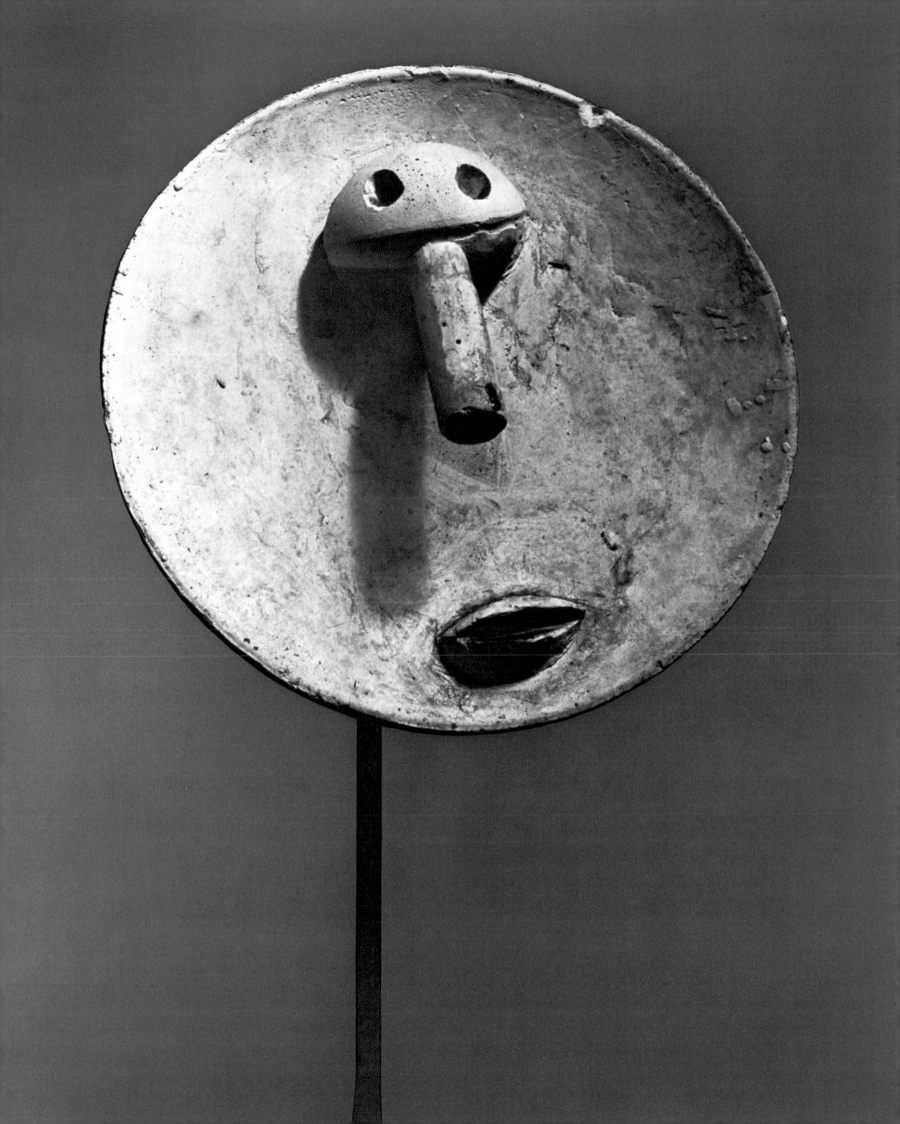

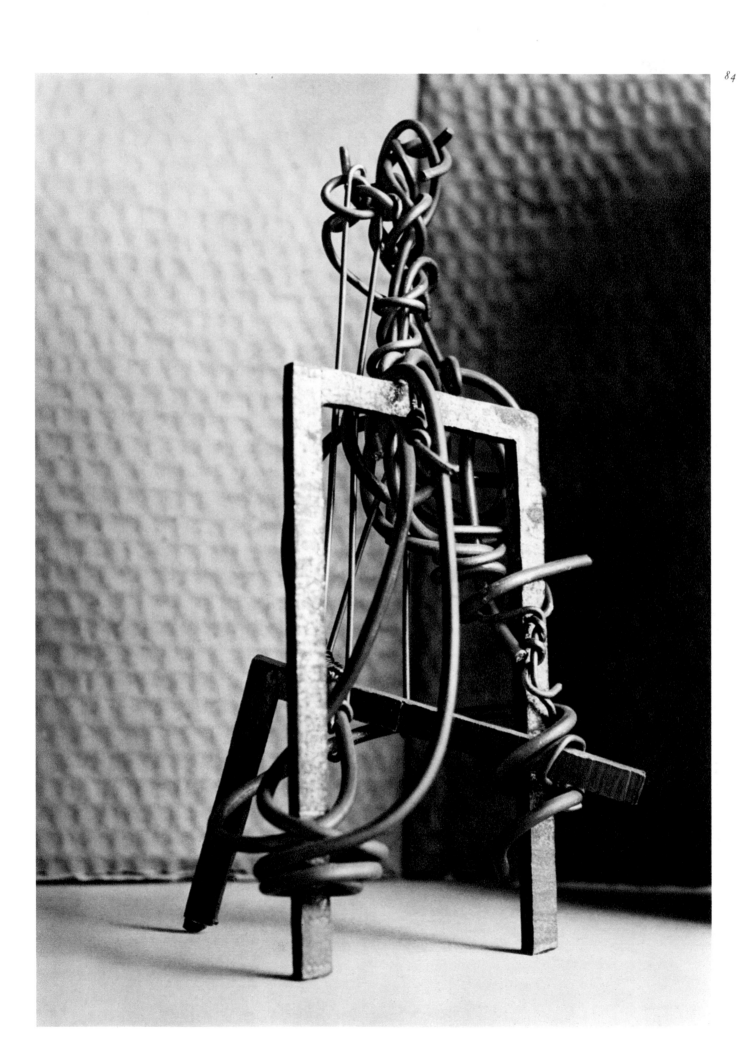

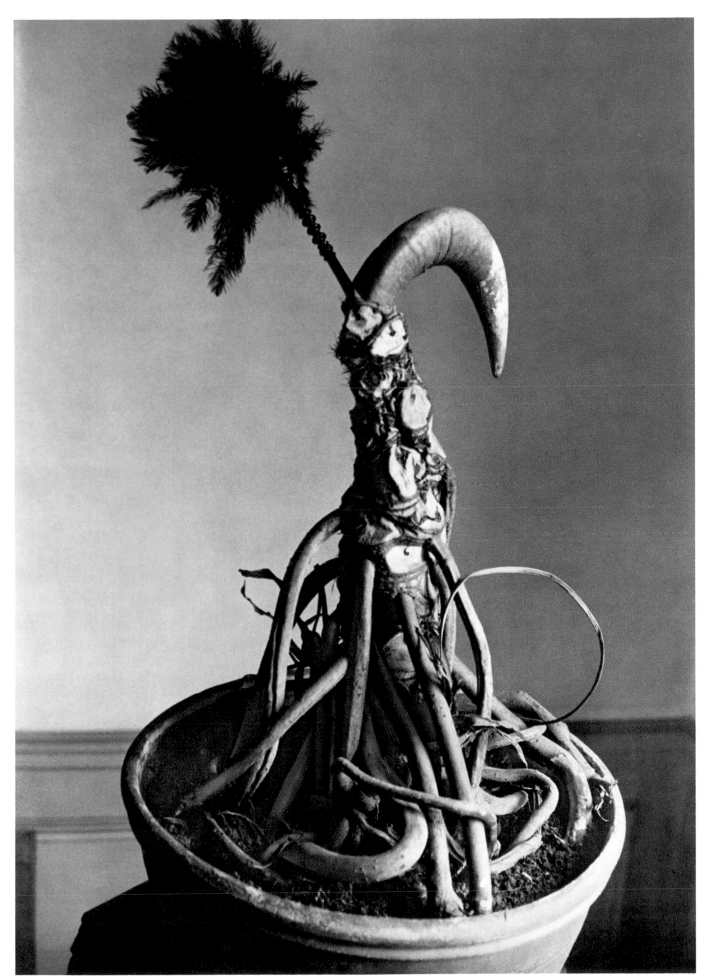

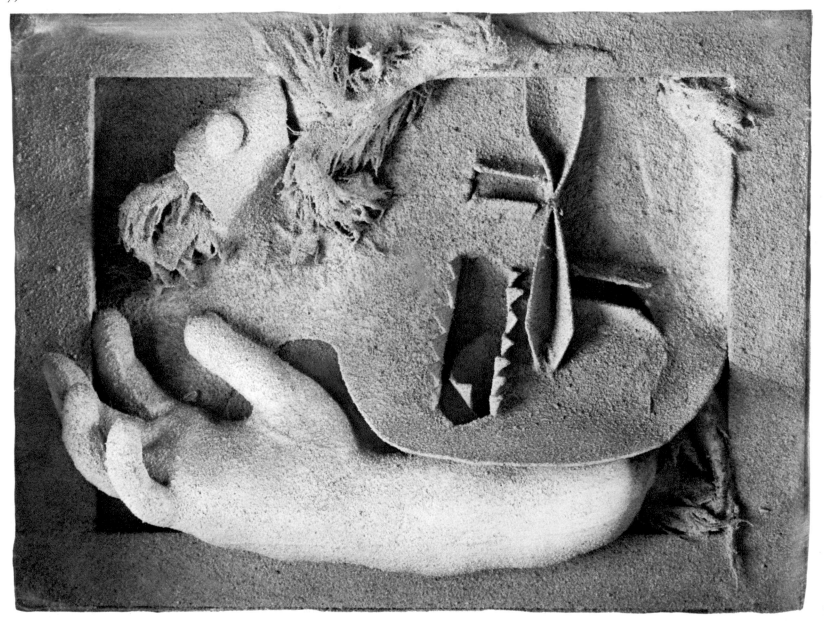

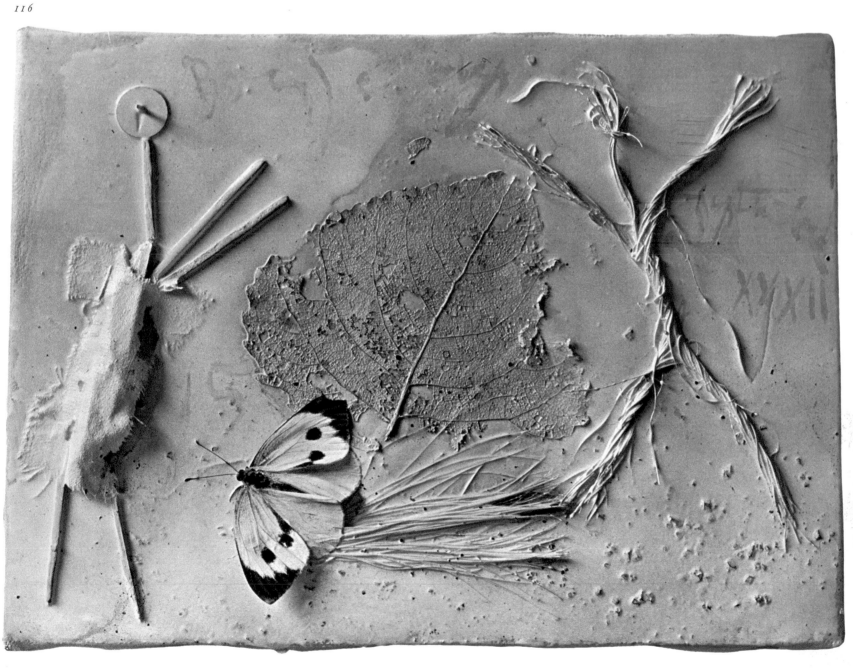

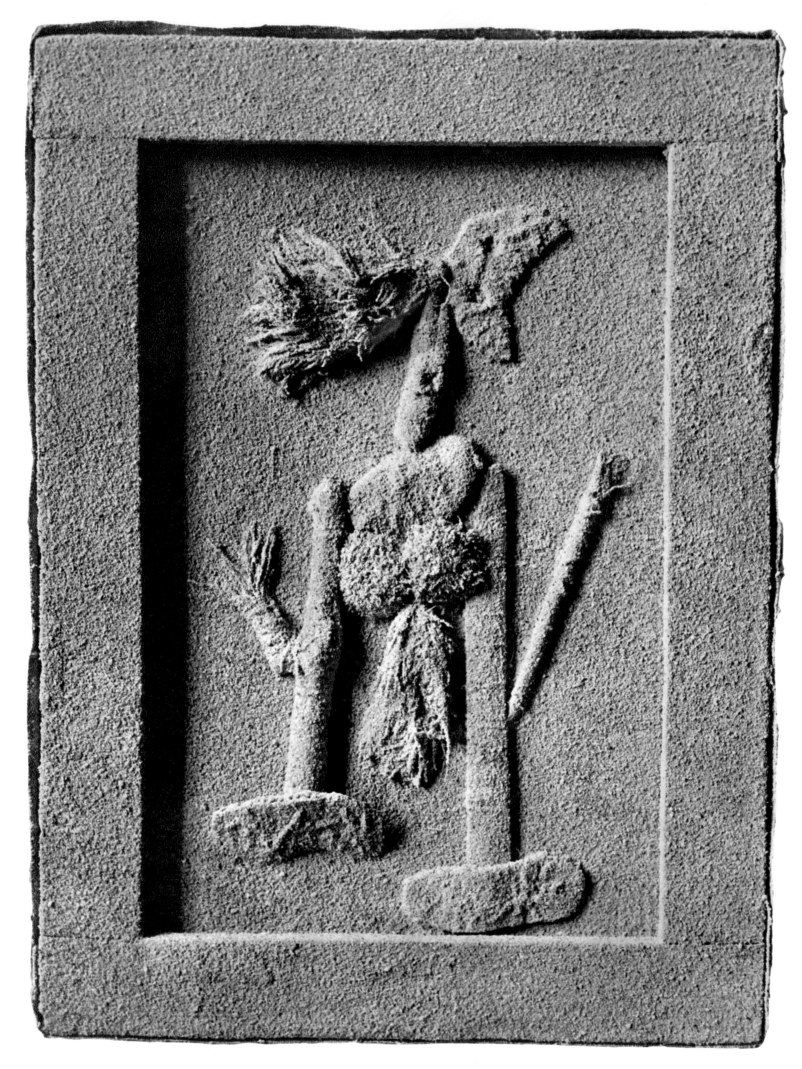

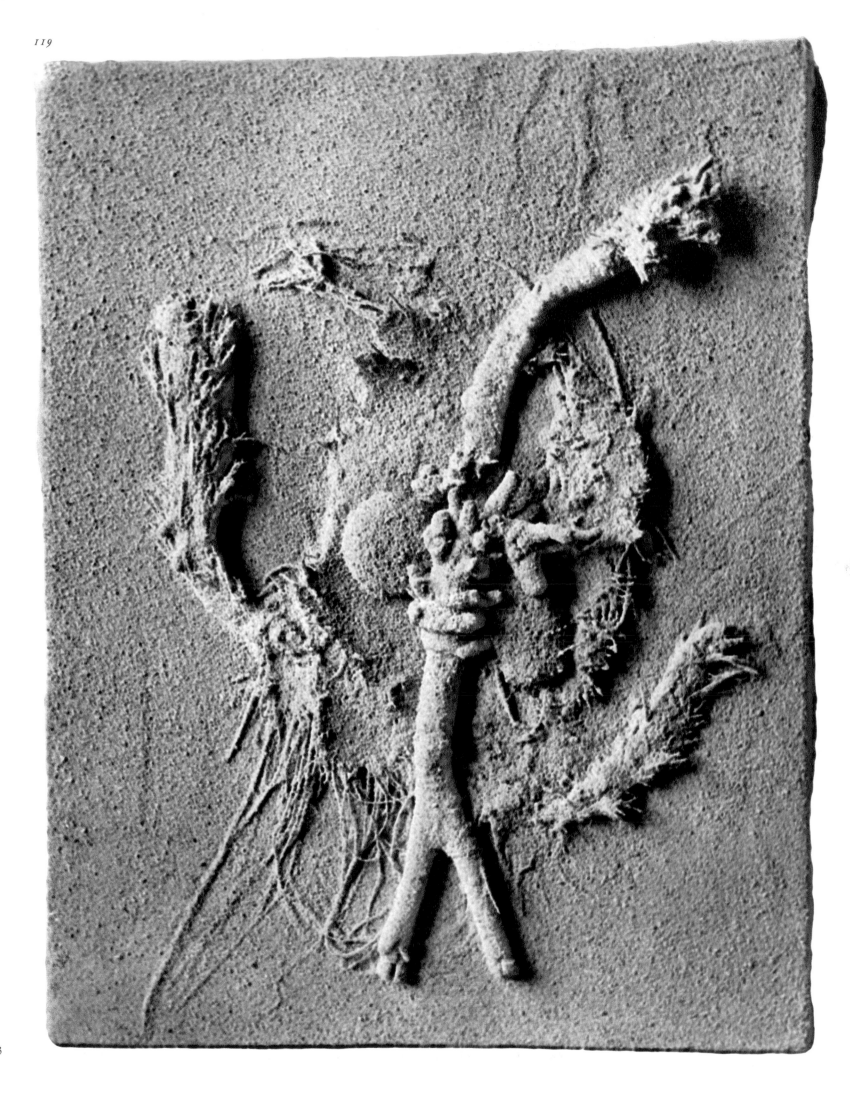

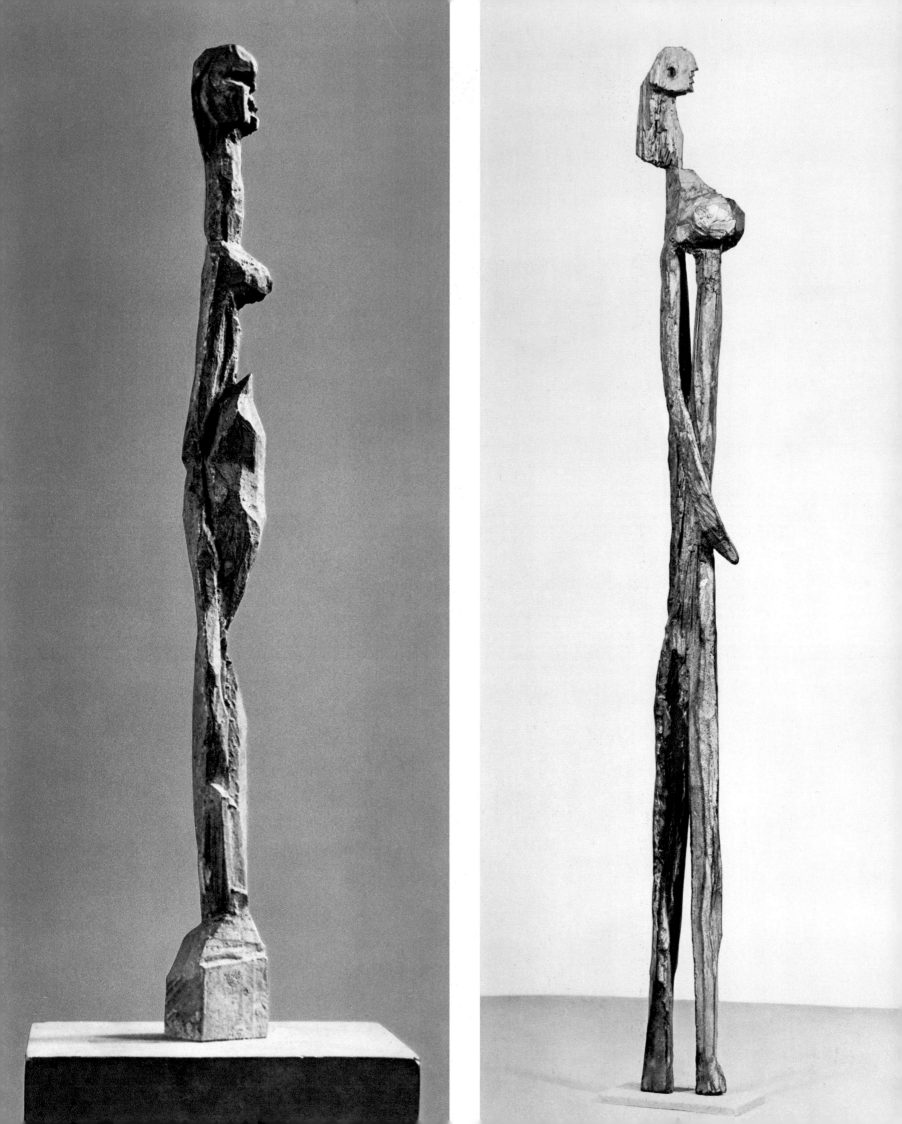

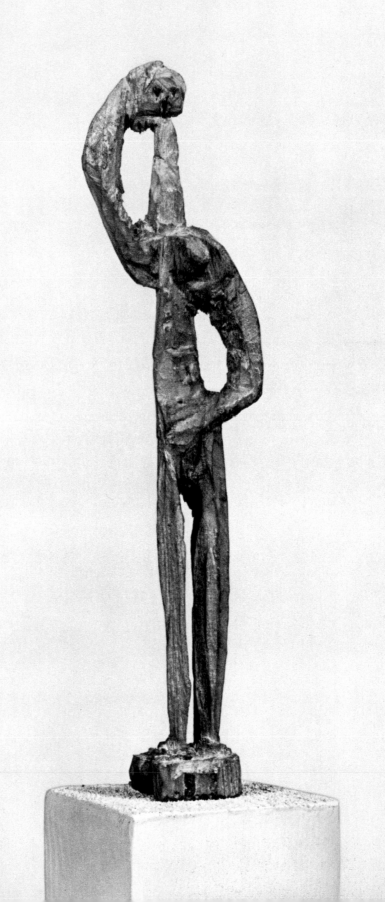

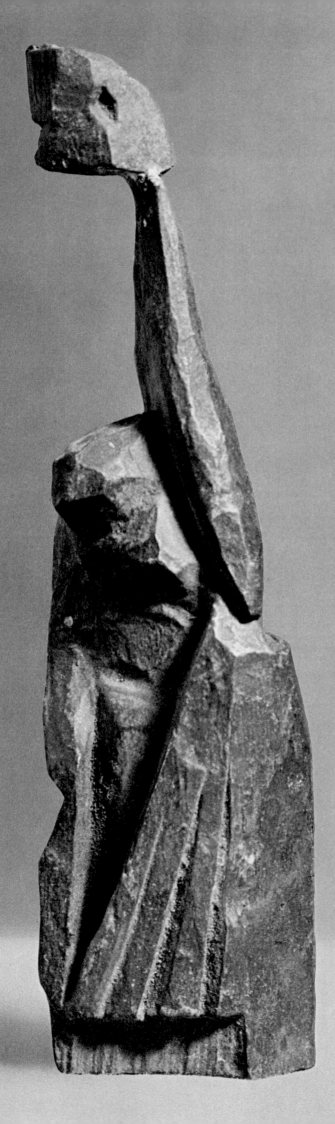

The return to modelling

BOISGELOUP

In 1931 Picasso established a studio at Boisgeloup, near Gisors, in a seventeenth-century château with many rooms. The extensive stables and subsidiary premises gave Picasso room to work on large-scale sculptures, works which could hardly have been produced in his cramped Paris studio. He also installed a printing-press for graphics. Picasso's association with Boisgeloup was not fortuitous. He had been looking for premises where he could produce sculptures. As we have seen, his painting and drawing in preceding years had become increasingly concerned with sculptural form, but these potential sculptures had to stop short at the design stage. Picasso had monumental figures in mind, as his sketches show. The scale-drawings of elements (human figures, beach-huts) demonstrate that Picasso was contemplating sculptures of architectonic dimensions. Boisgeloup permitted him to fulfil many of these plans, but it would be wrong, even so, to talk as if Picasso had actually been engaged in producing monumental sculpture. Contemporary photographs which give us a view of the studio at Boisgeloup show only two sculptures which appear to be of exceptional size (*cat. 107, 135*). Picasso modelled his own sculptures, so he was subject to certain limitations. It would, moreover, have been unthinkable to use these sculptures as models for realization on a monumental scale; the irregular play of tactile values would have militated against enlargement. It is clear from Picasso's cry from the heart, reported in Kahnweiler's 1949 monograph, 'I have to paint them, because nobody commissions me', that his monumental projects remained on the drawing-board for lack of opportunity to realize them.

Most of the Boisgeloup works are products of separate, autonomous creative impulses. If only for that reason, it seems impossible to fix the development of the sculptural thought-process. The series of monumental heads (pp. 115–19) presents no exception. It would be nonsensical to marshal them into a suite in order, say, to demonstrate a process of transition from a naturalistic to an entirely abstract conception of theme. The most important formal modifications ascertainable in these sculptures had already been developed elsewhere. This in itself illustrates the great difference between them and the sculptural works of Matisse, who fully explored a theme in plastic terms and progressed from a realistic representation of individual plastic volumes to an abstractive treatment of such components. By contrast, Picasso now proceeded to realize separate volume-relationships which he had previously outlined in an almost limitless succession of drawings and paintings.

The transition to Picasso's fully sculptural, massive, large-scale works is provided by a *Seated Woman* (p. 105).[93] This bears a manifest relationship to the carved statuettes but differs from them in that, although the arms and legs diverge considerably from the thin and rigid body-stem, it forms a hieratic, symmetrical composition.

The Boisgeloup sculptures display great formal diversity. What invests them with a certain uniformity is their treatment of volume. Mass remains compact and rounded. Surfaces are usually smooth save for a sprinkling of minor irregularities. Particularly noticeable in Picasso's large-scale works, this absence of surface animation endows the sculptures with greater monumental unity. This can be seen with especial clarity in the series of heads which came into being from 1932 onwards. Here, Picasso selected a size which transcended that of the normal portrait bust and re-examined some of the problems inherent in the hypertrophic sketches made at Cannes and Dinard. A sculptural mass composed of organic bulges and nodes lends these works a soft, doughy appearance – a mode of composition which temporarily affects the paintings and drawings of the same period.[94] Picasso made some important allusions to this in a conversation with Brassaï: 'I have an absolute passion for bones. . . . At Boisgeloup I still have plenty more birds' skeletons and dogs' and sheep's skulls. . . . Has it ever struck you that bones are always modelled – that you always get the impression they're modelled in clay and reproduced from the model? No matter what bones you look at, you will always find the traces of fingers.'[95]

We have undoubtedly reached a classical phase in Picasso's work. This is indicated not only by his serene and harmonious dynamic motifs but also by certain formal arrangements derived from ancient classical sculpture, such as the Greek nose-and-brow.[96] The sculptures consist exclusively of plump, rounded shapes – positive shapes. The dialectic of spatio-positive and spatio-negative, the penetration of mass by surrounding space exemplified by the modelled sculptures of the Cubist period (*Head of a Woman, The Glass of Absinthe*), has disappeared.

The sculpture which most closely approximates to the drawings which Picasso produced at Cannes is *Woman* (pp. 110–11). The distortion of the body, and the massive organic deformation of its limbs, are closely linked with the theme of movement. The head and arms of this figure, which recalls a fertility idol, are atrophied.[97] The head, an abridgement which comprehends hair, brow, nose, eyes and mouth, is reminiscent of a cockscomb.[98] The contrast between the clumsy masses of the body and the helplessly frail impression conveyed by the little arms and head could not be more vivid. The dominant body, abandoned to its own momentum, supports a head and arms which could animate it but, instead, adhere to it like stunted appendages. In spite of its resemblance to prehistoric figurines, to construe *Woman* as an idol might be misleading. Symbolic thought is very rare in Picasso's work. Mythological motifs (Minotaur) and Christian motifs (Crucifixion) are not employed in a literal way. In this sculpture Picasso once again tackles the motif of the animated figure which displaces space. The preliminary drawings for a monumental female figure on the shore, which he had done at Cannes in 1927, seem to have rekindled Picasso's interest. Here, he constructs a body out of a minimum of solid, unsegmented parts. Its solidity is additionally stressed by

Figure · Boisgeloup 12 April 1936
Pencil · $13^{1}/_{2} \times 19^{7}/_{8} (34 \cdot 5 \times 50)$

the contrast between head and arms. The dynamic motif helps to emphasize the immobility and helplessness of the mass represented.

Compare *Reclining Woman* (pp. 108–09), elegant, fluid, and not intended to produce half so harsh a contrast. Everything about this work is euphonious – a sensual, eye-caressing succession of rising, falling, breathing shapes. The sculpture is composed of four plastic units of approximately equal size. These are knotted together at two points: in the centre of the body, the formal elements representing thighs and hips are linked with the upper part of the body, while the two hands and head are conjoined in the melodious arabesque of arms and breasts. These are the two pivots around which the sculpture develops, the two fixed points by which the beholder plots his position.

The *Reclining Woman,* with its fluid progression of slender volumes and the clay modelling that 'draws' in space, is the work which most nearly approximates to Matisse's sculptural works in respect of theme and suggestion of movement. At the same time, it illustrates the great difference between Picasso's treatment of volume and that of Matisse. Matisse never goes as far as Picasso in the convulsive rhythmic distortion of a subject. With Matisse, one can always perceive an intention to transform the body into a smooth definitive shape. Brancusi's influence – the desire to create a formal symbol with a minimum of surface incident – took precedence in Matisse's sculpture during these years.

A perfect example of this is the head *Le Tiaré.* Matisse obtains his formal grammalogues deductively, by means of a quasi-logical, gradual process. Not so Picasso. At the time when this magnificent and quantitatively important period opened – the beginning of the 1930s – he had at his disposal a formal inventory of unrivalled profusion. Picasso varies shapes, not objects. Compared with the arm movement described by his *Reclining Woman,* the solutions advanced during these years by Matisse or Laurens remain, to a far greater degree, translations of corporeality into abstraction. Picasso almost entirely disregards the restrictions imposed by reality: each element in his sculptures partakes of transformation to the same extent.

Woman (pp. 110–11) is closely related to *Reclining Woman.* There is a drawing for it dated 5 and 6 May 1929.[99] The slender body-elements are mounted on a compact mass suggestive of a pedestal turned on its end. This sculpture can be construed in two ways. If one regards it as a relief, the vertical mass reminiscent of the plinth on which *Reclining Woman* reposes becomes the background surface from which the body grows. The anchoring of a body in front of a surface occurs elsewhere in Picasso's work, namely in his drawings after Grünewald's *Crucifixion* from the Isenheim Altarpiece. *Woman,* on the other hand, admits of a second interpretation, in which the limbs and the rear section which sustains the relief merge into a fully sculptural form. The block defines the volume of the body and the framework-like projecting structure its mobility and articulation. In contrast to the linear treatment of *Reclining Woman,* which preserves a state of arabesque, hovering in suspension, this sculpture gives an impression of rigidity. The verticals which compose the body and the horizontal of the arm, which is intersected at right angles by two verticals at the level of the thigh, invest it with a hieratic flavour. Calm zones are created by the spherical shapes alone (head, breasts, belly), without which the figure would lose itself in verticality.

Animal sculptures, too, were produced at Boisgeloup. Two of these, *Head of a Bull (Heifer's Head)* and *Cock* (pp. 130, 131) remain close to their natural exemplars. We shall have more than one occasion to note that Picasso stays closer to reality in respect of animals than in his representations of the human form. The chunky *Head of a Bull* is rent open by the dark zones of muzzle and nostril. Horns and ears project from this mass, animating it; it takes on the tragic features of the Minotaur, a theme which was to exercise Picasso for two years to come in the Vollard Suite. *Cock* introduces movement. The arched neck, body and tail-feathers form a harmonious curve. The fixed point about which the two curves of body and plumage revolve is located in the centre of the figure. The turn of the leg, too, seems to accord with the overall propeller-like torsion. The elegance of this composition, with its rotation about a central point, is reminiscent of the eurhythmical development of the sculpture *Reclining Woman*. Freely modelled, this *Cock* differs fundamentally from another *Cock* (p. 135) which came into being one year later. In the later instance, Picasso confined himself to simple schematic representation. Head, body and tail-feathers fit into a V-shape, but the plastic mass is relieved by a new indirect modelling technique: leaf-patterns are imprinted in the moist clay, giving the bird a ruffled appearance.

BIOMORPHIC BULK

In *Head of a Woman* (p. 113) Picasso endows his organic, tumescent masses with autonomy in such a way that they become an almost anonymous formal symbol. He builds by analogy with an organic body, using spherical, tumid, curving elements. As in *Reclining Woman* (pp. 108–09), there is a juxtaposition of discrete formal units. Neck, eye, hair and forehead occupy the same plane, from which the only feature to emerge is the bulge that defines the nose and cheek. The construction of a head from rounded units is something which claims Picasso's attention elsewhere in his work. We can best comprehend this process of reduction from more realistic, rounded facial shapes to anonymous construction out of autonomous masses by studying the various states of the etching *Woman's Head*.[100] An initially realistic portrait is overlaid with mathematical lines of force – circles, ovals. This mathematical substance emerges ever more strongly. Anything that cannot be subordinated to a simple stereometric figure is omitted. What is left is a framework which attains formal independence.

This goes farthest in the sculpture *Head of a Woman*. The spandrels which occur at the points of tangency between the rounded shapes in the etching become cavities in the sculpture. The head is invaded by space. However, this spatial penetration possesses a different significance than it does in Picasso's Cubist sculptures such as *The Glass of Absinthe*. There, an absence of mass evokes mass itself. Here, space serves to guarantee the autonomy of individual plastic masses.

In *Bust of a Woman* (p. 112) sculptural masses are condensed into a rhythmically distended but generally tranquil shape which exhibits no dynamic intersections. Wholly sustained by the weight of symmetrical parts, this compact sculpture has an idol-like simplicity which makes it unique in Picasso's work. Indeed, although a similar tendency towards total reduction of the body occurs

in Oceanic art, even there the body is never so starkly replaced by symbolism. Such violent and brutal simplification is to be found only in Otto Freundlich or the young Giacometti. Brancusi, who likewise aspires to reduction, never diverges as strongly from the anatomical and structural rightness of the natural form: he seeks only to subject it to a maximum of compression. Neither 'concentration' nor 'distortion' can adequately describe a re-creation as magnificent as this. Picasso seems to take a hand in the creative process itself and compel a cellular structure, pregnant with the germs of future development, to evolve in another way.

The extent to which Picasso surrenders himself to the inherent message of form can best be seen in his total disregard of the traditional tricks whereby change is introduced into the architecture and expression of a body. Traditionally, the human torso in isolation serves to intensify expression; it alerts the beholder to the norm represented by his knowledge of the entire, intact, frame. Our sensitivity to form operates against this background: we assess the richness of the new plastic form by relating it to a totality which underlies it. It is precisely this form of extrapolation which Picasso's work renders not only impossible but superfluous, because the expressive intensification which underlies the use of the torso is replaced by a system of mobile, permutable units.

Four works, all over-life-size female heads, may be classified as a single group within the Boisgeloup period. They illustrate, in terms of the same motif, the stages through which Picasso passed during his time there. The first head (p. 122), an essay in harmonious beauty, recalls the early classicism of the Temple of Zeus at Olympia; the ensuing stages appear to destroy this classical image. Consummate, serene, and pellucid of form, the first work actually seems to invite such supersession. The formal clarity, the hair bunched into separate formal elements, the strong nose, the firm rounded cheeks – all combine to render formal autonomy possible. The other three heads (pp. 116–119) carry compression and simplification to extremes.

All these heads, like *Head of a Woman* (p. 113) and *Bust of a Woman* (p. 112), aim at an impression of solid volume. Their visual impact is, however, more complex and manifold. In *Bust of a Woman* and *Head of a Woman,* two different halves of a face are mutually contrasted. Additionally, *Head of a Woman* presents a countenance which is entirely harmonious and of balanced proportions. By virtue of its polished surface and the way in which the work has been integrated in a fully modelled, compact shape, it is impossible for one element to overlap or extinguish another as one walks round the sculpture.[101]

Head of a Woman (pp. 116–17) most strongly develops the principle whereby a sculpture is composed of rounded, protuberant formal elements. The head seems to be assembled from removable parts – nose, cheeks, eyes – which preserve their natural proportions. Its power of expression derives from the fact that individual parts of the face are isolated in their correct position and normal size. This does not apply to *Bust of a Woman* (p. 119), in which no consideration is paid to facial topography. Nose and brow merge into a single massive formal unit which is picked up and echoed by the rolls of hair.

These sculptures are true sculptures in the round. They afford the beholder numerous visual experiences, a circumstance promoted by the comparatively large size of the heads. This prevents the viewer who walks round them from being bombarded by too swift a succession of plastic phenotypes. The

sculptures reveal themselves by stages. The powerful individual shapes wax and recede, lapping over each other and yielding an abundance of fresh impressions. The beholder's experience depends, not on his reception of a series of changing symbols, but on his awareness of the sculptural energy which dynamizes the space surrounding the sculpture.

This is particularly manifest in *Head of a Woman* (p. 113). Here, the separate parts which are assembled into a face possess sufficient formal autonomy to permit of constantly self-renewing perception. The autonomy of sculptural experience here goes far beyond that which Matisse sought to achieve in his *Jeannette* heads. Because this sculpture crystallizes into an equally valid plastic experience from any angle, the quest for a correct angle of vision becomes immaterial. Only one Matisse sculpture, *Le Tiaré,* which might most readily be compared with this one, goes as far towards relativizing the position adopted by the beholder.

The most distinctive element in these sculptures – the solid fusion of nose and forehead into a single protuberance – did not in fact originate in experiments with plaster and clay. As a pictorial idea, this form of head occurs as early as 1926,[102] but it was not until 1932 that Picasso carried out variations of it in a large number of paintings and drawings.[103] In one painting[104] the tendency towards stylistic unification of body and head by means of formal linkage and formal references is particularly striking. Picasso did not originally intend to have these works executed in bronze. As he remarked during a conversation with Brassaï: 'They looked better in plaster. . . . I didn't want to have them cast at first . . . but Sabartés kept on saying: "Plaster is perishable. You need something durable. Bronze lasts for ever."'

Comparisons between these heads and other sculptures of the Boisgeloup period which represent the female body show that both themes are closely linked by stylistic principles. The same shape can mean different things in different locations. This demonstrates that one of Picasso's early laws of composition, that of permutation, was continuing to operate. It is the reversion to certain constant shapes which gives the modelled works of the Boisgeloup period their magnificent homogeneity.

In the realm of full sculpture, Picasso drew at Boisgeloup on a rich and varied range extending from skeletally constructed works to full and voluminous ones. The largest sculpture, modelled in plaster during 1933, is over seven feet high (*cat. 135*). Two stiff legs are surmounted by a bulky body. The monumental effect is accentuated by fluid biomorphic bulk. There are two shallow depressions on each side of the round head, bringing an echo of *Bust of a Woman* (p. 112). A long, powerful arm protrudes from this mass, holding a vase. We encounter the same simplified shape, though on a reduced scale, in two other works of the same period. In the heads, surface effect is strongly suppressed. Most of the irregularities are no more than slight recesses in the otherwise smooth and polished volume. The relief *Head of a Woman* (p. 122) is no exception in this respect. No attempt is made to impart pictorial and tactile values to the bronze. The impact of this relief derives from the accentuated distance which the individual shapes – bridge of nose, mouth, cheek, eye and hair – preserve from the background slab. Exceptionally deep recesses occur principally in the region of the mouth. The resulting stratification could be related to the problems of relief posed by Picasso's Cubist

constructions. There, too, he seems to prefer distinct and sometimes abrupt graduation to modelled transition.

A whole series of sculptural works, among them *Head of a Woman* (p. 123), schematize this relief technique. Here the hair and various parts of the face protrude from a two-dimensional ground in the form of ridged, conical symbols. The emergent shapes project so far from the ground that shadow plays an important role. These works are attempts to discover new optical values in bronze sculpture.

They are also reminiscent of Gallo-Roman coins. In them, the relief likewise juts vertically from the background. The almost smooth alternation of concave and convex areas endues Picasso's relief with a great deal of animation. It is this which gives the work its strong and lively tactile appeal.

BORROWED TEXTURES

The new sculptural forms modelled by hand were accompanied by a series of new sculptural techniques. For the first time, Picasso sought to animate the surface of his sculptures by mechanical means. He applied textures to the plaster. In contrast to the material collages which he and González had undertaken some years earlier, and in which the materials employed had conveyed their own direct message, material now functioned as a model. It did not oust the plaster, nor did it entirely supplant the hand of the modeller, but it presented them with objective opposition. Picasso made a breakthrough in the medium of sculpture, just as he had once done in the medium of painting, by partially suppressing the artist's handwriting.

Helmeted Head (*Head of a Warrior*) (p. 132–33) illustrates the transition from sculpture freely modelled in plaster or clay to sculpture which incorporates excerpts from reality: on one side of the figure's neck, the moist plaster has been imprinted with corrugated paper. At the rear, the head is impaled on a metal rod, a support reminiscent of the works which Picasso executed with the help of González. This is not an auxiliary construction which assumes a genuine static role, but something intended to stress the contrast between the modelled and constructed portions of the work. In *Head of a Warrior* this coupling is more fortuitous than anything else, and does not determine the overall impression. Nevertheless, when Picasso again devoted himself to sculpture in the 1940s, this linking of masses in plaster or clay with graphic elements such as iron or pieces of wood was to make a substantial contribution to the general appearance of his sculptures.

Head of a Warrior had its origin in the etchings and aquatints for *Lysistrata* which Picasso produced in January and February 1934. Preparations for the theme can be found in some drawings dated December 1935. Confronted by the sculpture alone, one would be tempted to assume that it was a caricatural work. No such intention can be observed in the drawings and graphics. In them, even the warriors are represented with the harmonious Ingresque draughtsmanship familiar to us from the Vollard Suite, begun not long before. To prove that Picasso was not interested in creating a ludicrous bogy-man seems to me to have an important general bearing on the interpretation of his work. Compared with the works that precede it, *Head of a Warrior* introduces no added distortion which would entitle us to talk of an ironic representation.

If we construed his distortion in this way we should be bound to regard his remoulding of bodies and faces into formal symbols as monstrous. In fact, however, Picasso distorts in order to create new sculptural values and give sensible shape to the formless.

Head of a Warrior poses an interesting problem. To what extent is Picasso, who has converted distortion and deformation into a neutral, non-psychological basic principle, in any position at all to create a caricature? Even the head of General Franco in *Dream and Lie of Franco,* produced in 1957, first occurred as the head of a *Seated Woman* before he committed his attack on the Caudillo to paper. When tackling this cycle, Picasso had to resort to other means in order to make his intention plain. One such expedient was that, instead of employing deformation as a stylistic principle throughout, he contrasted the deformed representation of Franco with freely drawn but undeformed interlocutors. Another expedient consisted in the use of attributes which convey vileness and malignity. In *Head of a Warrior,* too, an interpretable mood is created not by the head itself but by the impact between distorted face and undistorted helmet. We may construe the subject as a clown condemned to the horrors of war. The headgear characterizes to the same degree as the fool's cap on Max Jacob's head in *The Jester*: not psychologically and literally, but symbolically. Other works of the same period introduce a series of structures: crumpled paper (p. 134), leaves (pp. 136–37), and, ever and again, corrugated paper (pp. 138, 139).

In *Woman with Leaves* (pp. 136–37) and *Woman Leaning on her Elbow* (p. 139), Picasso reverts a great deal more strongly to the mechanical texturing of surfaces.[105] Indeed, experimentation with textures becomes a major theme. The parallel flow of the corrugated paper pleats on the dress recalls the fluting on classical columns and the drapery of Greek statues. This regular structuring is contrasted with the vegetable veins in the leaves which have been impressed into the fresh plaster. The surface of the sculpture consists almost entirely of borrowed textures.

Woman with Leaves seems to me to be one of the greatest of Picasso's sculptural achievements. A mere enumeration of the structures which go to make up this sculpture does not, however, explain its peculiar fascination. The folds of the peplos are reminiscent of classical sculptures. Picasso dwelt at considerable length on Ovid during the 1930s, particularly in his etchings. We are reminded of Daphne, who was transformed into a tree while fleeing from Apollo. Picasso imbues this stiff, firmly rooted figure with immense sculptural animation. The leaf-veins and rippling folds of drapery seem to make it tremble.

Another sculpture, *The Reaper* (p. 140), which was made some years later than *Woman with Leaves,* is quite as much invested with life by an alien element and by the magical power of a reinterpreted shape. Picasso cast the head from a sandcastle-mould, using a positive impression. A head-shape of this kind suggests more than one interpretation: we can construe it either as a straw hat or as the sun behind the reaper's head. The representation of the body itself displays analogies with the works executed in relief style and with the small modelled figurines of the 1930s.

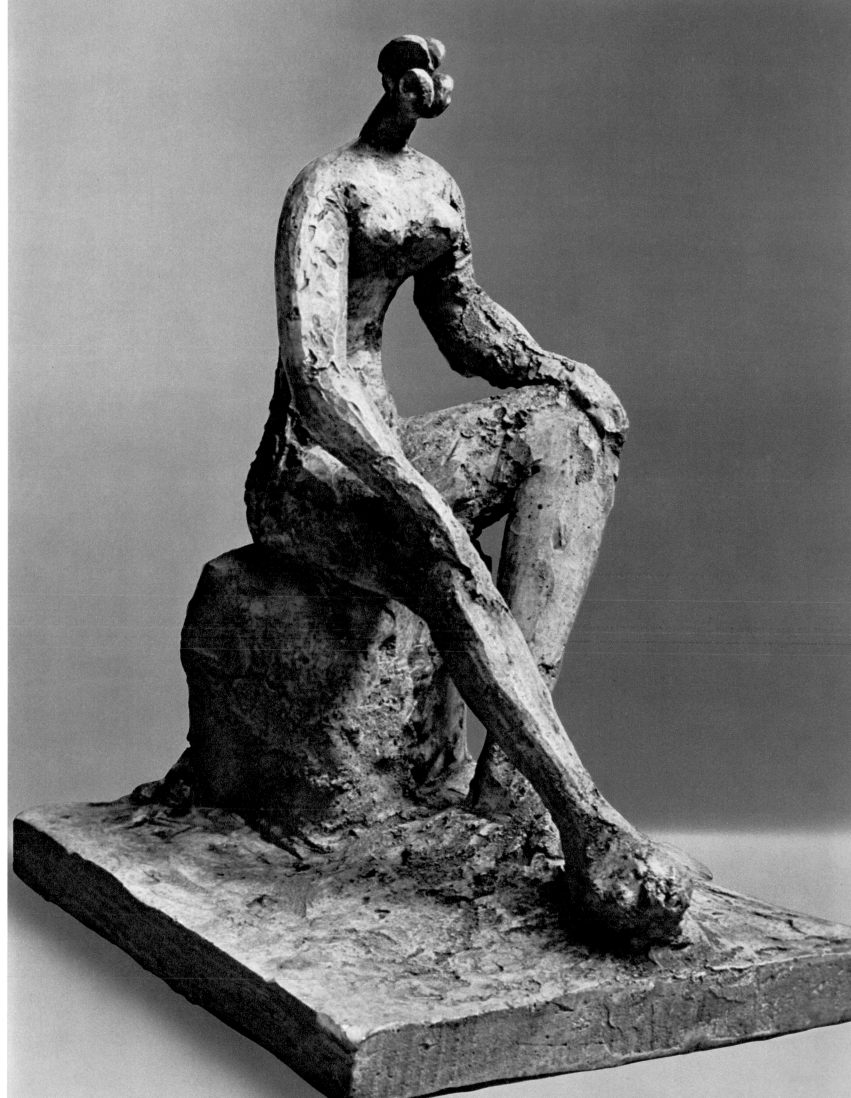

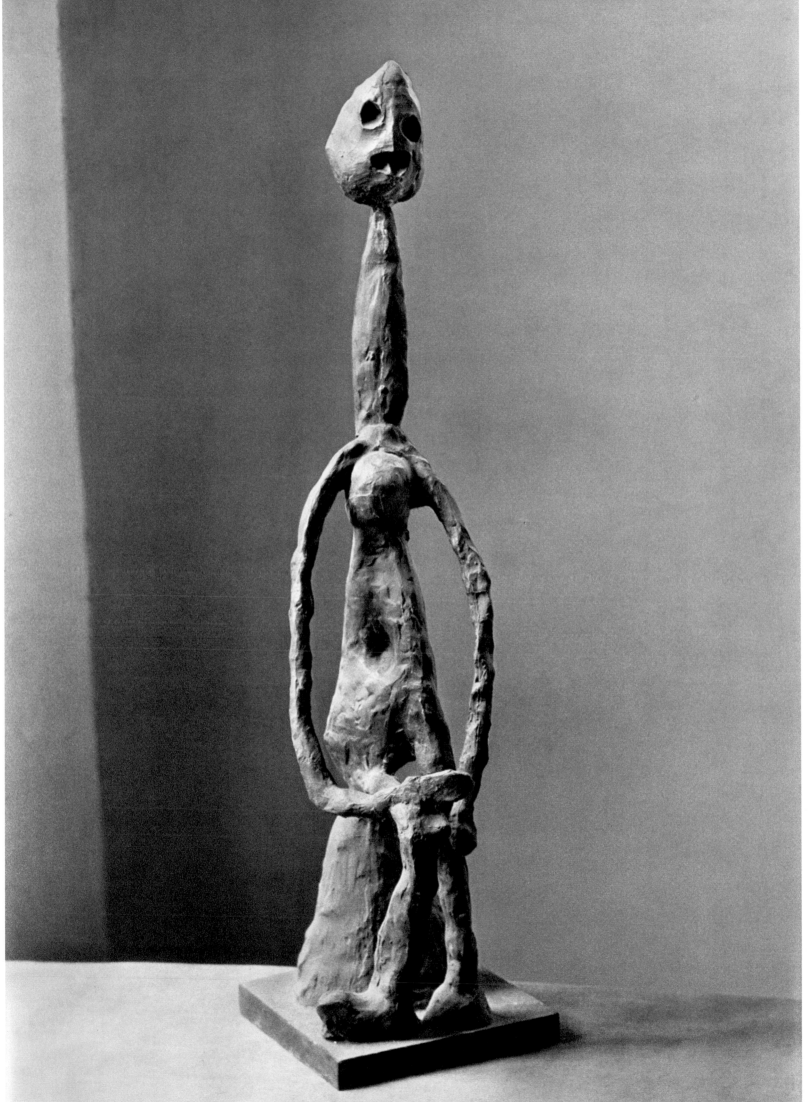

109 ▷

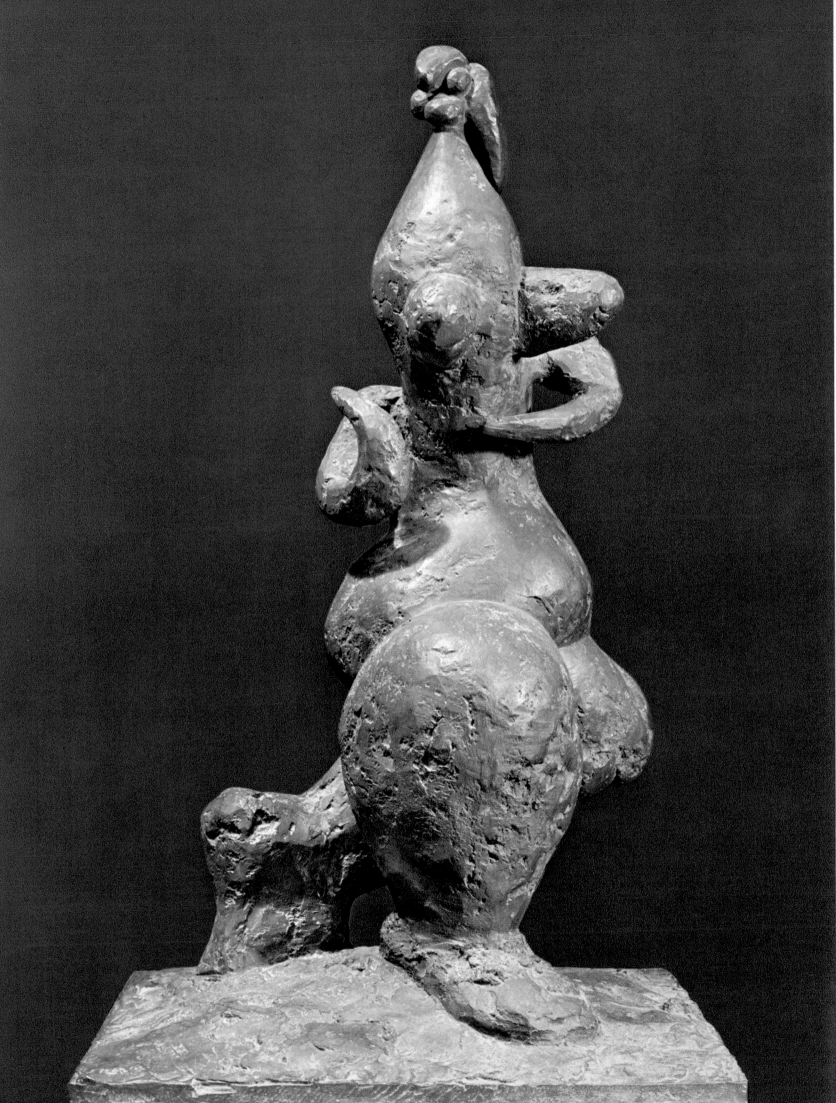

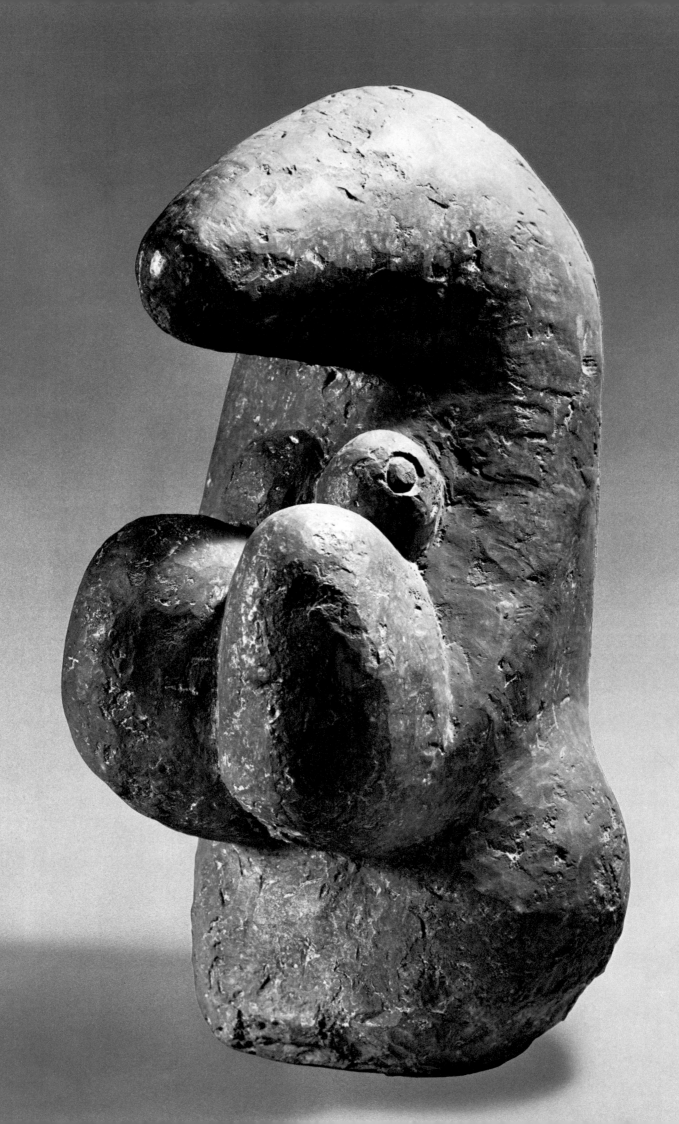

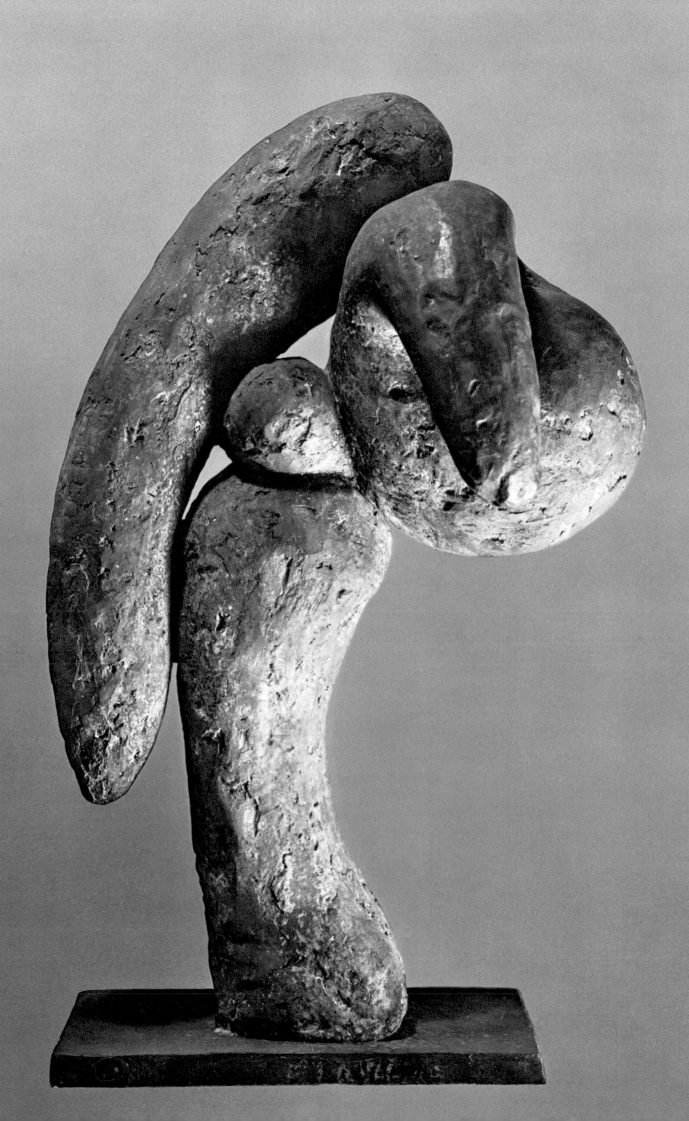

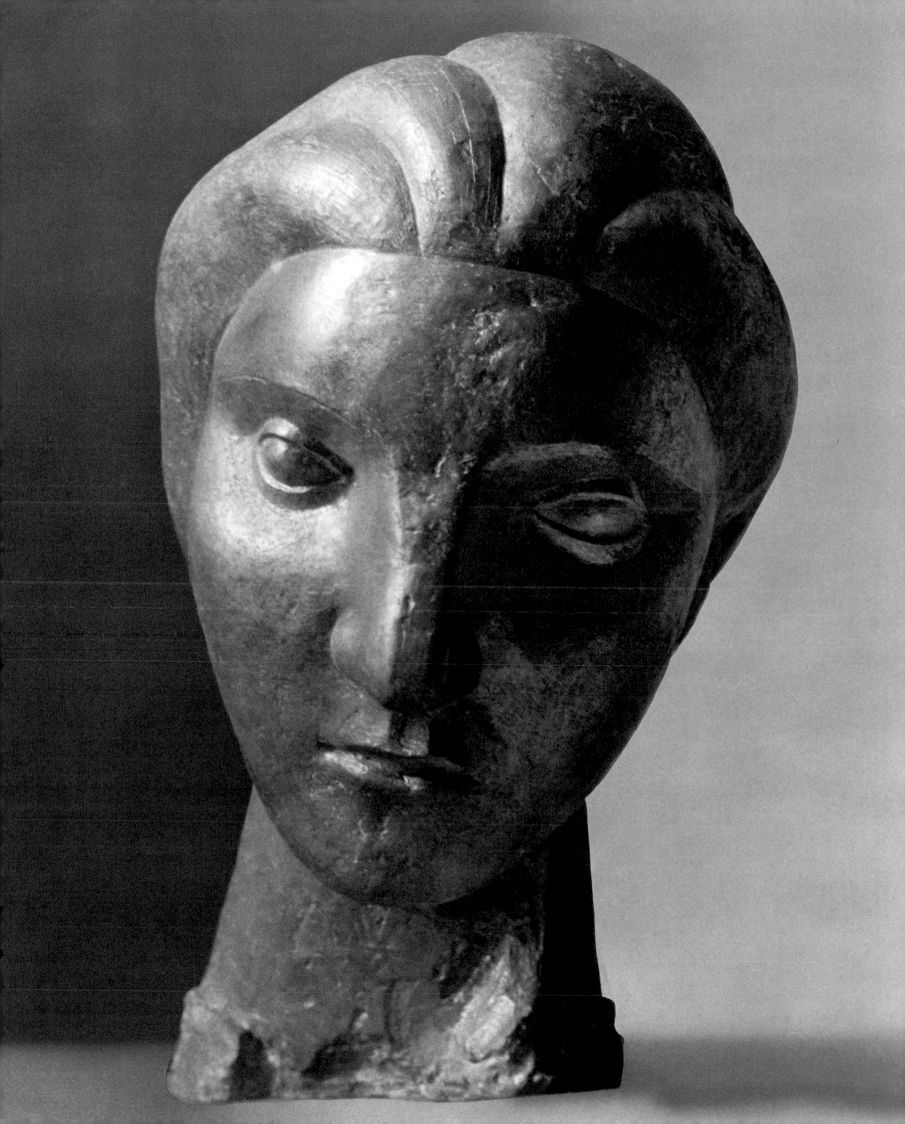

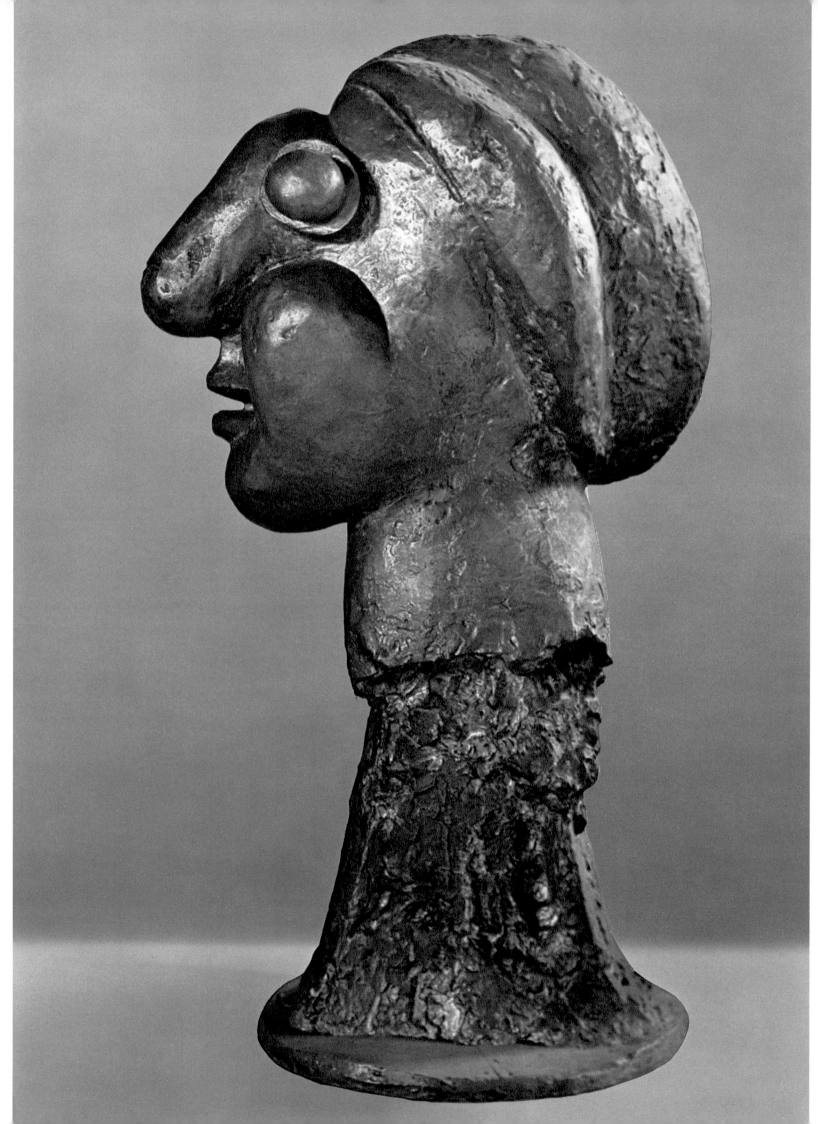

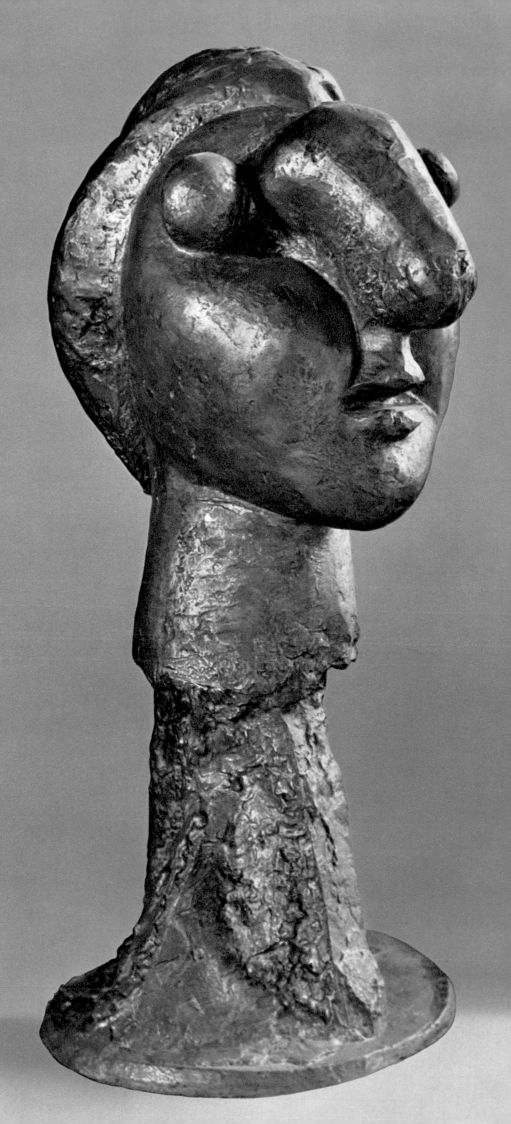

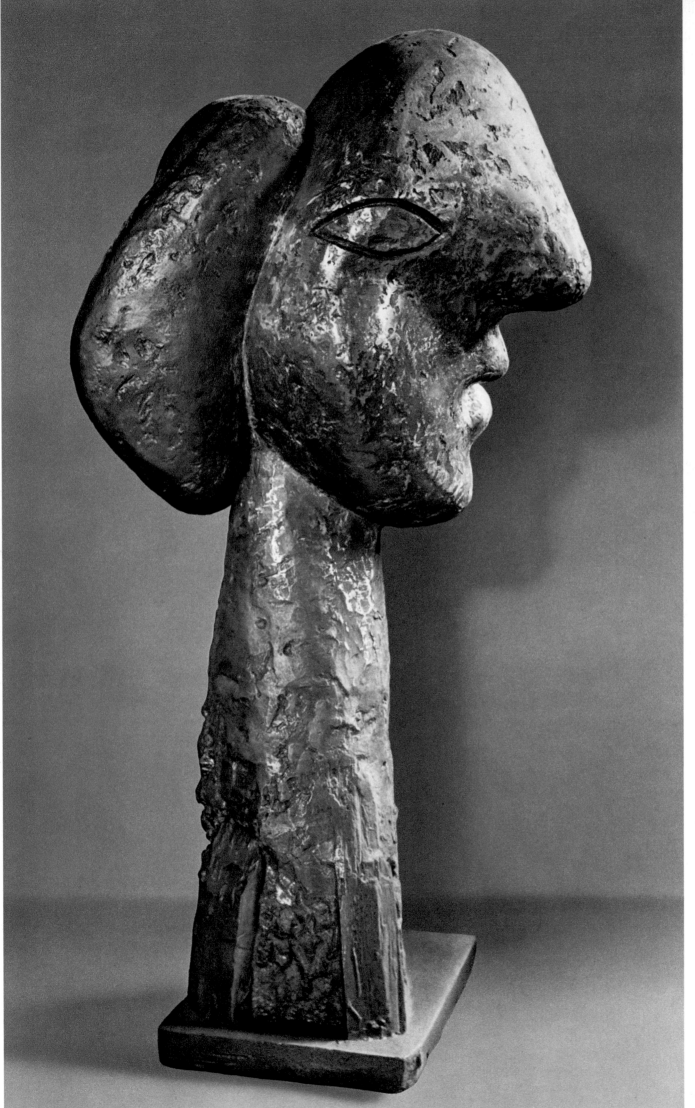

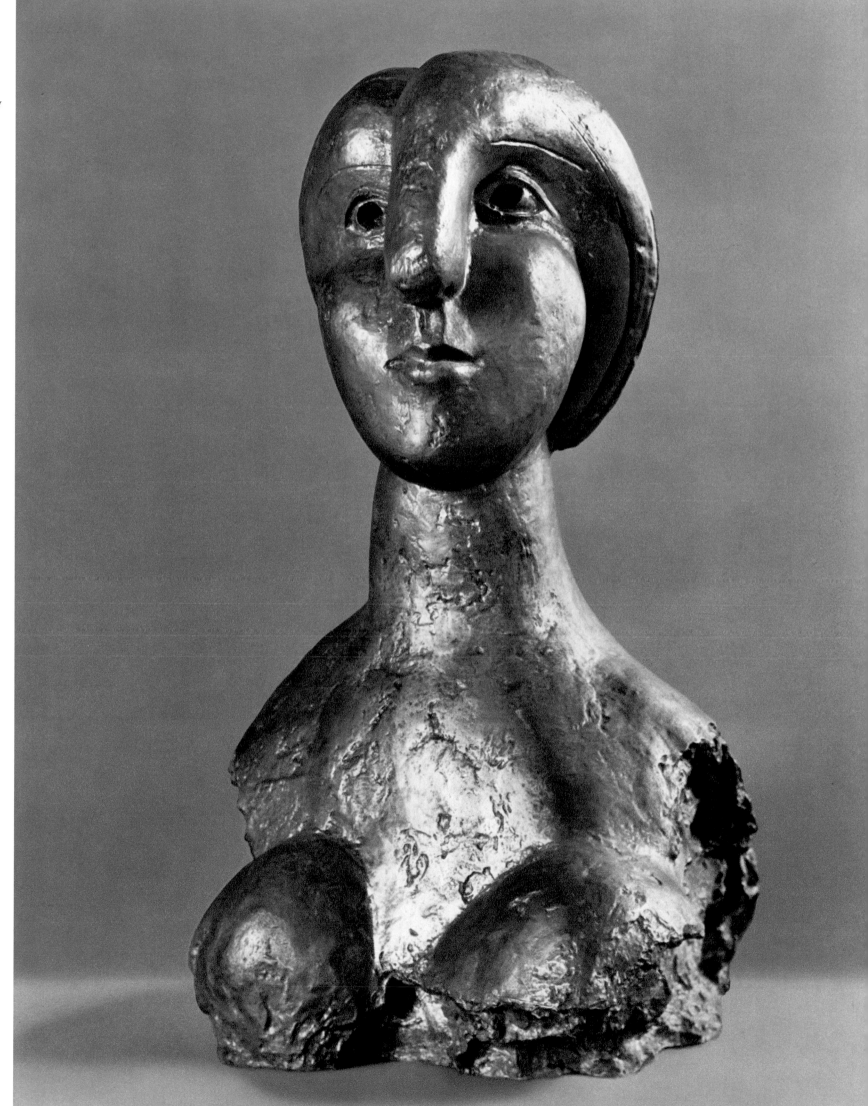

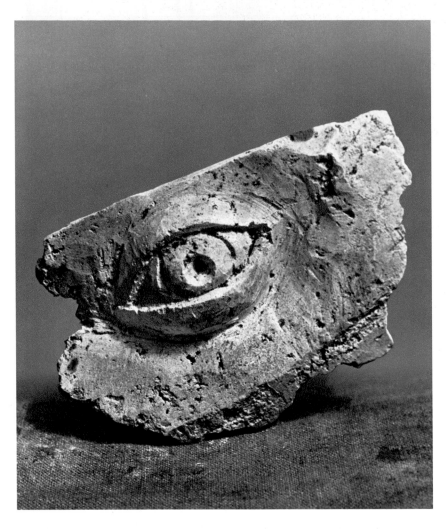

122

124

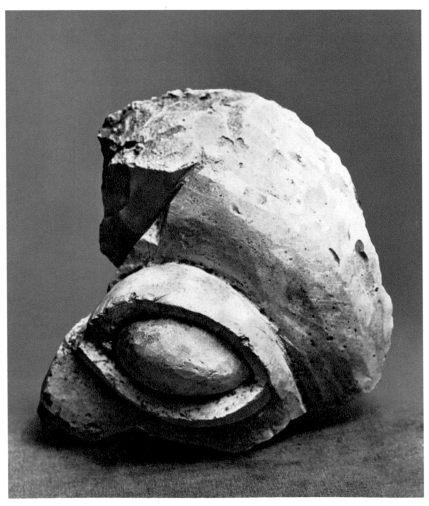

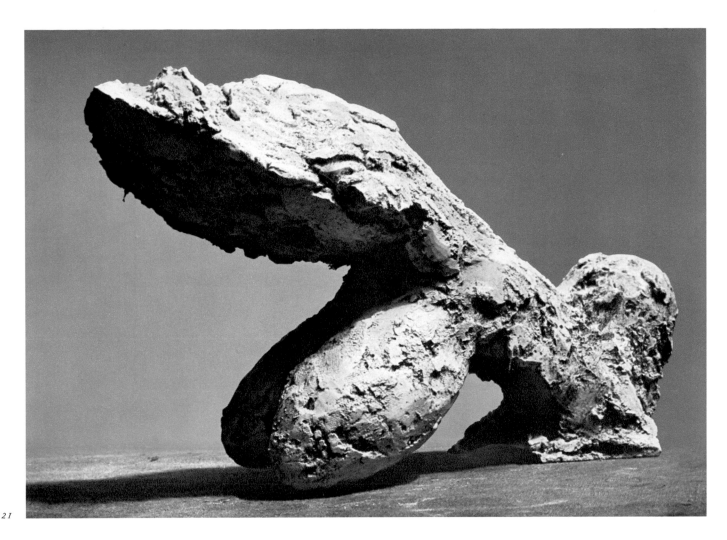

124

125

121

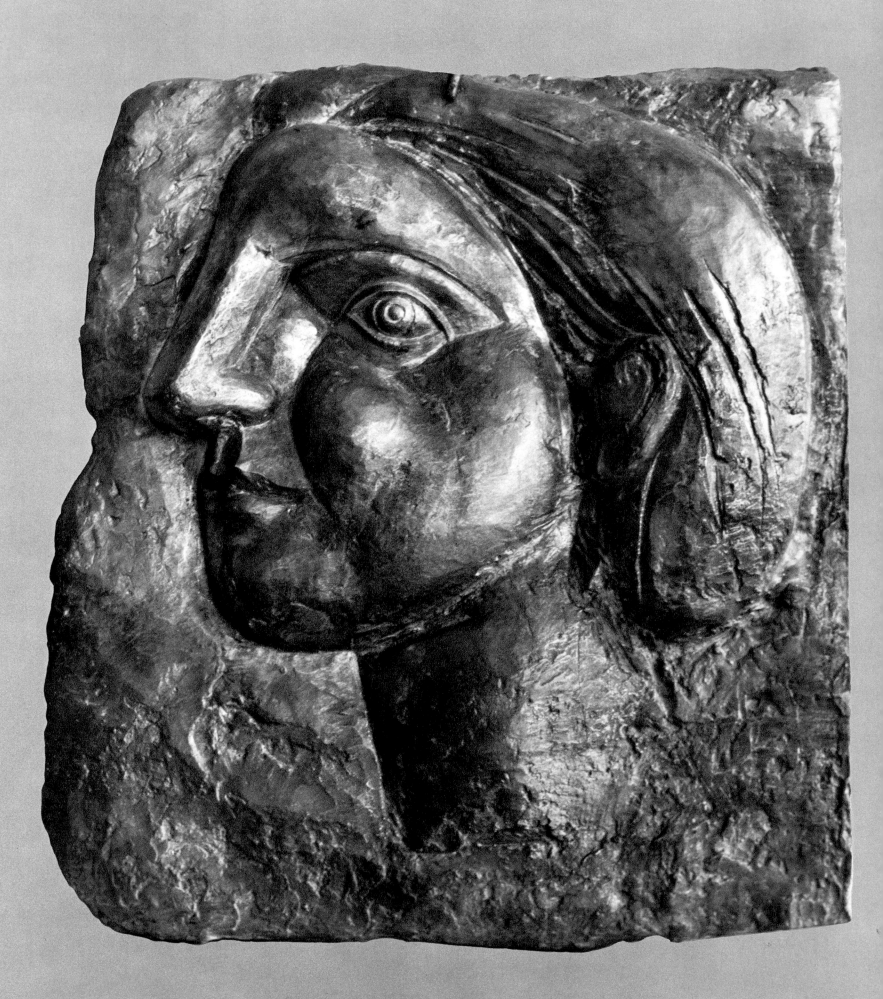

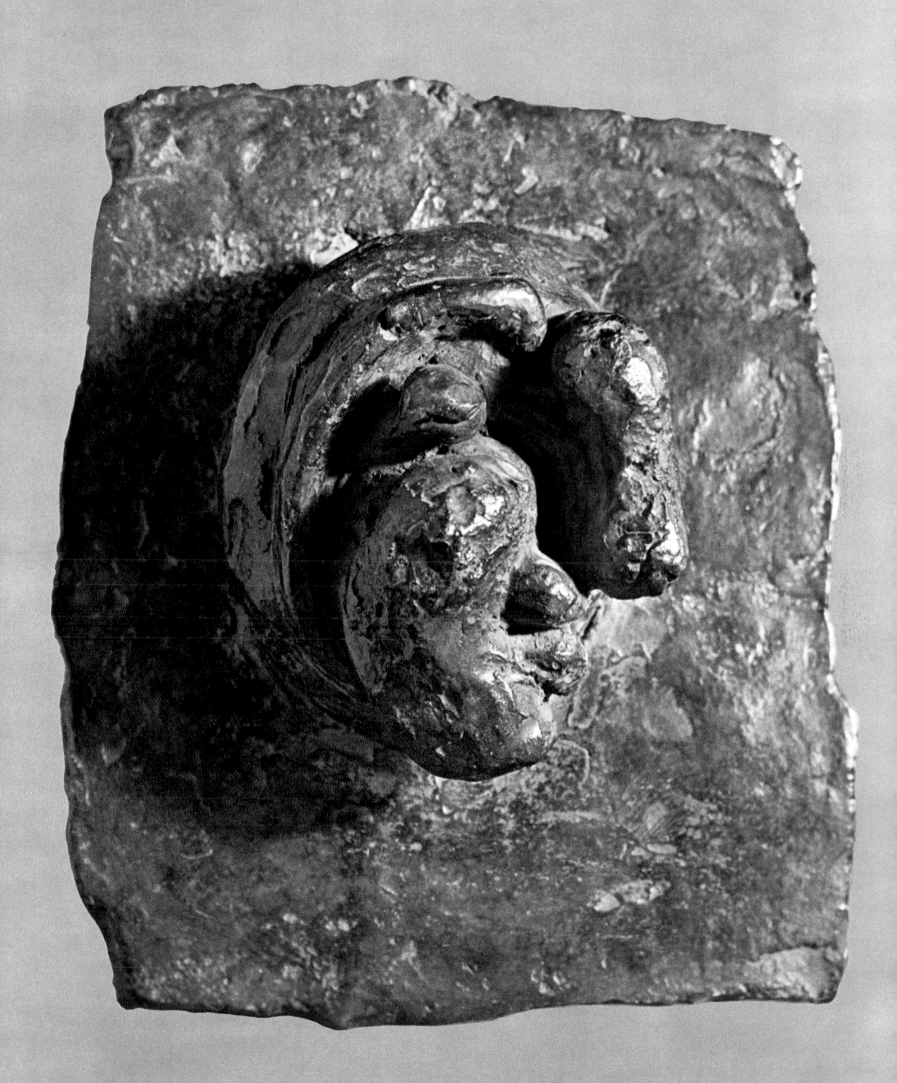

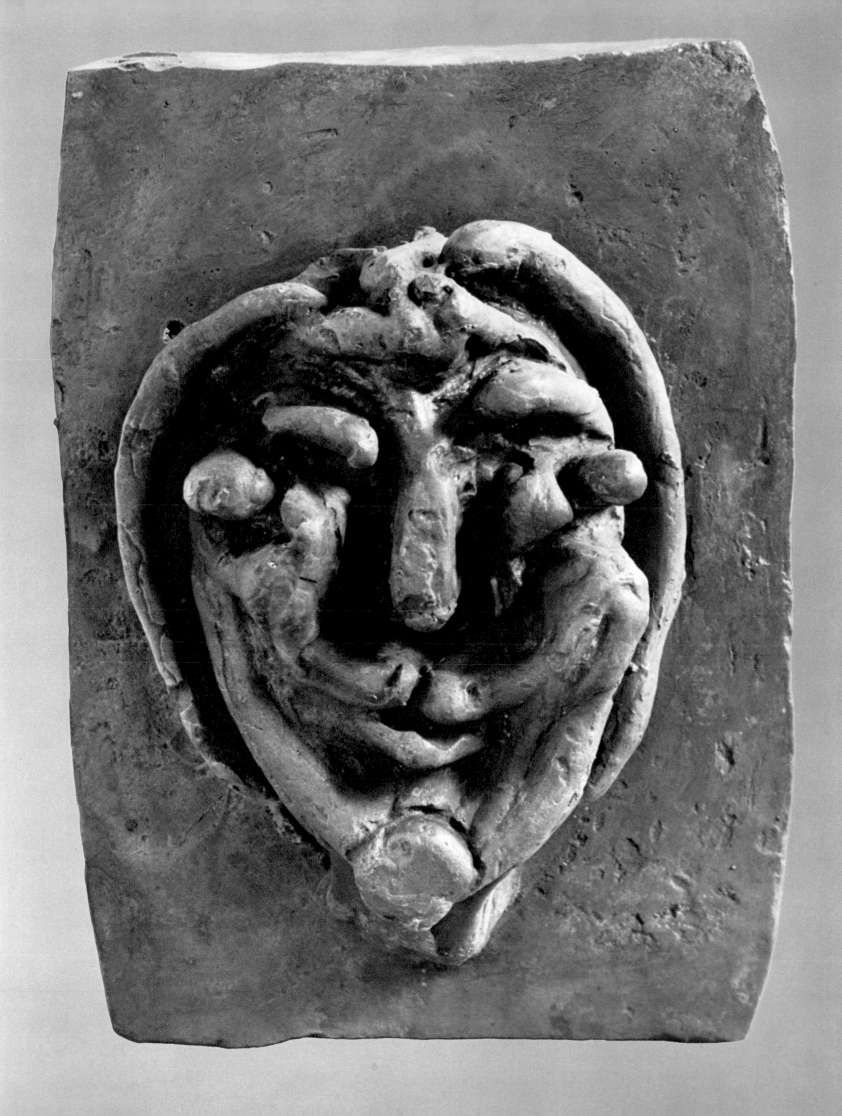

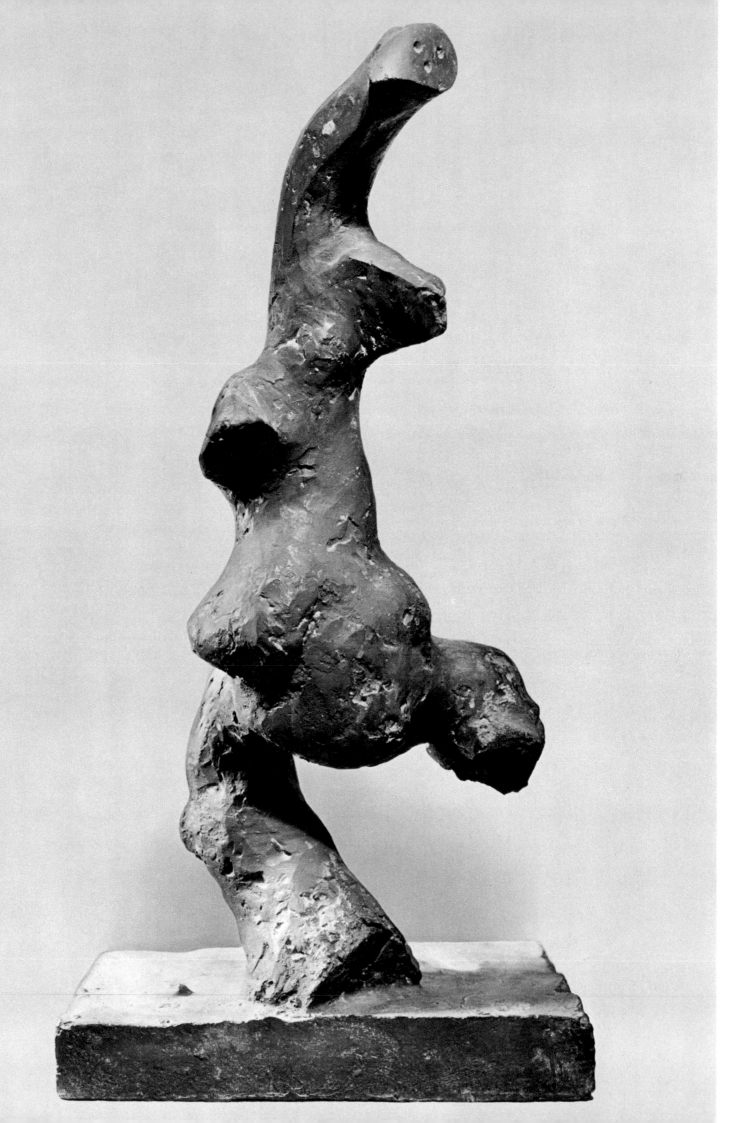

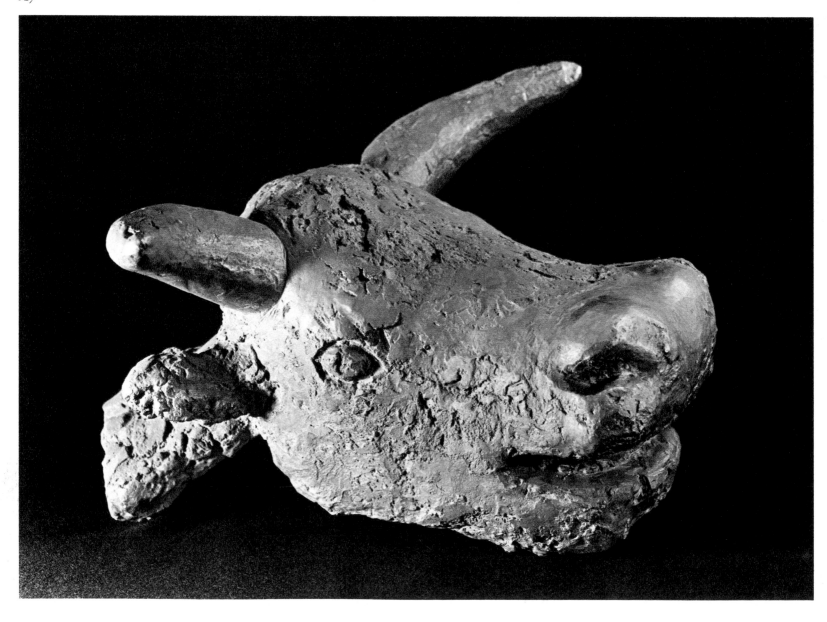

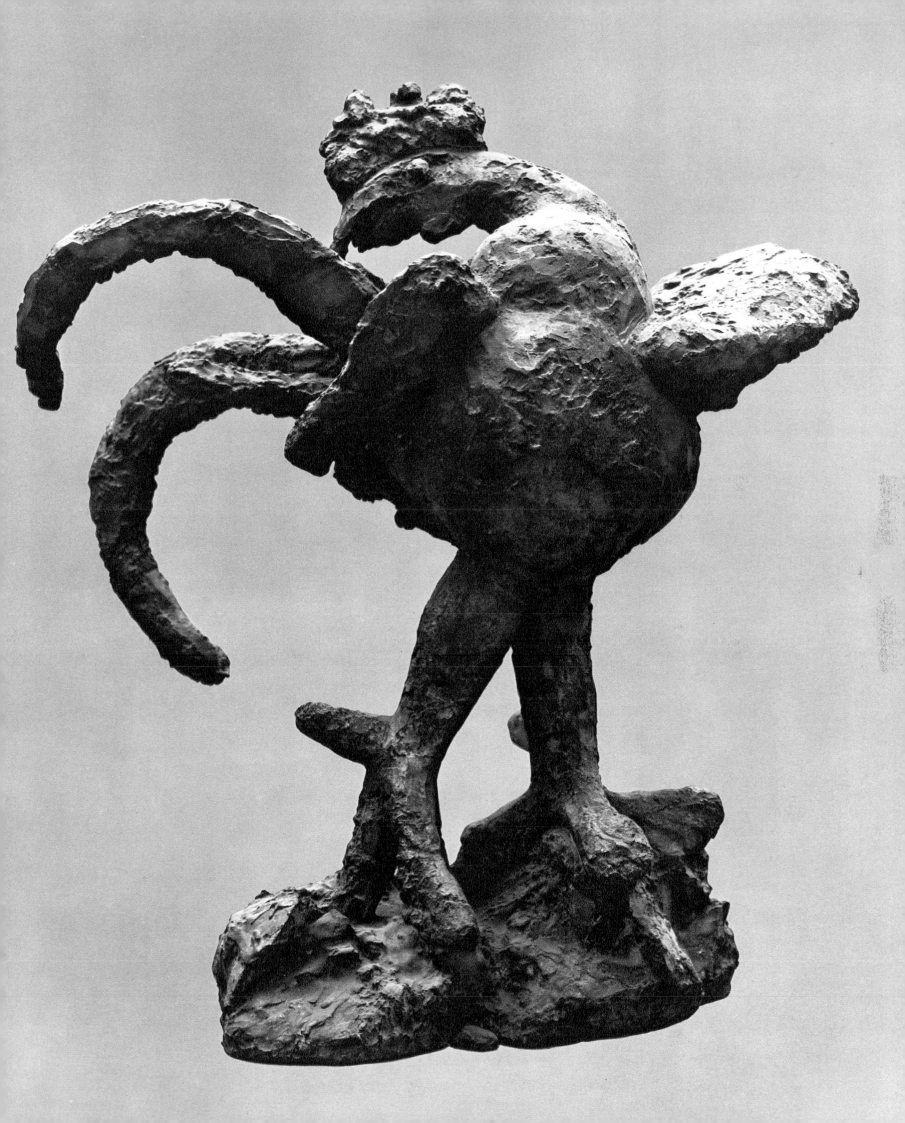

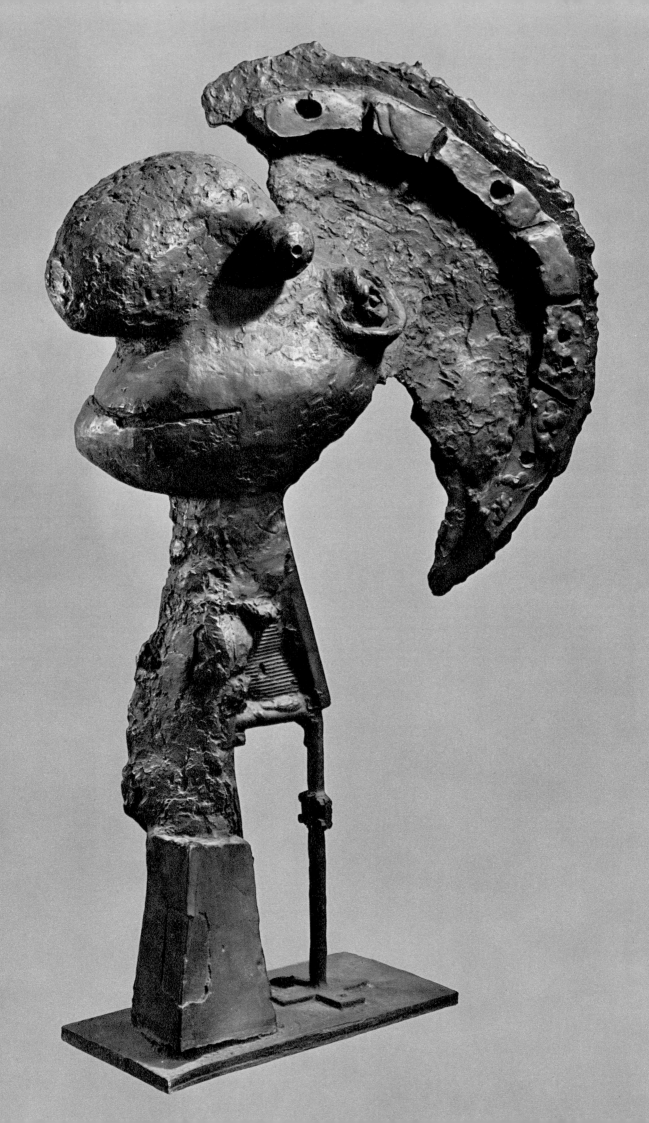

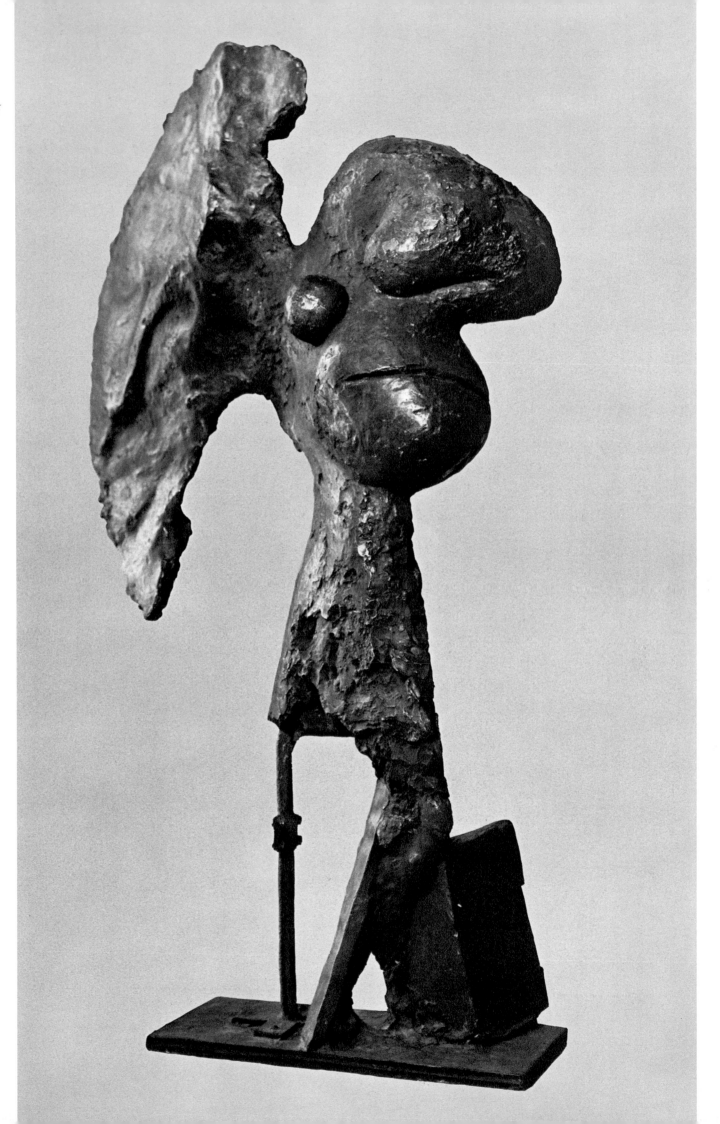

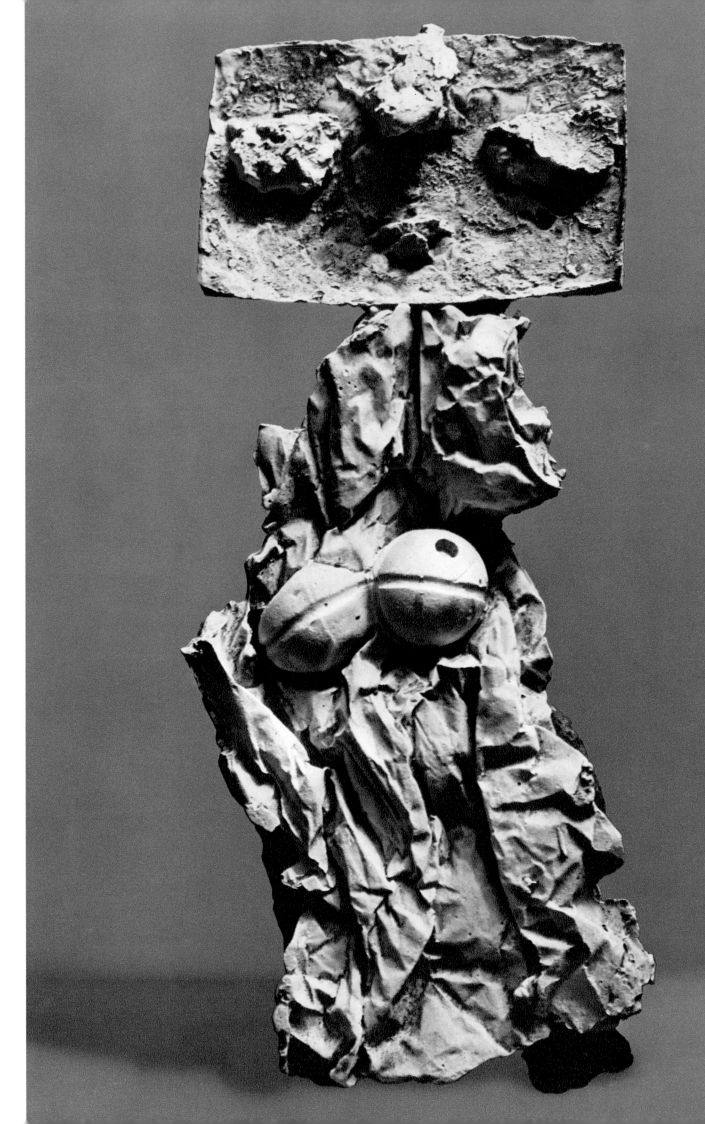

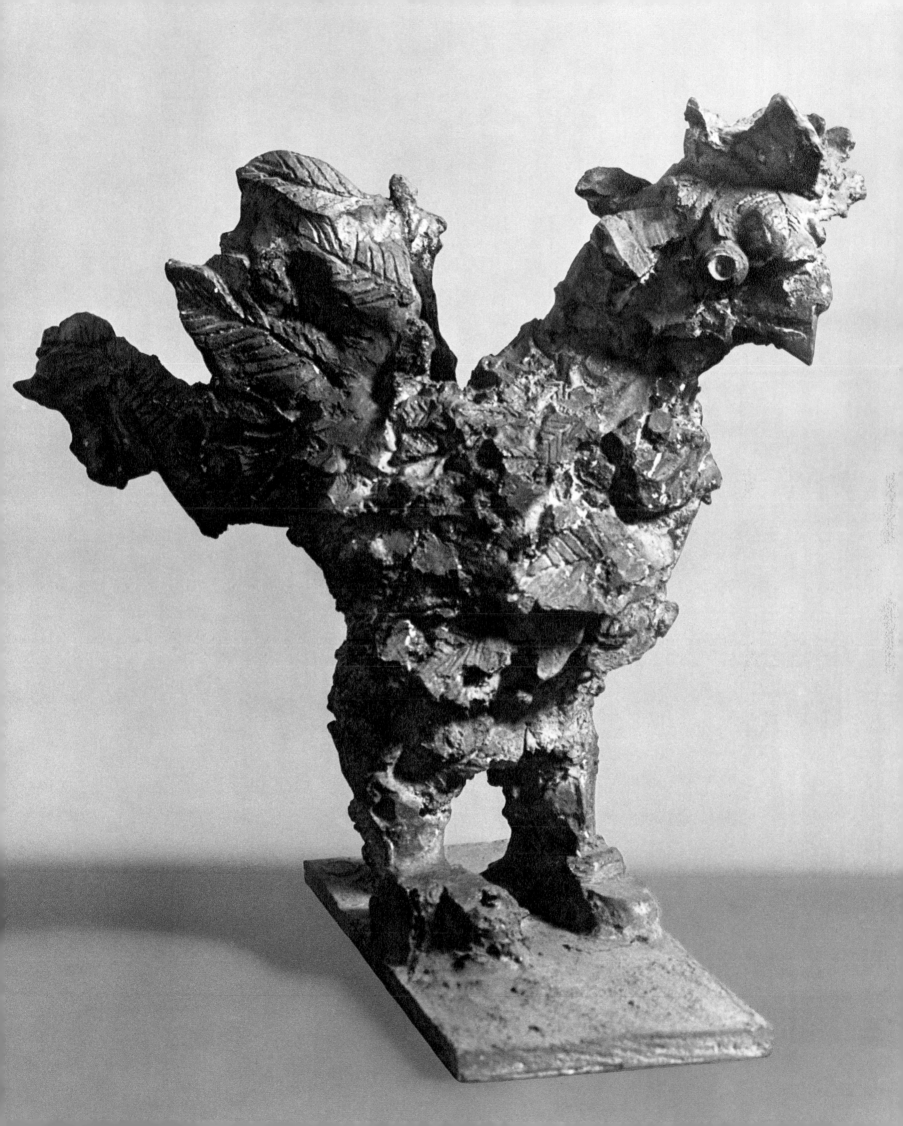

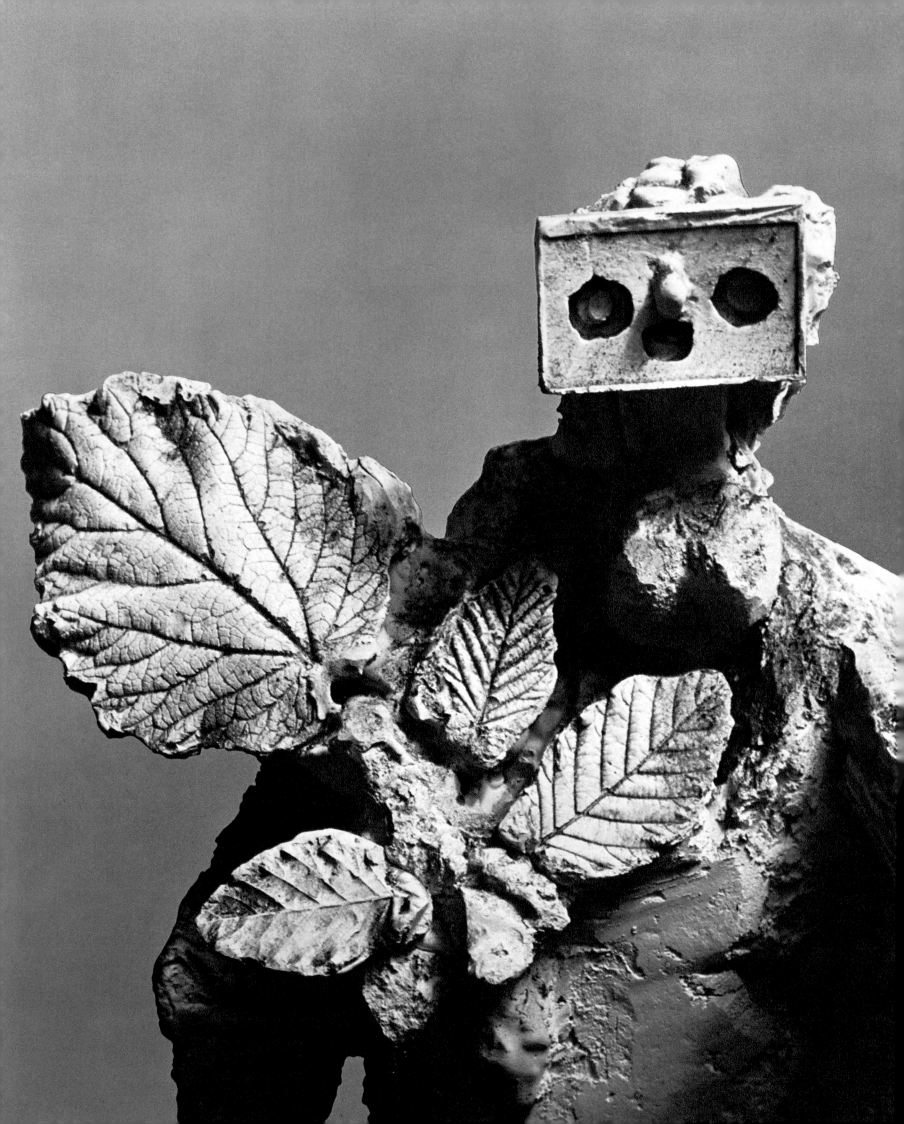

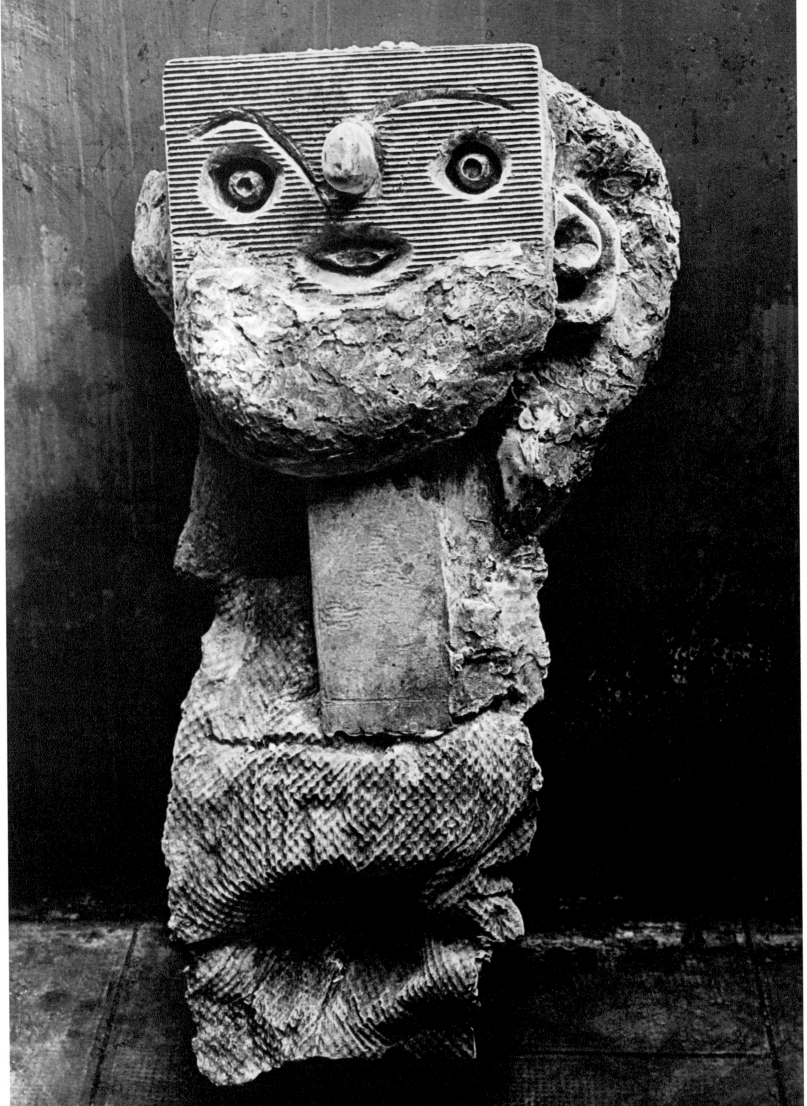

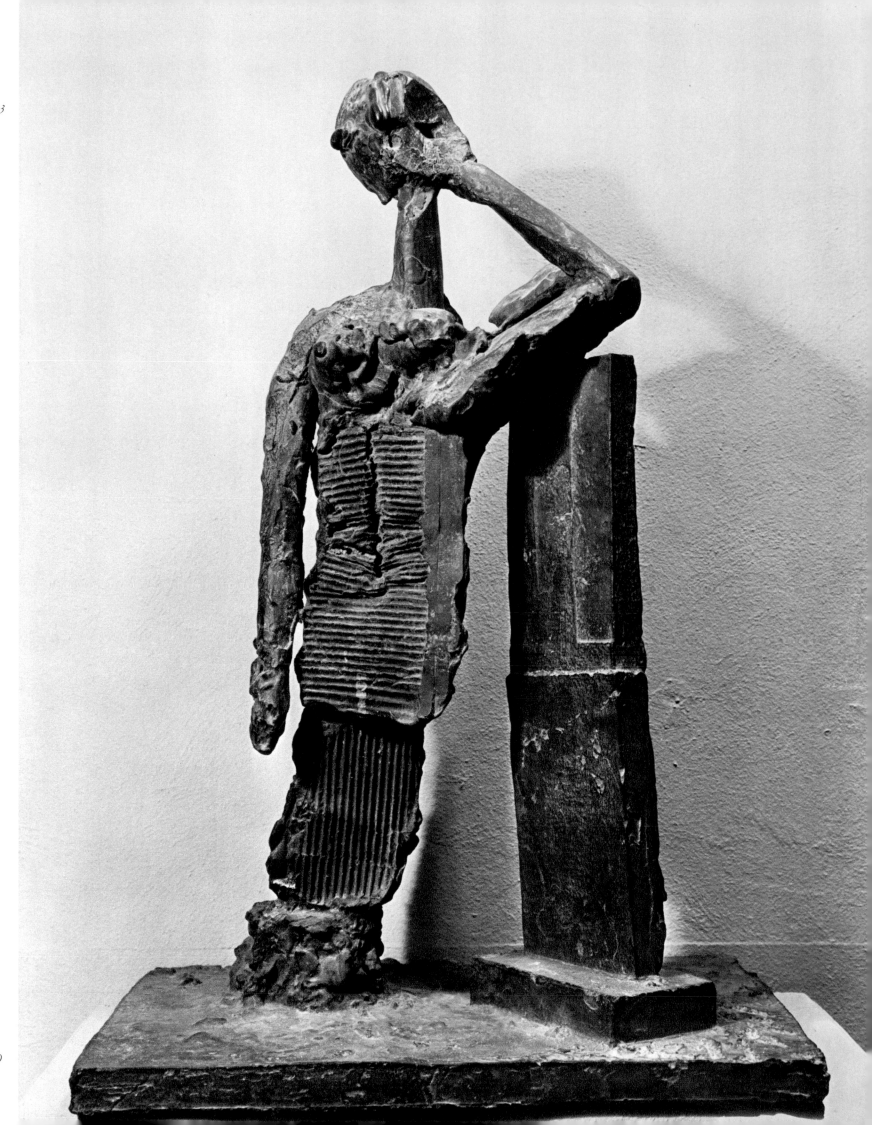

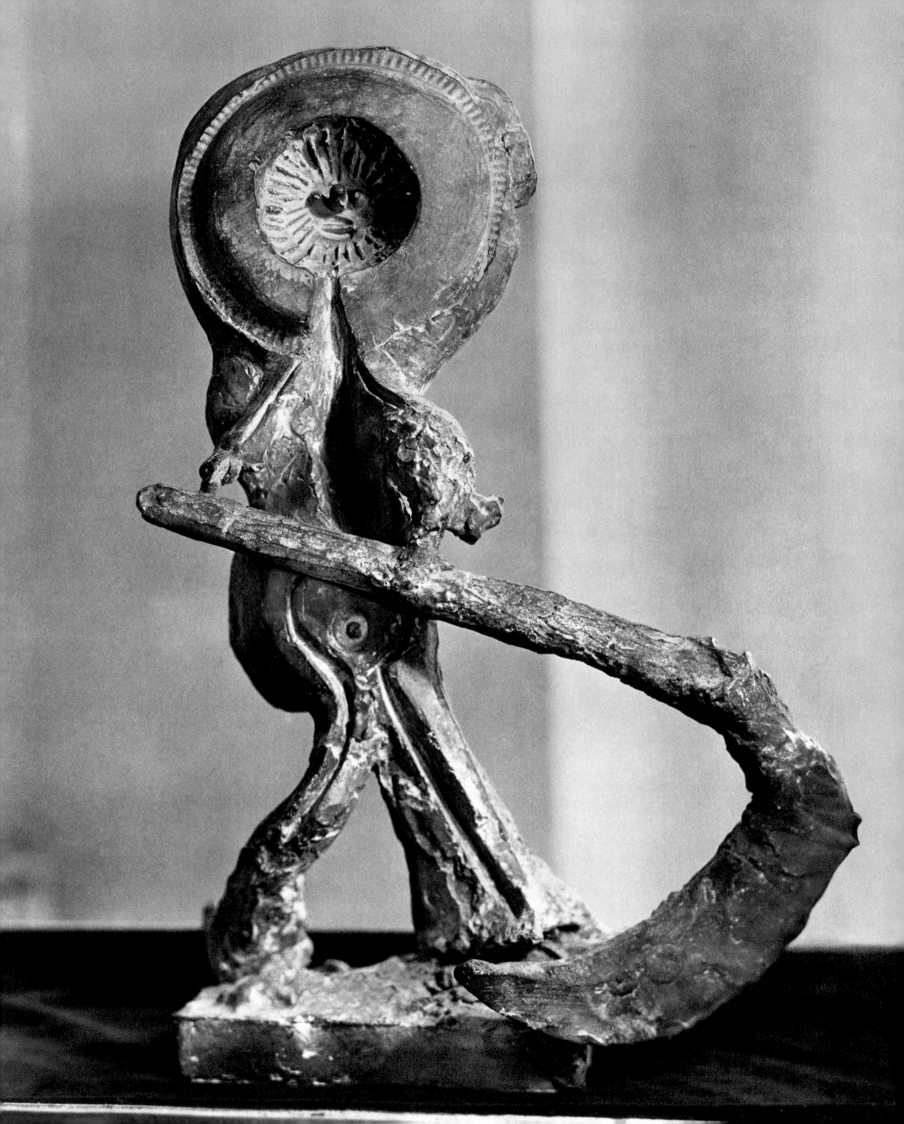

CHAPTER 5

Given materials

Picasso's sculptural activity waned during the years 1934–40. His output was limited to a few constructions (pp. 152, 153; *cat. 168, 170*), dolls and assemblage figures (pp. 149–51; *cat. 160–62*); the constructions and reliefs which convert materials into still-lifes are a resumption of works begun in 1930.

This time, however, Picasso does not coat the materials he employs with a layer of sand. Instead he homogenizes them by painting them, investing them with the serene and harmonious character which is detectable elsewhere in his work.[106] These are works which seem to equilibrate the expressive phase of which *Guernica* forms the centrepiece.

The *Figures* of 1935 (pp. 149–51) provide further examples of Picasso's use of various found objects within a construction. Even during his collaboration with González, he had taken ready-made articles and given them new meaning. In the small figures to which we now allude, Picasso adopts a different procedure in that he juxtaposes the objects and materials he uses and allows them to preserve their contrast. The fact that they are cast in bronze does not transfer them to the same material plane. On the contrary, homogeneity of material is replaced by the assonance of materials of different kinds (wood, sheet metal, iron, string, cloth). In 1943, Picasso was to enlist this procedure in creating the most effective and celebrated of his reinterpretations of found objects, *Head of a Bull* (p. 161). In this, the simple coupling of two unmodified portions of a bicycle generates a new formal symbol which is so active and functions in so intelligible a manner that the reality of its components is overlooked by the beholder and serves merely as an undertone in the new meaning that is imparted to them.

Figure (p. 151) represents the most important first step towards *Head of a Bull*. Here, excerpts from the world of objects are limited to two small rakes and a ladle. The ladle becomes the head, defining this not only by its round shape but also by the significance of the object itself, which connotes eating. The two rakes likewise represent something more than formally parallel structures which bear a direct relationship to the shape of a hand: they symbolize the act of raking together. Ladle-head and rake-hands refer to a psychological attitude: they might be construed as a manifestation of human greed and rapacity. The architecture of the rest of the body is an airy structure of wooden struts and string which recalls the constructions of iron wire (pp. 78–79).

It is worth examining each of these borrowings in terms of its specific message. In some sculptures such excerpts represent themselves. One case where

an object has been used for a purpose identical with its real function is the spoon in *The Glass of Absinthe*. Then, again, there are instances where an object is allowed to retain its material nature and natural colouring but (like the ladle and rakes in *Figure*) forfeits its original significance through association with other objects. One variation occurs when an immediately obvious excerpt from reality is incorporated in a sculpture modelled in clay or plaster (as with the leaves and corrugated paper in *Woman with Leaves* (p. 136). *Head of a Bull* (p. 161) represents an ultimate stage of development. In this – as in Duchamp's *Wheel on a Kitchen Stool* – two elements are brought together: the saddle and handlebars of a bicycle. The intention is fundamentally different in each case, however. Duchamp meant simply to set forth the incongruity of two objects as a polemical and insurmountable gulf, whereas Picasso is concerned to explore the formally evocative power of objects and create new reality by means of transposition.

Head of a Bull is one of Picasso's most famous and most frequently reproduced sculptural works. The beholder is for ever astonished by the realization that this work consists of two elements only. Picasso has here attained the ultimate in simplicity of sculptural expression. The work itself (*Head of a Bull*) and an awareness of the act underlying it (the juxtaposition of a bicycle saddle and handlebars) belong together. Replying to Michel Leiris, who had congratulated him on this piece, Picasso said: 'That isn't enough. One ought to be able to take a piece of wood so that it becomes a bird.' Varieties of objects and materials were to play an increasing role as time went by. The combination of free sculptural shapes, reinterpreted excerpts from reality and directly appropriated real elements was to culminate in Picasso's sculptural assemblages.

However, Picasso's course of development never follows a straight line. It is interrupted, ever and again, by individual works whose formal representation diverges from his otherwise cyclical manner of working. The *Man with Sheep* of 1944 (pp. 168–69), for example, remains a lone example of the large fully modelled sculpture.

This diversity in Picasso's sculptural work steadily increased from the early 1940s onwards. In addition to fully sculptural works, constructions, and pieces that combine alien materials and objects, we find ceramics and figures of wood or sheet metal. A further problem, and one which exercised Picasso from an early stage, is the painting of sculptures.[107] All these works exert a reciprocal influence. Nowhere do we encounter clear-cut divisions between techniques. Picasso swaps them around, combines them, and does all he can – from his own point of view – to reduce questions like legitimacy of material *ad absurdum*.[108] New themes, new techniques and wide variations in format are characteristic of this later phase.

SCULPTURAL SKETCHES

Boisgeloup was the time of major sculptural achievements effected by modelling or by the addition of textures extraneous to art. During the second half of the 1930s this period of fulfilment, which was also distinguished by its large scale, gave way to sculptural activity which occurred more sporadically and tended to find expression in small-scale sculptural gestures. For the time being, projects seemed to assume greater importance.

Picasso often confined himself to tackling small, sketchy pieces of modelling. Many of these testify to an experimental treatment of material or to an attempt to extract expression from a meaningless, amorphous element. A series of heads in relief, reminiscent of Gallo-Roman coins, comes into this category (*cat. 140, 146*). Picasso started on this series at Boisgeloup in 1933. Having first modelled negative reliefs in clay to act as matrices, he filled the depressions with plaster. Other items which form part of this group of small and incidental works are some scratched stones, the first of which can be dated 1937 (*cat. 171–175*). Sometimes they serve simply as a ground for an engraved drawing, and the rotundity of the stone becomes a head. Then, again, expression is wrested from the shape of the stone itself (polished flint), and a stone bizarrely fashioned by the elements is transformed into, say, a fish (*cat. 190*). In addition to stones, Picasso used the structures and graining of bones. The porous surface of a fragment of bone, for example, is reinterpreted as the plumage on a bird's head (*cat. 176*). In their capacity as plastic grammalogues, almost all these small subsidiary sculptures lend expression to a potential shape inherent in every amorphous object. Brassaï's account of Dora Maar's collection of small sculptures of this type illustrates Picasso's susceptibility to stimulation by found objects. He takes shapes which come into his hands by chance and transforms them into symbols.[109]

However incidental their genesis, these works do in some cases wield far-reaching influence. The same may be said of the works torn and cut from folded paper (*cat. 247–70*). These are harbingers of the sheet-metal sculptures which so impressively dominate Picasso's later sculptural work.

The scene is set for a new phase whenever Picasso allows himself to be stimulated by objects and materials. Surveying his sculpture as a whole, one observes that there is a great predominance of works whose inspiration stems from precise objects. The one period genuinely devoted to free sculpture in which Picasso based his work on traditional materials (plaster or clay) occurred during his time at Boisgeloup. This was where he realized ideas of form which were already to hand in his work as a painter and draughtsman. It is instructive to hear what Picasso has to say about sculpture which does not proceed from formal and inherent stimuli in the material used: 'Strange, isn't it, that people hit on the idea of making statues out of marble. . . . I can understand someone being inspired by the root of a tree, a fissured wall, a weathered stone or a flint – but marble? It only comes in blocks, gives no stimulus of any kind, doesn't inspire. . . . How could Michelangelo have recognized his David in a block of marble? After all, man only thought of capturing images because he found them around him, almost complete, within reach. He recognized them in a bone, in the roughnesses on the wall of a cave, in a piece of wood. . . . One shape resembled a woman, another reminded him of a bison, another of a monster's head.'

PARIS AND LARGE-SCALE WORKS

In 1941 Picasso began to devote himself to sculpture once more, this time in Paris. The works produced at Boisgeloup had travelled with him to the capital. He stored them at a small mews in the rue des Grands-Augustins, not far from his studio and apartment, which were in the same street. In 1937 he had

Dressing-table · 11 April 1936
Pencil · 25 1/8 × 18 7/8 (64 × 48)

rented a large studio at No. 7, where he had painted *Guernica*. There, in the early years of the war, he also produced some small female figures modelled in clay (pp. 158–59), the celebrated *Head of a Bull* (p. 161), and a plaster head of Dora Maar (pp. 156–57), which now, cast in bronze, stands outside the church of Saint-Germain-des-Prés as a monument to Apollinaire.

The new Paris premises enabled Picasso to resume work on large-scale sculptures: *Standing Figure* (p. 165), *Woman with Apple* (p. 163), *The Madame* (p. 166), *Woman in Long Dress* (p. 167) and *Man with Sheep* (pp. 168–69). Each follows a different sculptural principle. *The Madame* and *Man with Sheep* best illustrate the extremes between which Picasso's sculptural activity ranged at this time. The former is entirely assembled out of found objects, the latter was entirely modelled in clay. The other three sculptures present a synthesis of both techniques.

Woman with Apple (p. 163) provides a transition from the Boisgeloup period to this new period, in which Picasso increasingly couples the expressive potentialities of modelling with the use of given objects and materials. The head and fluted upper part of the body, which is topped by a small cake-tin, construed as a collar – all these features are known to us from a bust, no longer in existence, which can be seen in a photograph taken in the studio at Boisgeloup.[110] The rectangular head-motif, too, recurs frequently at the beginning of the 1930s. In its method of objectivizing the modelling process, in which prefabricated textures are applied to the surface, *Woman with Apple* displays a technical variant: Picasso presses wire mesh into the wet plaster. This produces a fine network of lines perceptible as a bas-relief and gives the figure a sort of reticulated skin which contrasts with the corrugated-paper fluting on its upper reaches.

The construction of the body, which tapers upwards, is strictly vertical. The cake-tin ruff interrupts this convergence and seems to present the head section as if on a small dish. The rigidity of the body, which strongly recalls a tree-trunk, is in sharp contrast to the gesticulating arms which reach asymmetrically into space.[111] One hand holds an apple which becomes – to preserve the same imagery – a fruit on a branch. The other arm, which bends back on the body like a handle, holds a vessel. The movement produced by both arms taken in conjunction resembles the writhing of a serpent and conjures up Eve and the apple.

Standing Figure (p. 165) likewise exhibits a contrast between upper and lower portions of the body effected by the use of different patterns. A further contrast is obtained because the head and chest occupy one plane, while the lower part of the body is represented in terms of surface-sculpture.

The face is modelled, this time, but in a wholly schematic way. The modelling strives for effects which Picasso achieves in other works of the same period by means of borrowed shapes. Eyes, nose and mouth stand out against the disc-shaped face like formal grammalogues. Instead of two arms and two legs, Picasso gives the figure a right arm and left leg only. These omissions further underline the symbolism of the work. Only one detail, the fluttering of the skirt, transcends the simplicity of a formal symbol and enables us to construe the work as a female figure.

In the third important sculpture in this group, *The Madame* (p. 166), the basic formal idea is conveyed by very different means. The elongated pro-

portions are reminiscent of *Woman with Apple*. But whereas the head of the latter recalls a series of Cyprian heads published in *Cahiers d'Art* (1929), the head of *The Madame* puts one more vividly in mind of African Wobe masks. Where *Woman with Apple* derived its lean, slender volume from the modelling process, *The Madame* does so exclusively from the use of found objects in which slenderness is already inherent. Different working methods are echoed by a contrast in formal structure. This is particularly evident in the line of the arms. In *Woman with Apple* the arms detach themselves from the body in an arabesque movement. The rigidity of *The Madame* is accentuated by an angular and geometrical arm arrangement. There is no modelling here, only an assembly of parts. For example, a gutter-tile has been used for the shoulder and chest section.

The compact, rigid structure is relieved by the incorporation of void areas in the upper part of the body. The right breast is represented by a mass of mortar adhering to the tile, the left by a missing portion of the same. The varying height of the elbow-joints gives the figure additional articulation. All these elements, which enliven the upper part of the body, remain subordinated to an overall shape, an upright rectangle. The figure is suggestive of the celebrated war god from Dahomey, which was reproduced in *Cahiers d'Art* and is preserved in the French capital's Musée de l'Homme.[112] There is no strict conformity to be found between the two pieces, but the technique employed by the African smith, who assembled his figure out of nothing but European ironmongery, corresponds to that which Picasso had already used at the end of the 1930s, during his collaboration with González, and which was to continue to govern his work in other techniques.

In *Woman in Long Dress* (p. 167), Picasso augmented a dressmaker's dummy with a head and two arms. The head and right arm are fully modelled, whereas the left arm takes the form of a found object, a fragment of an Easter Island sculpture.[113] Picasso supplemented the figure with modelling to shoulder-level, the head being very ruggedly fashioned.[114] The contrast between borrowed shape (dummy) and modelled amplifications is stronger in this work than in the rest of the sculptures in the same group. It depends for its effect not least on quantitative displacement in favour of borrowed parts. Qualitatively, an important role is played by the contrast between the unevenly modelled head and the smooth, harmoniously simplified body. The dummy, usually a vehicle for clothes, becomes a vehicle for the body itself.[115]

The polished, rounded shape, whose smoothness in the case of the dummy is accentuated by casting in bronze, has been employed by Picasso in a number of other sculptures, notably in ceramic works, some of which have likewise been executed in bronze. *Vase Face* (p. 184), *The Centaur* (p. 183), *Female Form* (p. 185) and *Pregnant Woman* (pp. 196–97) belong to that conscious category of sculptures whose effect depends primarily on their plump, balloon-like volumes. We here encounter a treatment of material which is entirely new in Picasso's sculptural work. Even the monumental heads of the Boisgeloup period, which sacrificed pictorial variety of texture in the sculptural epidermis for the sake of volume-tension, are animated by comparison. This polished outer surface most nearly recalls Giacometti sculptures of the Surrealist period or the works of Max Ernst and Hans Arp, with their immunity to surface stimuli.

Man with Sheep (1944, pp. 168–69) occupies a special position in Picasso's work, thematically as well as technically. The theme is related to that of the Good Shepherd, and it is conceivable that the artist intended to contrast this peaceful figure with the notion of war.

It is surprising that Picasso should have tackled a wholly modelled work at this period, let alone one of such dimensions. However, this sculpture stands apart from the rest of his work in terms of form as well as technique. Picasso did not deform his theme, but modelled it in proportion. His only sculptural interventions relate to the partly detailed, partly summary modelling technique. The work appears to have been conceived with an eye to long-range effect, as the schematically smoothed legs would indicate. On the other hand, the shepherd's face is modelled in such abundant detail that his features are conveyed with the clarity of portraiture. We have to go back to Rodin to find so mythical a representation of the human figure.

The prior history of the sculpture shows how intensively Picasso worked on the man-and-sheep motif. The theme first occurs in drawings made on 16 July 1942. The sheep's posture was finally crystallized in the sixth sketch, also the relationship of shepherd to animal in terms of dimensions and intervals. A further series of drawings, which were done on 18 and 19 August, introduced the theme in profile. Not until then did it become clear that Picasso intended a sculptural realization of the group.[116] Four more drawings produced on 19 April 1943 schematized the classicist studies and reduced the theme to its lines of force. They are sketches which study the relationship of the shepherd's vertical body to the sheep's bulk, which interrupts the vertical flow. The tenor of the sculpture itself, its classically calm and undistorted appearance, is never in doubt. What makes this all the more surprising is that Picasso produced fifty-two drawings for this one work. In every other instance where he makes drawn studies of a theme, this activity sooner or later debouches into a system of paraphrases, variations, profound thematic and stylistic changes. Here, by contrast, he displays exceptional consistency. The one striking difference between preliminary drawings and finished work consists in modifications to the shepherd. The drawings show him first as a young, then a mature, man, whereas the sculpture ages him still more and gives him a bald head.

The most important sculptural detail occurs in the very first preliminary drawing. It is a formal grouping typical of Picasso: three of the lamb's legs and three of the shepherd's fingers are combined into a loose composition in front of the shepherd's body. His head and legs have a tranquillity and sculptural solidity which contrast with the animated central zone. It may have been for the sake of this basic idea that Picasso substituted a bald pate for a youthful head framed by hair. The first sculptural version, which Picasso modelled in clay in the course of a single day, collapsed. *Man with Sheep* is one of the most exceptional creations in Picasso's sculptural work. Not only did he fully model a large-scale work reminiscent of Rodin, but the canon of the human figure itself remains traditional. Nothing testifies to the sculptural problems which pervade the rest of Picasso's sculpture.

From now on, sculptures fully modelled in clay and plaster occur more frequently in Picasso's work. Their scale remains small, however, and they retain the character of swiftly devised maquettes. If Picasso again makes greater use of traditional modelling technique in addition to his technique of assemblage, this accords with his stylistic pluralism. Just as numerous stylistic planes coexist in his work – the formal dissection which extends beyond his Cubist period, deformation, classically undistorted drawing – so, in the realm of sculpture, he simultaneously employs techniques of different kinds.

Surveying Picasso's figurative representations since the Boisgeloup period, we can, where full-length figures are concerned, identify two basic themes. The first presents figures which adopt a more transient pose, which run or leap, the second introduces static and immobile figures. The works of the first group are modelled, whereas those of the second almost always exhibit a combination of assemblage and modelling. This distinction may be amplified by a further observation. The static appearance of the assemblage figures is almost always enlivened by accessories, whereas the more animated modelled figures have none. In Picasso's view, animate subjects already contain elements sufficient to stimulate our vision; inanimate ones, by contrast, do not genuinely arouse his interest unless the static principal form is coupled with small subsidiary shapes. An additional stimulus occurs in the assemblages as soon as the objects and excerpts from reality which together constitute a human body suddenly turn back, under the influence of a foreign body acting as an accessory, into the objects they are. The eye is struck by the gulf between the object that is subordinate to the organism and an object which is an accessory of that organism.

One example of this is *The Madame*, which, as we have already mentioned, is a figure constructed of separate found objects. A tile forms the breast, pipes serve as arms and legs. All these objects are endowed with new meaning by the overall structure to which they are subordinated. Only the key in one of the hands remains a key, thus introducing a break into the meaning of the objects employed. The objects which constitute the female figure remain ambiguous (i.e. embody an original meaning and also one which has been modifed by their novel use), whereas the key in the woman's hand remains unaffected by this alternation. It is identical with itself and does not become the repository of a second meaning.

'DEATH'S HEAD'

Before Picasso reverted during the 1950s to large and – in the field of assemblage – intricately constructed works, he produced sundry smaller pieces such as the *Death's Head* of 1943 (p. 170), a number of small bronzes, and, last but not least, a series of ceramics. The death's-head theme recurs frequently in the paintings and drawings of these years. It also occurs in the small works fashioned from torn paper or paper napkins (*cat. 256–58*).[117] Picasso conceived *Death's Head* not as a skeletonized skull but as a fleshy, semi-decayed residue. Preparations were made for this sculpture in a series of small heads (*cat. 212–16*), modelled studies characterized by salient forms and by cavities

and recesses which penetrate deep into the mass.[118] They are not really identifiable as death's heads but develop the solid, concave-convex flow of head-shapes which had been evolved at Boisgeloup (*Woman with Vase, cat. 135*). What distinguishes *Death's Head* from all these works is its startling realism. It owes its impact not only to the flaunting of details drawn from reality – sightless eye-sockets, eroded nose, ruined mouth – but also to its hypertrophic format.

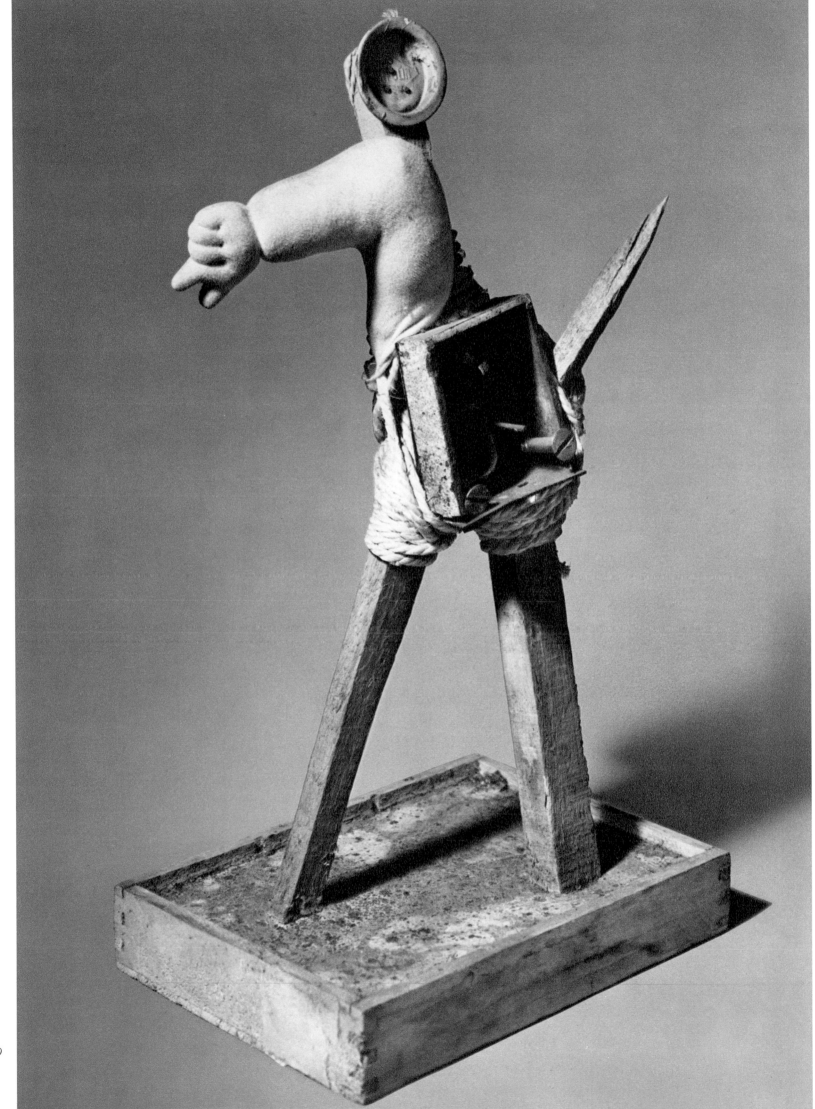

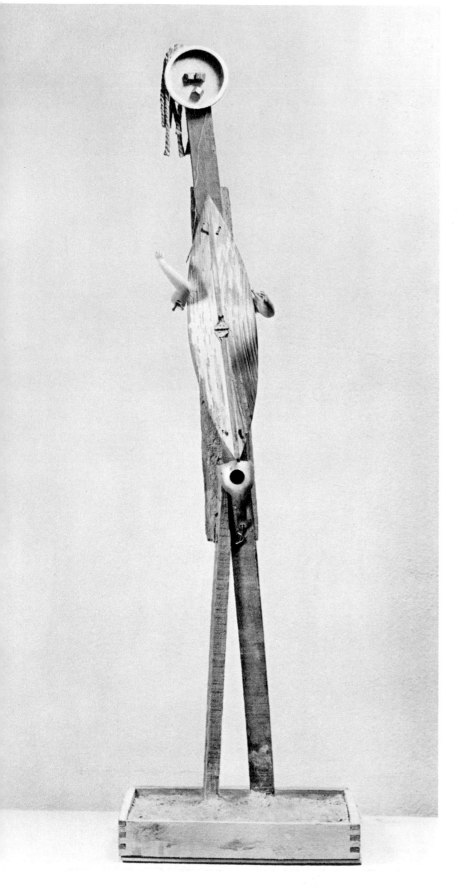 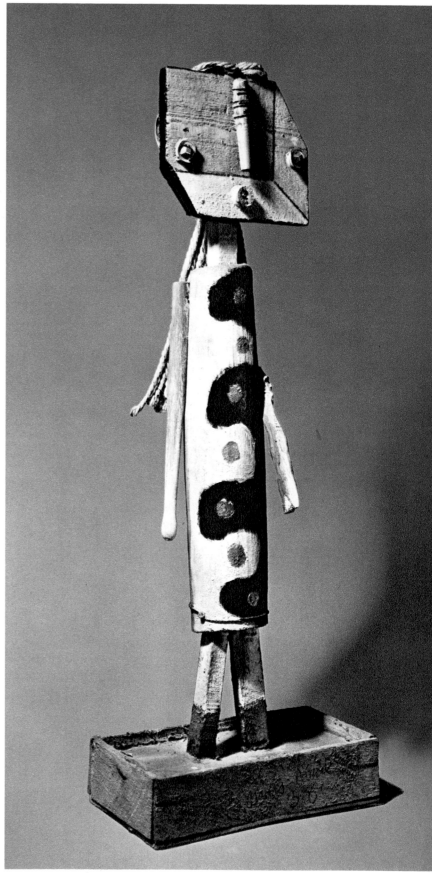

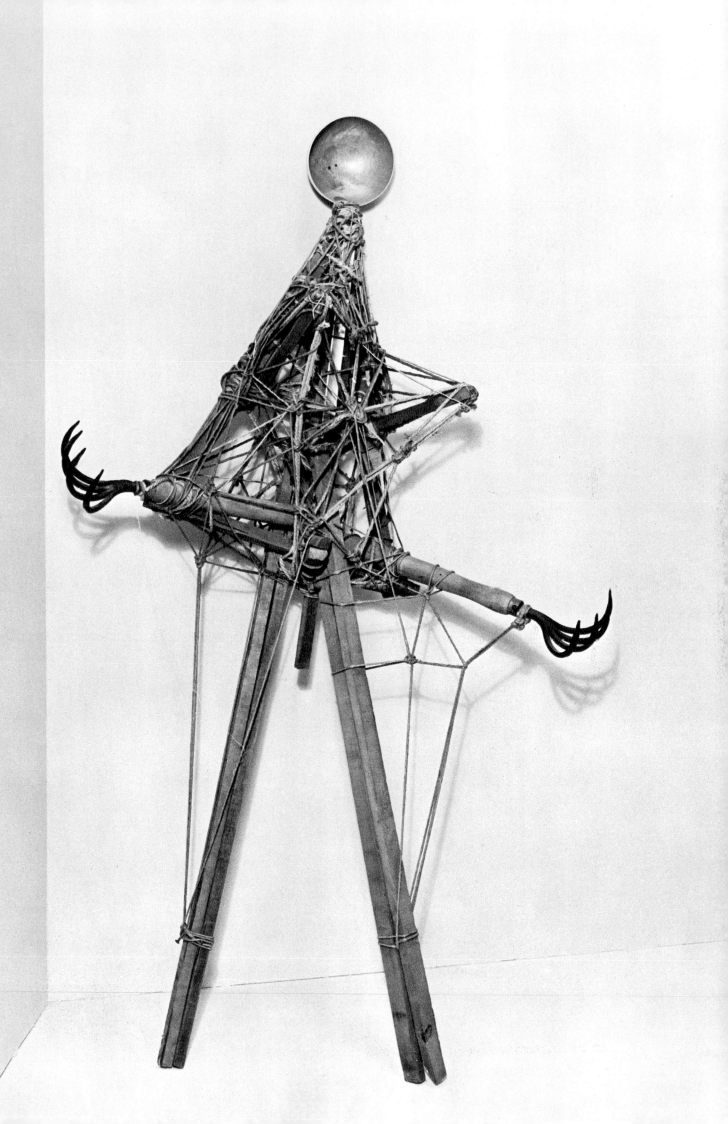

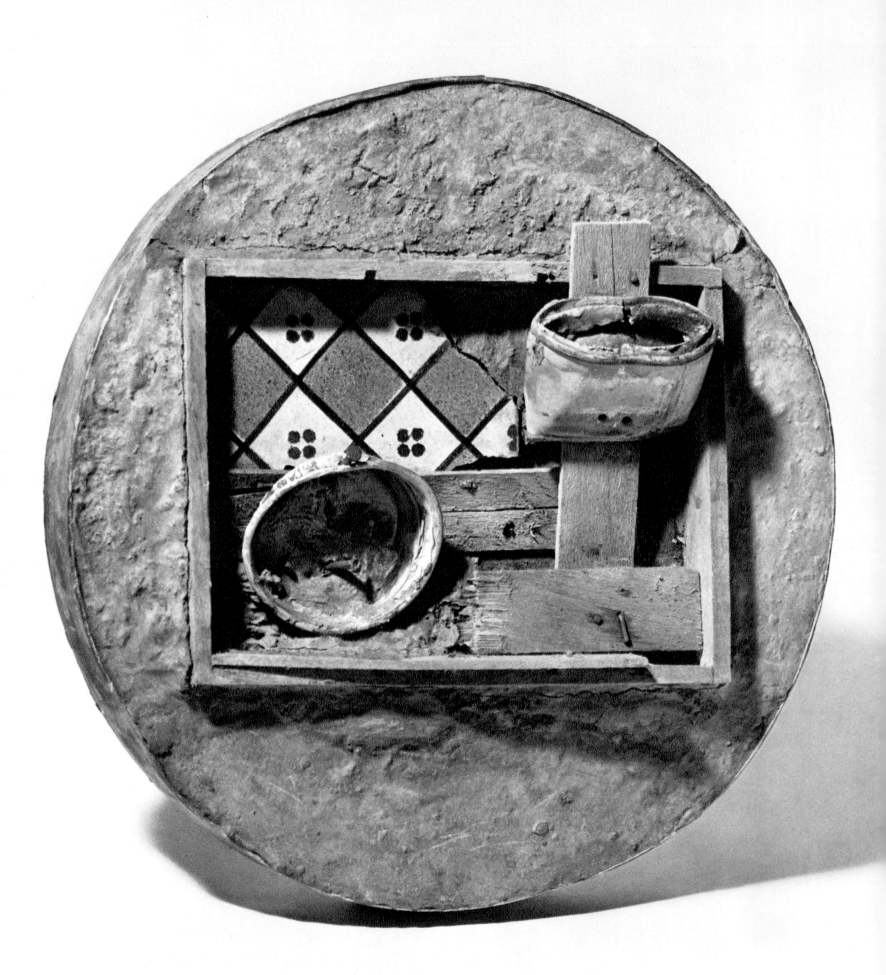

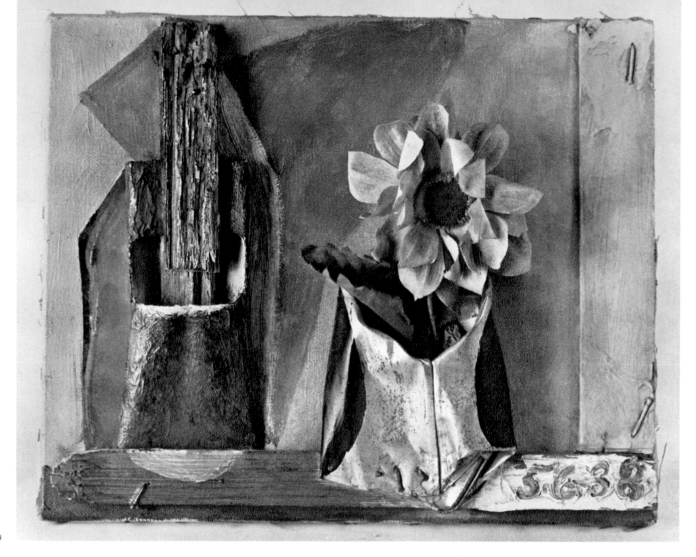

179

178

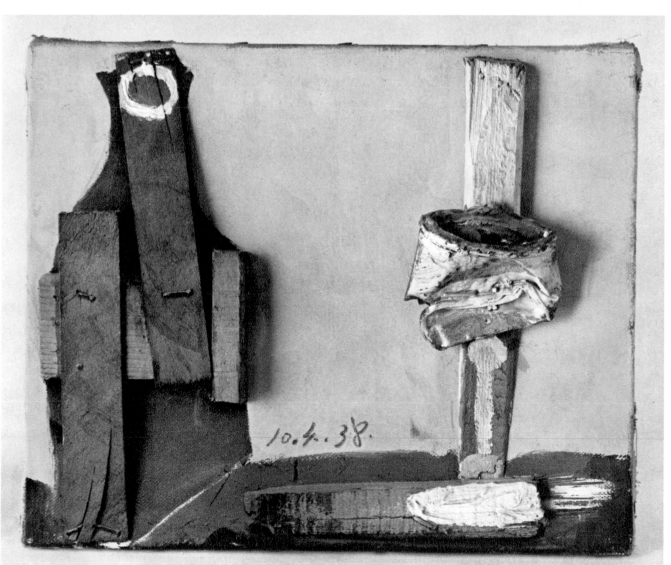

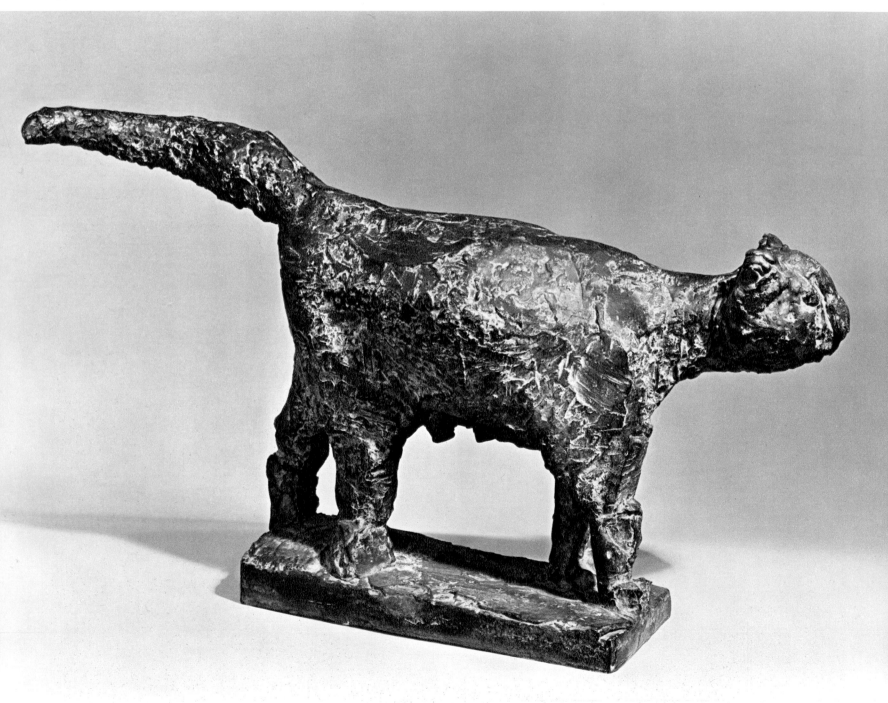

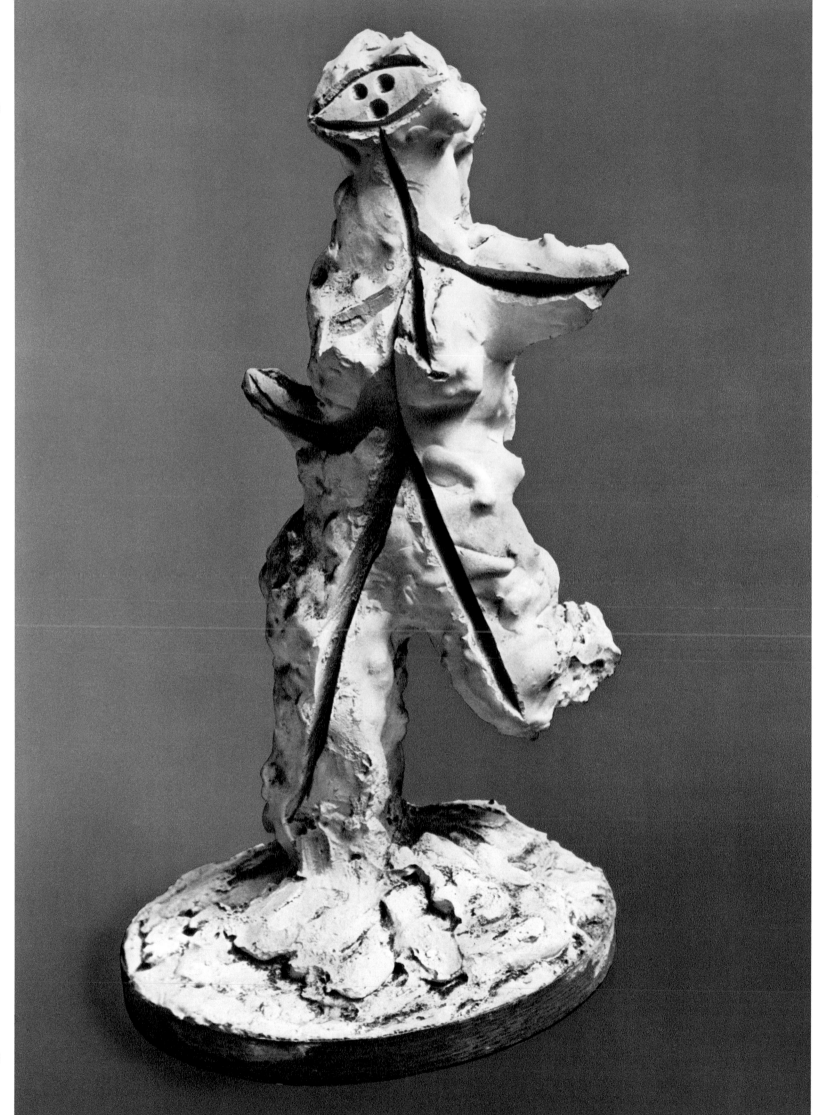

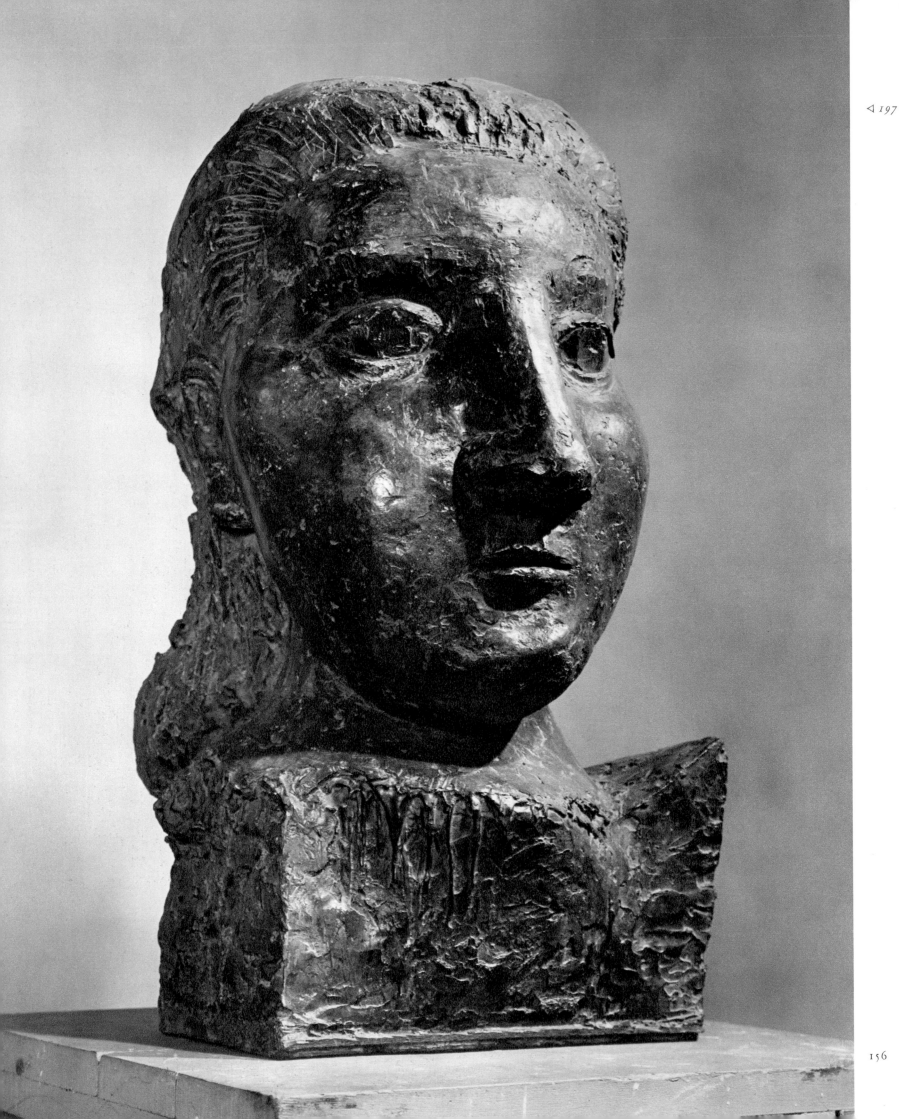

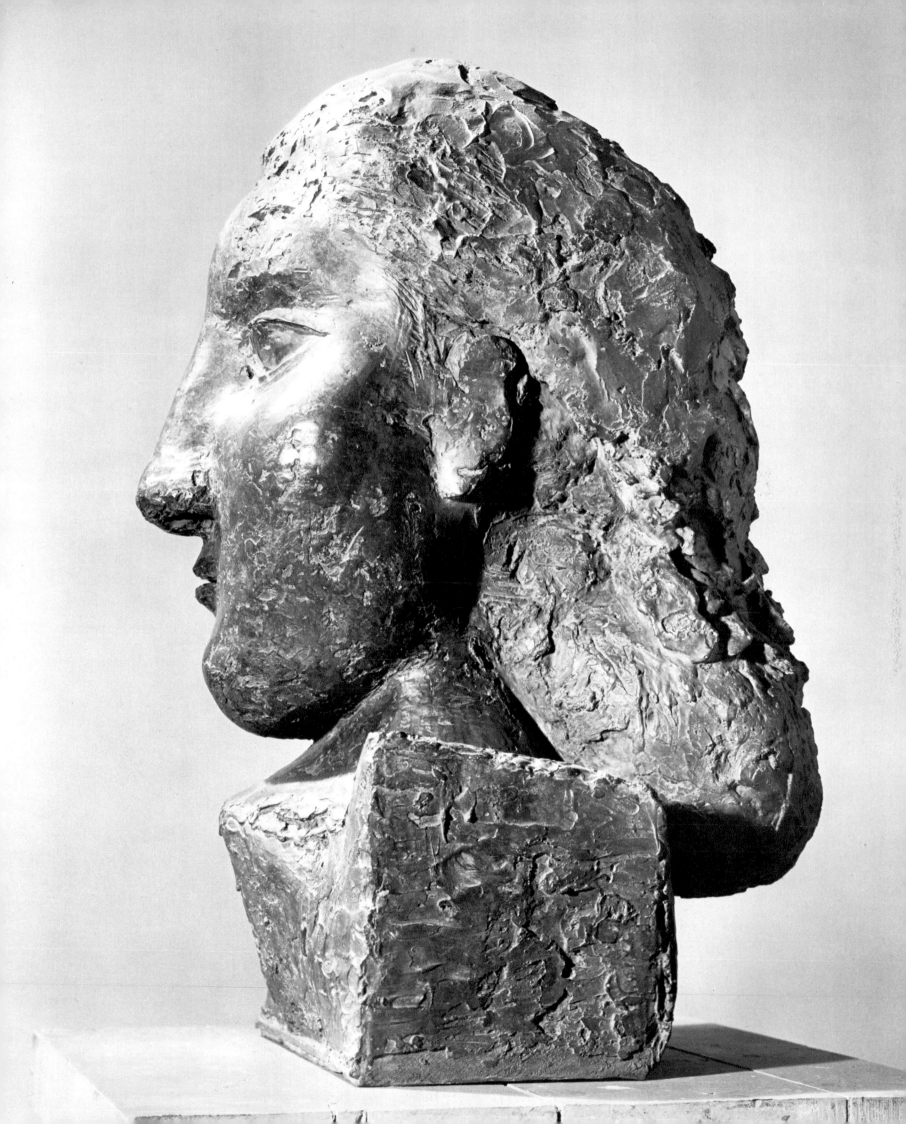

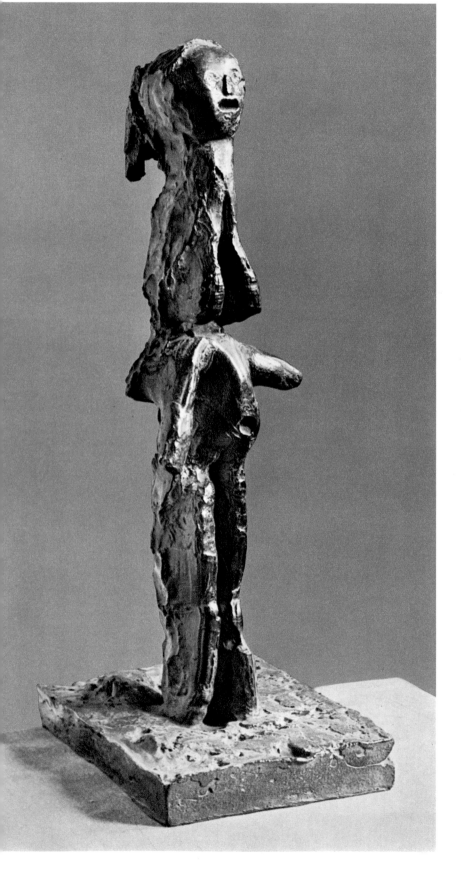 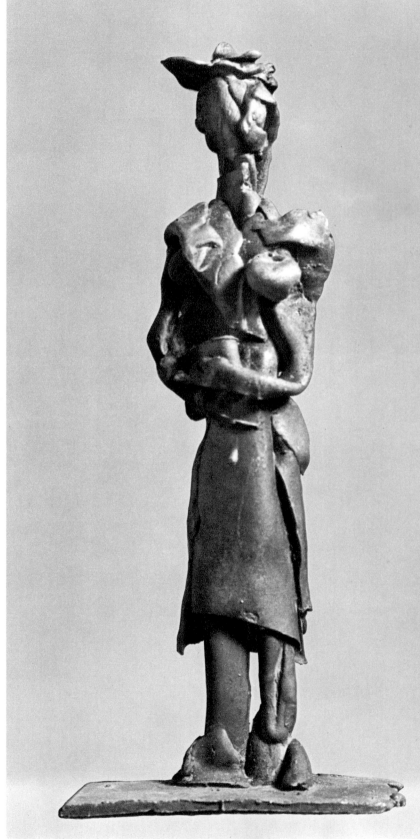

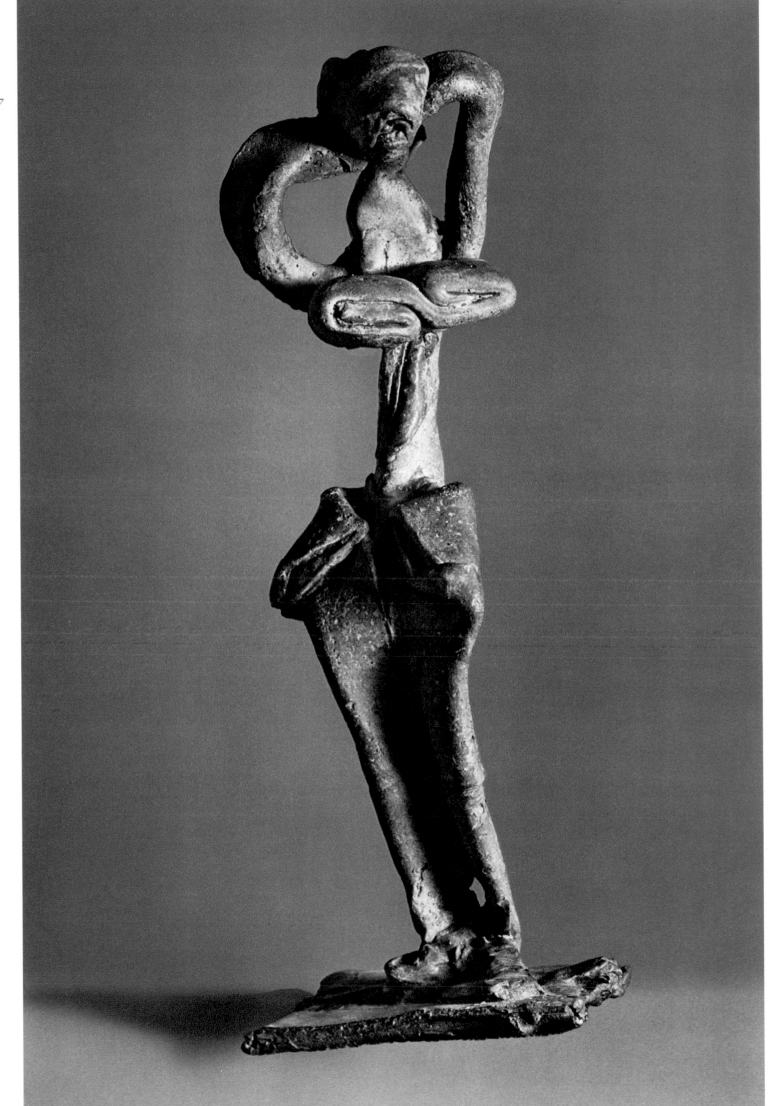

201

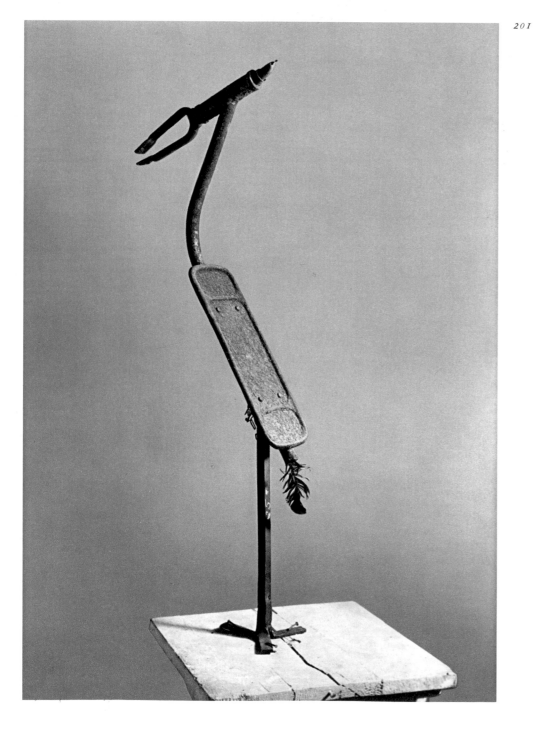

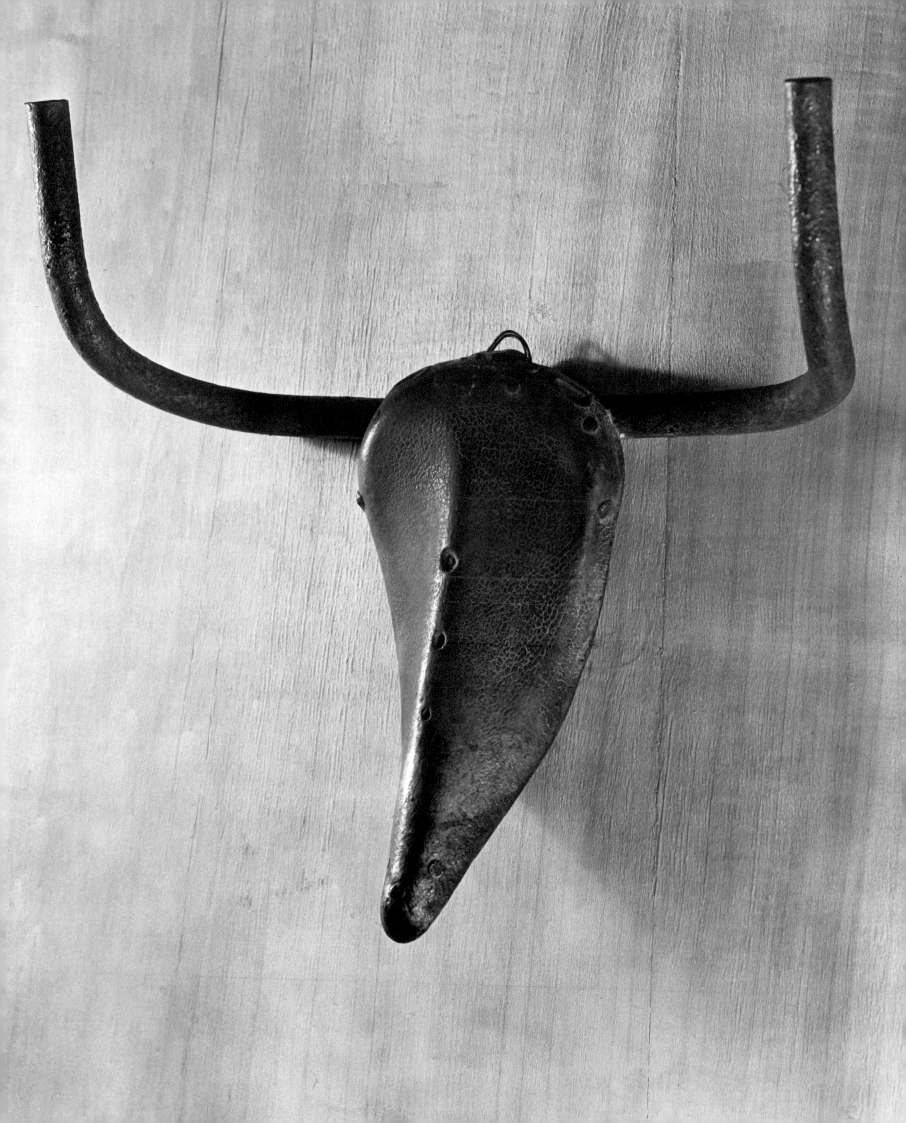

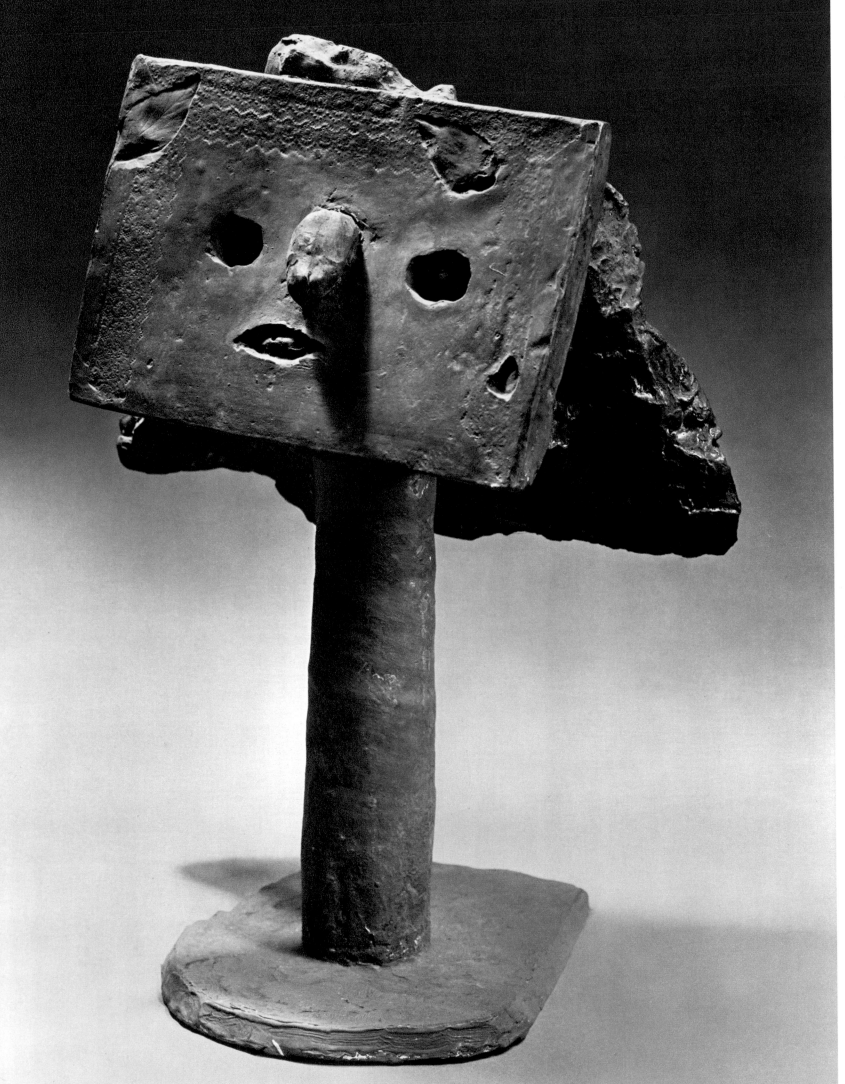

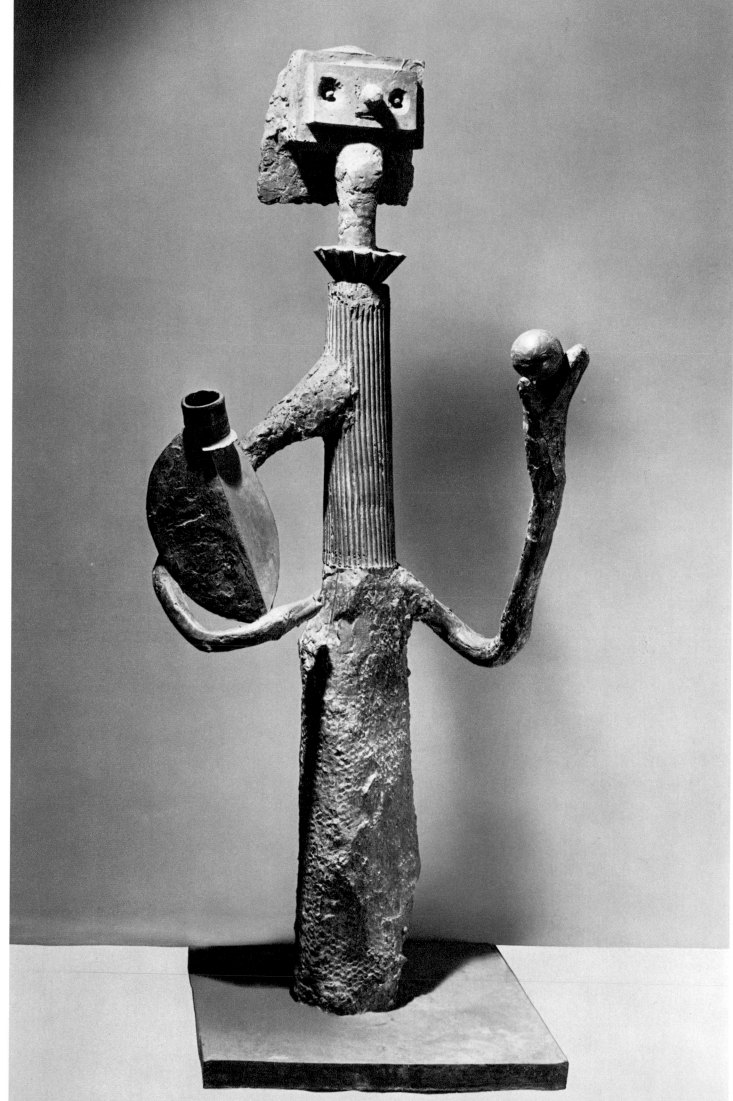

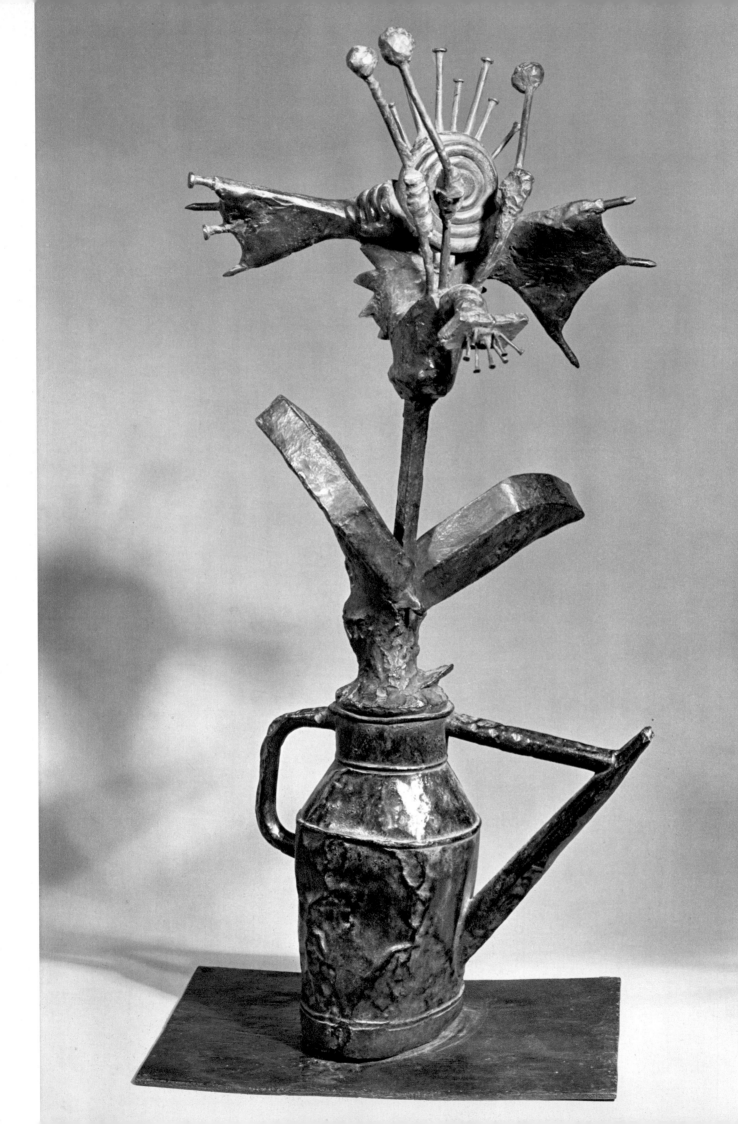

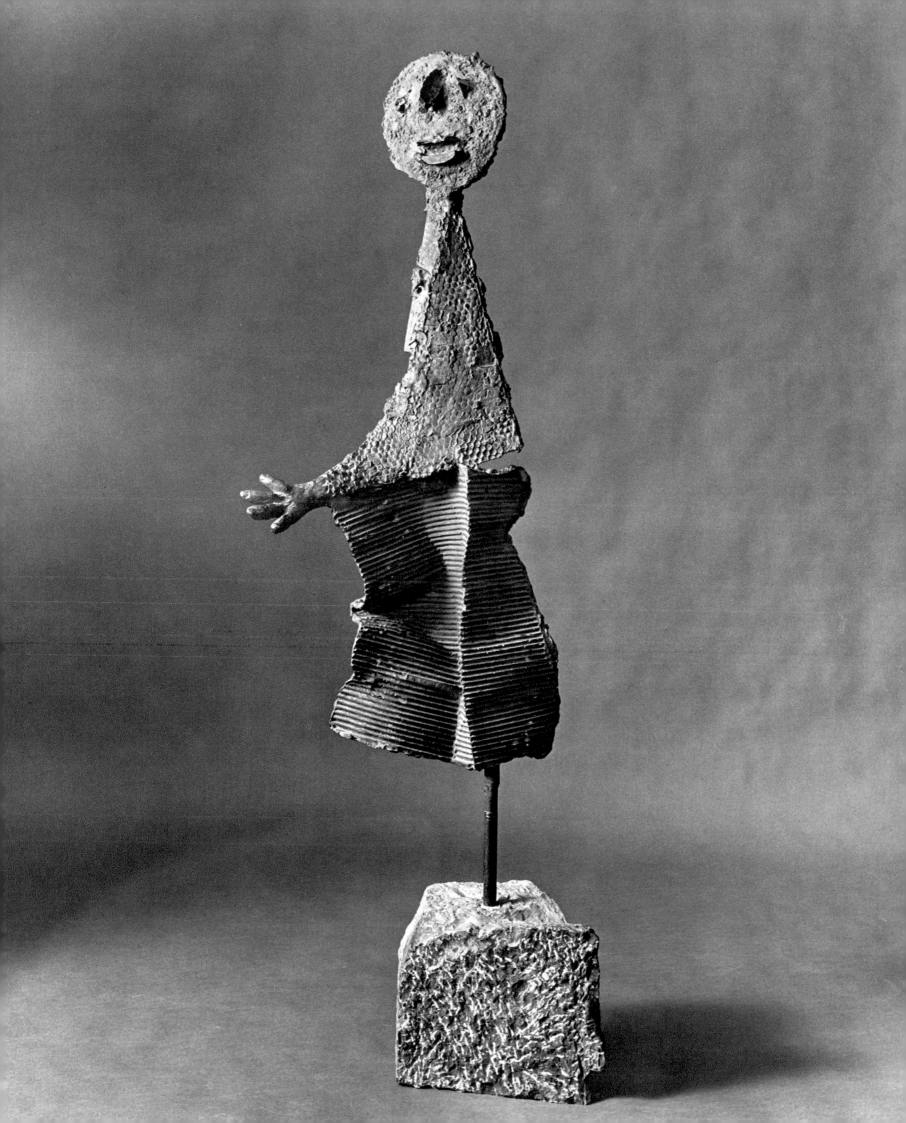

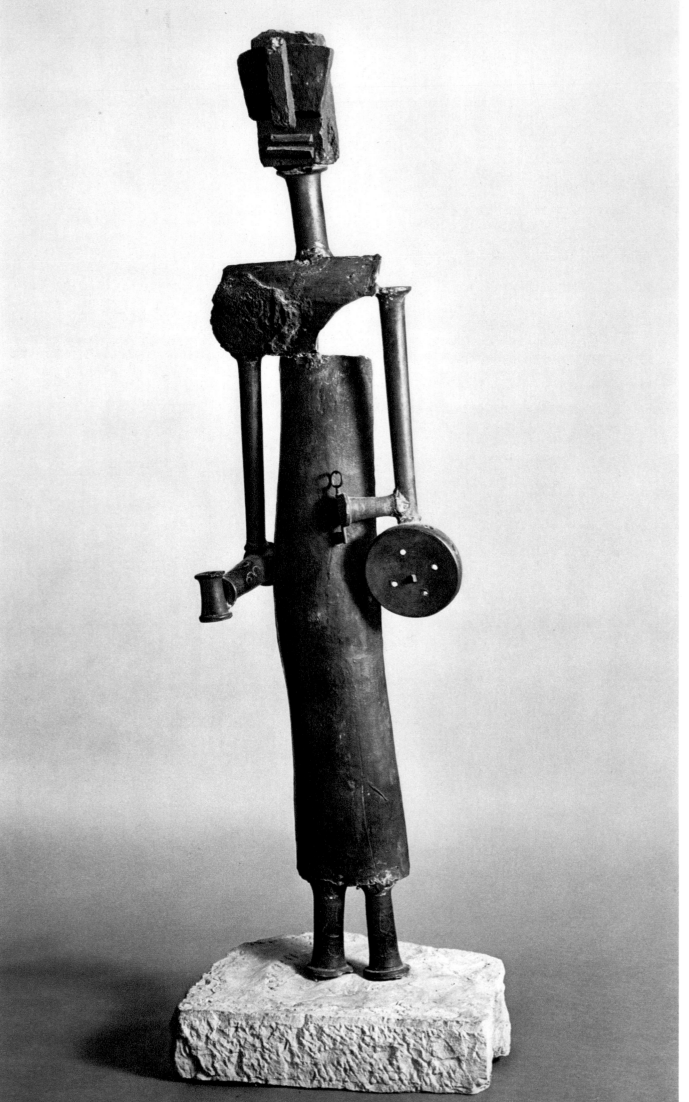

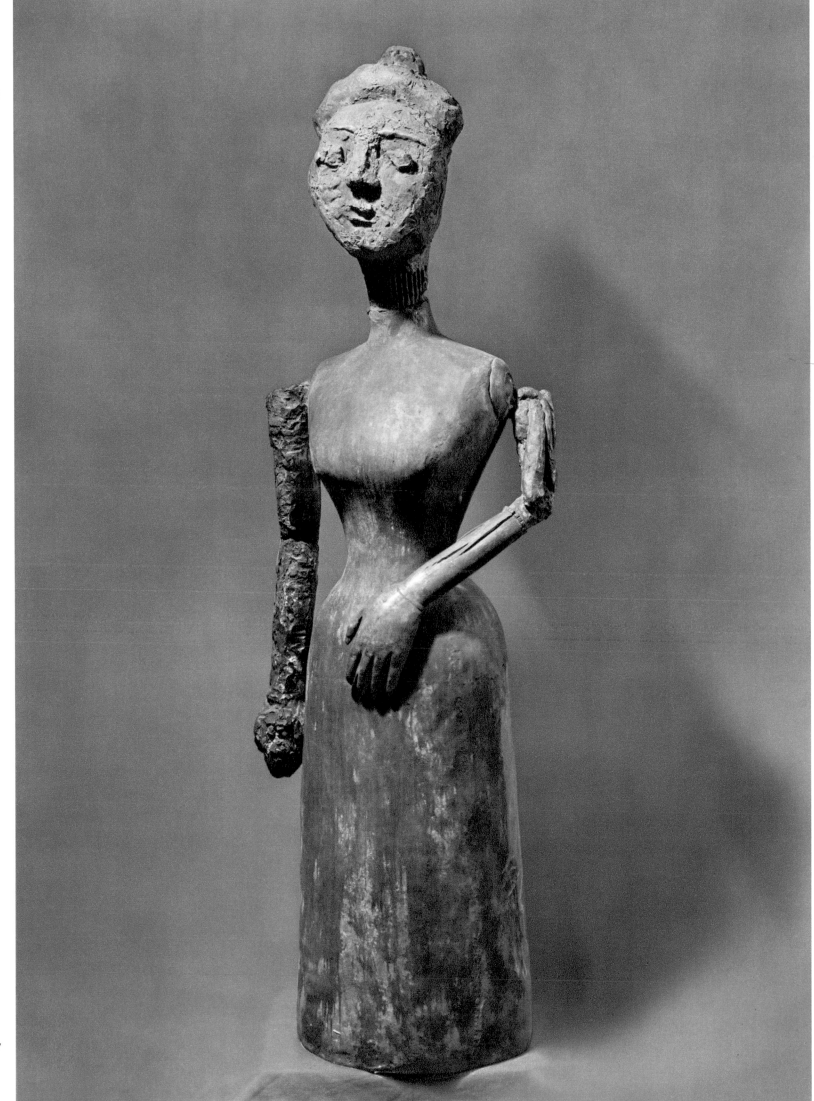

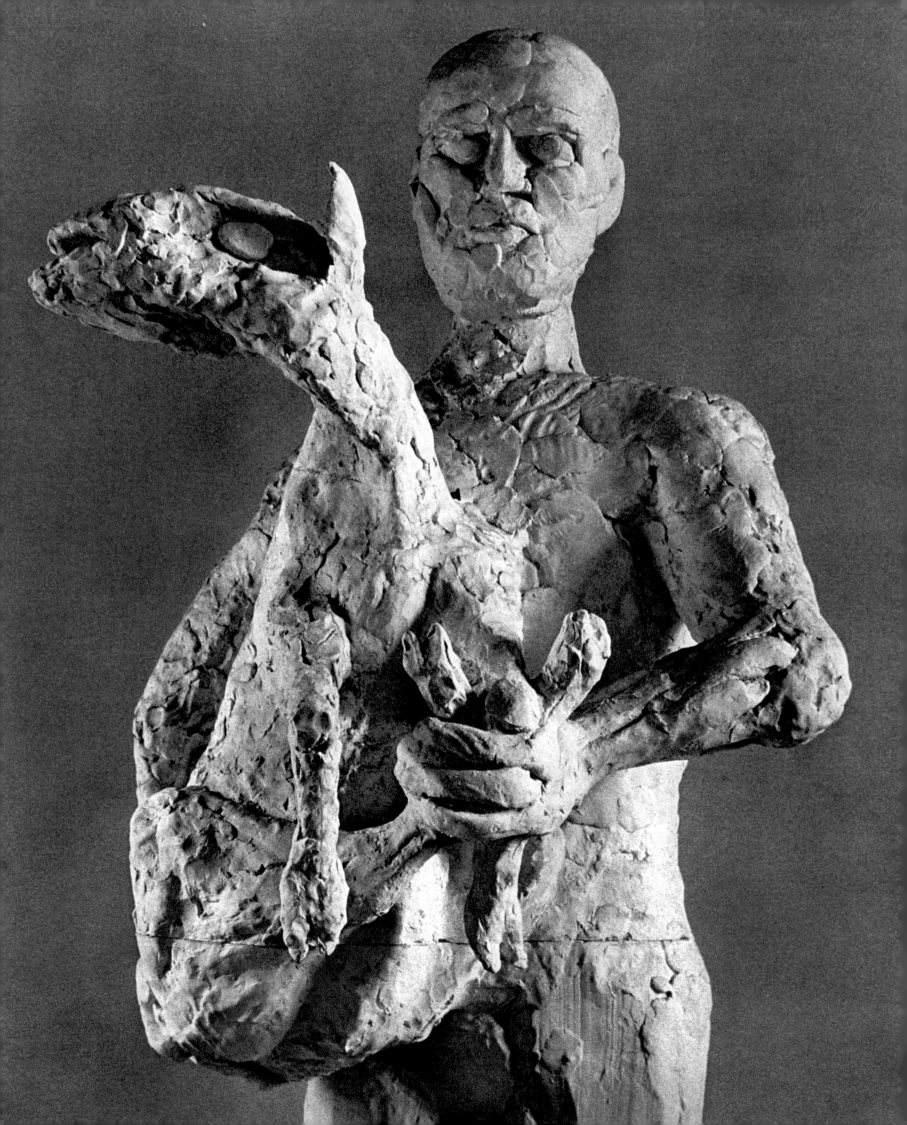

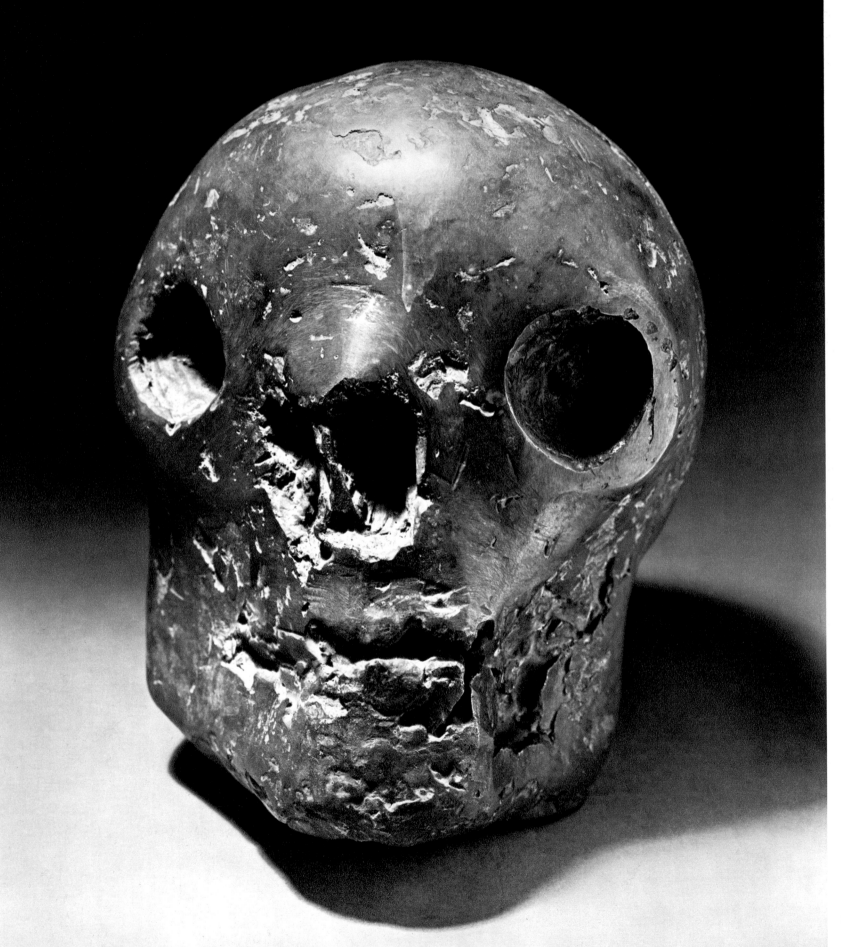

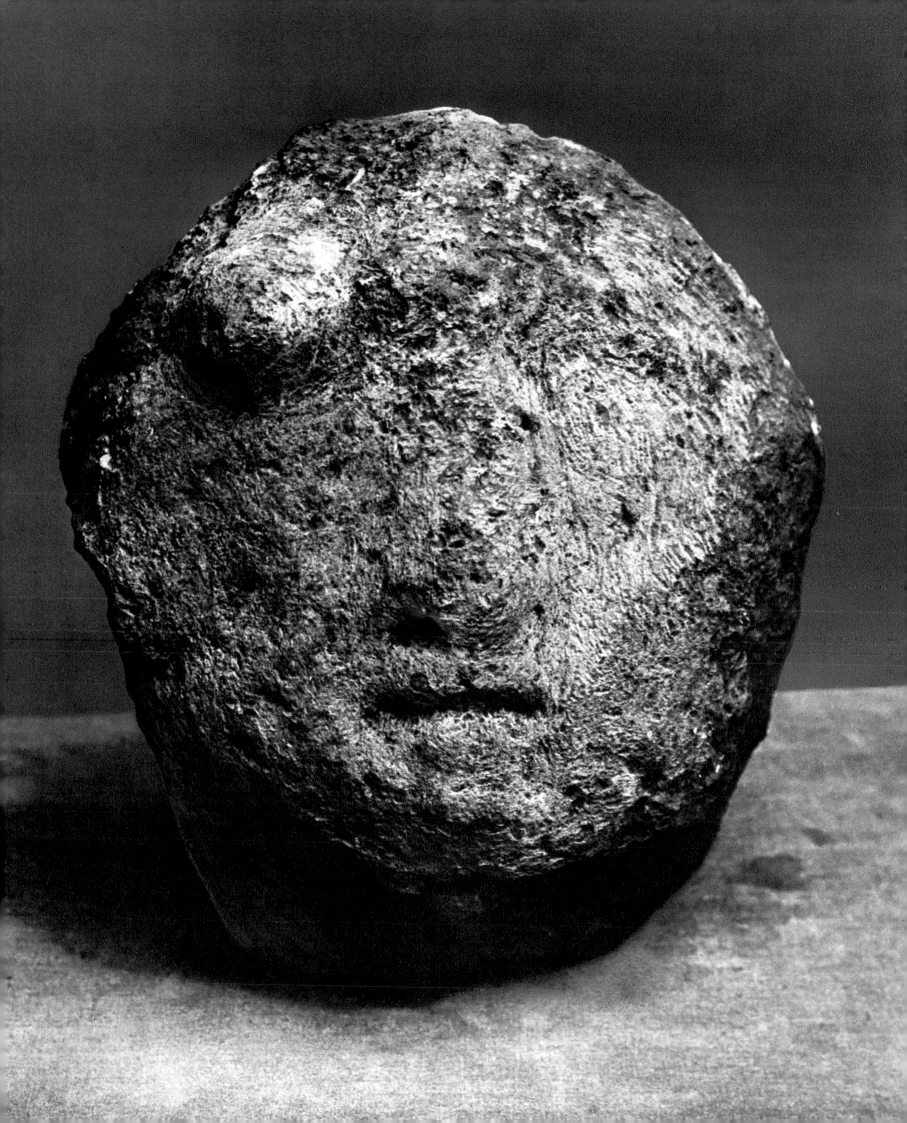

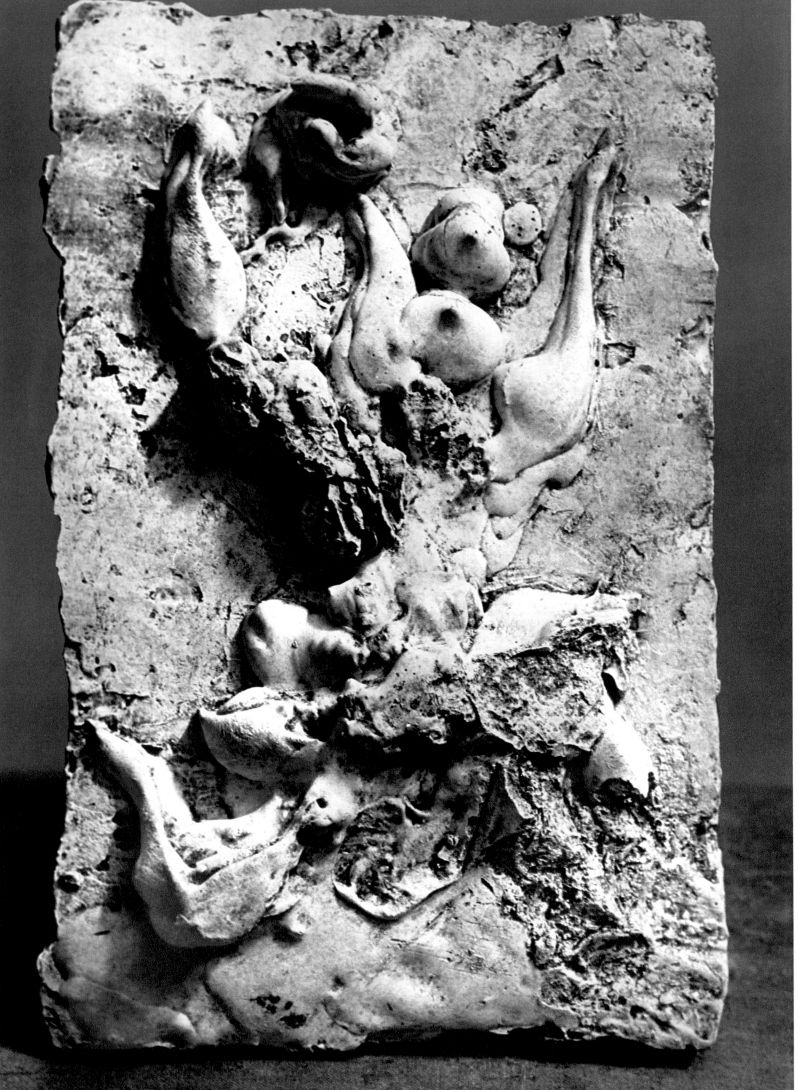

Post-war departures

CERAMICS AND SCULPTURE

In the mid-1940s Picasso began to model a suite of small figurines, choosing soft and pliable clay as his material (p. 181). The surface of these small pieces has a lumpy consistency, and their shape recalls the Tana figurines of Greece. In a further series of small sculptures Picasso used his clay like puff pastry, obtaining volume by folding layers of clay and stratifying them. In other instances he worked on the clay with pointed implements, slicing it up or puncturing it – a modelling technique dependent on mechanical aids. Instead of using his hand or mechanically imprinted structures, Picasso employed a small arsenal of tools to breach the sculptural epidermis.

These doughily modelled figurines are developed from 1947 onwards in Picasso's ceramics. In his youth, as I mentioned when discussing his early work, Picasso came into contact with Paco Durio, in whose studio he produced the ceramic originals of *Woman Arranging her Hair* (p. 37) and *Head of a Man* (cat. 9). *Mask of a Woman* (p. 44) and *Seated Woman* (p. 29), too, originated as terracottas. The Fauves also turned their attention to ceramics at that time; in 1907 the ceramist André Methey put his kiln in a Paris suburb at their disposal. Matisse, Rouault, Derain and Vlaminck decorated ceramic pieces, but exerted no influence on their form itself. Picasso went a good deal further, even at that stage.

Daniel-Henry Kahnweiler was the first to publicize and explore Picasso's ceramic works. He sees their importance in the 'long-sought link between painting and sculpture', a problem which was already exercising Picasso in *The Glass of Absinthe* (p. 49). 'In addition, an entirely new problem arose: painting on uneven surfaces.' In this connection, Kahnweiler quotes a conversation of 8 July 1948 between Picasso and Laurens.

The ceramic works of 1947 were at first produced in Georges Ramié's studio at Vallauris. In 1948 Picasso installed himself there, in the villa known as La Galloise, and took a studio of his own in the rue de Fournas. On a nearby rubbish-dump he found smashed ceramics and pieces of metal which he was to employ in his assemblages of the 1950s.

Picasso's ceramics may be divided into two groups. In the first group, pottery was used simply as a pictorial support: Picasso painted plates, dishes and vessels of various kinds, taking an interest in the chromatic quality of this glaze-painting, its light values and its immutability. He was also interested in the application of drawing and paint to uneven surfaces. Within

the context of Picasso's sculpture, however, greater importance attaches to the category of works in which Picasso determined the actual form. Most of these sculptures are based on functional ceramic shapes; Picasso derives inspiration from a given shape which he modifies on the potter's wheel or manually. In *Vase Face* (p. 184) he simply bends the neck of the bottle downwards and converts it into a nose. The mouth is incised into the surface and the eyes are rendered by nicks, a very simple gesture which demonstrates Picasso's unrivalled sense of latent form. The end-product is not fortuitous. The nicks and concave-convex zones are reminiscent of the expressive hollows in the various heads which paved the way for the big *Death's Head* (p. 170). This refunctioning of a shape is not always successful. The development of a vase into a woman's body is unduly obvious in its symbolism.

It is clear that at least in part of his output at Vallauris Picasso was less interested in ceramics as such than in sculpture. This is evident from the fact that he had bronze casts made of a number of his clay models. Having acquired an arsenal of sharp, pointed, graphic shapes during his collaboration with González, Picasso was now furnished by his knowledge of pottery with an abundance of sculptural elements which conveyed fullness and roundness. Full-bodied Mediterranean forms with their clear and melodious outlines were not new in his work. The new feature was that he now employed ceramic products as material for sculptural assemblages. He seized upon amphorae, jugs, basins and handles with the same natural ease that had characterized his use of metal objects, structures and materials in sculpture (pp. 186–89).

In so doing, he pulled out a new stop in his organ of design. Where earlier borrowings had been directed towards form and texture, Picasso's association with ceramics initially enabled him to use anonymous rounded shapes. These he employed so as to create a glassy-smooth outer skin. The smoothness of the dummy continued to operate as a stylistic principle. Once again, however, Picasso soon began to explore the potter's technique for further possibilities of expression. Fullness and perfection of form interested him, but so did jagged fractures and the cracking of baked clay. He drew his inspiration for one series of heads from some smashed pantiles (p. 258).

One of the most successful examples of the way in which Picasso integrates free modelling and ceramic shapes is *The Pregnant Woman* (pp. 196–97). The breasts and belly are pot-shapes which have been embedded in the plaster. Picasso was guided in his modelling by the curves of these given shapes. The tranquil posture of the body accentuates its harmonious proportions and formal structure. Four round shapes combine to form the body: head, breasts, and pregnant belly. Picasso invests this theme with abstract sculptural coherence. The curve of the head is repeated by the breasts, and these, taken together, govern the breadth of the belly section. Breasts and belly could together be inscribed within a large oval. This quietly compact and symmetrical form is reminiscent of *Bust of a Woman* (p. 112). As in the latter, Picasso has endowed rounded, protuberant masses with formal autonomy.

A new method of handling clay made its appearance during these months. Picasso loves to manipulate smooth materials, as the difference between the first and second versions of *The Pregnant Woman* clearly illustrates. The difference lies in the treatment of the feet. Neglected in the first version and reproduced simply as amorphous lumps, these are elaborated in greater

detail in the second. The toes become concave and take the form of small depressions. Picasso also enlists this modelling procedure in *Hand* (p. 198) and *Head of a Faun* (p. 199).

The general image of Picasso's sculptural works changed decisively during the 1940s and 1950s, at least in one respect: his forms of representation became more manifold. Where sculpture had earlier been confined principally to figures and heads (in the round) and still-lifes (in relief), a new type of work now occurred: the free-standing still-life. Picasso abandoned relief sculpture in its favour, though his interest in the former never waned entirely. Indeed, he later tackled the problem of relief afresh in his sheet-metal sculptures and solved it in a completely new manner.

FLOWERS AND VASES

The flower-and-vase group (pp. 164, 202–05) enables us to trace the course of development that led to the fully sculptural still-life. The first of these sculptures came into being during the war. The flower itself, a withered blossom with projecting stamens and a few wilting leaves, differs from the Picasso sculptures constructed of found objects in adopting some of the major stylistic details of these years. It is an imaginary flower based on no specific natural prototype. The leaves are delicately constructed, like a bat's wings. We do, in fact, possess a record of a remark made by Picasso to Brassaï during the period when this work originated: 'I adore bats! . . . It's probably the loveliest creature of all, constructed with incredible delicacy' (25 October 1943). Individual elements in this flower-piece hark back to the works in metal which Picasso produced with González's assistance. He used nails as formal symbols even then, and González himself later used nails in many of his sculptures, notably the *Cactus-People* series which he did at the end of the 1930s. However, González's wrought-iron sculptures derived from free treatment of metal. Found objects and modifications of solid shapes endowed with inherent meaning are hardly ever found in his work. Excerpts from reality predominate in Picasso's wrought-iron figures, whereas the technician and craftsman in González based his work on personal activity in the realm of design. The nails that occur in the *Cactus-People* are naturalistic details. They do not *denote* cactus spines, they *are* them. Not so with Picasso. The nail is an element of reality which can assume various roles: it can denote hair, stamens, legs, plumage, rays of light, bristles. We once more encounter the working method which can be detected so early in Picasso's work: his habit of composing with basic shapes which in course of time become repositories of diverse symbolic ingredients – which, in other words, are permutable.

Picasso puts his flower in a watering-can. The can is unevenly dented. Vases, jugs, bowls and coffee-pots are also angularly represented in numerous painted still-lifes of the period. The sculpture *Flowering Watering-can* (p. 164) seems to have been based on this pictorial reality. Another example (p. 203) uses the vase-and-flower theme as part of a group representation. Here Picasso reproduces a cactus-like, prickly blossom. A subsequent *Vase with Flower* (which again presents the flower-vessel contrast between a compact shape and one that is open and filigree-like) gives the subject a simpler interpretation (p. 202).

Two more flower pieces form an interesting contrast. The first piece (p. 205) has an affinity with the monumental heads of the Boisgeloup period, being a fully sculptural work dissected into various perceptual stages. The division of the vase into discrete surfaces recalls works from the synthetic phase of Cubism. The treatment of the bunch of flowers itself is startling in that Picasso has taken a full, neutral volume and engraved the flowers into its surface. The contrast between the flower-mass and the delicately engraved drawings of individual flowers and grasses invests this work with an entirely novel character. Hitherto, when Picasso engraved a drawing into a compact sculptural mass, the latter conveyed maximal reduction of an element which was, in essence, non-sculptural. In this instance, however, the real sculptural content – the bunch of flowers – is imposed on an anonymous mass. The second bunch of flowers (p. 204) represents a plastico-sensory counterpart of this solution. Picasso used a ceramic pot to mould the vase and modelled the flowers with the aid of small cake-tins. The leaves, which consist of solid masses, recall those that occur in *Flowering Watering-can*. Division into genres cannot be anything but superficial because Picasso permutes within genres too. The numerous allusions for which scope is afforded by the shapes and materials he employs do not stop short at the frontier of a particular genre. There is no thematic hierarchy. No one theme is subordinated to another, and each participates similarly in the quest for form – a circumstance which denotes a certain indifference to the mental aspect.

ENCYCLOPAEDIC SCULPTURES

The culmination of these rich and diversely composed sculptures came in five large-scale works created in the years 1950–52: *Woman with Pushchair* (p. 211), *Little Girl Skipping* (pp. 208–09), *Goat* (pp. 206–07), *Baboon and Young* (pp. 214–15) and *Goat's Skull and Bottle* (p. 178). In company with a number of smaller works which belong to the same category, these are the last of Picasso's sculptures in which free modelling and excerpts from reality combine to form such impressive syntheses. They bring Picasso's assemblage technique to its supreme consummation. We have only to compare *Woman with Pushchair* with the figures which Picasso was producing seven years earlier. Properly speaking, *Woman with Pushchair* is Picasso's first group sculpture. Comparison with *Little Girl Skipping* demonstrates that the group introduces an important formal medium. In *Woman with Pushchair,* the combination of the open frame-work of the pushchair and the compact volume of the woman's figure is a determining factor. In *Little Girl Skipping,* this synthesis is achieved within a single figure: Picasso has produced an air-borne sculpture which derives its charm from the suspension of a compact, solid volume within a light frame-work. Some of the objects used in both works are given a new objective significance. The pushchair, for example, is adopted as a reality but endowed with a slightly alien flavour at the same time: one of its wheels is replaced by an old bottomless sieve. No other sculpture by Picasso so openly displays a found object, and none so directly embodies an excerpt from reality. The modification of reality occurs in the structural unit 'pushchair-child'. The child is constructed with the aid of clay handles (arms and legs) and a clay vessel (hat and head). The fluid line of the arm-rest which encircles the vehicle picks up the linear and fluid movement of the child's body. During the develop-

ment of the work, the graphic structure of the pushchair – its elements of space-drawing – seem to have suggested that the child should also be rendered as a loose 'space-drawn' structure. The mother, although richer than all previous assembled figures, in many respects recalls works of the early 1940s. The cake-tin occurred in *Woman with Apple* (p. 163), the convex skirt appeared as an entire and undifferentiated piece in *The Madame* (p. 166). The elongation of female figures constructed out of found objects had already been initiated in earlier sculpted and modelled works. An interesting parallel can be found in a modelled sculpture of the Boisgeloup period, more than six and a half feet high, *The Large Statue,* which is known only from a photograph (*cat. 107*). Picasso told me that the work still exists in fragmentary form and that he planned to reassemble it.

Picasso does not employ shapes and materials at random in his material assemblages, but selects them in accordance with a prior decision. One of the constants in the great period of the 'encyclopaedic' assemblages is ceramics. Picasso's interest in materials themselves, so intense during the 1930s, waned perceptibly until, in his late work, its subordination became a thorough-going law. All his assemblages are cast and their borrowed materials rendered alien by this process of transformation. Castings were made even of works that were patently and wholly constructed of wood. Indeed, in some cases Picasso goes still further by painting the bronze. *Woman with Pushchair* and *Little Girl Skipping* were also intended for painting. Both sculptures may be defined as works in which a maximum of form is created by borrowed objects or by a mechanically applied surface texture. Among previous works, only *Flowering Watering-can* and *The Madame* were so exclusively composed of objects as vehicles of structure. *Woman with Pushchair* and *Little Girl Skipping* introduce a psychological, realistic dimension into their mode of representation with greater force than all previous assemblages apart from *The Madame*. The theme is richer, more narrative, and full of humorous details: the little child's bandy legs, the lace-trimmed brim of its sun-hat, the little wind-blown skirt of the skipping figure, its neatly combed hair, and the brilliant device of switching the outsize shoes which give the child such a stiff, awkward appearance. The assemblage character is far more strongly apparent in both these sculptures. Another thing which seems to stress this is that Picasso invariably tackles one texture with *one* vehicle of structure. He does not create a single sculptural form with different structures. One structure characterizes the hair, another the blouse, another the skirt. The boundary of each structure coincides with the extent of the imitated article of dress. In *Woman with Pushchair* and *Little Girl Skipping,* Picasso's spirit of invention is conspicuously at work in his figures' clothing. This brings additional shapes and surface stimuli into play. The richly ornamented hob-plate becomes a lace-trimmed blouse, a broad wicker basket deputizes for a child's richly pleated dress. The unclothed portions of the body – head, hands, legs – are modelled, whereas the hair and clothes prompted Picasso to deploy the whole arsenal of material and structural imprints which he had so far developed.

Picasso never constructed these works out of random objects which just happened to have come into his possession. On the contrary, the objects which he selected during his excursions were those which matched his predisposition. Anyone who dismisses Picasso as a talented rag-and-bone man is doing him

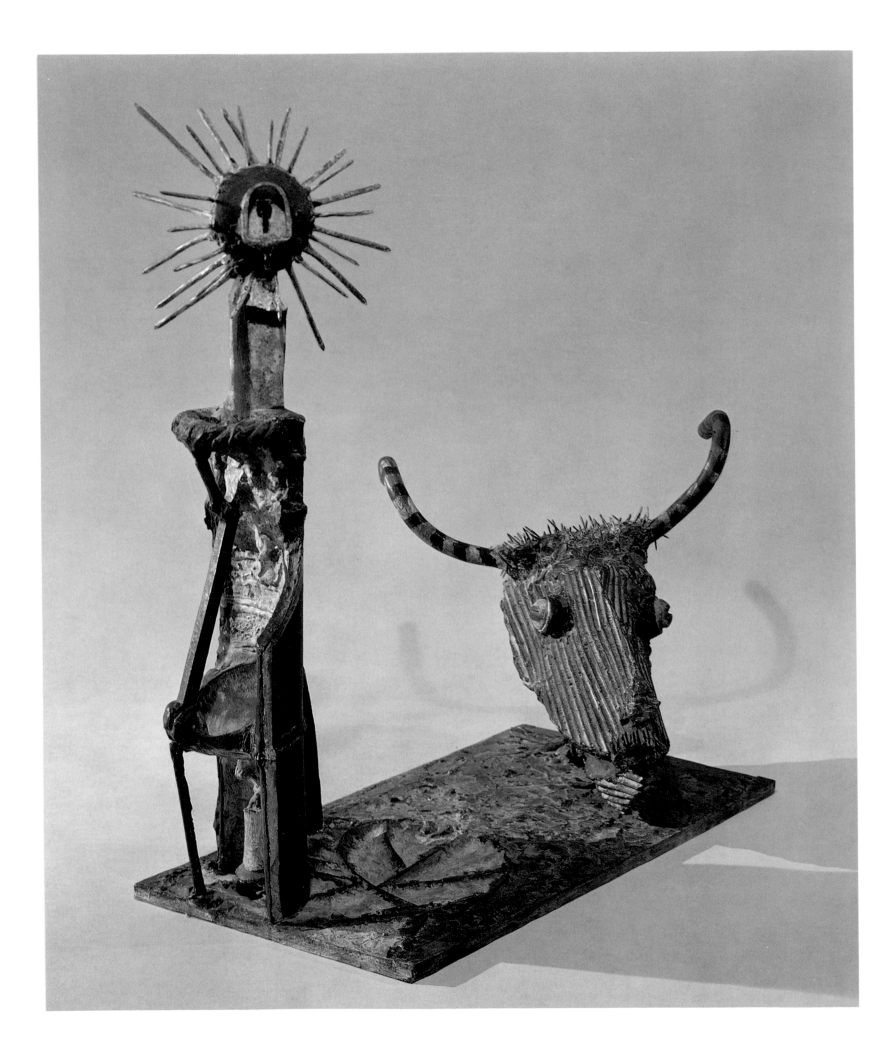

an injustice and ignoring the synthetic character which underlies his quest for structures. The inventory of the *structures* which Picasso enlists for his assemblages is a limited one; the inventory of the *shapes* on which the structures depend for their emergence is unlimited. The fact that Picasso makes do with a limited inventory of structures can be demonstrated in respect of his paintings and drawings as well.

There is, on this point, a striking correspondence between Picasso's pictures and his painted bronzes. In the paintings and drawings of this period he favours a surface treatment characterized by close-meshed parallel lines. We rediscover something similar in the painted bronzes of these years – *Goat's Skull and Bottle* (p. 178), *The Crane* (p. 217), *The Little Owl* (cat. 475), *Jug and Figs* (p. 216). Picasso did not paint these works entirely but coated them with a structure of lines in black and white. In one case (*Goat's Skull and Bottle*) the painting accentuates the structures used in the sculpture. This lends stronger visual impact to the textures present in the sculpture and intensifies the beholder's stereoscopic vision.

Woman with Pushchair and *Little Girl Skipping* exemplify a form of sculpture which conveys Picasso's love of assemblage at its most comprehensive; *Goat* (pp. 206–07) and *Baboon and Young* (pp. 214–15), by contrast, introduce a wholly different kind of sculpture. Where *Woman with Pushchair* and *Little Girl Skipping* derived their realism from the incorporation of isolated characteristic details, it is a peculiarity of *Goat* that it seeks to imitate its subject completely. It, too, is almost entirely composed of found objects, but these are used more because of their imitative formal properties than for the sake of their texture. All the objects incorporated serve to define the goat's body, nothing more. For this, Picasso makes exclusive use of materials and objects which express something about it: details of the animal's skin, its lean build, its udders, its genitals. The smoothly polished forehead and hairless back are made from the smooth wood of a palm-frond. The distended belly takes the form of a large woven basket. Strips of metal go to make up the lean flanks. The horns are carved from vinewood, the ears fashioned out of cardboard, the legs and feet out of pieces of wood, the hind quarters out of a lighting appliance, the genitals out of folded cardboard. Metal tubing represents the anus, twisted wire the tail, and the udder takes the form of two ceramics.[119] In the finished sculpture these ingredients are blurred by the hand of the modeller and do not emerge as discrete and definable elements. The creative principle of material assemblage is disguised.

Picasso achieved one of his most startling transformations in *Baboon and Young*. His procedure – the modification of borrowed shapes and objects by means of modelling – comes very close to that of *Goat*. The head of the baboon consists of two toy cars which Picasso contraposed so that the roof of one became the ape's receding brow and the divided windscreen its two eyes. The bonnet forms the muzzle. Picasso fashioned the ears out of two metal handles. For the spherical body he employed a large jug whose handles indicate the shoulders. The hind quarters and the young baboon with its exaggeratedly long arms were modelled, and the long tail was produced with the aid of a metal rod bent up at the end. As in *Goat*, Picasso achieved a rich surface effect in the bronze. Matt and shiny sections alternate, and areas where the surface is roughened contrast with others which suggest that the fur has been worn away.

Picasso obtains as veristic a representation of his subject in *Baboon and Young* as he does in *Goat*. He never abstracts, but simply accentuates. *Goat* and *Baboon* both introduce new subjects. Each theme gives Picasso so much scope for spatial development and tactile stimuli that even within the realistic norm – the reproducibility of the subject – startling plastic effects become practicable.

The Crane (p. 217) belongs to the same category. The elements which constitute this assemblage make their appearance with no disguise whatsoever: the small gas-tap which forms the bird's crest, the two forks which represent its legs, the shovel which defines the plumage on its back. And yet all this material combines to form the consistent image of a crane strutting on tiptoe.

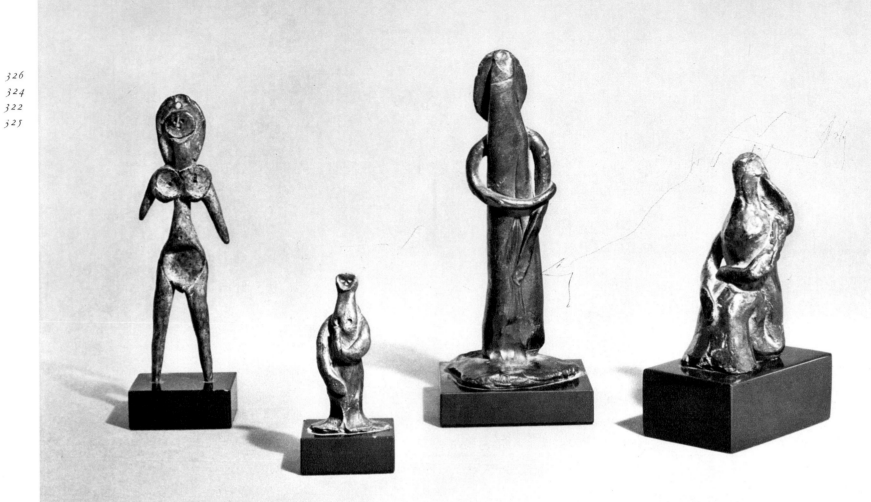

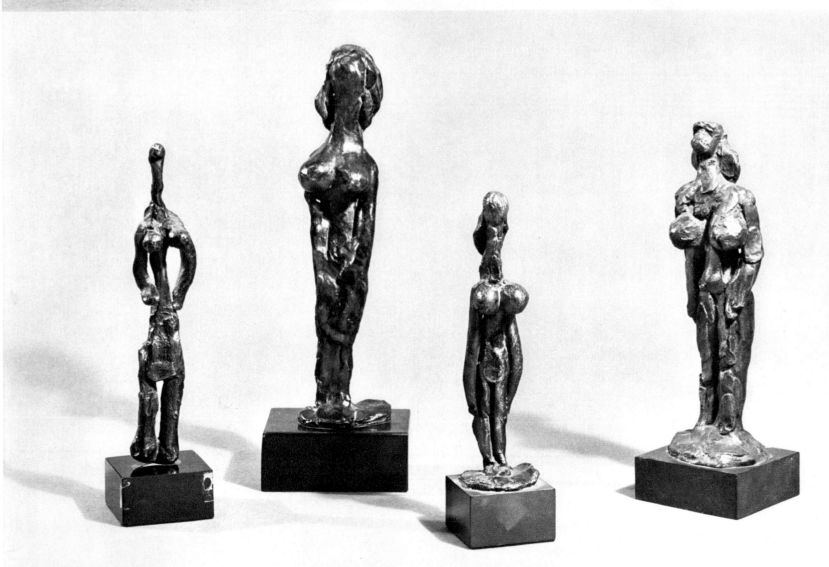

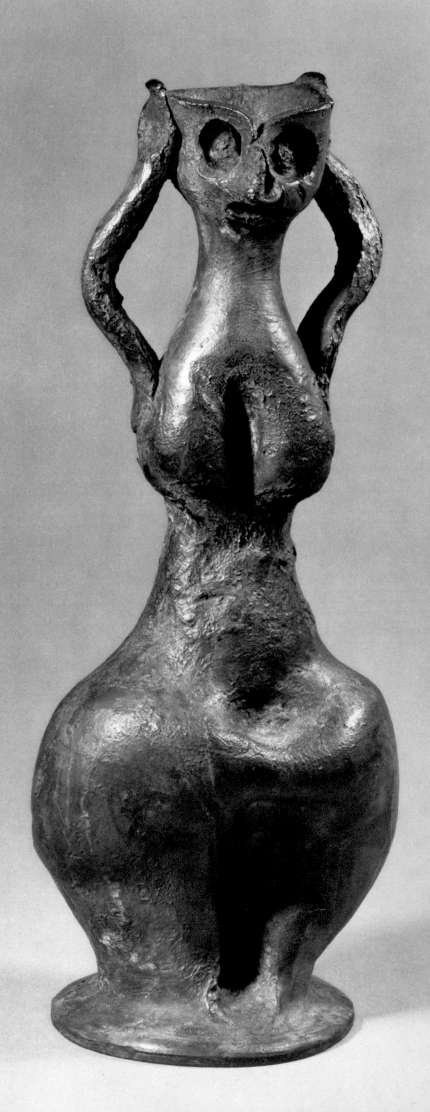

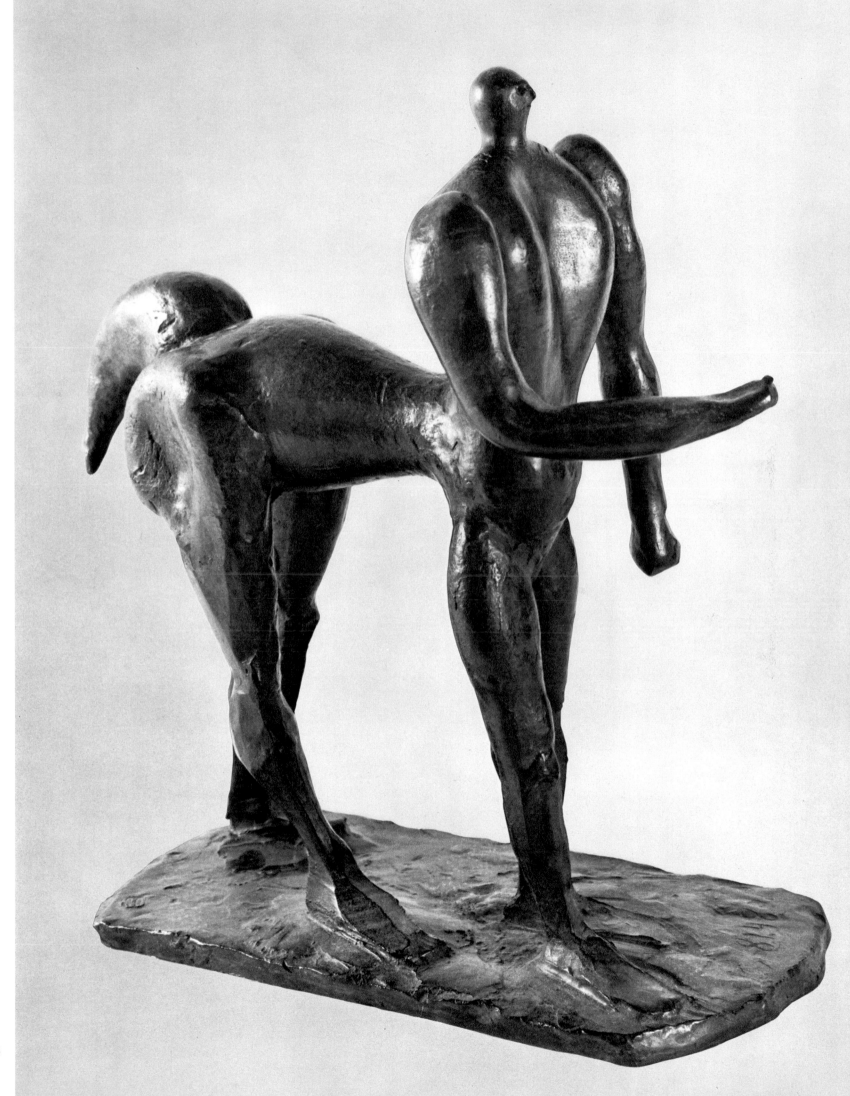

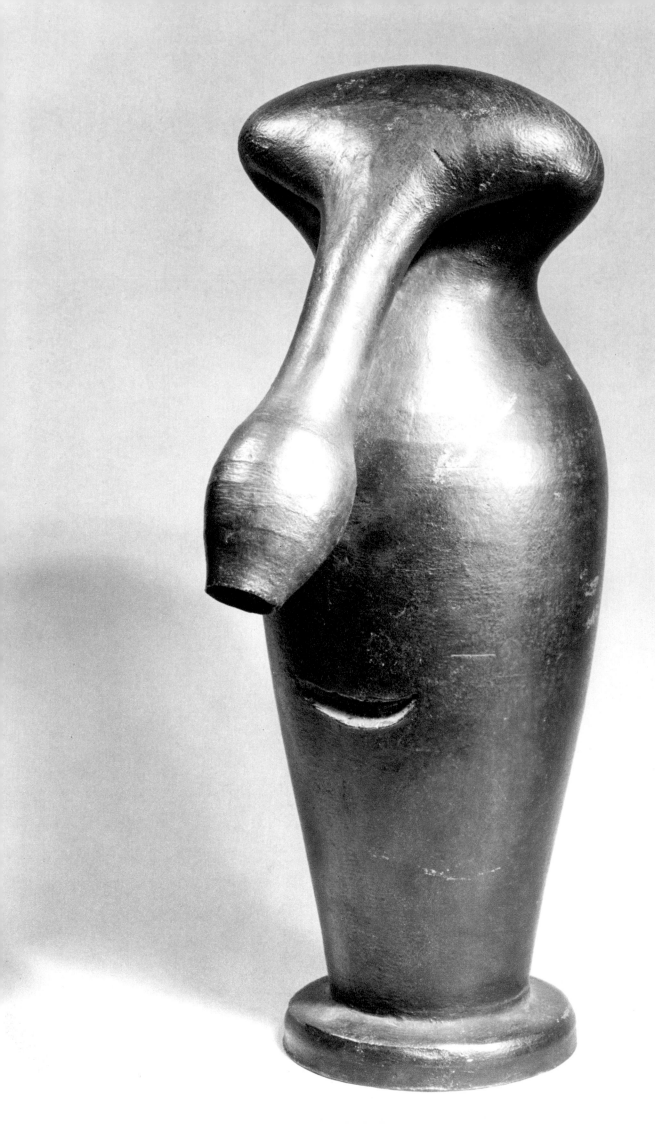

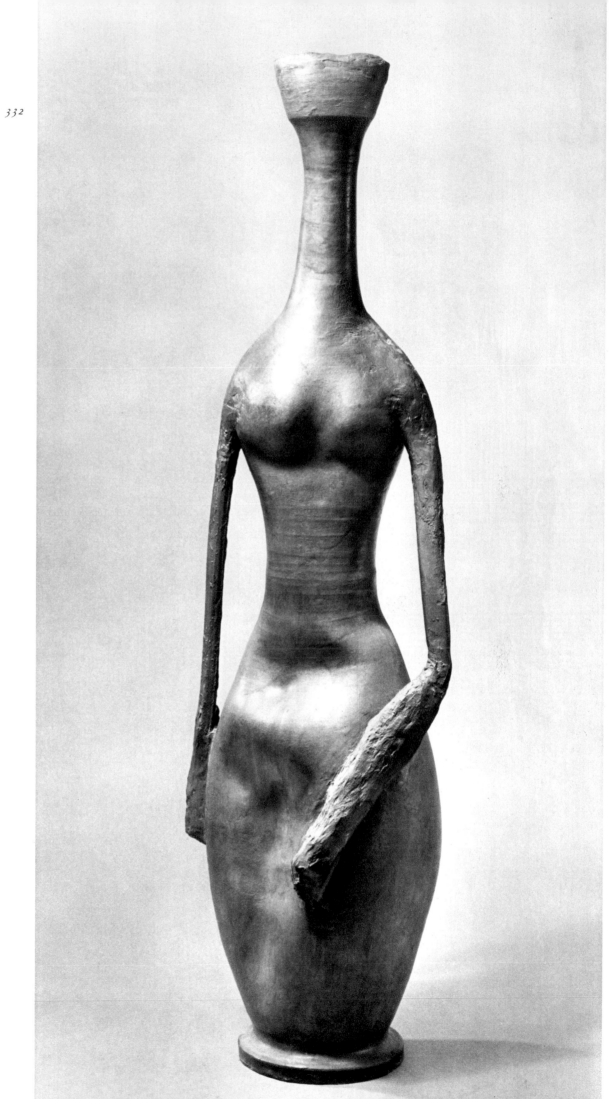

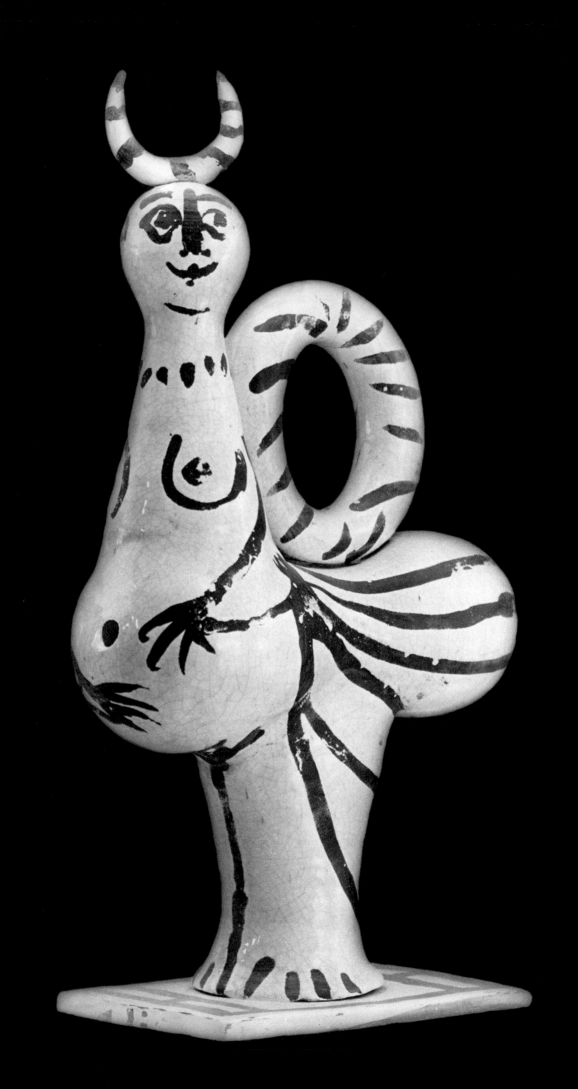

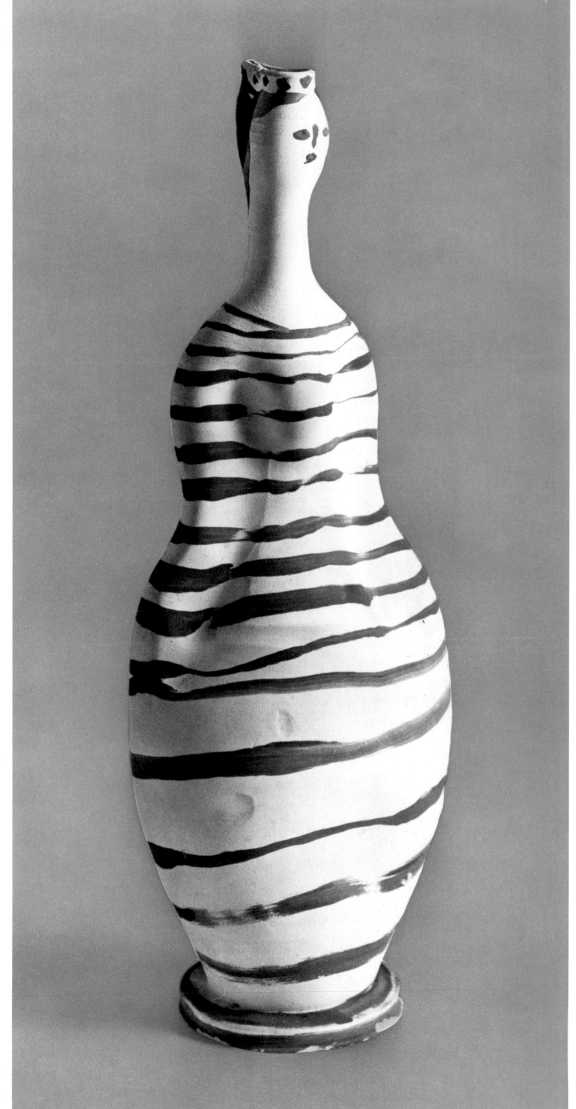

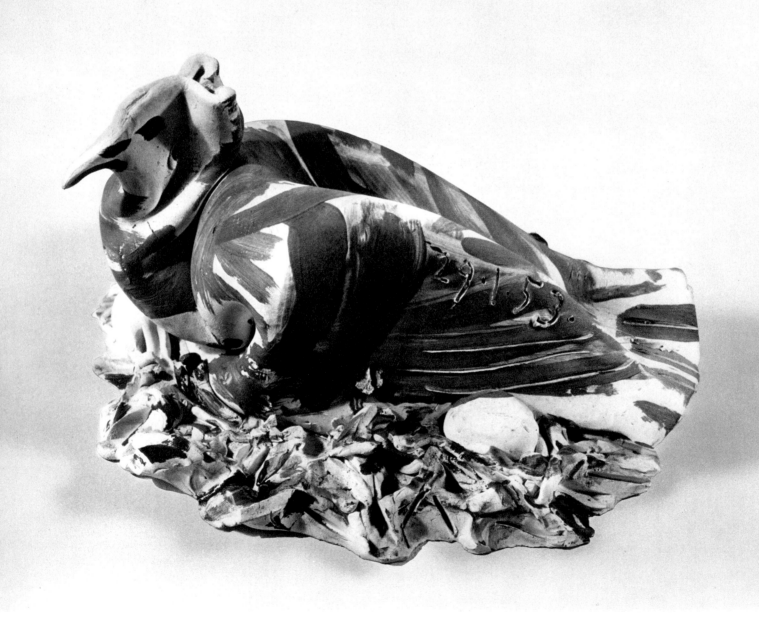

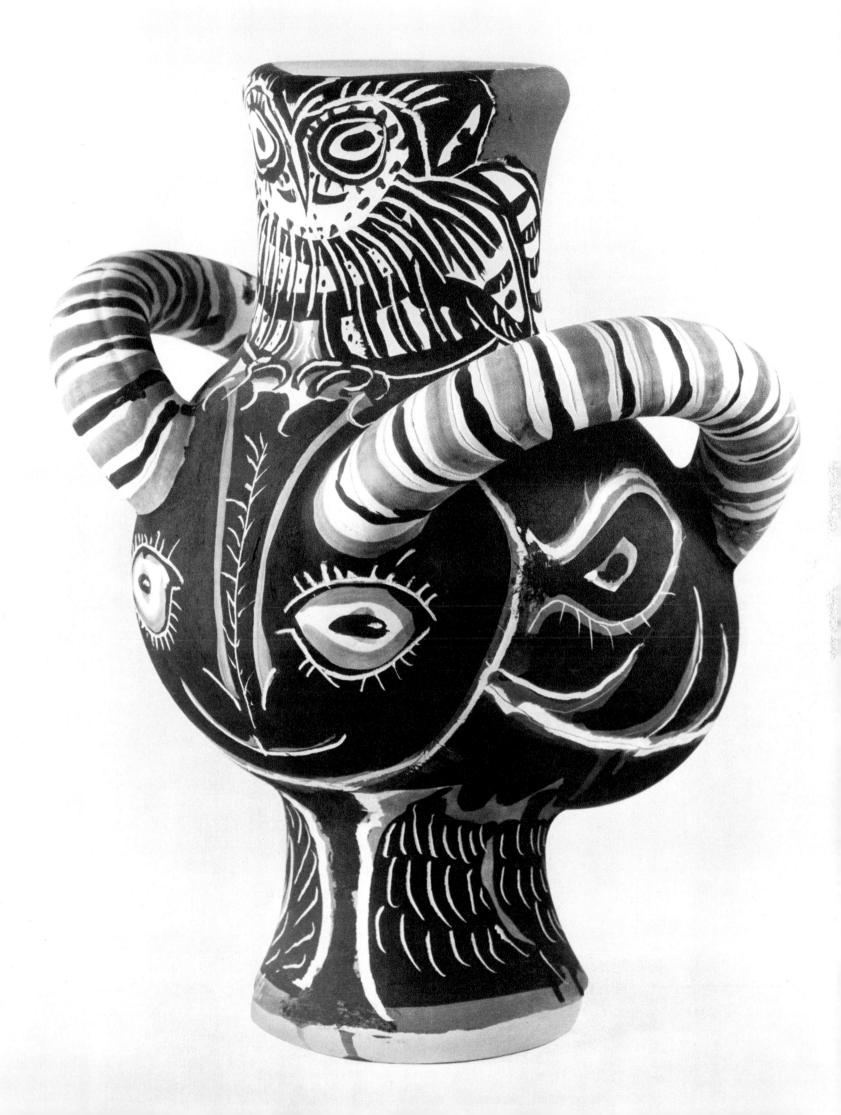

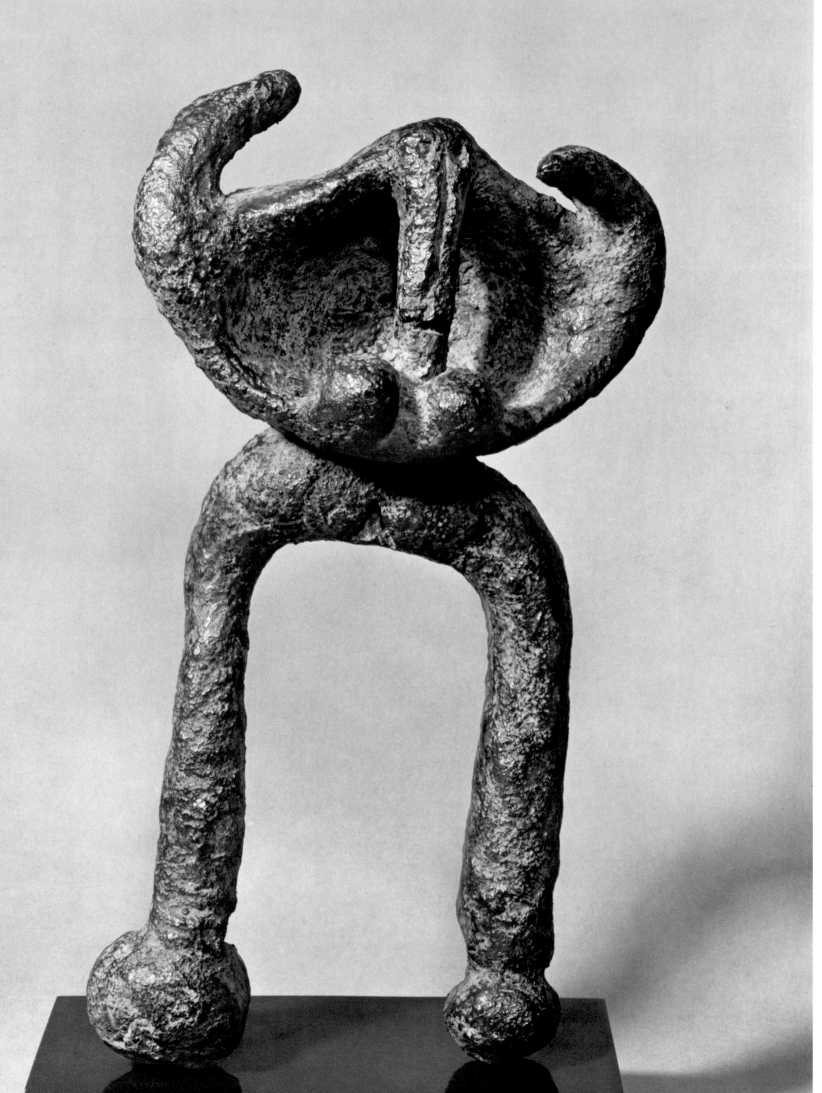

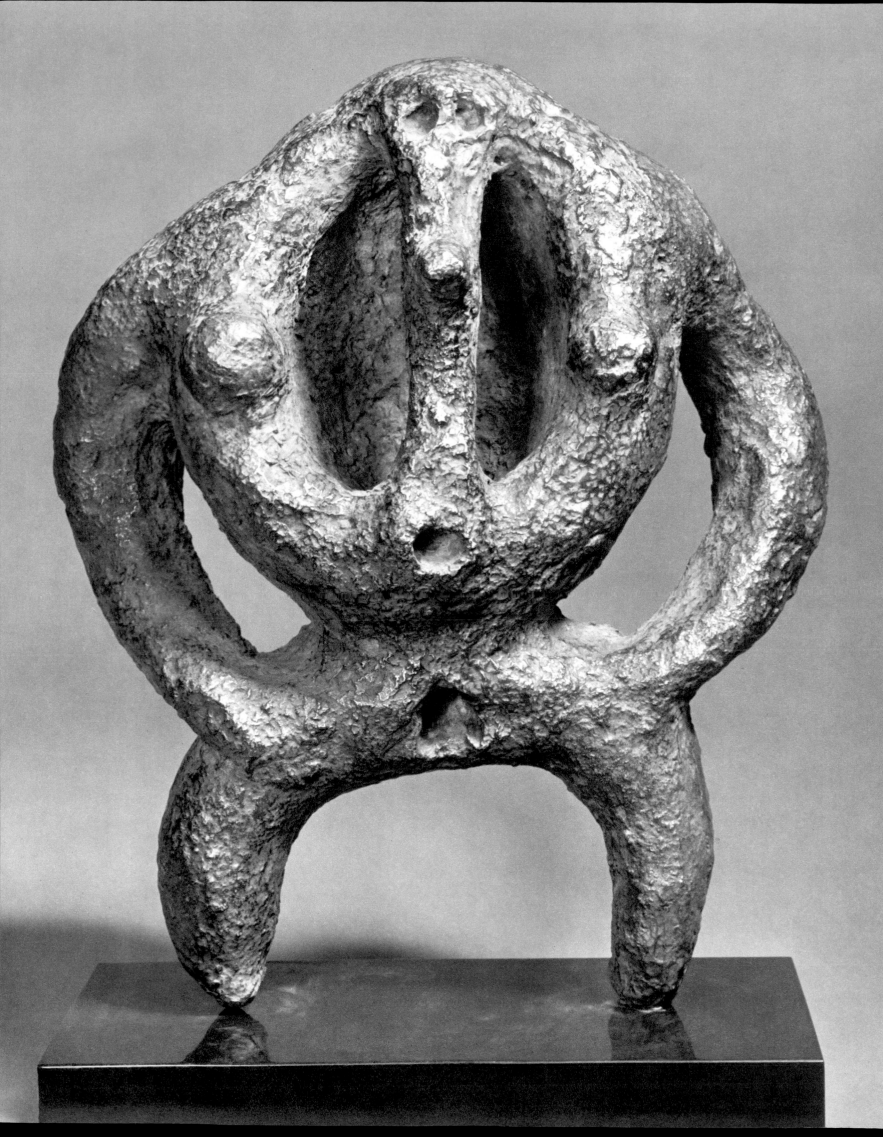

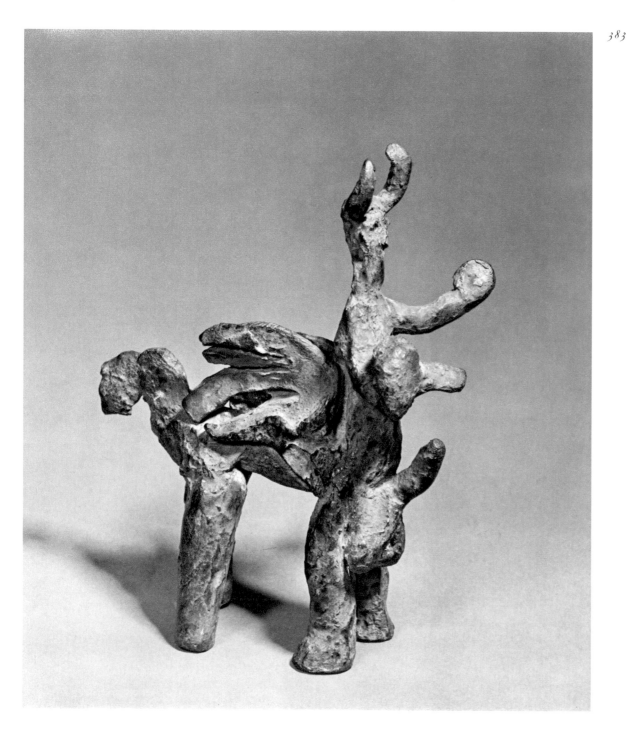

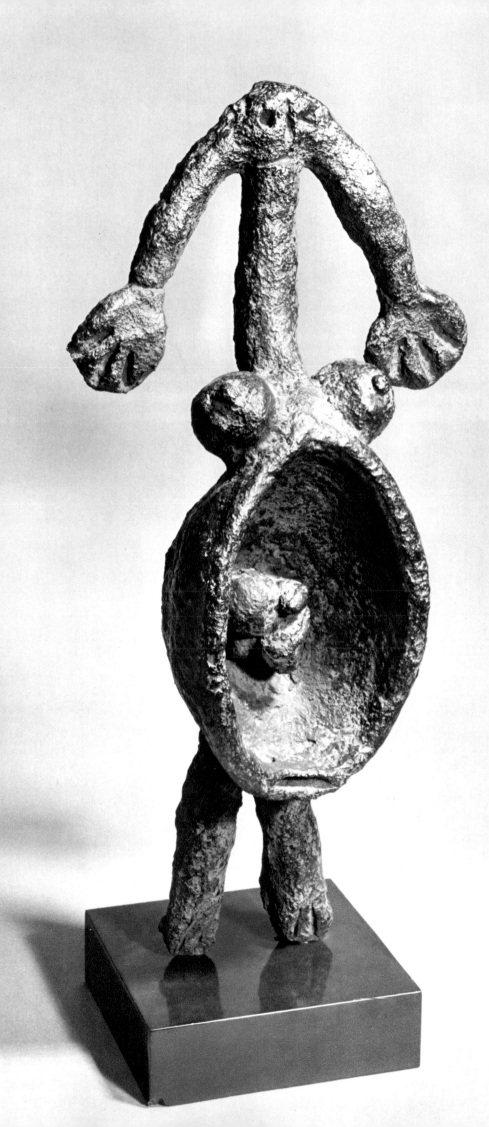

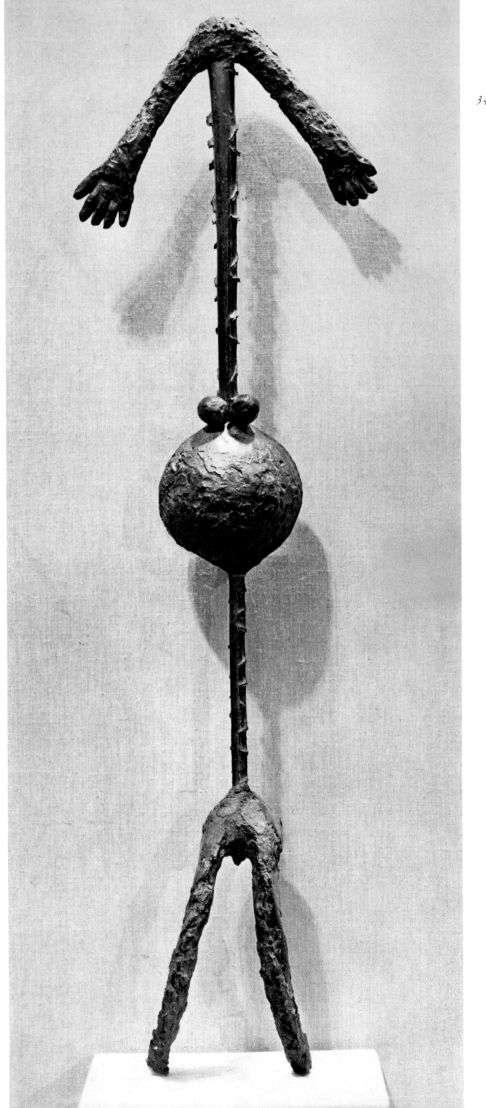

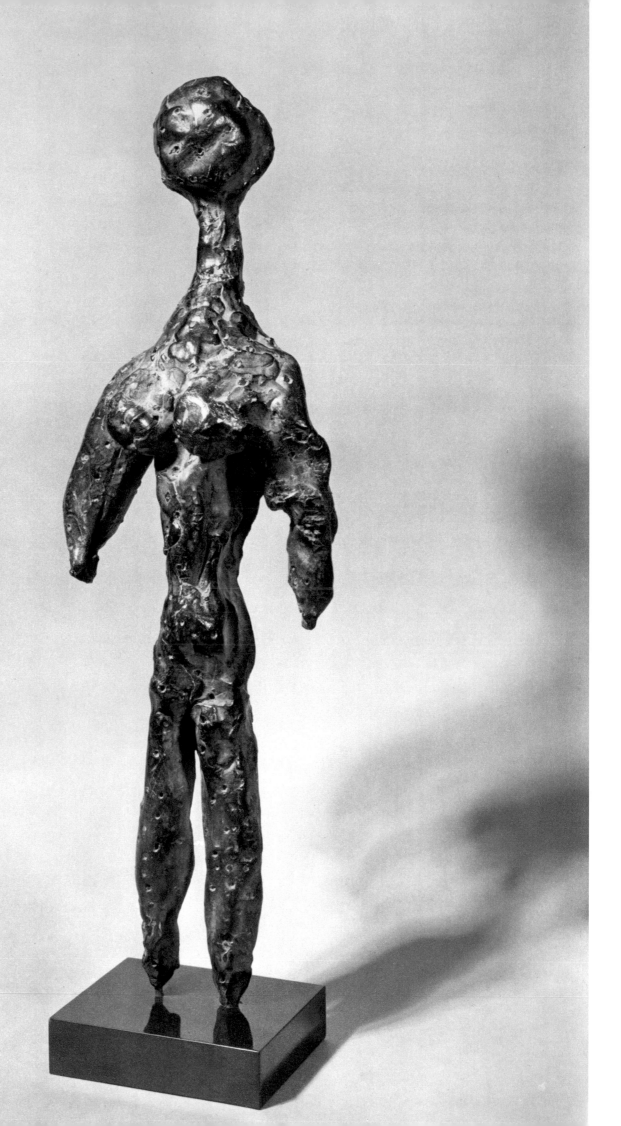

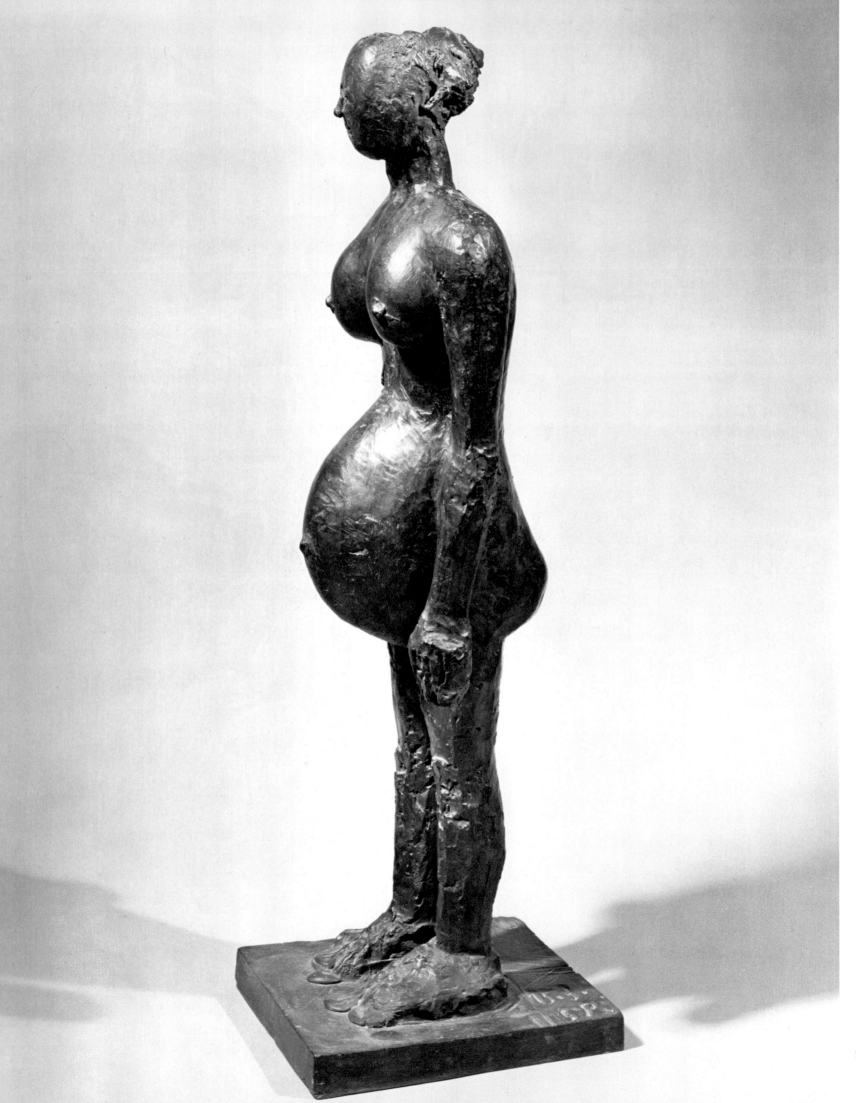

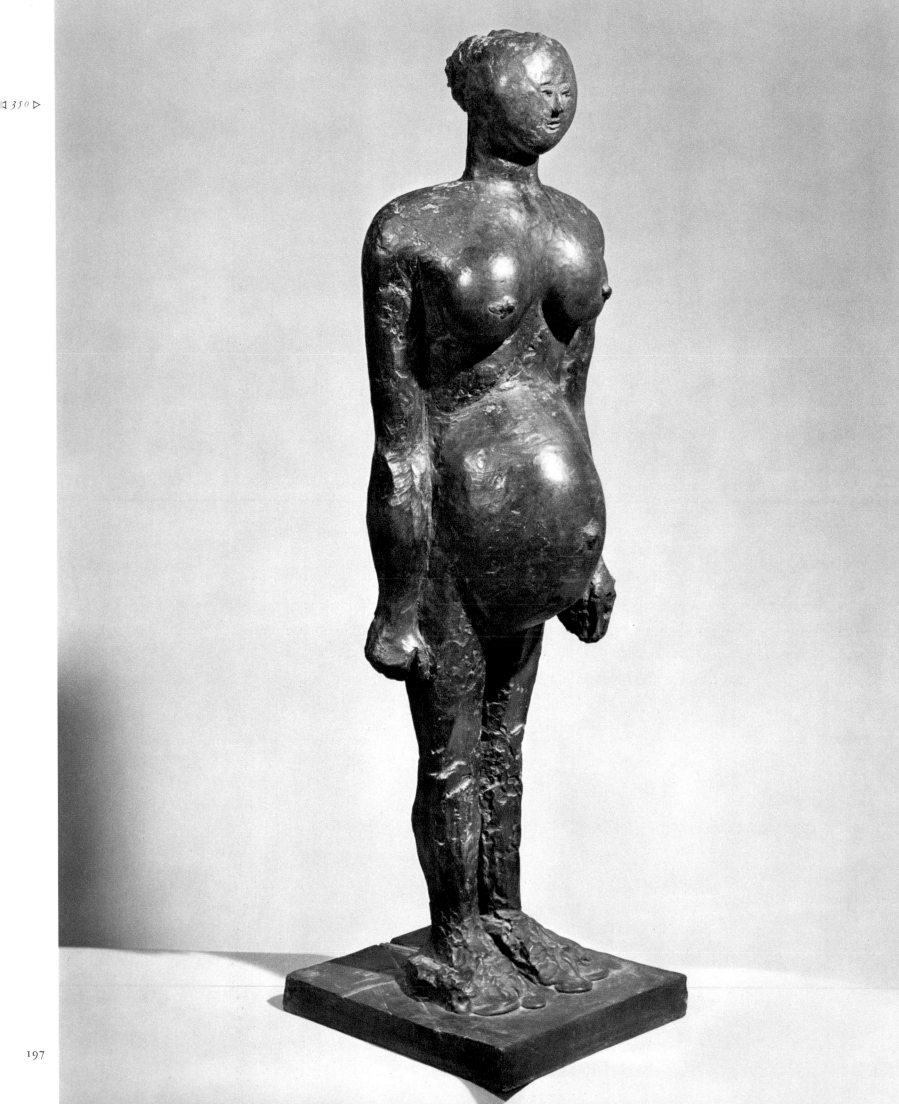

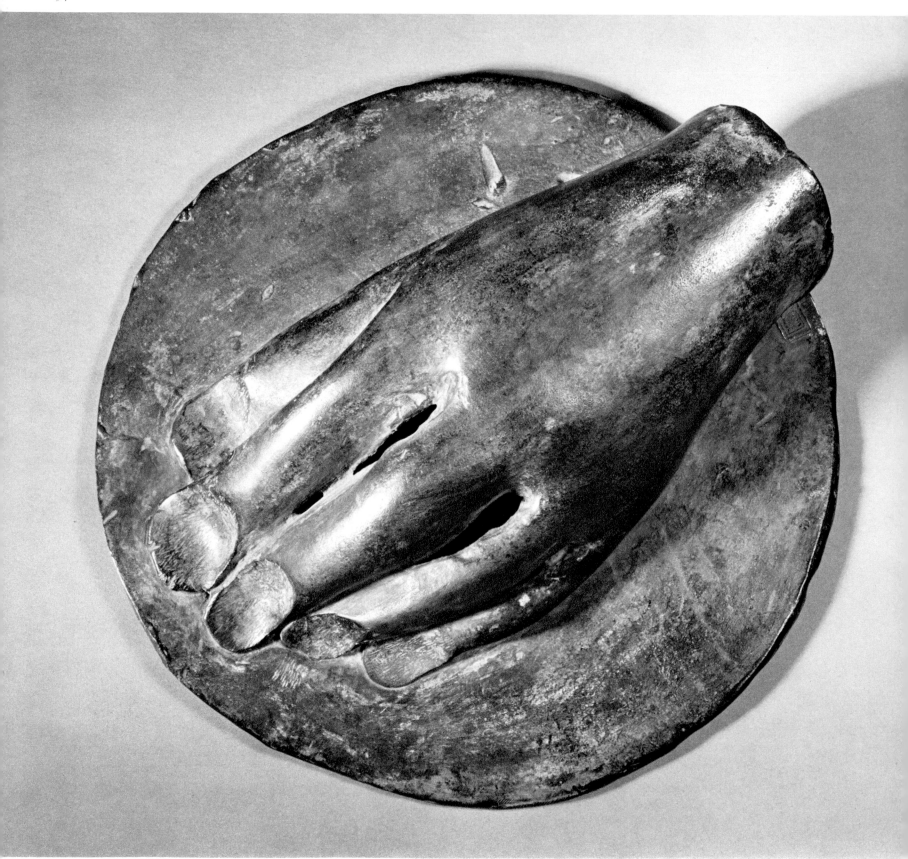

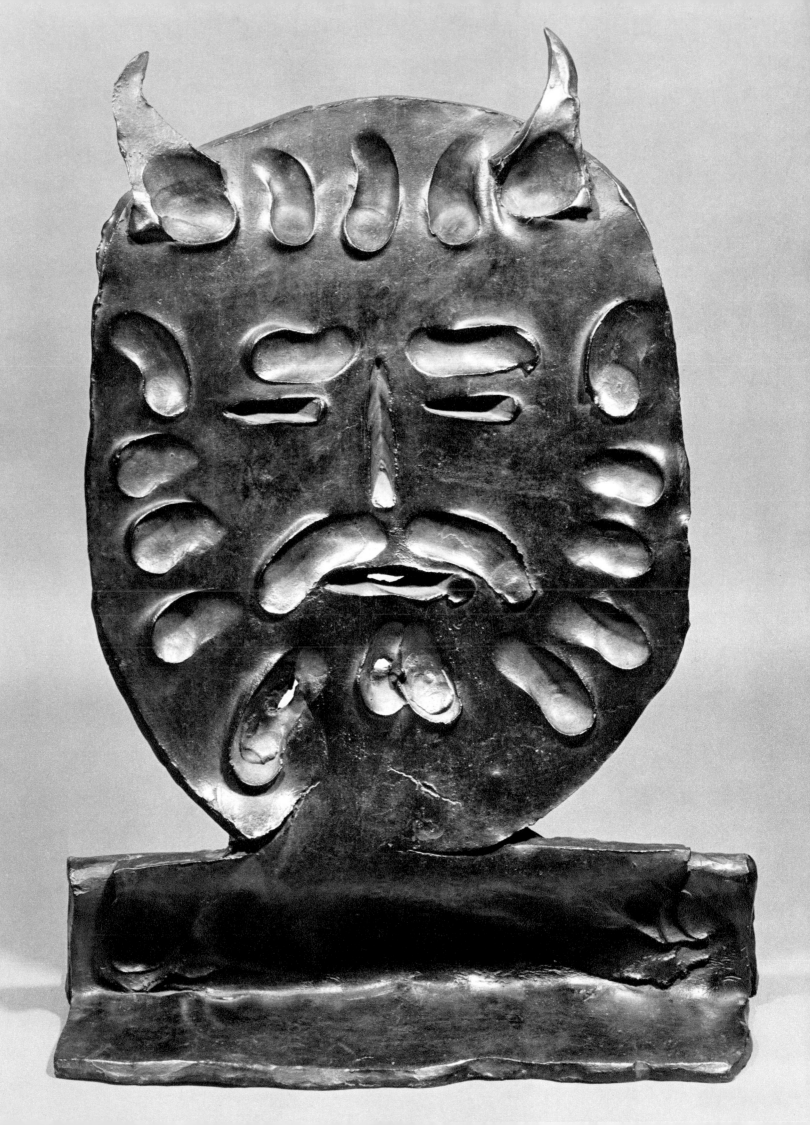

341

199

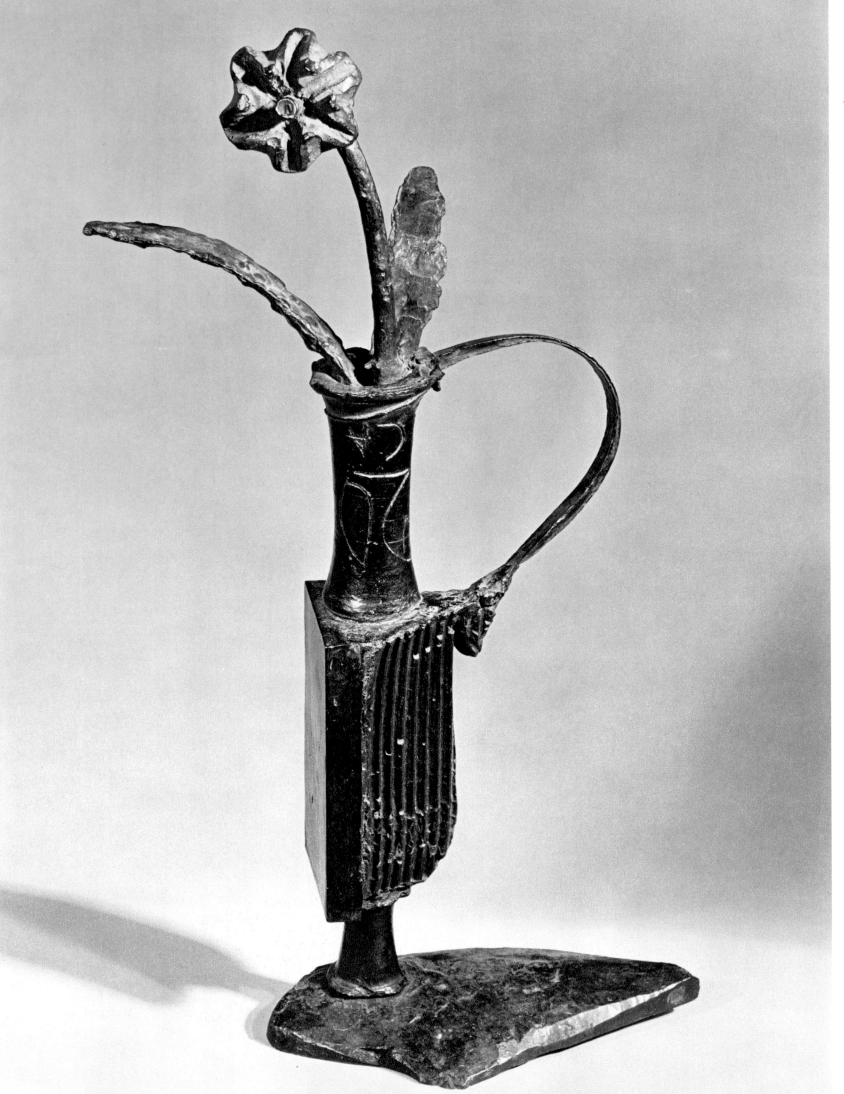

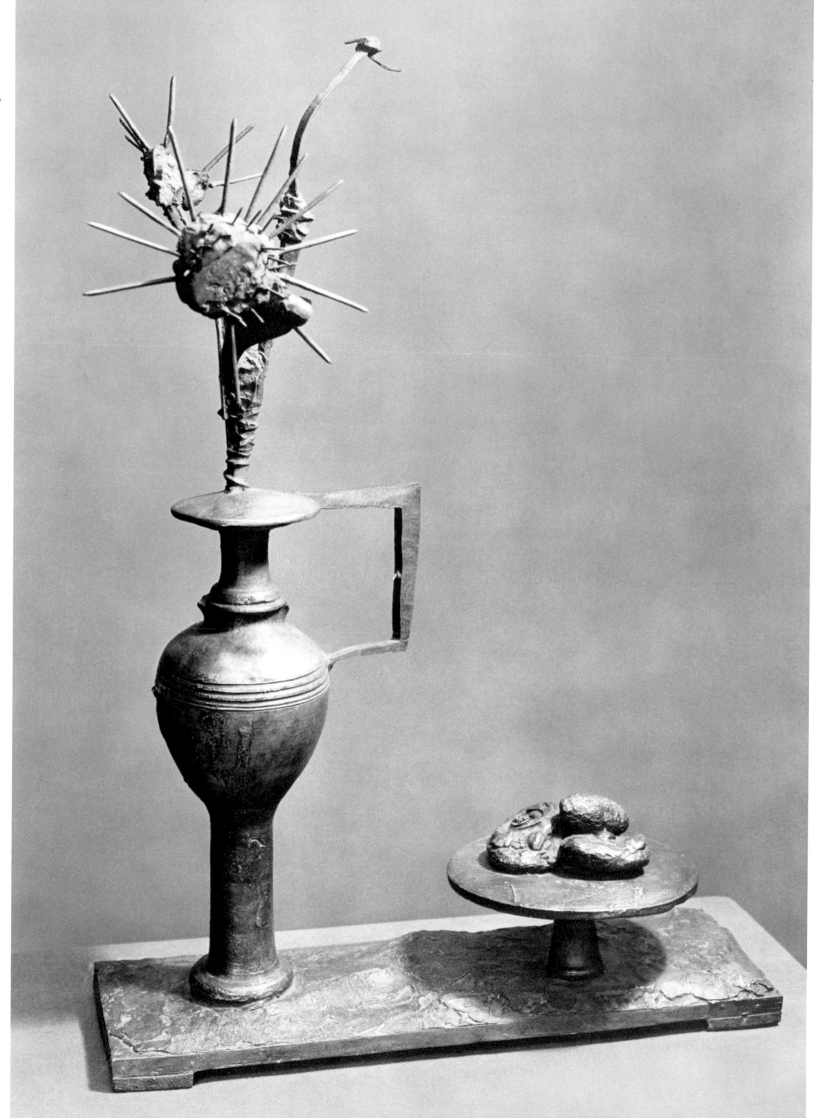

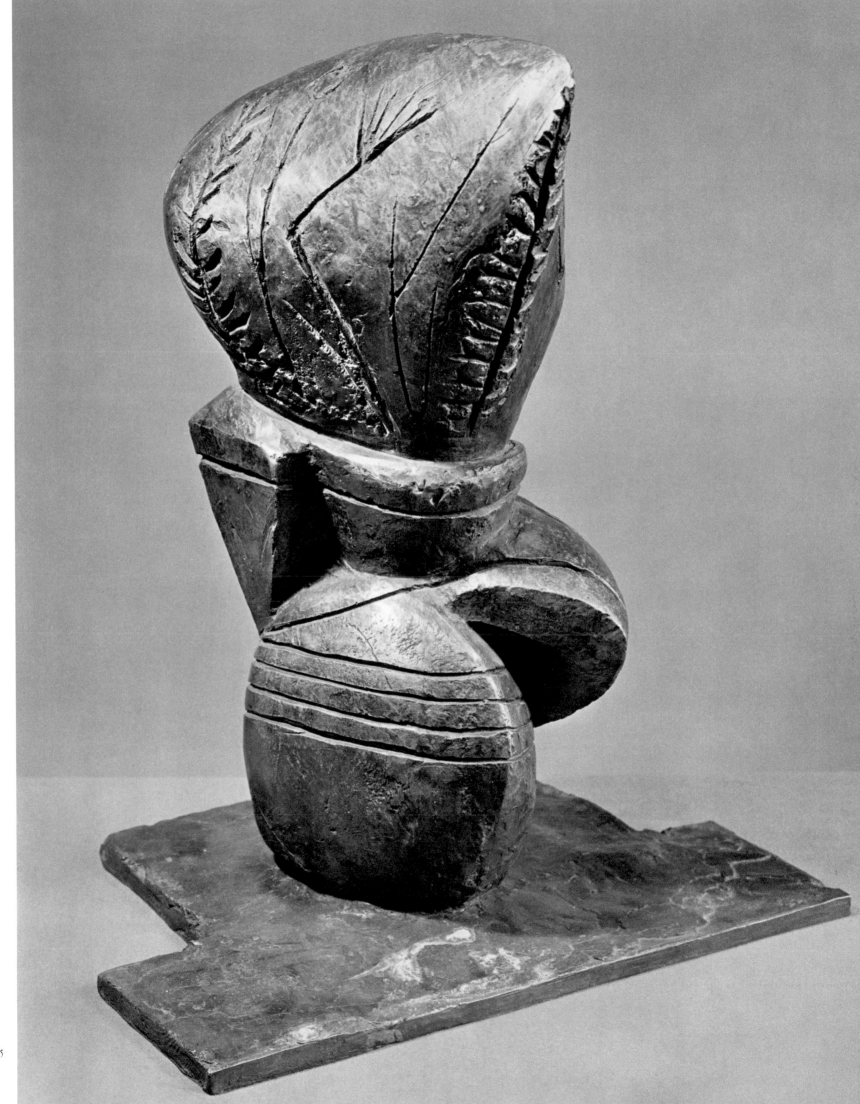

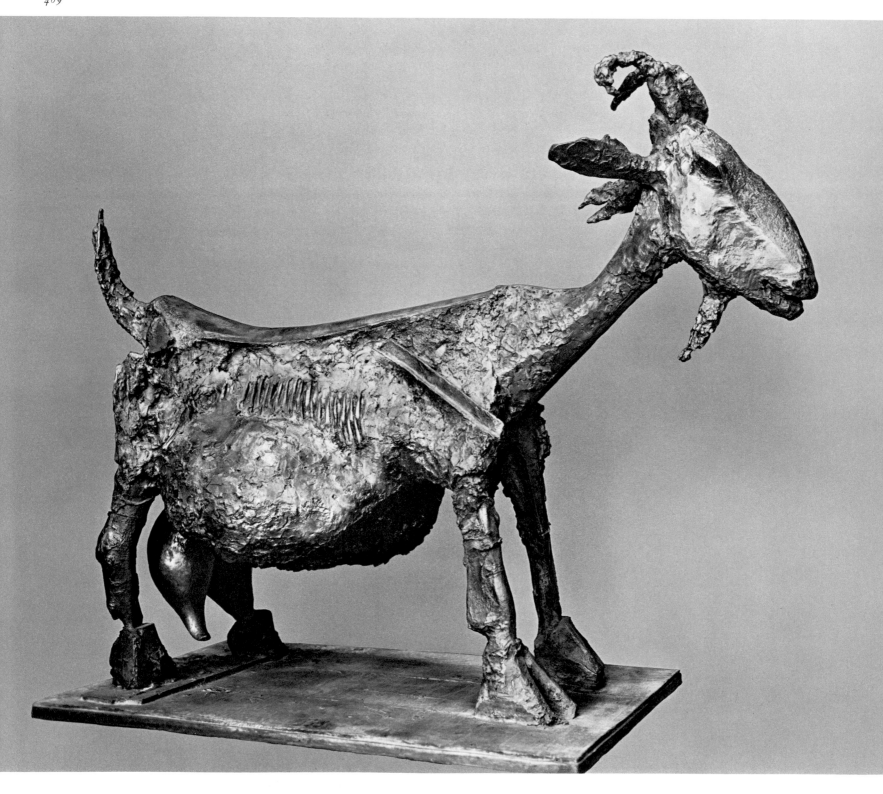

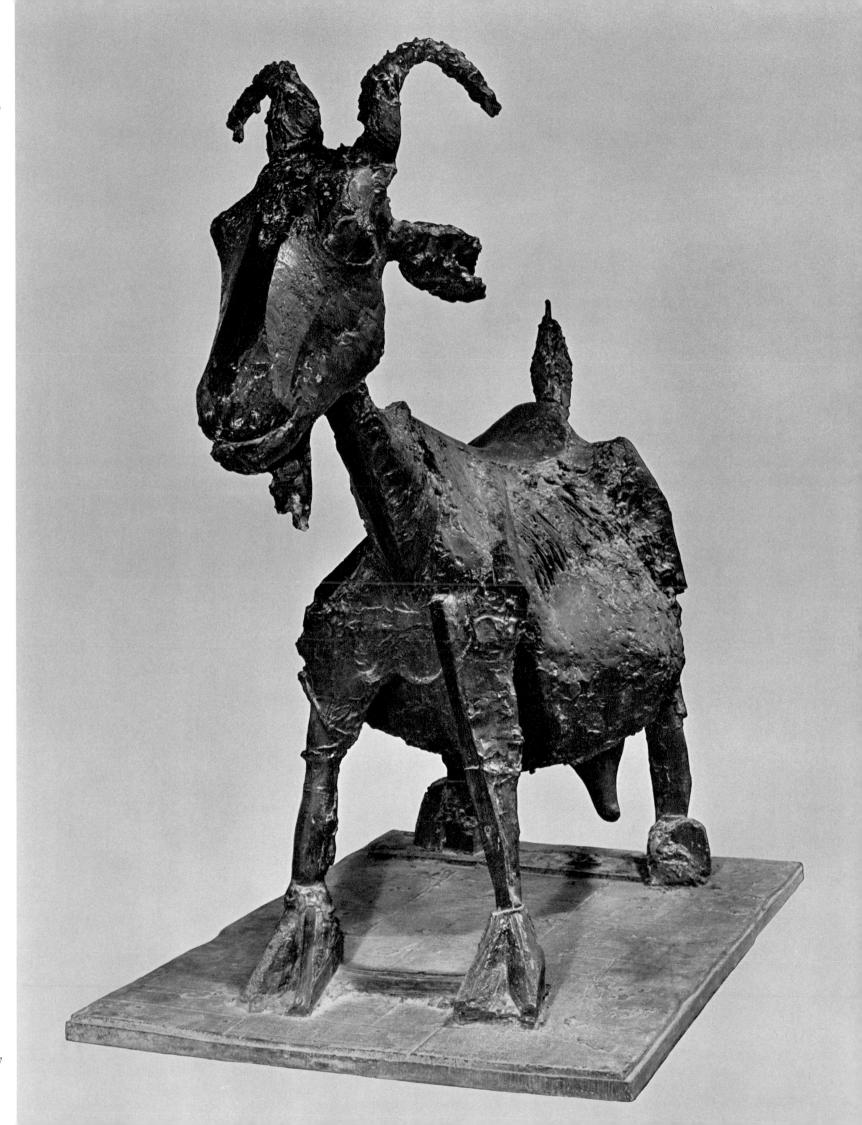

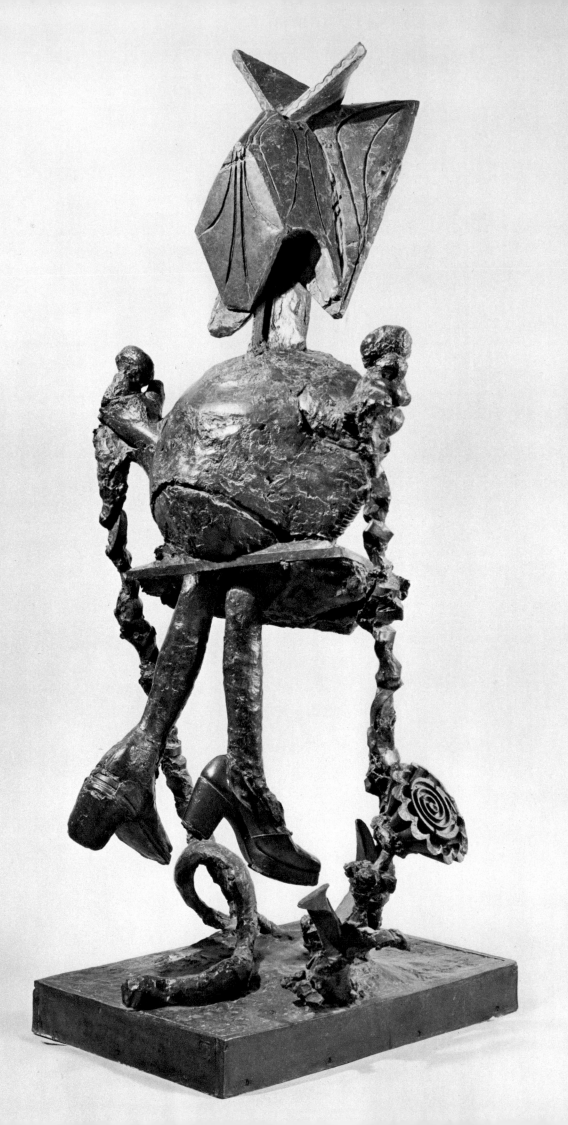

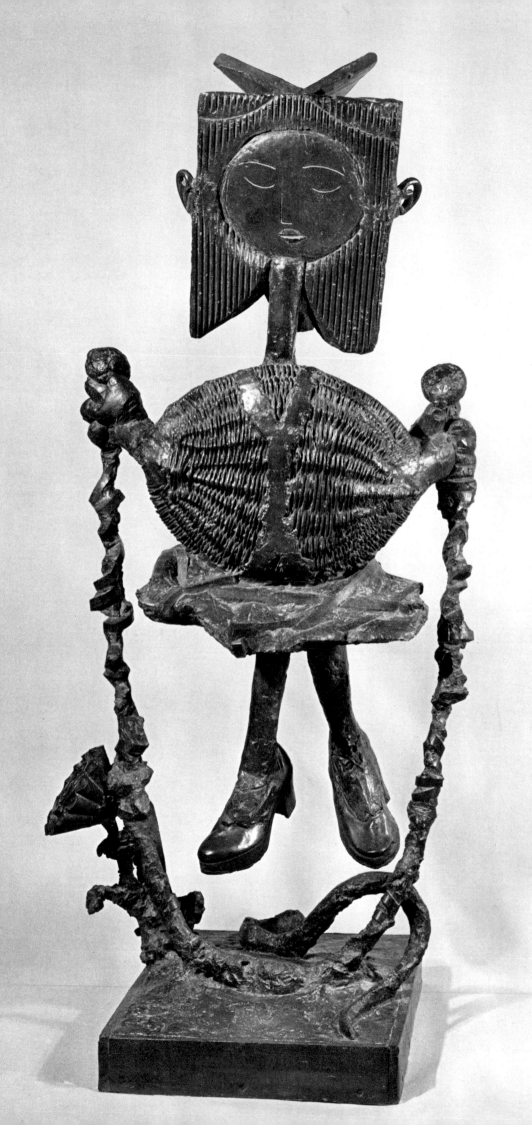

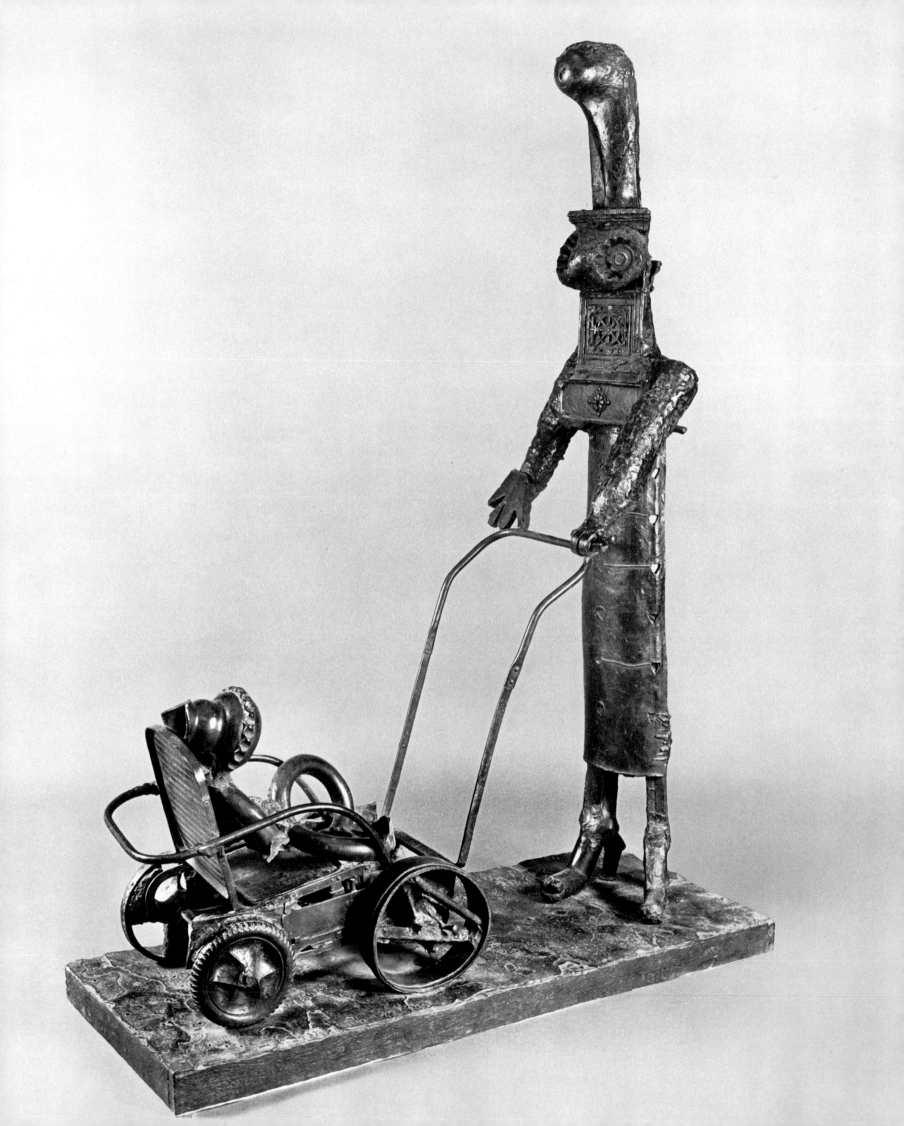

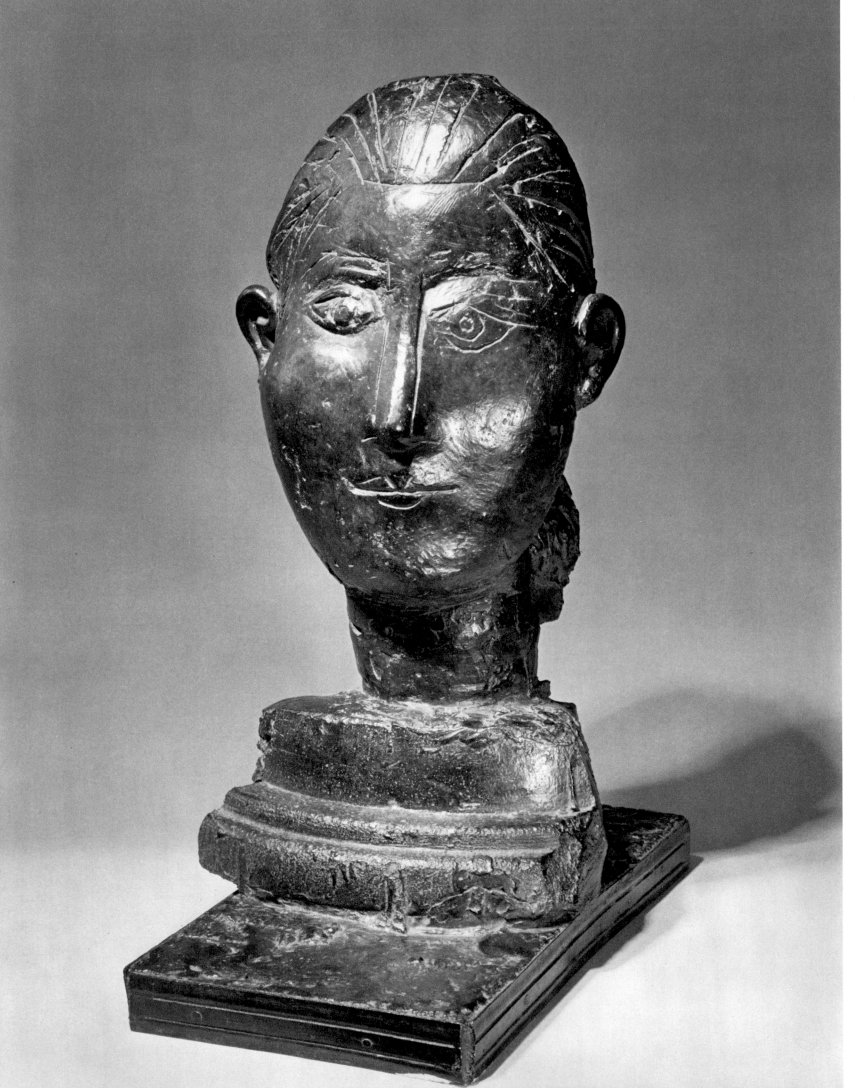

463

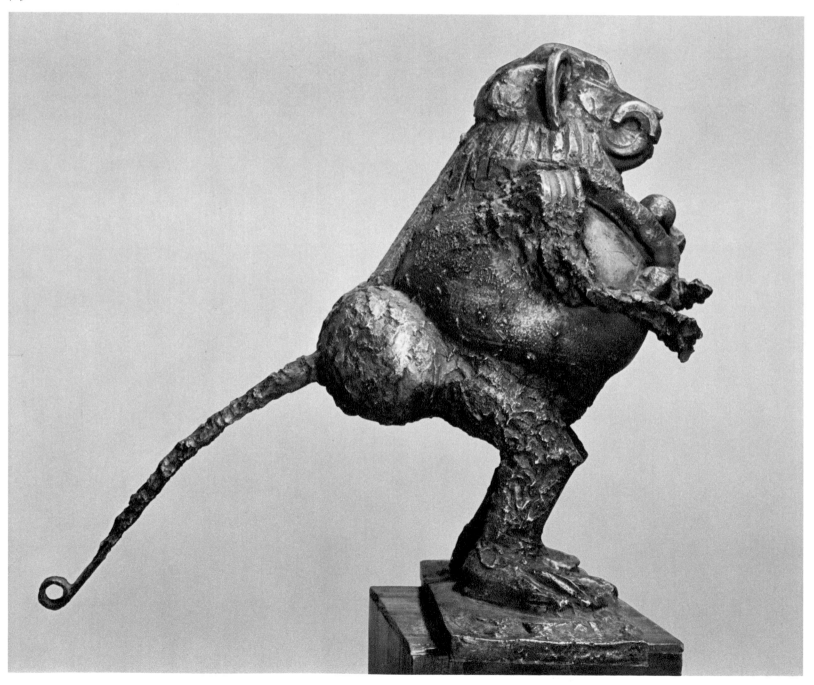

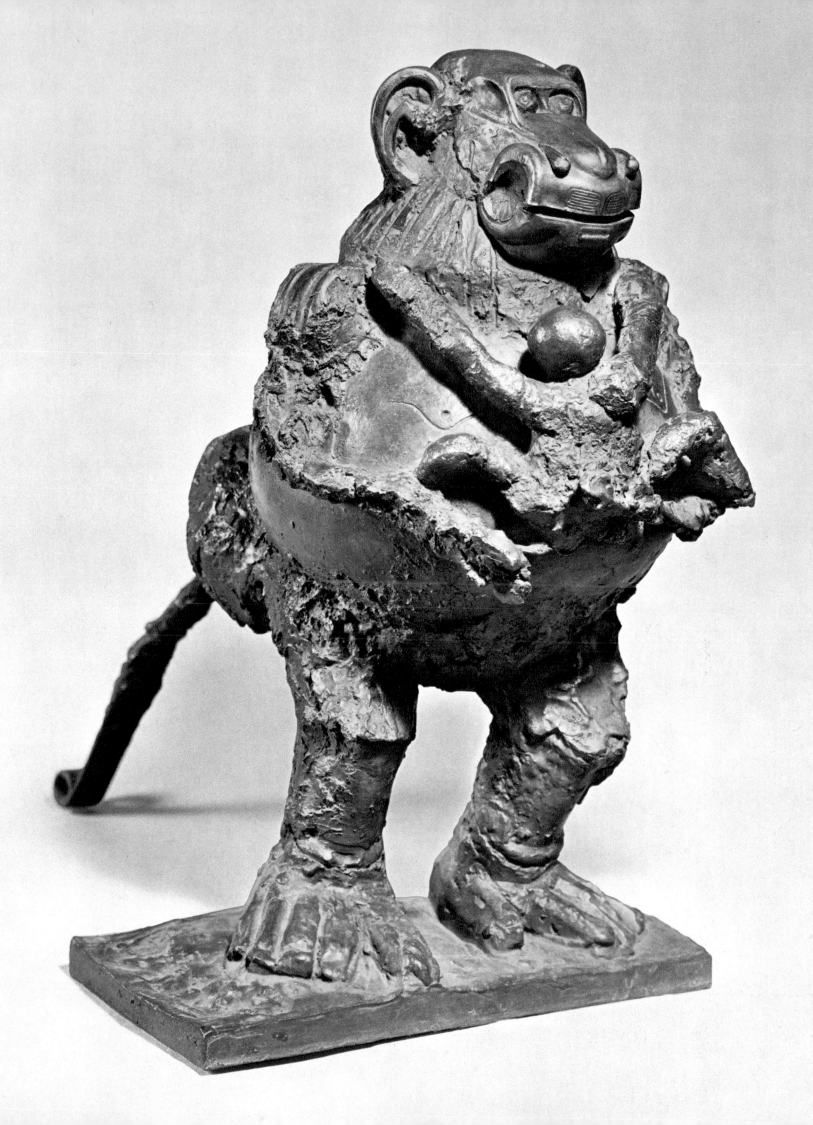

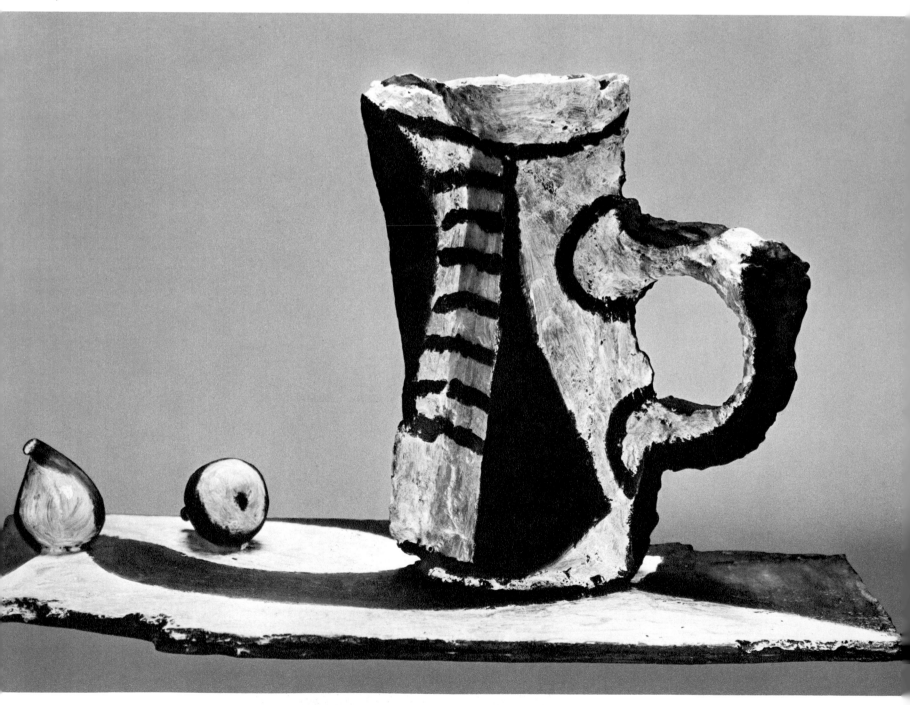

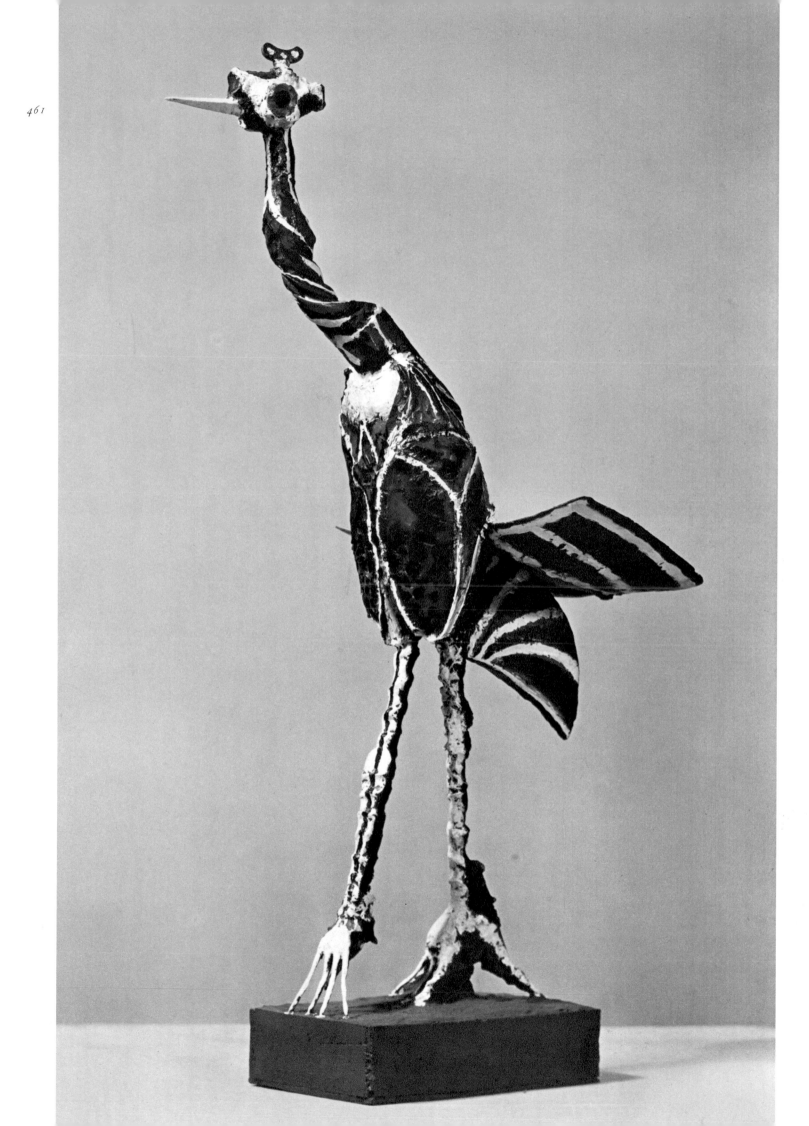

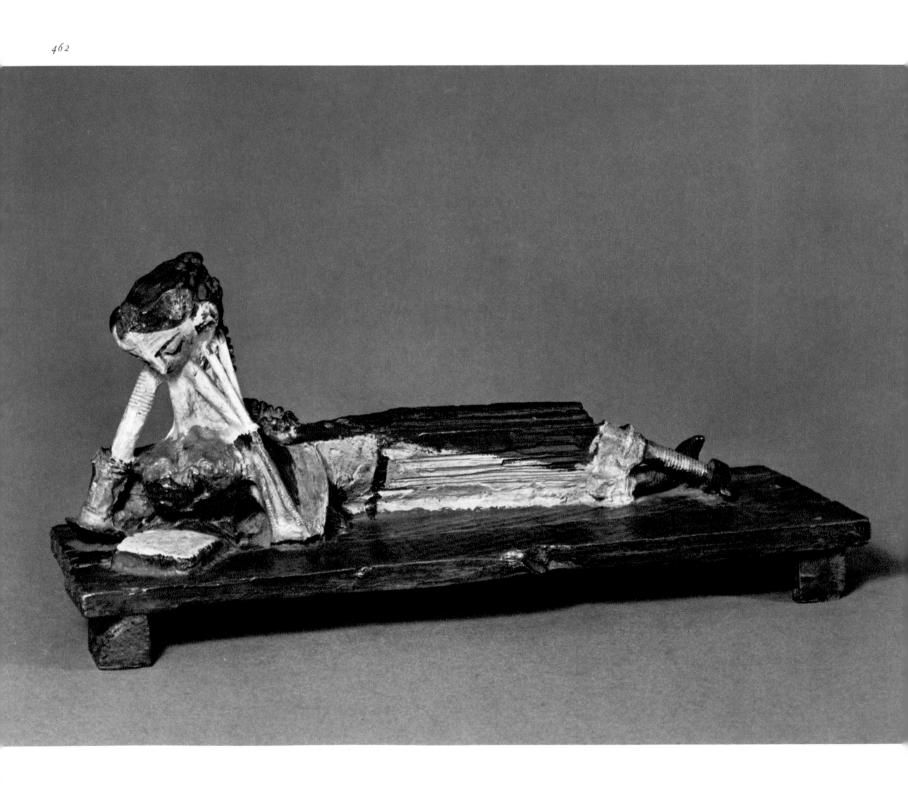

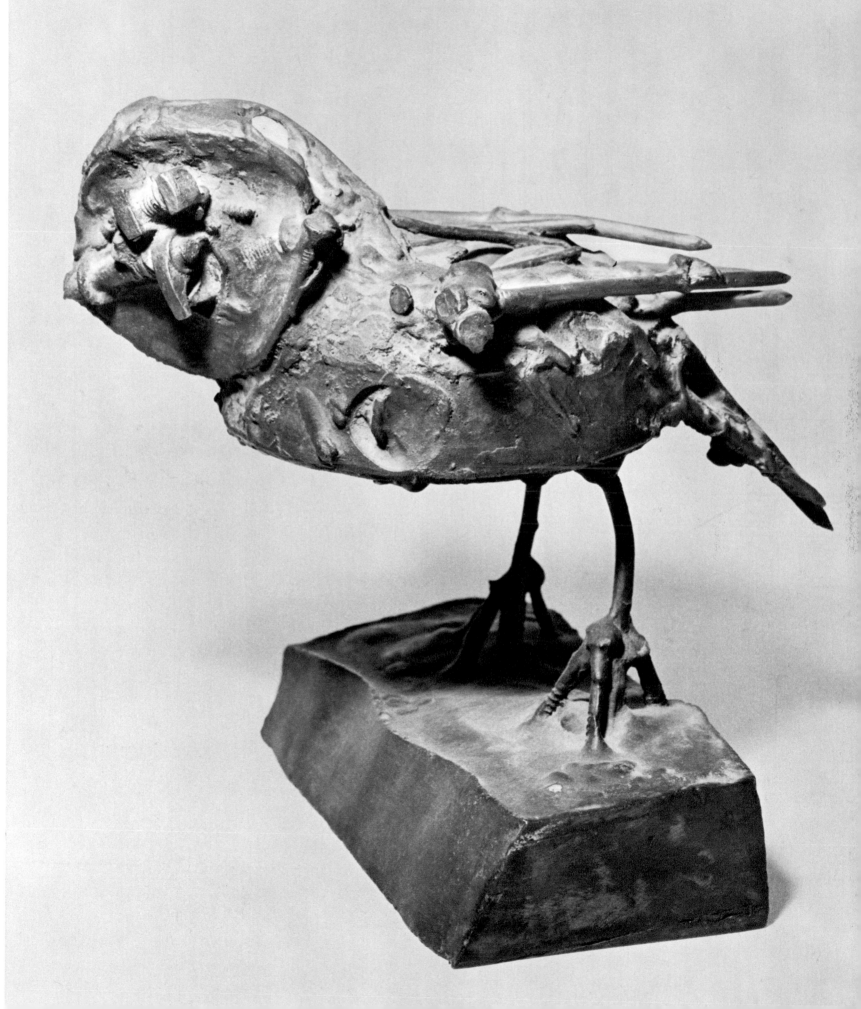

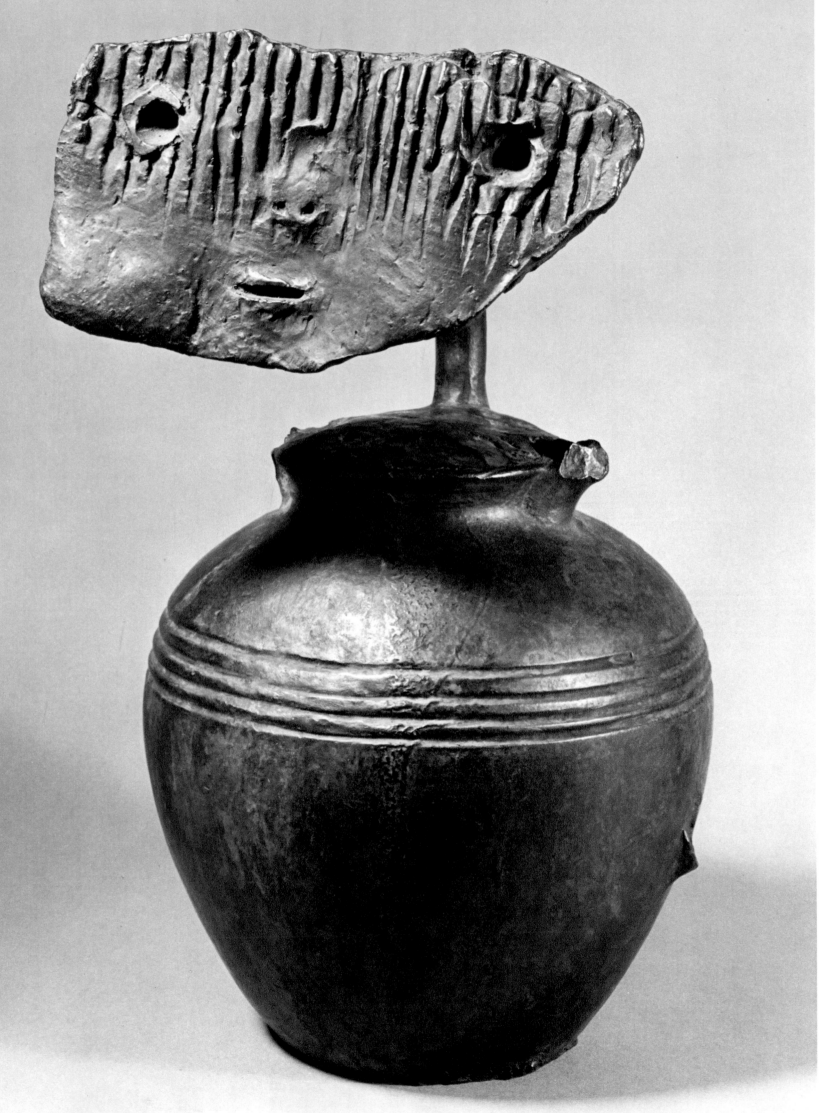

Late variations

SCULPTURE AND PAINTING

The fifth of the great Vallauris bronzes of 1950–51, *Goat's Skull and Bottle* (p. 178), represents something of a departure from the realm of sculpture in the round. It heralds a transition to the last phase in Picasso's sculptural activity, that of painted works in wood and sheet metal. The link with painting springs to the eye, but it is a deceptive proximity; in this work and those which followed it Picasso does not simply translate pictorial motifs into spatially perceptible planar sculpture. The novel feature of these works is that they impose a strict rhythm on the eye. The group might be entitled 'folding sculptures': successive fields of vision unfold as the observer walks round them, each one vanishing as the next deploys.

Picasso's output contains a number of preliminary steps towards this method of codifying the beholder's visual impressions. The question of a correct and adequate angle of vision crops up even in his early works, as in *Woman Arranging her Hair* (p. 37). The beholder is likewise ushered towards a specific vantage-point in Picasso's Cubist constructions, though these are more concerned with relief. The monumental heads of the Boisgeloup period, although fully sculptural, prompt the beholder to seek contrasting and varied visual images as he walks round them. Finally, technical precursors may be found among the constructions in which Picasso spatially distorted sheet metal.

While ushering in this new period, *Goat's Skull and Bottle* once more summarizes the whole wealth of sculptural thinking inherent in Picasso's work. The bottle harks back to the problem of open, transparent sculpture exemplified by *The Glass of Absinthe* (p. 49); the metal framework constructed in the bottle to suggest volume recalls the works in metal which Picasso produced with González; the use of handlebars as horns is a reminder of *Head of a Bull* (p. 161). Small nails *form* the bristly hair between the goat's horns; large nails *represent* the rays of light from the candle; the surface of the skull, obtained by impressing corrugated paper on plaster, is reminiscent of Picasso's incipient use at Boisgeloup of structures which replaced free modelling. The eyes are made out of metal bolts.

As in *Woman with Pushchair* (p. 211), we are here dealing with a sculptural group which comprises two contrasting plastic forms. Here, too, the contrast is strong: the goat's skull, a self-contained body which permits the continuous deployment in space of a fully plastic mass, is contrasted

with a shape (a bottle topped by a candle) which presents the eye with an alternation of the spatially positive and the spatially negative. The dissection of the bottle into convex and concave areas follows a far more systematic course than in *The Glass of Absinthe* to 1914. The latter was produced by rough superimposed layers of modelling which failed to produce a consistent, architecturally complete outline, whereas, in the bottle, Picasso cuts through a volume of regular shape. He uses two curved Provençal tiles to indicate the diameter of the bottle. They are so disposed round the central axis as to produce an S-shaped curve. This the eye associates with a propeller or paddle-wheel which, if rotated at sufficient speed, produces a solid, regular volume.

The manner of painting is noteworthy. In the case of the goat's skull the alternation of black and white ridges or grooves accentuates the structure of the corrugated paper. In that of the bottle, the concave side of one tile is painted white and the adjoining convex side of the other is black, while the convex reverse of the first tile is half white, half black, and the concave reverse of the convex tile entirely white. These differing chromatic quantities produce an added contrast between the two shapes. The bottle, which is divided into curved surfaces, acquires a certain repose from being painted; by contrast, the solid mass of the goat's skull is violated by a restless alternation of white and black bands. It could be said that the paint has been used antithetically: solid volumes are made to vibrate, and open, non-voluminous portions are consolidated. The base on which skull and bottle stand has an important bearing on the impact of the sculpture, which is intended to be viewed slightly from above. Picasso has recorded the shadow cast by the bottle – the downward projection of its transparency – on this base in the form of a bas-relief.[120]

Both shapes, the goat's skull and the bottle used as a candlestick, complement one another. The open, transparent, rotating bottle-shape contrasts with the squat mass of the goat's skull. The group creates visual relationships not found elsewhere in Picasso's work. The two shapes displace, overlap or stand clear of one another as one walks round them. Perception of the shape which signifies the bottle is governed by a precisely regulated visual process. What is vitally important is the perceptual break that occurs when the beholder's eye travels from the face of the tiles to their reverse side. Its smooth progress along the curved S-shaped surfaces receives a sudden jolt at this point. The transition from face to reverse occurs abruptly and with a hint of violence. This mode of perception makes demands upon the eye quite different from those imposed by the solid sculptural presence of the goat's skull. A new field of vision opens up from one moment to the next.

The treatment of the bottle in this work heralds the long series of works in sheet metal, the 'folding' sculptures, which characterize Picasso's sculpture in the 1950s and 1960s. This principle applies particularly to the first series of these works, whose plasticity derives from a concertina-like ebb and flow of surfaces. Greater emphasis is laid on certain views than on others, so that the plastic perception of these painted sculptures is predetermined in two ways: first, by the juxtaposition of mutually independent, reciprocally cancelling fields of vision, and, secondly, by the fact that Picasso gives priority to certain fields of vision by painting them in greater detail.

This procedure is typical of all Picasso's later output, and relates to one of the chief problems in his work: the varying and paraphrasing of a shape or theme. Variation and paraphrase assume a status of increasing importance. Picasso seldom pursues a single pictorial solution. He almost always evolves a series of solutions for the same image, many of which differ in detail only. Painting, drawing and graphics, with their mobility and independence of ponderous technical apparatus, are eminently well suited to this manner of working. In a similar sense, the sheet-metal sculptures also enable him to present a great number of variations within a single motif. Picasso's mode of execution facilitates this. He produces small models in paper or cardboard and employs a craftsman to cut larger-scale versions from sheet metal. In some instances he goes over the sculptures himself, using pliers to bend them at various points. Finally, he paints them. The first works of this type were made at Vallauris in 1954, in a locksmith's workshop. Six years later, between 1960 and 1963, Picasso applied himself exclusively to this technique. The majority of these works – more than 120 sculptures of this kind came into being in the course of eighteen months – were executed by Lionel Prejger.[121]

The preliminary phase opened in 1954 with the *Sylvette* heads (pp. 232, 233; *cat. 490, 491*). The sheet metal used in this case is thin, and the cut-out shapes are folded. The surface of the metal is left smooth. In the works of the second phase, the surface is adorned with metal ribs suggestive of relief, which protrude from the surface like welded seams. This relief-like application of metal, which is laid on like a drawing, sometimes replaces paint altogether. Viewing possibilities are strictly predetermined.

Sylvette begins by presenting an overall view of itself. The folds invest the form with a hint of movement which stems from the protrusion and recession of parts. However, because the painting itself embodies spatial allusions, particularly in the central zone, the plastic situation remains vague. The folded sheet-metal form begins to exert a sculptural effect when we dissect it into its surfaces of action and take each of the four surfaces as a separate basis of observation. Viewing it frontally, as it is shown in the illustration, we are presented with an overall view. If we move to the left, Surface 1 'folds' shut. Instead of the round termination presented by the whole face, the latter is bounded on the left by a small tapering triangle. Proceeding still farther, we find that the large dominant central field (3) also 'folds' shut, and the part of the sculpture which links it most strongly with the painting of these years disappears from view. Surfaces 2 and 4 (angular facial expression and long hair, respectively) remain. Another version of the sculpture divides the overall view into six different surfaces, thereby affording more visual possibilities. In addition, the reverse side is painted.

A second group of planar sculptures, which also originated in 1954, presents female heads mounted on a sort of signpost (pp. 234, 235; *cat. 492, 493*). The round post itself forms part of the face. The signpost shape is not new in Picasso's work. A head fashioned in cardboard as early as 1943 (*cat. 277*) bears a strong relationship to these sheet-metal works, and, in turn, to a design for a monument dated 10 March 1933. In these works,

some of which were executed as monumental sculptures during the 1960s, plasticity is obtained by making two plane surfaces intersect at right angles. Here, as in the bottle in *Goat's Skull and Bottle,* rounded volume is suggested by two intersecting surfaces. The variations which present themselves to the gaze are rich in the extreme: surfaces become superimposed, are obscured by each other, cancel each other out. The painting helps to accentuate this impression of mobility. A sculptural signal as simple as that conveyed by the 1954 *Head of a Woman* (p. 234) confines itself to the intersection of a rectangular surface and one which tapers towards the front. This work does, incidentally, evoke a problem of representation which had exercised Picasso twenty years earlier at Boisgeloup. It can, in fact, be construed as a planar shorthand version of the rounded *Head of a Woman* of 1932 (p. 118). There, too, the sculptural script was radically simplified to achieve a maximum of fully sculptural effect, being reduced to plump and rounded shapes which ignore details altogether. In the sculpture in the round, the shape projecting from the mass of the head (hair-brow-nose) was summarized by a continuous tuberosity constricted at the apex only; in the planar sculpture, this role is assumed by the shape which tapers towards the front and intersects the rectangle. It is a plastic symbol which signifies hair-brow-nose. In another head Picasso uses painting to accentuate the ambiguity produced by walking round a sculpture: a flat profile is so treated that it can, from another angle, be construed as hair.

The Chair (p. 247) was made in 1961. Picasso cut the paper model from a large sheet of paper and folded it outwards. The problems posed in the Cubist constructions recur here.[122] The *Woman and Child* series also reverts to constructional problems of the early period (pp. 248–49).

The construction of 'geometric' sculpture – made up of flat cut-out shapes – was variously undertaken in a series of subsequent works. Picasso gave up the practice of producing models for enlargement by others; instead, he constructed the works himself out of wood. The most impressive example is the *Bathers* group (p. 237). In this Picasso limited himself to constructing figures out of parallel surfaces. Each figure is intended to be viewed from the front only. An active spatial relationship comes into being only when the contrasting individual figures are combined in groups.

Not even the planar sculpture represents a complete novelty in Picasso's work. The *Bathers* suite takes account of shapes which he had developed before the First World War, during the synthetic phase of Cubism. The first indication that, decades later, he was beginning to take a renewed interest in the plastic stratification of surfaces occurred in 1953, in the form of a flat sculpture nailed together out of wood. Picasso built a series of works conceived from a single viewpoint (pp. 229–31). The consistent and vigorous use of paint stresses the essentially pictorial nature of these objects.

The *Head* of 1958 (p. 240) represents an in-depth sculptural version of works of this kind. Picasso's painting contains numerous indications which make it clear that at that stage in his career he was addressing himself once more to the two-dimensional mode of composition typical of synthetic Cubism, with its juxtaposition and superimposition of planes. A very important role in the pictorial variations on Delacroix's *Woman of Algiers* and Velázquez's *The Maids of Honour* is played by the juxtaposition and superimposition of discrete planes

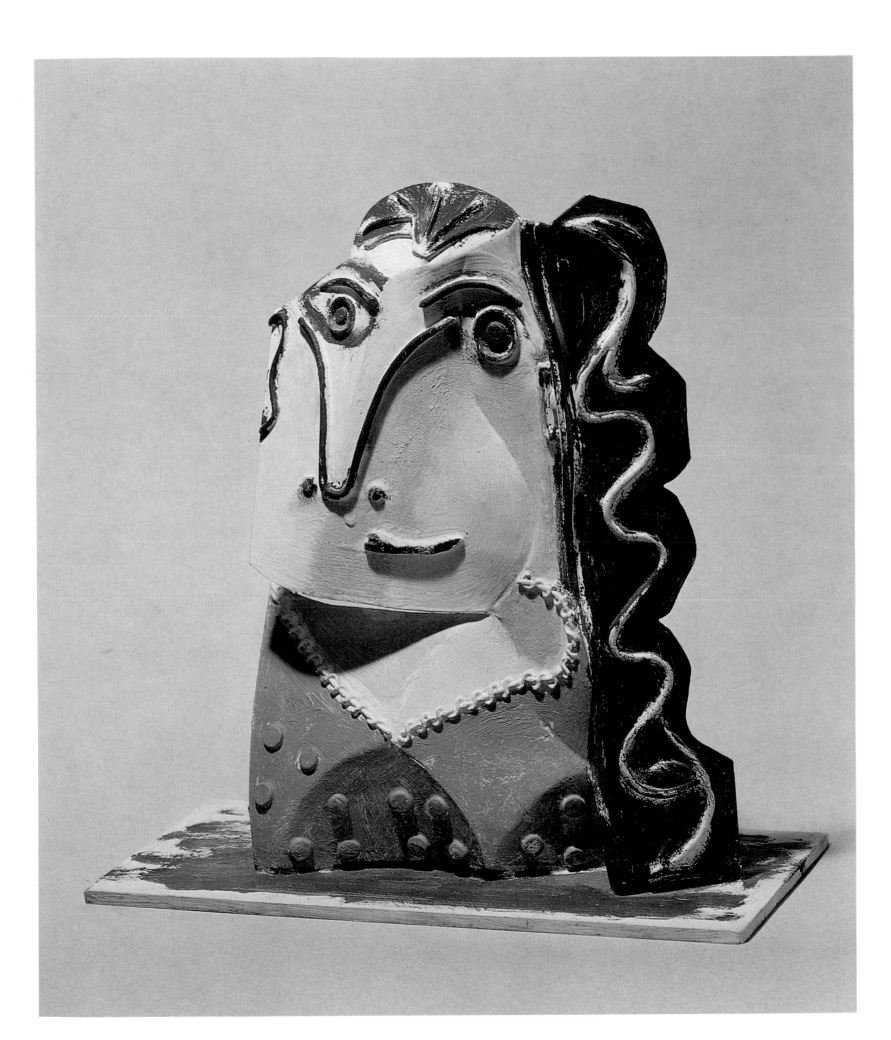

additionally distinguished from each other by colour-values. The first great variation on *The Maids of Honour,* dated 17 August 1957, is unmistakably influenced by *The Bathers.*

SCULPTURE IN A PLANE

Picasso bade his farewell to solid sculpture in the round with the large works of the early 1950s, half modelled and half constructed of found objects. The ensuing late phase displays an unprecedented – for Picasso – concentration on a single theme: that of the flat sculpture which slices into space. For the first time, he was able to have sculptures executed on a monumental scale.

The Norwegian painter Carl Nesjar made available to Picasso a new technique, termed betongravure or concrete engraving, which had been developed in Oslo by the architect Erling Viksjö and the engineer Sverre Jystad. In this process, a drawing is worked into the surface of concrete by sand-blasting. With the aid of templates, Nesjar succeeded in producing concrete sculptures from Picasso's flat designs.

A number of other large works were done by this means, among them *Woman with Outstretched Arms* (1962, p. 264), *Le Déjeuner sur l'herbe* (1965, cat. 652), *The Profiles* (1965, cat. 649) and *Head of a Woman* (1965, p. 263); the last-named attains a height of 49 feet. Apart from free-standing sculptures, Nesjar has also executed mural reliefs, e.g. for the Colegio de los Arquitectos in Barcelona (1960–61, *cat. 566*) and for Douglas Cooper's Château de Castille, Avignon (1963, *cat. 641*).

In 1965 Picasso designed an iron sculpture 65 feet high for Chicago's Civic Center (pp. 260–61). Its basis was one of the female heads of 1962 (p. 256). The hair is applied to the metal surface in the form of separate strands of metal. Viewed from the front, the face contracts into a narrow geometric shape flanked on each side by hair. The connection between the shapes defining the hair and the full-face view is created by straight iron wires which run parallel. As in *Bather Playing* (p. 243), plastic volume is evoked by the contrast between full two-dimensional surfaces and void areas. A preliminary drawing, *Head of a Woman,* demonstrates how Picasso conceived this work. He also reverted, in the Chicago sculpture, to his *Wire Constructions* of 1928–29 (pp. 78–79). The interference patterns set up by the wires shift constantly as one walks round the sculpture, endowing it with animation. Its openness is such that it does not obstruct the plaza where it stands. It is not a fixed monument but a focal point which reflects its architectural surroundings and the activity of passers-by.

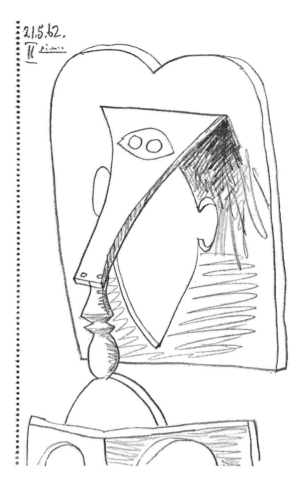

Bust of a Woman · 21 May 1962
Pencil · 16¹/₂ × 10⁵/₈ (42 × 27)

Conclusion

The aim underlying this account and analysis of the work of Pablo Picasso the sculptor has been to incorporate it, as an autonomous constituent of equal status, in his output as a whole. My starting-point has been the fact that Picasso the sculptor long remained almost unknown. In 1918, after his initiative had already generated a vast profusion of Cubist sculpture, he was still unrecognized even by otherwise well-informed contemporaries. Popular ideas of sculpture were still focused on Rodin. Apollinaire himself wrote in 1918: 'The death of Rodin has not prompted the critics of art to speak of M. Medardo Rosso, who is now without any doubt the greatest living sculptor.'[123] Coming from Apollinaire, this reflects a peculiarly unadventurous definition of the concept of sculpture, and one which seems all the more surprising when one reflects that he had reproduced five constructions by Picasso in the first issue of *Soirées de Paris,* which he directed from autumn 1913 onwards. His manifesto *Les Peintres cubistes,* written in the same year, contained the statement: 'The real object, or the object as an optical illusion, is undoubtedly destined to play an increasingly important role.'[124]

The fact that, by producing his 1909 *Head of a Woman* and his constructions, Picasso had opened up entirely new horizons for sculpture, long went unheeded.[125] What certainly contributed to this was that Picasso's early constructions, unlike the Cubist sculptures produced by Lipchitz or Archipenko, were not cast in bronze in the traditional manner. Even later, and until after the Second World War, the dissemination of Picasso's sculpture was left to chance. No proper editions were made of his modelled works, or of the assemblages designed to be cast in bronze.

Vollard was the first to publish four Picasso sculptures before the First World War. Further casts appeared in the early 1930s, for Georges Petit's Paris exhibition of 1932 and the New York exhibition of 1939. In 1932 the periodical *Minotaure* introduced Picasso's sculpture to the public. André Breton devoted an essay to Picasso the sculptor. In the same year, Christian Zervos wrote in the first volume of his *catalogue raisonné* of Picasso's paintings and drawings: 'Bearing in mind what Picasso has to offer art by virtue of the mere existence of his work, we have to recognize that it is changing states of mind in a way which calls for a principle of total renovation in painting – and perhaps even in sculpture – which Picasso has been dangerously stirring up.'[126]

It was Brassaï who produced the photographs for the *Minotaure* issue, and it is to him that we owe the most systematic inventory of Picasso's

sculptural work. Brassaï supplies much valuable information about Picasso's working methods in his *Picasso & Co.*[127] His accounts still provide the only reliable documentary basis for any study of Picasso the sculptor. The presentation of Picasso's sculptures to which Daniel-Henry Kahnweiler wrote a foreword in 1949 was based upon Brassaï's historic photographs. At that time, Kahnweiler could take for granted an almost total ignorance of Picasso's sculptural work: 'In the immense literature about Picasso, his sculpture takes up very little room. It seems to have been considered more or less as a sideline, a hobby. Wrongly, in my view. The obstinate passion which moves Pablo Picasso is incompatible with the tranquil pursuit of a pastime. . . . As for sculpture, its importance cannot be overestimated.'

Today, Picasso's sculptural output stands revealed in all its abundance. Like the rest of his work, it defies reduction to a single concept. No one formula can encompass the unrivalled tactile excitation which emanates from these works. By tactile excitation, I mean Picasso's response to a multiplicity of materials and shapes. Apparently, his incentive for a sculpture may often be no more than a slender clue running through a shape or piece of material. A primary fragment the size of a human hand can become an over-life-size form.

Picasso confronts us with an unparalleled diversity of problems and solutions, materials and techniques. Did he ever essay anything which has not in some way become a trend and manifesto in the course of this century? Very early on, long before anyone else, Picasso thought of producing mechanically-driven sculptures. At Vallauris after the Second World War, he made a drawing of a centaur in the dark, using an electric light. This light-sculpture is preserved on film. Again one asks, is there anything he has left untried?

Many of his ideas have not been put into effect, in some instances because, like most of the designs for monuments in the late 1920s, they were deliberately conceived as utopian sculpture. The year 1927 saw the appearance of drawings for monumental sculptures which Picasso planned for the Croisette in Cannes; in 1928 there were the preliminary sketches for his constructions in iron wire, and at Dinard he produced drawings hich wcombined biomorphic and Constructivist tendencies. Finally, in 1933, he drew the series *An Anatomy* which brought object and anthropomorphic structure together. One glance at the magnificent sketchbook sheets of *An Anatomy* is sufficient to convey the artist's wealth of objective inventions. The pierced figures which admit space, which displace as much of it as they allow to penetrate, provide models for one of the most fertile sculptural themes of the present century. We have only to look at Henry Moore's sculptures to see what sort of impetus sculpture was to derive from this motif. What applies to form applies in equal measure to the materials which Picasso has employed. His combinative mode of vision enables him to use a multiplicity of objects and structures. Either he integrates them in a modelled work or he allows them (as in *Head of a Bull*) to impinge with such force that a new structure is born of the resulting explosion. Anyone who drew up a purely abstract list of these themes, techniques and materials might conclude that Picasso had seized at random upon all available media of expression. His urge to express himself was so strong that it exploded all the categories of sculpture.[128] One nonetheless discovers, again and again, the existence of parallels and recurrences of problem and theme: the laws of Picasso's creative process.

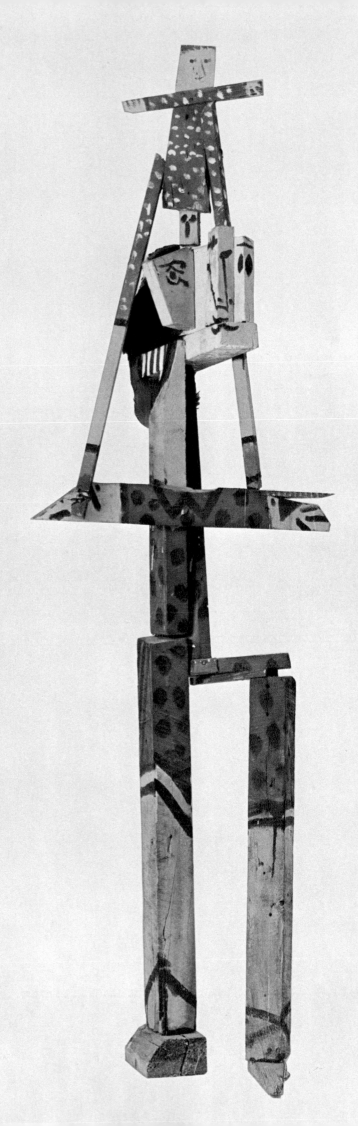

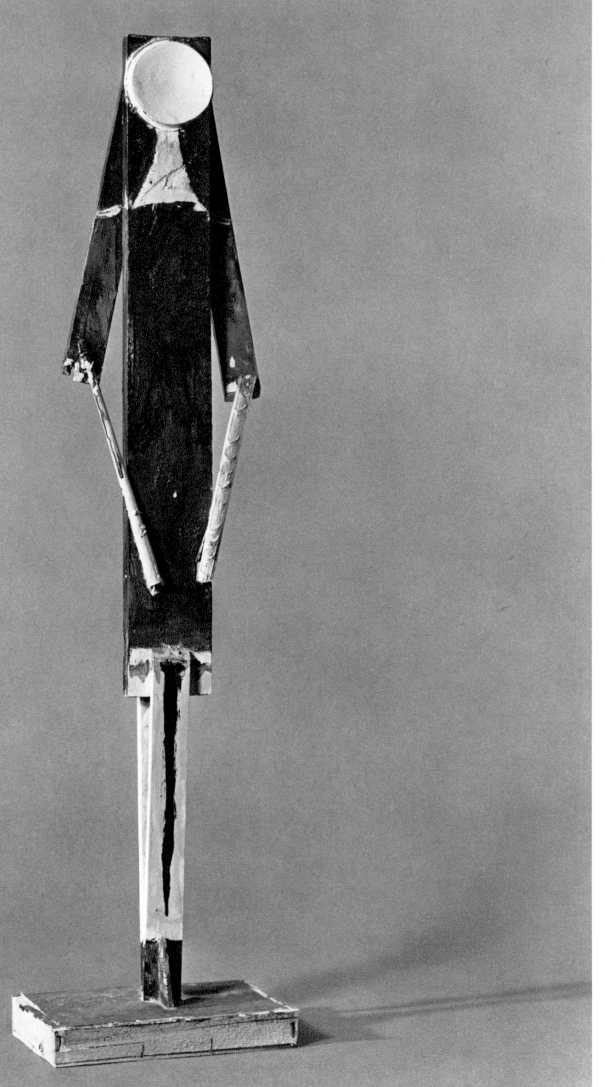

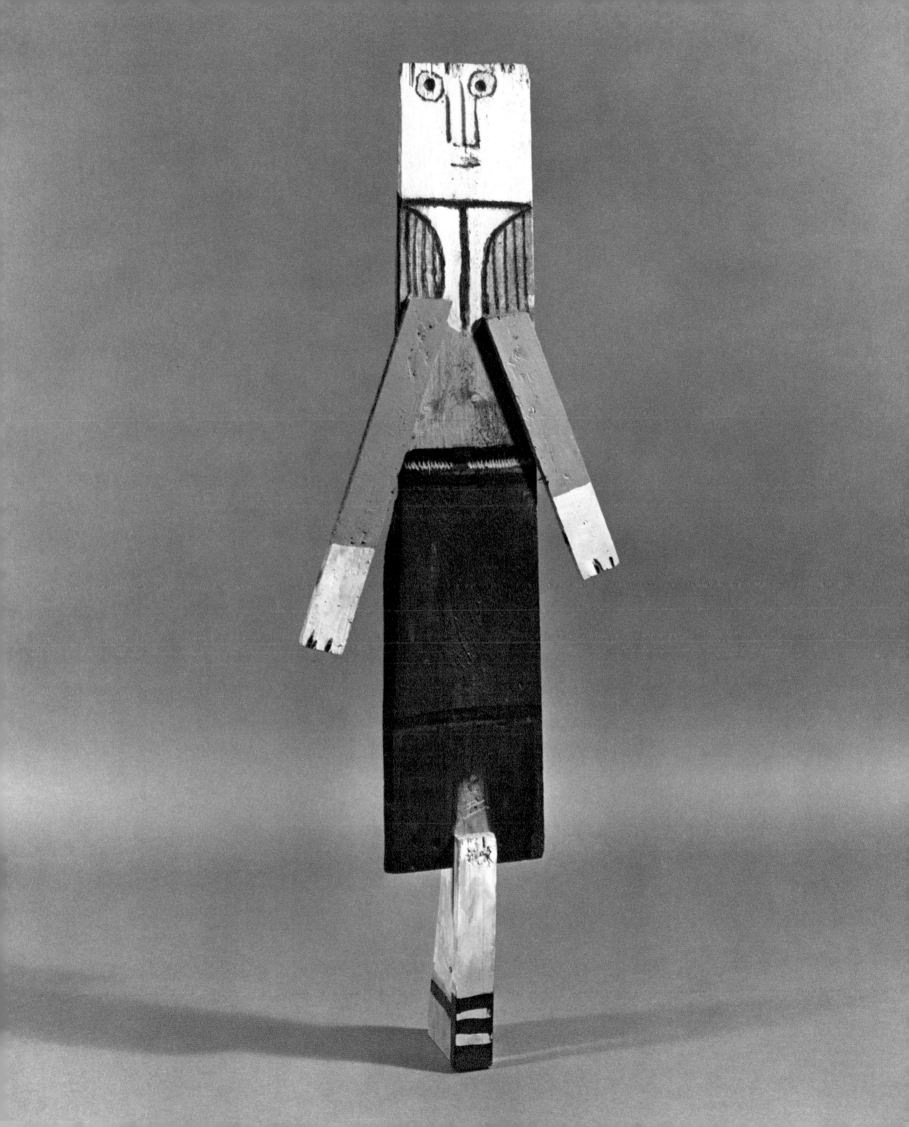

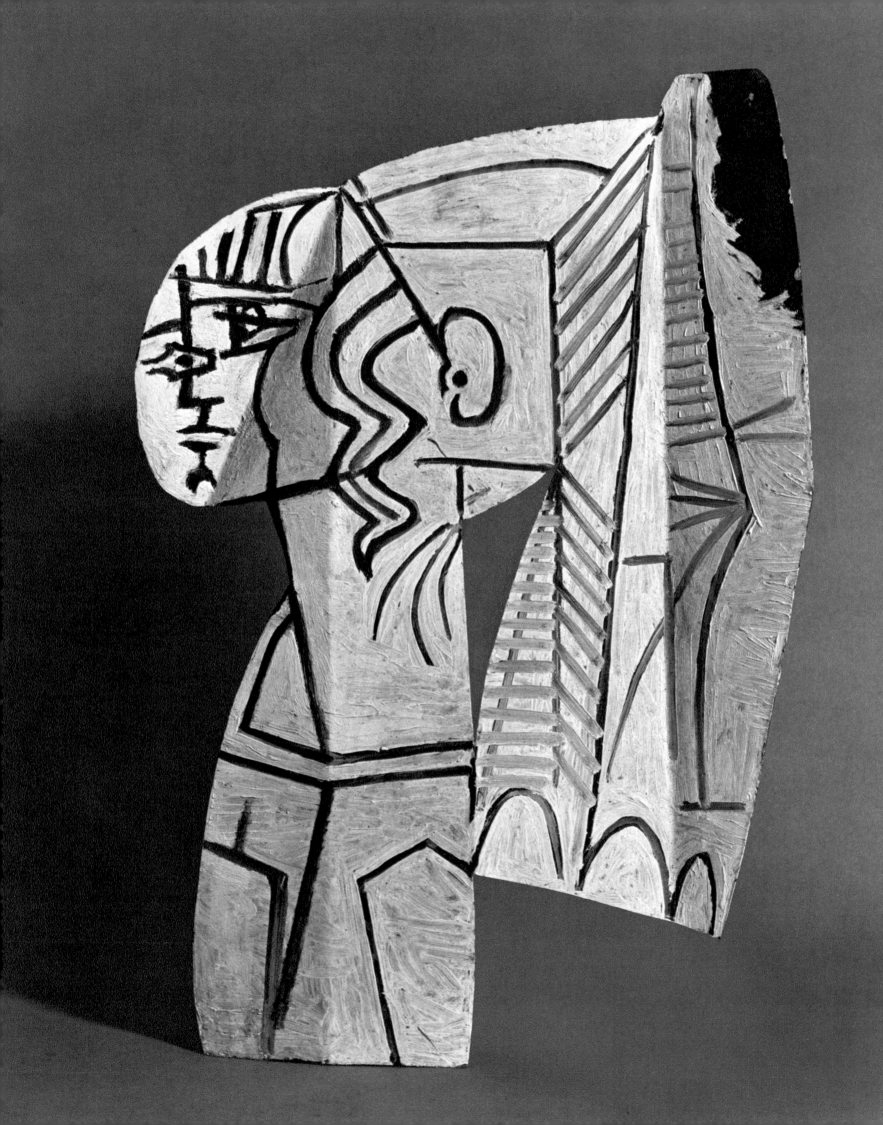

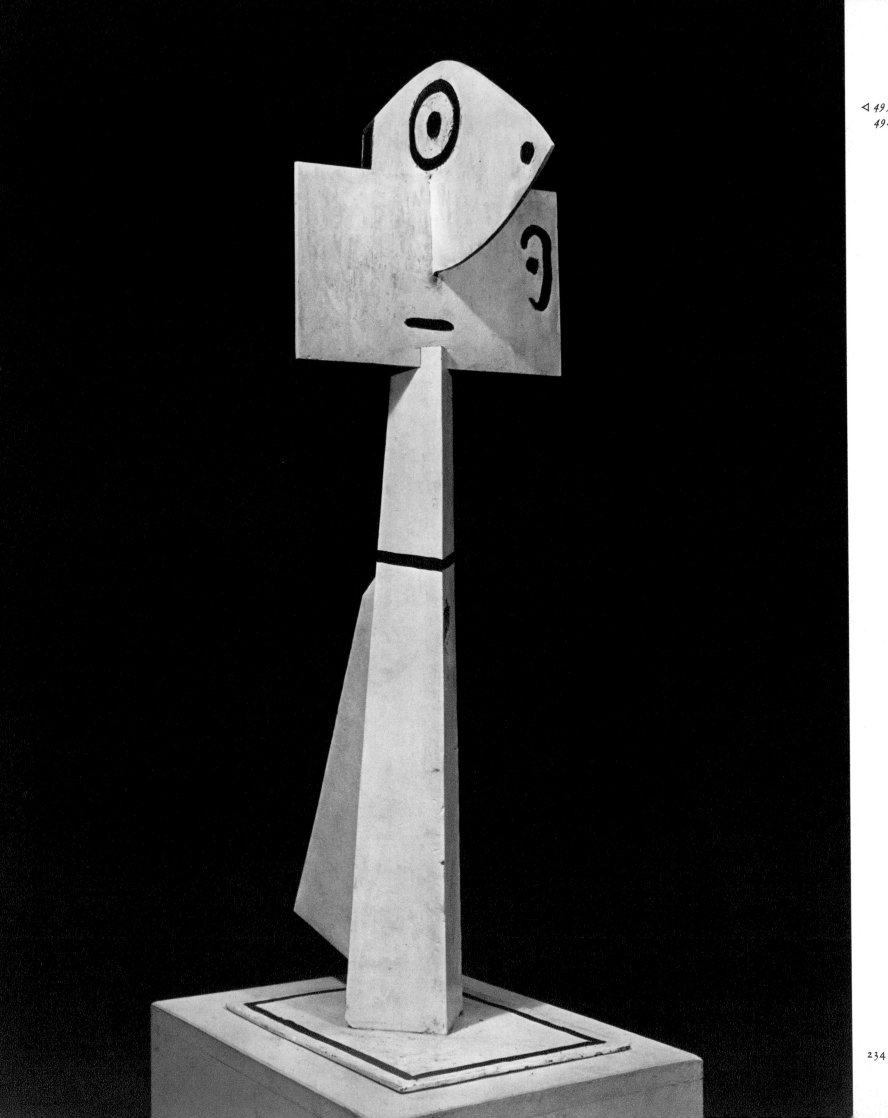

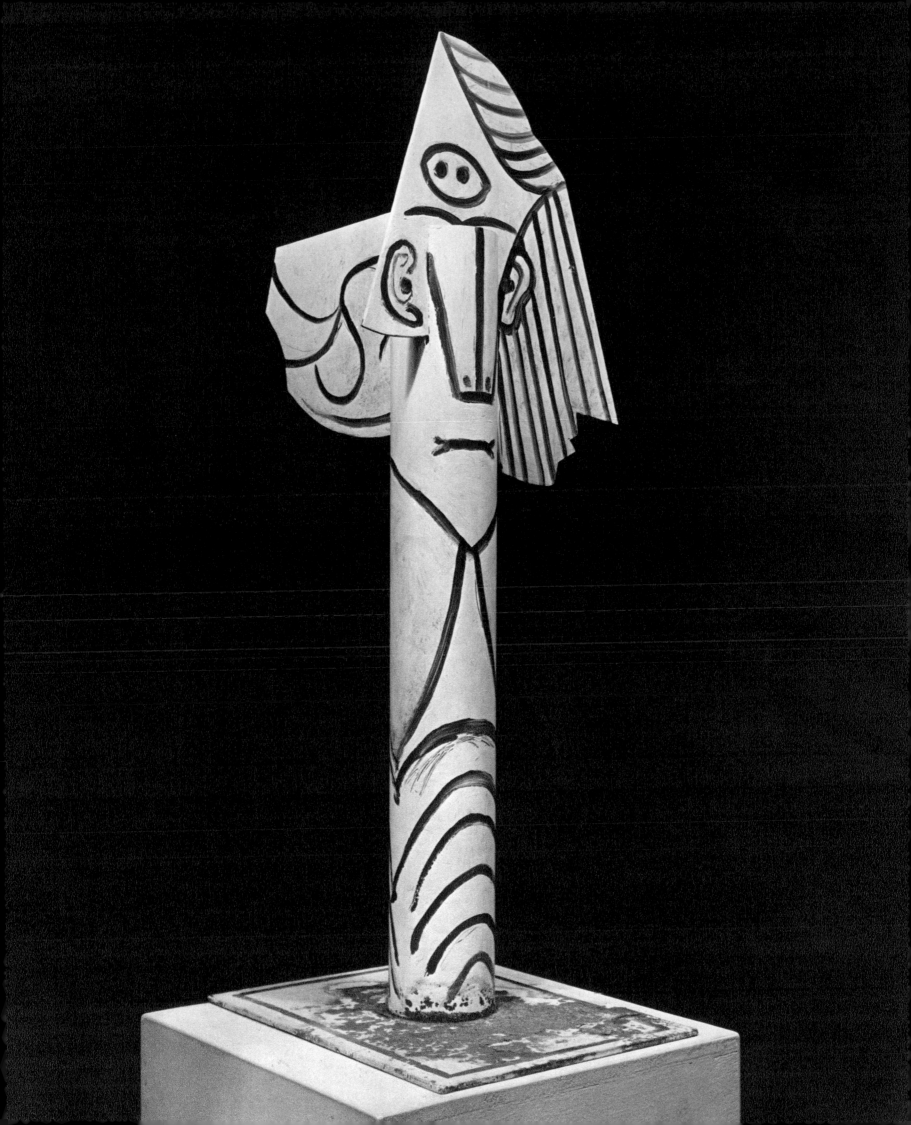

503-508 ▷

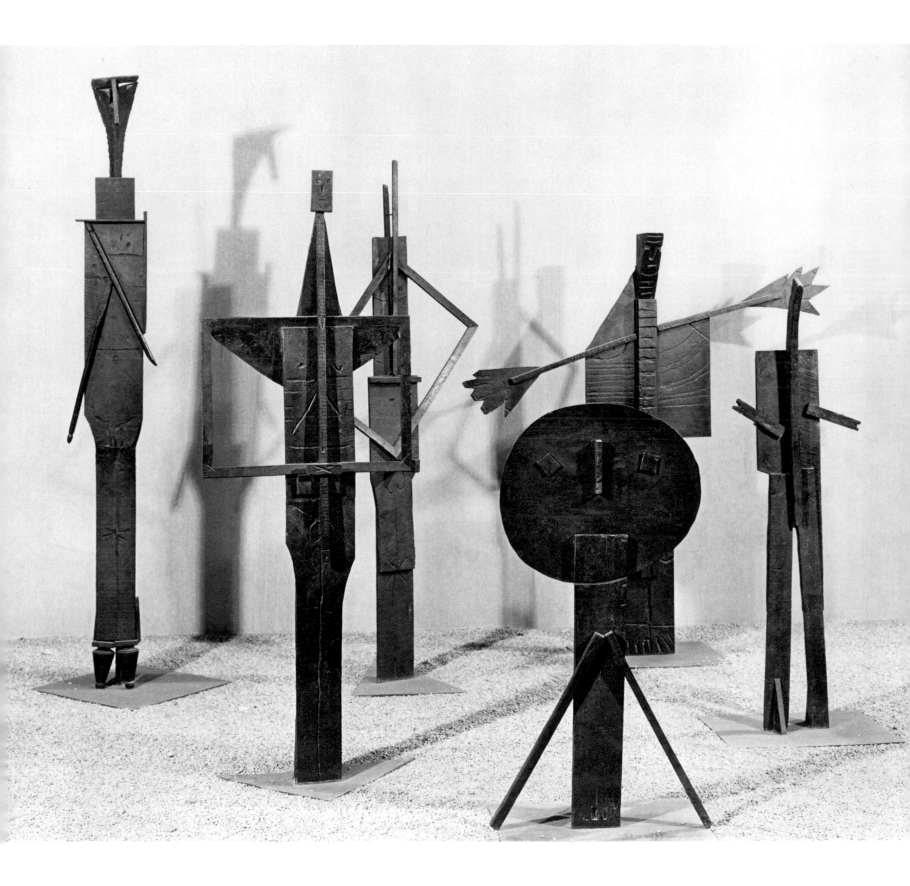

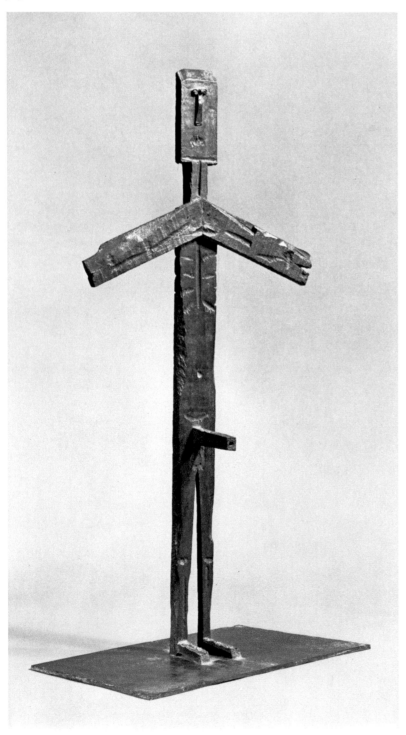

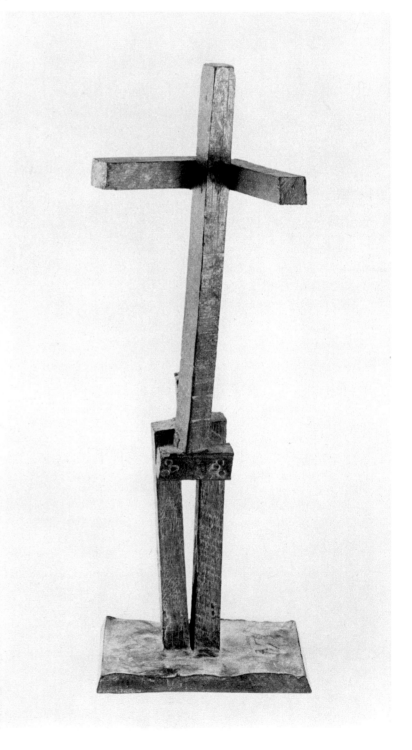

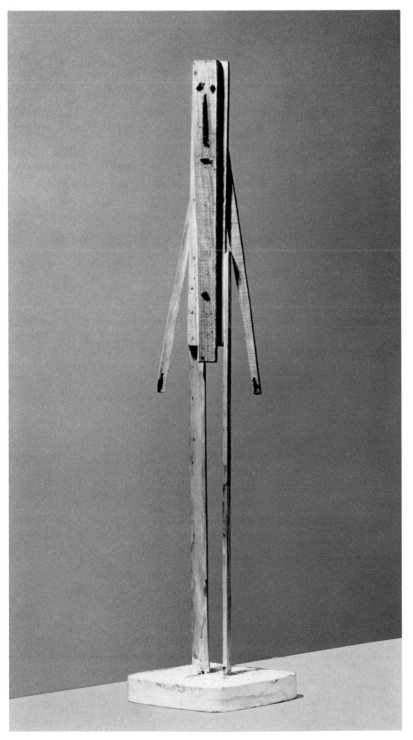

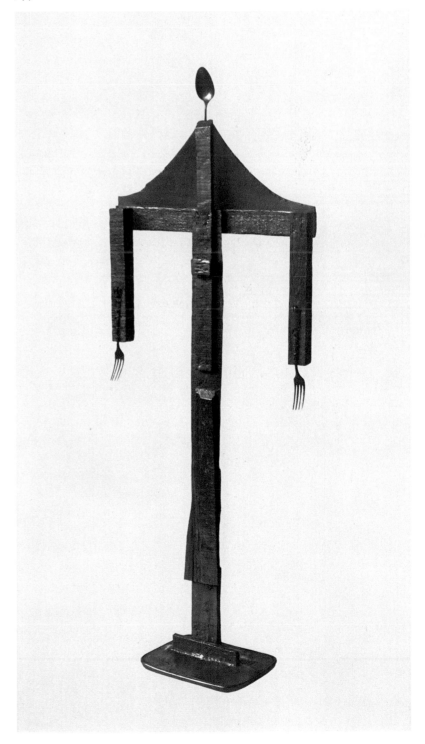

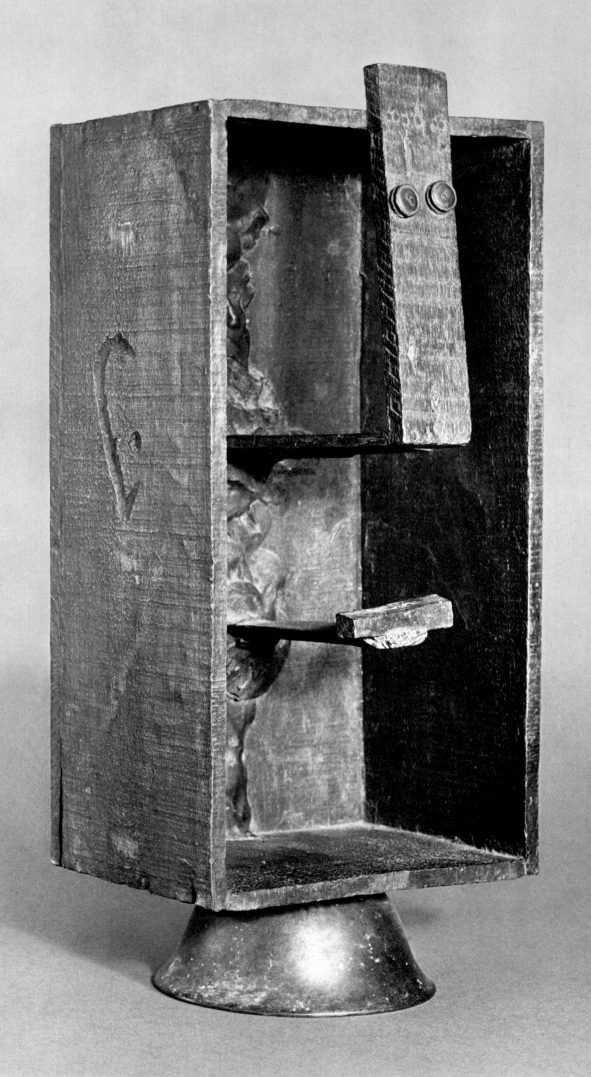

537 ▷

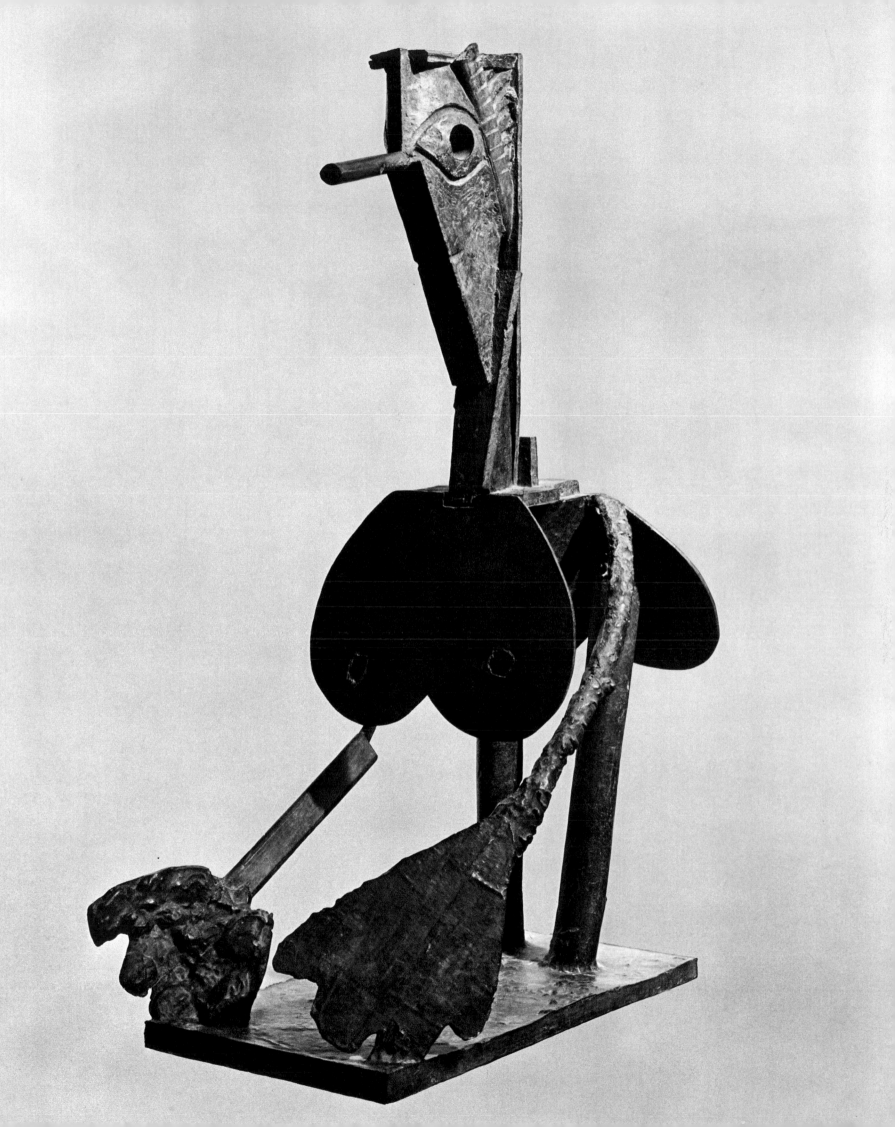

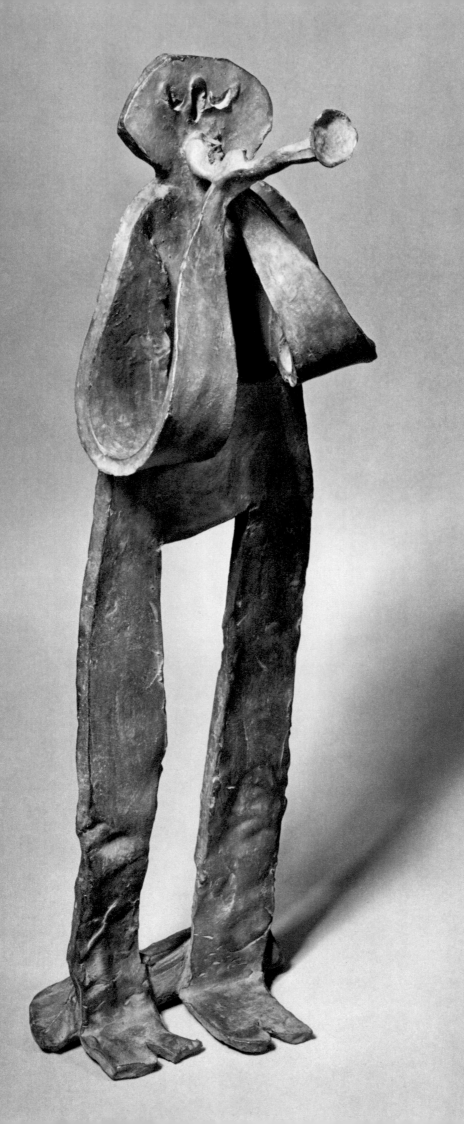

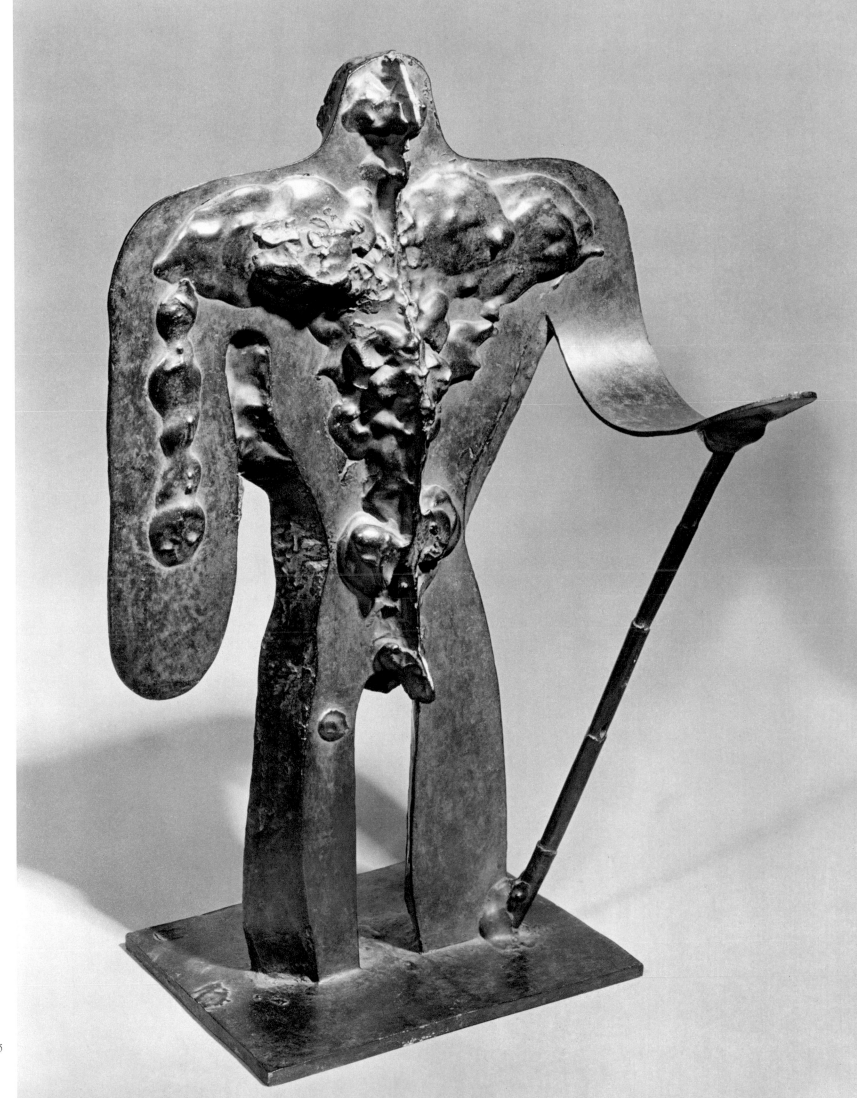

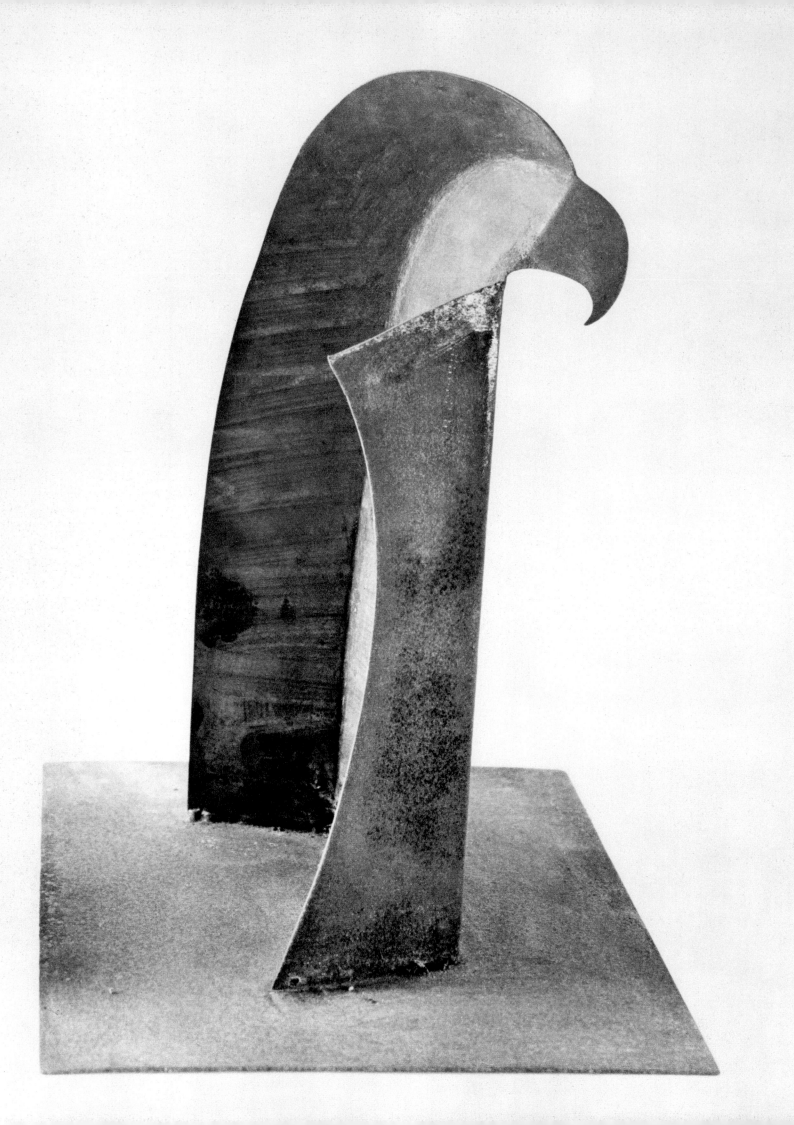

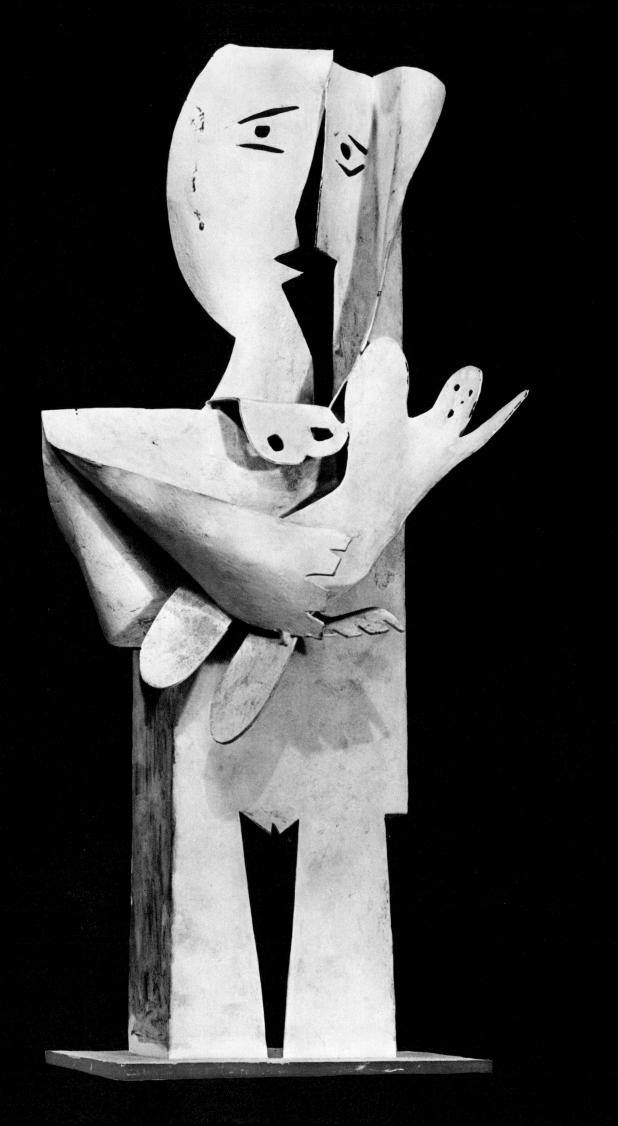

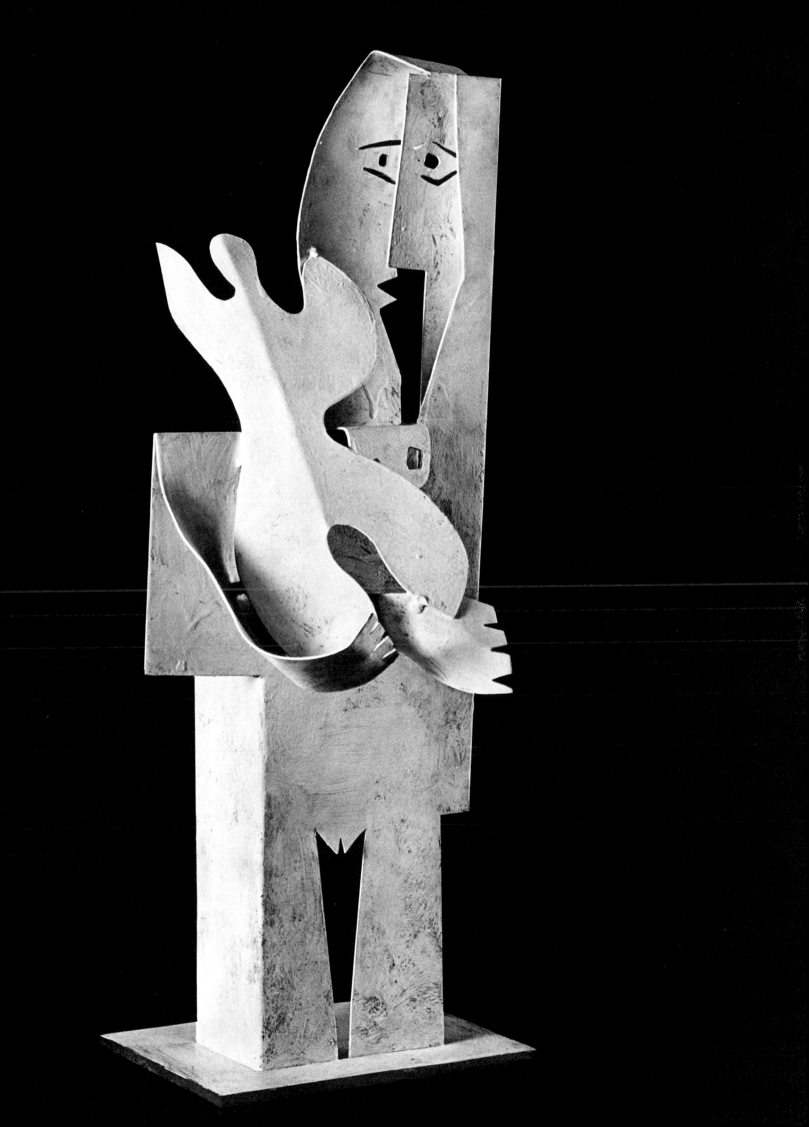

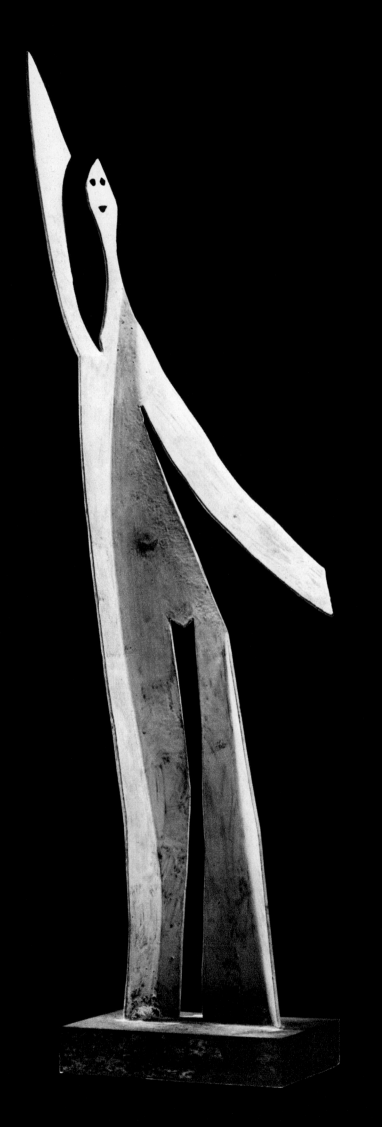

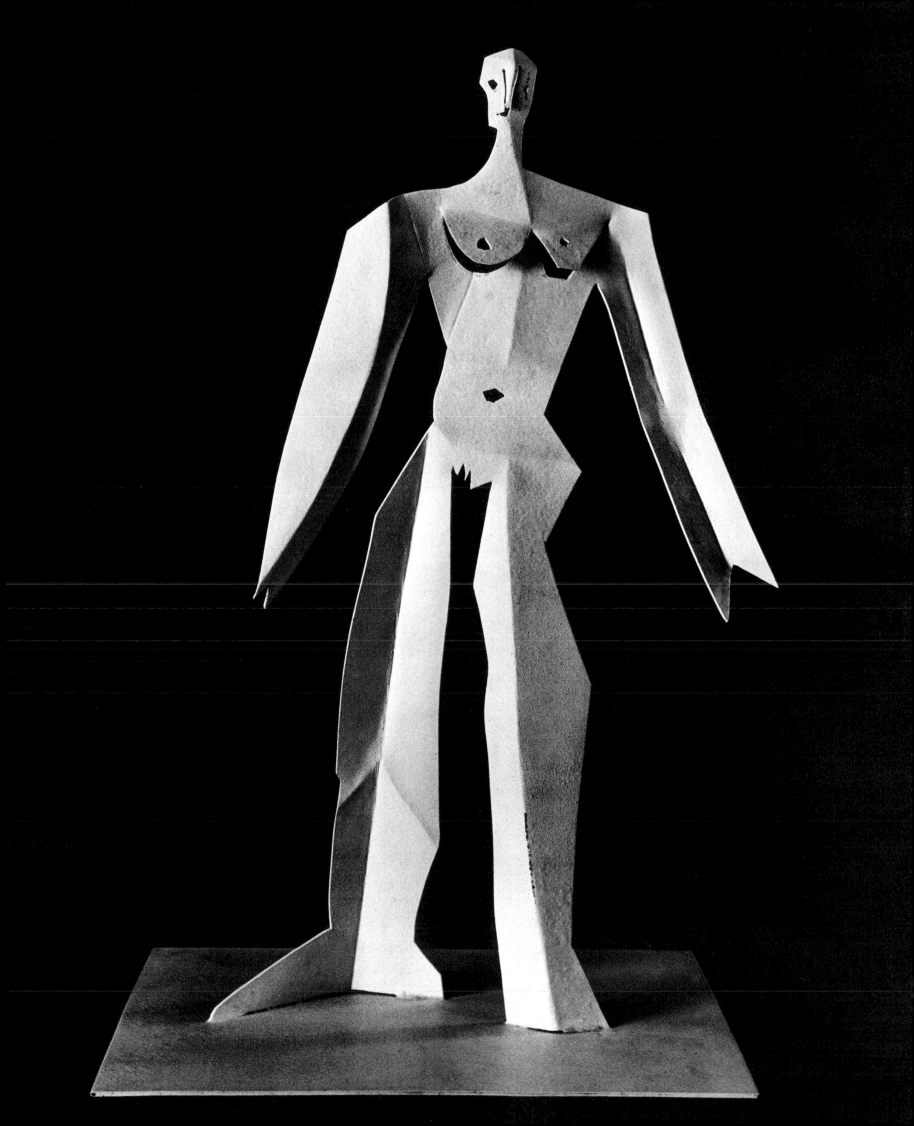

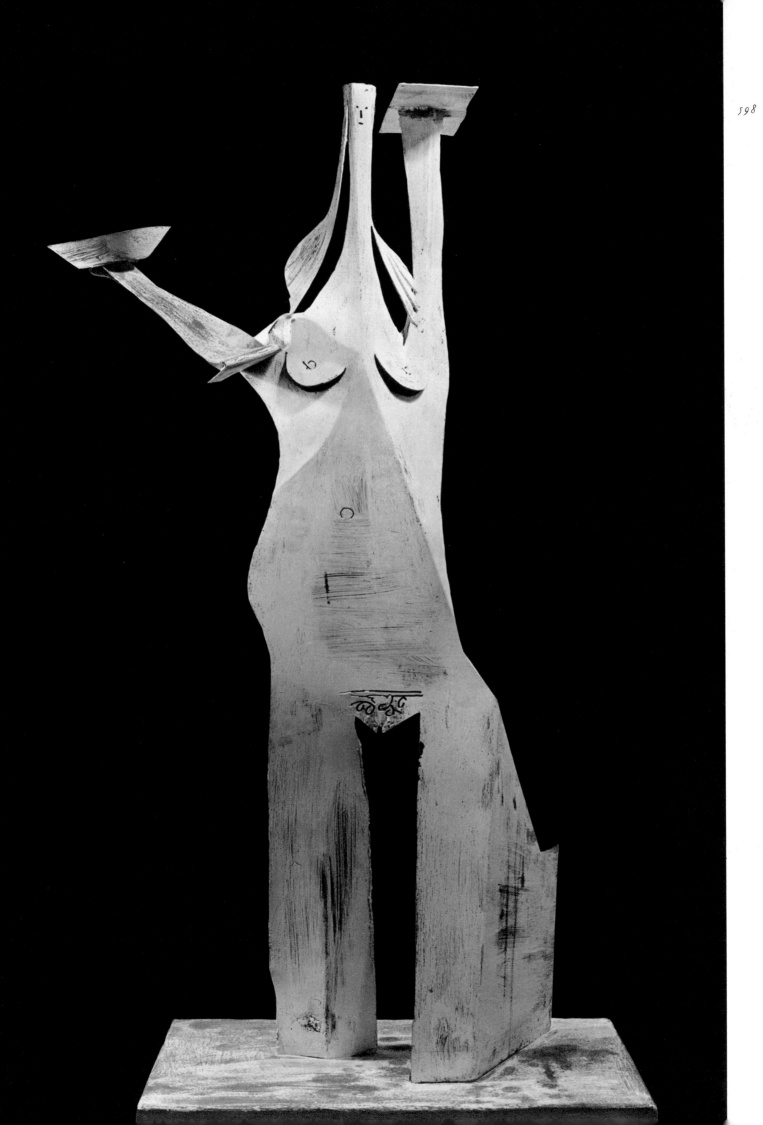

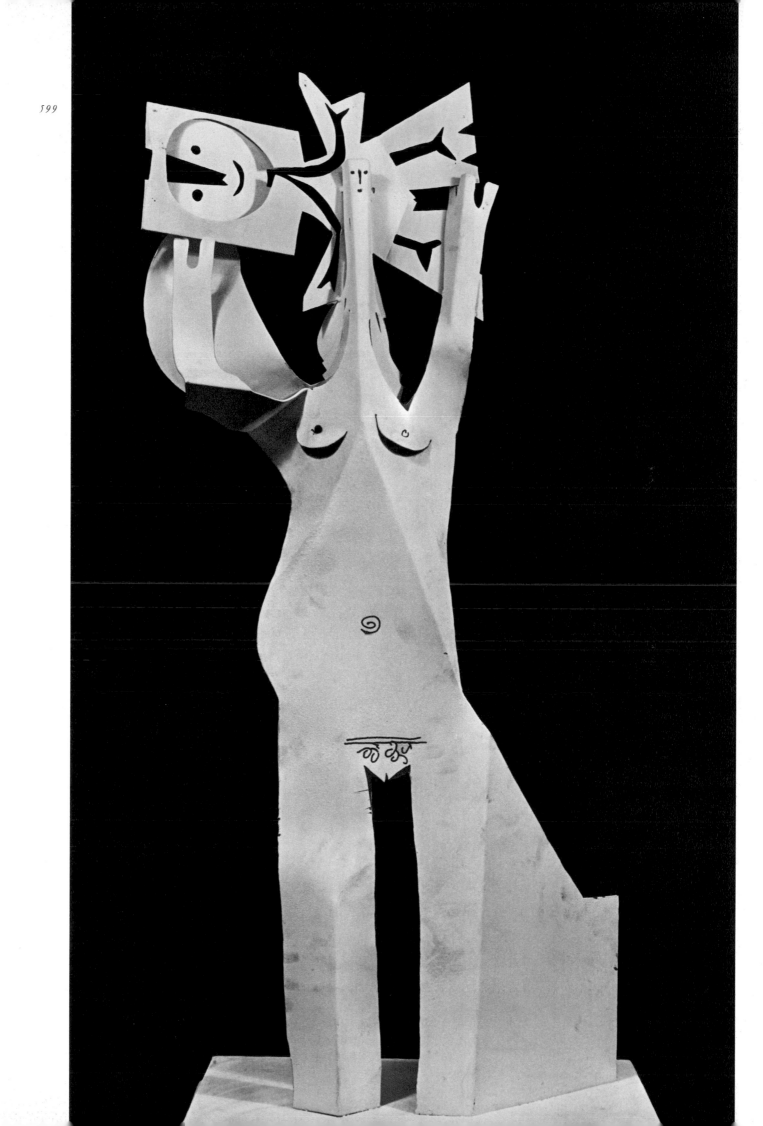

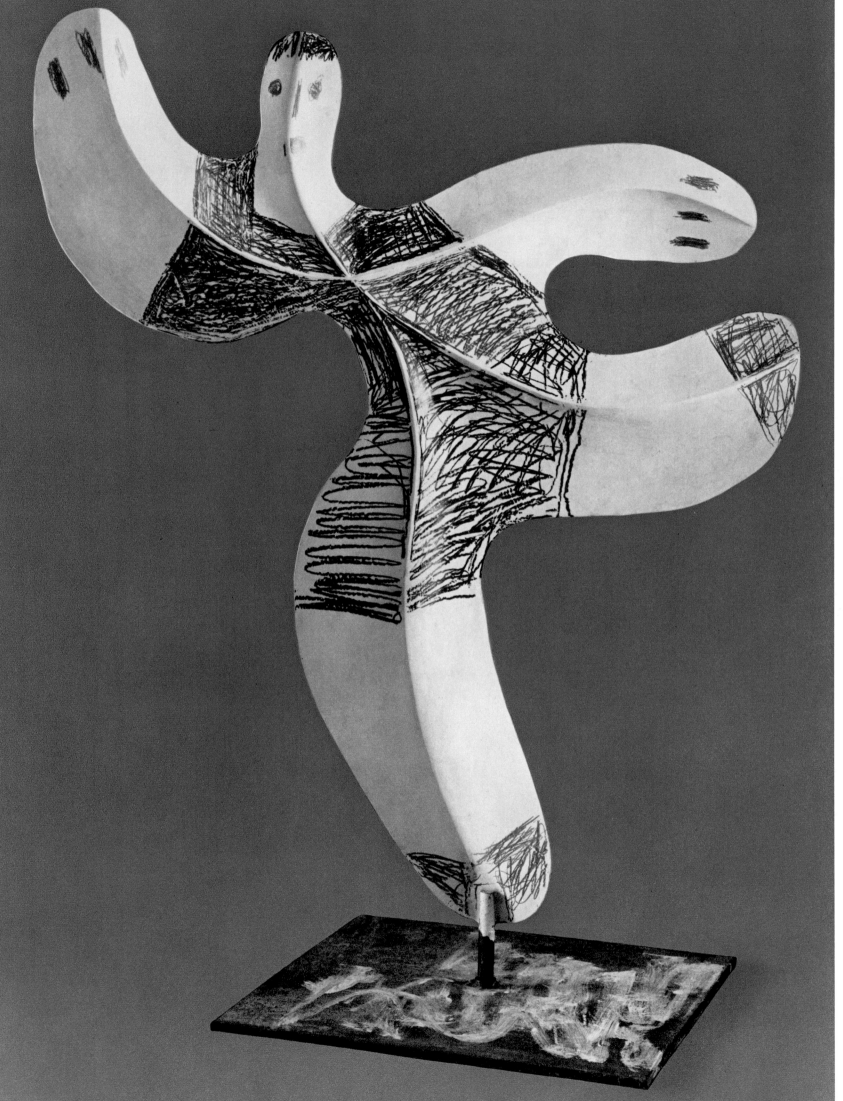

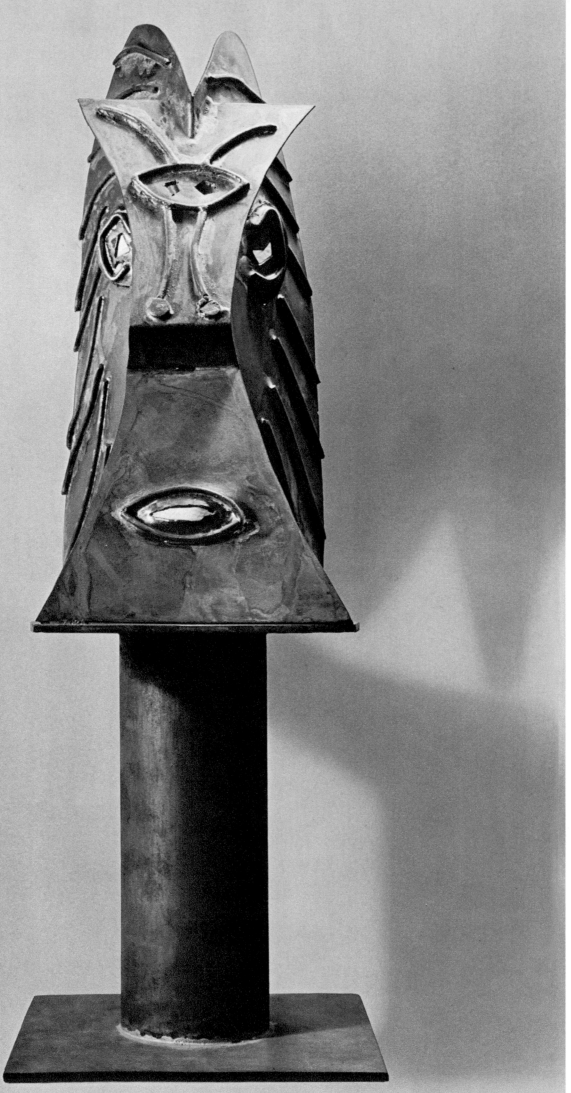

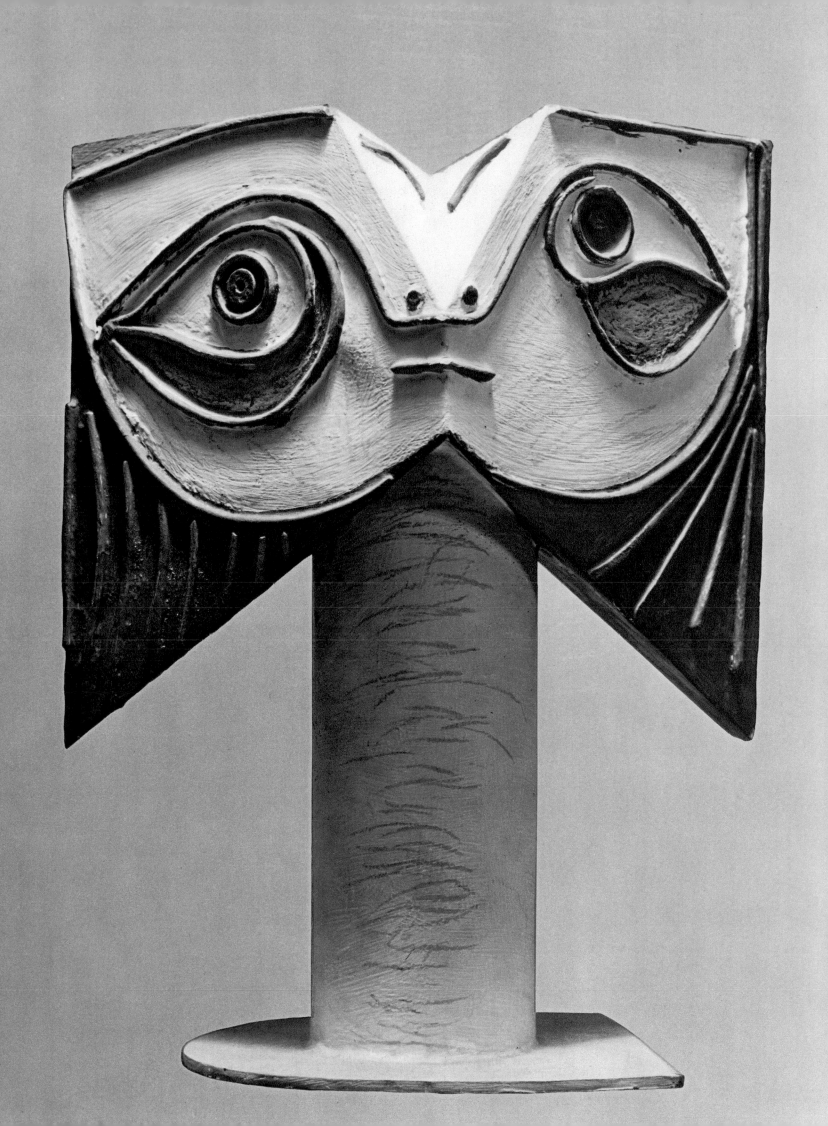

C 5 C 6

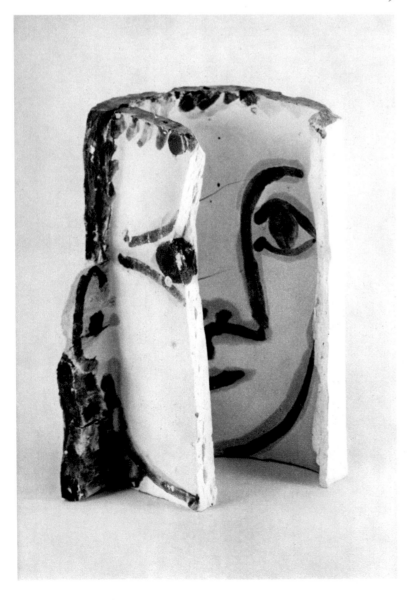

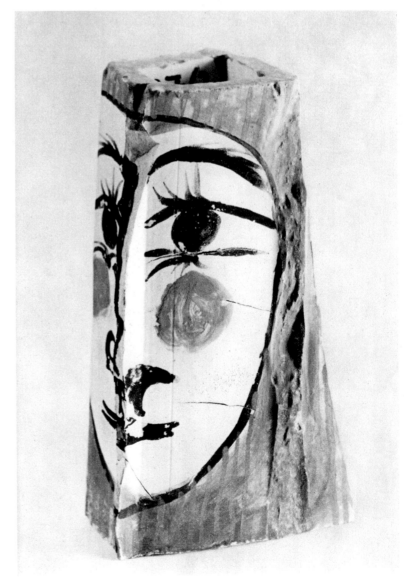

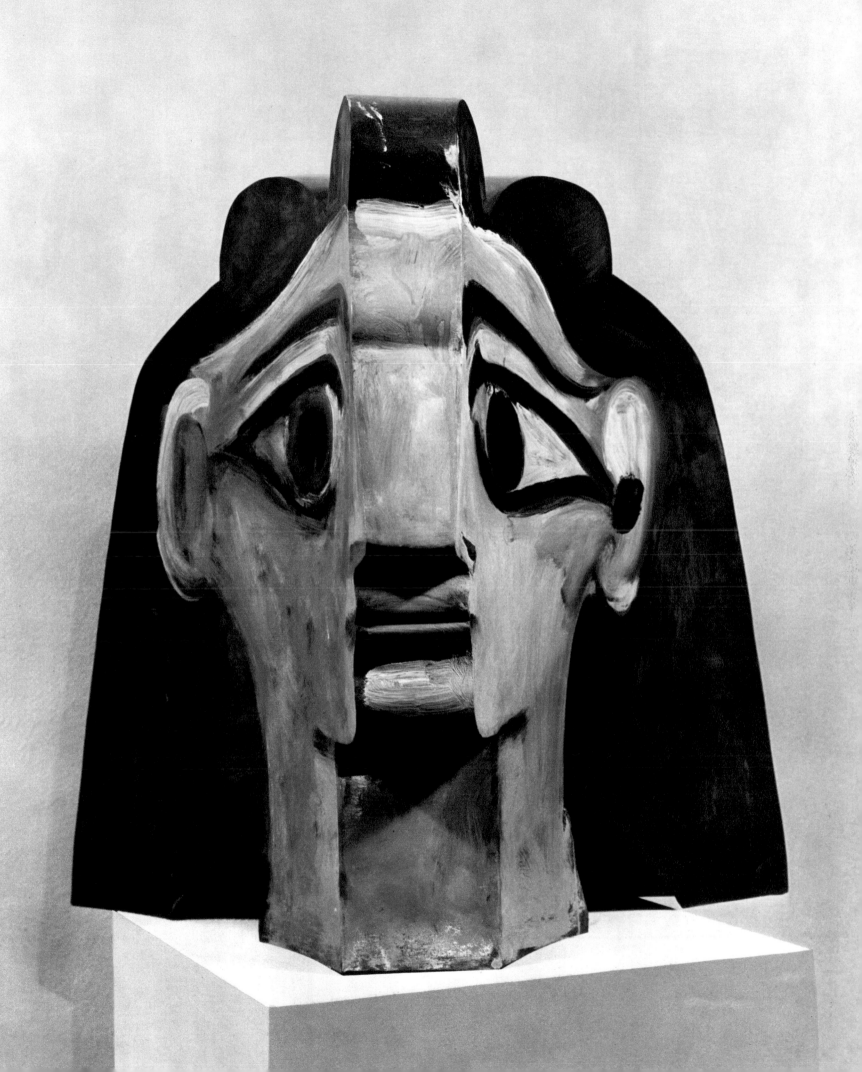

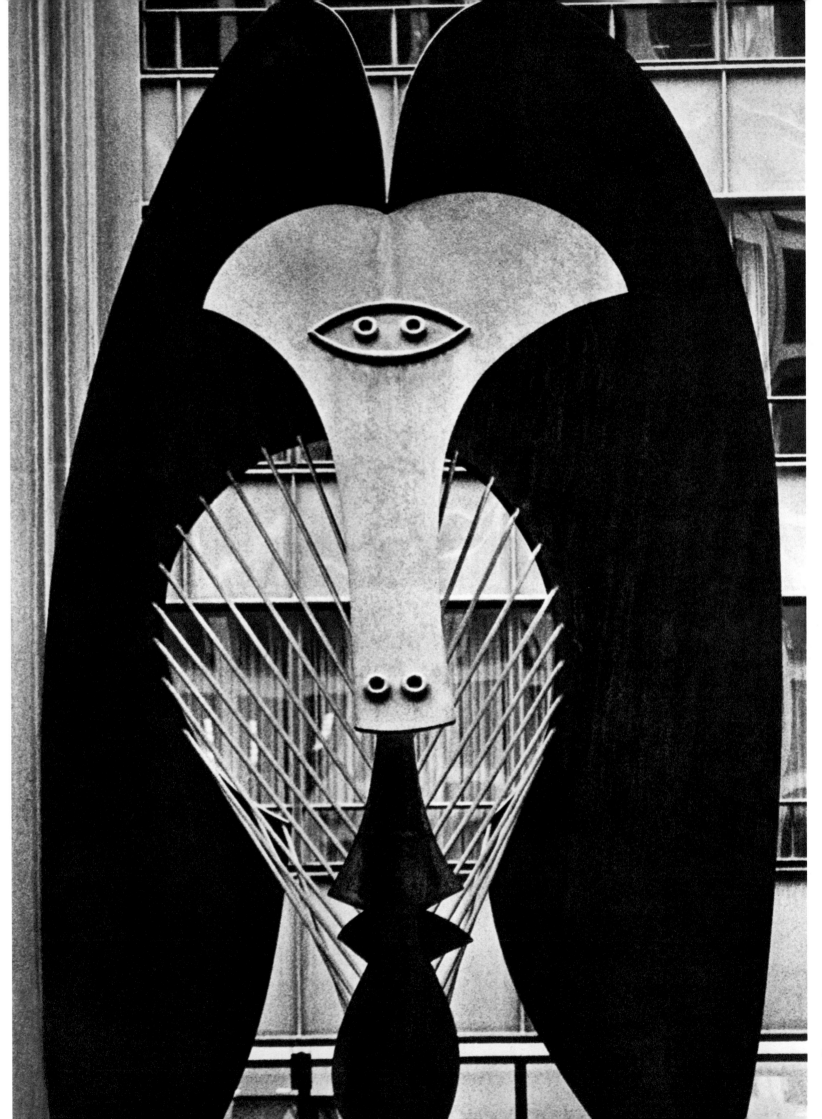

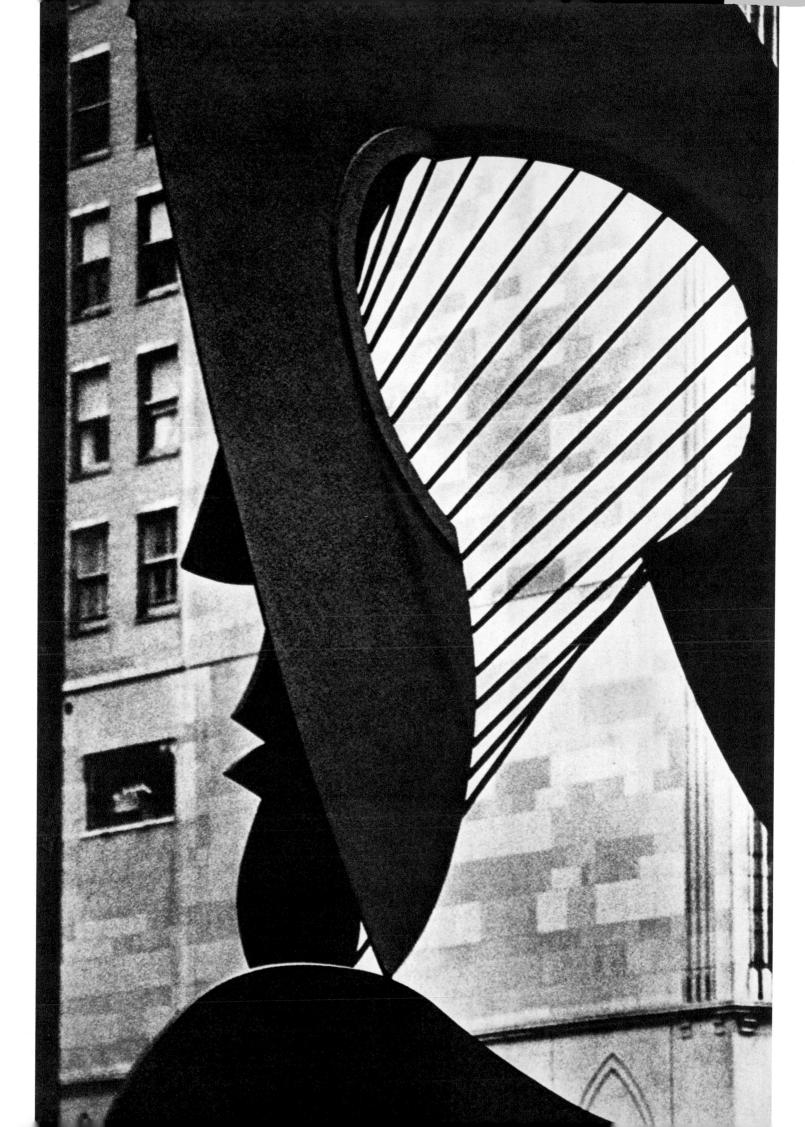

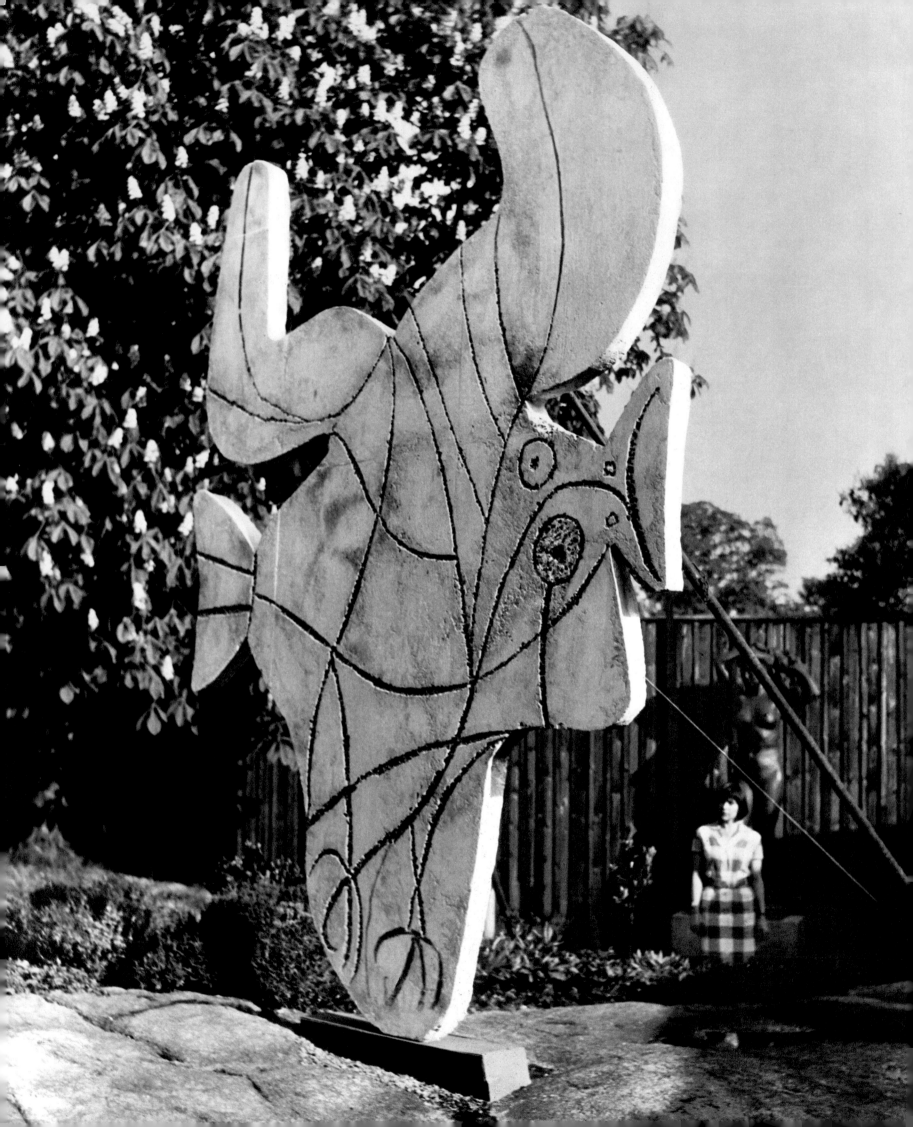

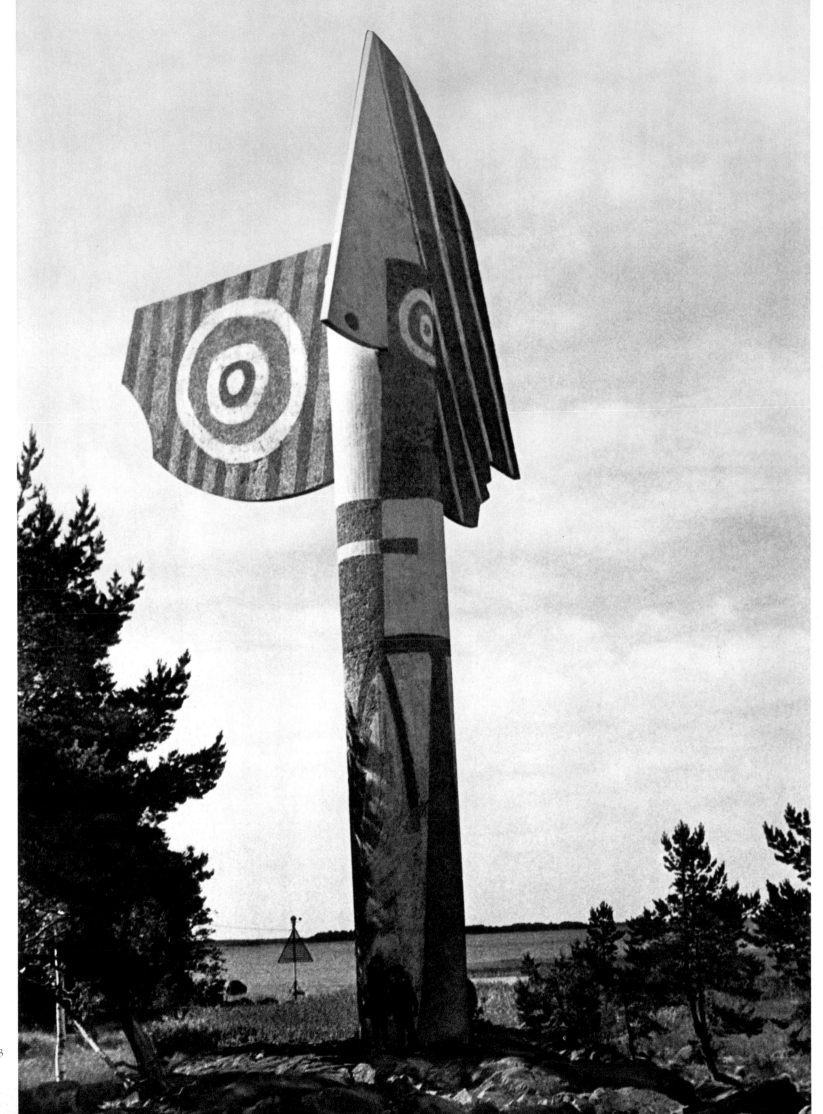

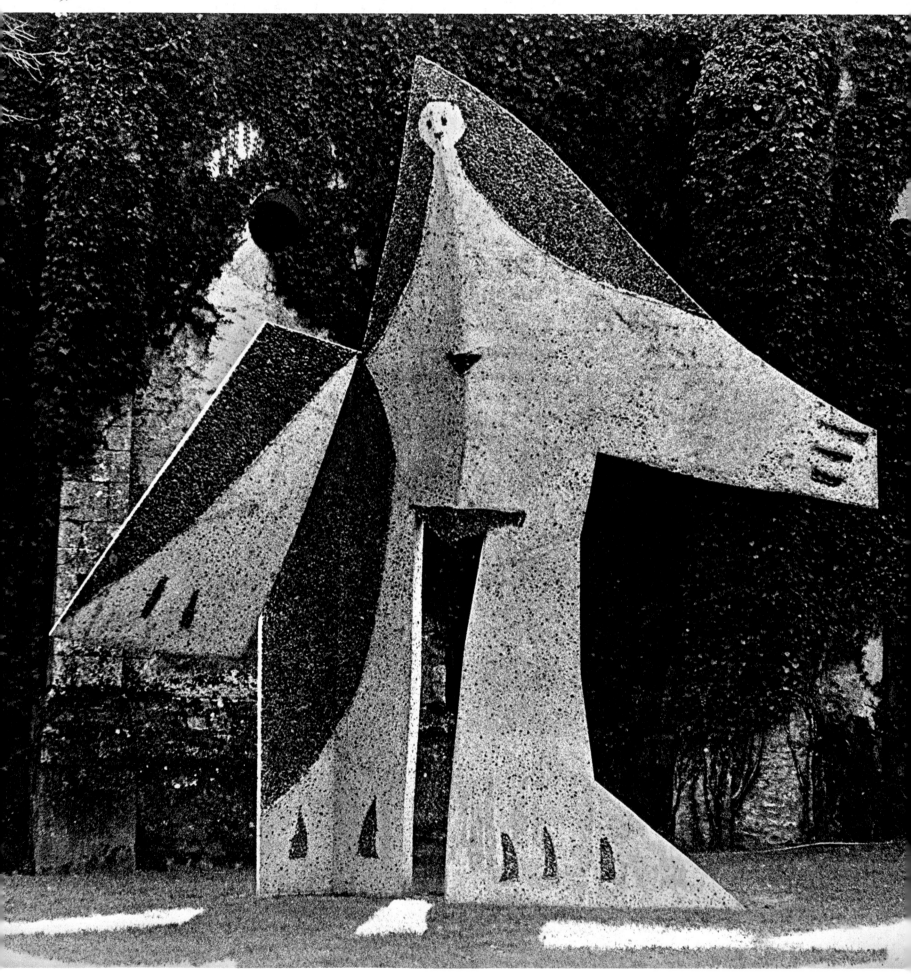

Notes on the text

The initial letter Z refers to Christian Zervos's *catalogue raisonné*; see Bibliography.

1 Although Picasso did not deny this anecdote in conversation, he qualified its importance by stressing its fortuitous nature.

2 Further information is supplied by Alejandro Cirici-Pellicer: *Picasso antes de Picasso,* Barcelona 1946; French edition, *Picasso avant Picasso,* Geneva 1960. In conversation with me, Picasso pointed out some inaccuracies in this account. He denies, for example, that he visited Majorca in 1901 to experiment with ceramics.

3 Cirici-Pellicer, p. 155.

4 The Madrid seated figures, mostly with hats, have a social context; they are engaged in actions.

5 There was no sculpture in the exhibition 'Picasso' which was held by Vollard in Paris from 25 June to 14 July 1901.

6 The resemblance may best be verified in *Figure of a Woman with a Fringe* (Barcelona, 1902, Z. I, 119); Picasso here captures the seated pose in profile, while in *Streetwalkers in a Bar* (Barcelona, 1902, Z. I, 132) he presents two rear views which correspond perfectly with the back-modelling of *Seated Woman*. Like the latter, the two figures are pinched in at the waist and have arms which coincide with the silhouette. Also as in the sculpture, the waists are enlivened on either side by concave, plastically perceptible zones. Another picture (*Seated Woman with Fichu,* Barcelona, 1912, Z. I, 133) presents a further variant of this sculpturally conceived corporeality. Here, as in the two seated figures, the muscular body is discernible beneath the dress, rendered so by the relationship between light and dark areas within the painting's overall blue monochromy. An even more systematic exercise, patently concerned with sculptural problems alone, was not

catalogued by Zervos. This turned up at the Picasso exhibition in Paris in 1955 (Musée des Arts Décoratifs, Catalogue No. 5, with illustration).

7 Reference might be made to the *Laocoon,* to Schlüter's *Dying Warrior* and, nearer in time, to Rodin's *Head of Pain* and *The Prodigal Son.* This is a basic expressive formula which we rediscover in a man's head by Bourdelle (1910), in González's shouting mask *Montserrat* (1936), and in Giacometti's *Head on a Pole* (1947).

8 Z. I, 384.

9 Rodin, too, supplies a forerunner in his *Man with Broken Nose* (1864). Bourdelle's *Beethoven* is also in the tradition of these portrayals, in which expressive quality is heightened by deformation.

10 1901, Z. VI, 308.

11 The drawing Z. VI, 305, does not constitute an exception, while drawing Z. VI, 597, was actually taken from the mask in question.

12 Penrose, *Picasso: Life and Work,* p. 131.

13 Z. I, 225.

14 The pastel *Le roi Dagobert,* a variant of which is preserved in Moscow's Pushkin Museum, also falls into this category.

15 Here, too, in the book-plate, we are confronted by a transformation scene: Apollinaire turns into a king – an ironic, opulent monarch rendered alien by the shape of his imperial crown. The ironical aspect of this scene of royal revelry is further emphasized by a quotation from the Blue Period: the festive board is laid with the same sparse utensils and culinary offerings that are found in the etching *The Frugal Repast* (1904, Geiser 2). Picasso merely changes the personnel.

16 In the meantime, a change has come over the portrayal of the king as found in *Le roi Dagobert* – solemn, tragic, Lear-like – and in the book-plate for Apollinaire – parodistic and wryly humorous about his own wretched circumstances.

17 Picasso inserts this cap in many pictures as a sort of rhymed response to the lozenges of the jester's costume. He is fascinated by the formal possibilities inherent in this geometrical pattern, which might be regarded as an early objective geometricization legitimized by the object itself. Its prime function is to accentuate and act as a *contrapposto* to a freer and more animated mode of composition.

18 In type, the head itself refers us to several works by Picasso, notably *Bust of a Man* (Geiser 5), a dry-point etching made in February 1905.

19 This type of head, posture and hairstyle may be compared with the etching *Head of a Woman* (Geiser 3), done in January 1905.

20 But this applies only to a technique which Rodin also employed in his *Balzac* under the influence of Rosso, and later, in 1908, probably under the influence of Carrière's *sfumato* painting, in *Mother and her Dying Daughter.*

21 It would be easier to draw a parallel with Brancusi than with Medardo Rosso, and a certain affinity exists – if one compares the two profile views – between *Fernande* and Degas's *Little Ballerina.* In both cases, the head is fashioned into a similarly compact mass.

22 This motif does not occur in Gauguin, who exerted a great influence on Picasso during the development of this phase. The first example in Picasso to be listed by Zervos (Z. I, 259) is dated by him 1905, Paris, before the trip to Holland. We are also familiar with

earlier instances of the motif, though in an entirely different conception which has none of the melodious quality evident in the later eurhythmical version. We find it in *Harlequin's Family* (1905, Paris, Z. I, 298) and in an etching (1905, Geiser 15). Daix and Boudaille demonstrate the motif which leads to the sculpture in a group of works which came into being after the visit to Holland, or in autumn 1905 (Daix-Boudaille, XIII, 1). I would suggest the Salon d'Automne of the previous year as the *terminus post quem*.

23 'Salon d'Automne – rétrospective Ingres' No. 1, p. 185. The picture was acquired for the Louvre from the collection of Prince Louis-Amédée de Broglie in 1911.

24 Maurice Denis gave an account of the exhibition in *L'Ermitage* (15 November 1905) and described Ingres as 'the newly discovered master'.

25 Matisse adopts from Ingres certain motifs which he combines with the group of dancing figures already used in his own *Luxe, calme et volupté*.

26 *The Harem* (Z. I, 321).

27 Although it is precisely in the case of Ingres's influence that such literal borrowings do exist; his work made too strong an impact. Direct influence is most readily discernible in *The Harem*. One of the central figures, the woman with her hands above her head, also occurs in Matisse's *Joie de vivre,* which was likewise begun in November 1905, after an encounter with *The Turkish Bath*.

28 Picasso admired the ceramic work of his fellow-countryman Paco Durio, and owned two of Durio's anthropomorphic vases, *The Mormons*. Another of Durio's works, a *jardinière,* was relinquished by Kahnweiler to Picasso at the latter's request. Picasso produced the sculpture *Woman Arranging her Hair* in Durio's studio as a ceramic.

29 Z. I, 336, where it is dated 1905; Daix-Boudaille, XVI, 6 (not in Z.).

30 Z. I, 380.

31 The Gosol period is a period of projected or 'potential' sculpture, and thus comparable with the works of the latter half of the 1920s, during which time Picasso was experimenting with the treatment of volume in painting and drawing. A sketch from *Carnet catalan* proves that Picasso was thinking of sculpture during his stay in Gosol.

32 This unusual, narrow physiognomical type first occurs in *Reclining Nude* (Z. I, 317) and *Woman with Headscarf* (Z. I, 319, listed in Daix-Boudaille, XV, 45, as *Fernande with Headscarf*). The same motif underlies *Woman Carrying Bread* (Z. VI, 735). The relief may also have been influenced by Gauguin's *Head of Tahitian Woman* (Wildenstein, 448), which was then in Paco Durio's possession. Picasso was also in a position to see *Portrait of the Artist's Mother* (Staatsgalerie, Stuttgart) and *Head of Breton Woman* (Wildenstein, 526) at Durio's studio, just as he had previously been able to study *Horsemen on Beach, I and II* (Wildenstein, 619 and 620) at Vollard's. The two portraits from Durio's collection seem most closely to combine with the studies pursued by Picasso at Gosol to form the new pictorial type which is discernible in *Portrait of Gertrude Stein* and in this wooden relief. The woodcut *Bust of a Woman* (Geiser, 212) also comes within the ambit of this relief and of Picasso's dialogue with Gauguin's iconography and technique. This captures the motif in reverse.

33 Z. I, 384.

34 Later, in the second phase of analytical Cubism, Picasso reverted to a stippling technique, this time that of the Neo-Impressionists; and here again the screen effect was contrasted with flat overall colour. This shows that Picasso used Neo-Impressionist dissection as an aid to contrast, not a technique.

35 Of all the many hundreds of works catalogued by Zervos between 1905 and 1907, only two or three are copies of African sculpture. Its influence is no more to be read literally than is the influence of El Greco, Egyptian art or Iberian bronzes. This seems surprising but is logical when one examines the question of influence within this particular period. Earlier influences were easier to isolate because, in their case, formal borrowings usually coincided with points of iconographic interest: this applies to the influences identified by Phoebe Pool in her account of the early period (which I consider to have ended in autumn 1905). There were literary and ideological factors, too, in the fascination which Daumier, Steinlen, Nonell and Toulouse-Lautrec held for Picasso: he took over a climate rather than a pure form. The situation changed after 1905, when Picasso increasingly withdrew from his concern with reality and substituted an interest in form for the object itself.

36 It is conceivable that, at a stage when superficial observers had equated knowledge of African sculpture with direct adoption, Picasso deliberately blurred this issue. Kahnweiler's denial of such influence, too, contains a note of polemical opposition to the idea that African sculpture represented a sort of recipe for Cubism. In the realm of painting, the quest for these influences assumes a different character. It is closely allied with a conception of space which played quite as important a role in the genesis of *Les Demoiselles d'Avignon* as did the influence of Cézanne. The latter's constructed, finite space came into conjunction with Picasso's own endeavours: Picasso's aim was to dispose objects in a shallow and constricted space in such a way that the material quality of space itself was rendered perceptible through the deformation of the objects. In a certain sense, these are problems of relief: one has to visualize objects sandwiched tightly between a shallow spatial backcloth and transparent sheets of glass. None of Picasso's contemporary sculptures, with the possible exception of this small relief, concerns itself with such problems. Here, he renders absolute the destruction of form; he presents the destruction without legitimizing it by pictorial structure or geometrical interpretation: the 1909 *Head of a Woman* represents the culmination of this activity, though it is preceded by a few works which transcend Picasso's attempts to stabilize the human figure as a compact mass (a problem inherent in a whole series of works begun at Gosol).

37 Robert Goldwater, *Primitivism in Modern Art,* 1938, revised edn, New York 1967. The chapter 'Intellectual Primitivism' is devoted to the relationship between Picasso and exotic art.

38 Jean Laude, *La Peinture française (1905–1914) et l'art nègre,* Paris 1968, pl. 9.

39 The original, together with a bronze cast of a *tiki,* is still in Picasso's possession.

40 Z. VI, 927.

41 We encounter this hieratical, chunky mode of composition not long afterwards, in *Woman with Fan* (1908, Z. II, 67) and *The Farmer's Wife* (1908, Z. II, 91). These chunky figures are not unique to Picasso. We find similar works by Brancusi and, more especially, in Derain's output of the same year. Derain's *Crouching Figure* (1907)

likewise seeks to leave intact the overall form of the block of material from which the sculpture is worked. This endows the mass with a superstructure which transcends the sculpted detail.

42 Z. II, 23, 31, 45, 48.

43 On the left-hand side of *Les Demoiselles d'Avignon* the noses (as in *Woman Arranging her Hair* and *Portrait of Gertrude Stein*) are drawn in profile on the full-face heads, while in the later heads of the right-hand side the noses take the form of two-dimensional discs situated in front of the faces.

44 Z. II, 113.

45 Picasso prepared for this head by producing a sculptural representation of an apple.

46 The dissection of a body-mass into round, conical and prismatic formal particles ensued upon the rectangular planimetric studies for *The Farmer's Wife*. These are now elaborated on a nude figure. This would seem to be important because in *The Farmer's Wife* a certain arbitrariness of structure is meant to be legitimized by the associated use of costume.

47 Z. II, 109, 111.

48 The first artist to produce 'Cubist sculpture' under the inspiration of Picasso appears to have been Auguste Agéro, whose works are known only from descriptions supplied by Kahnweiler and from a few references in Apollinaire's exhibition reviews. Kahnweiler: 'Agéro tried to put his sculptures together out of Cubist structures'. Apollinaire, writing about the 1913 Salon des Indépendants: 'The sculptor Agéro has contributed a group of stones in which the lines of force move irresistibly. It is not the most agreeable kind of sculpture but it is the most novel, despite its poverty of inspiration and wretched execution.' Again, speaking of Boccioni's sculptures in the same year, Apollinaire refers to Agéro, not Picasso, as the father of a 'new sculpture'.

49 In a three-dimensional representation, the impossibility of spatially fixing positive and negative facets in Cubist pictures readily turns into a trick. The pictorial concept took precedence in Picasso's thinking at this time. That the artists who had recourse to Picasso's analytical Cubism somehow realized this becomes apparent from their tendency to interpret such analysis in a flat and relief-like manner. The

renunciation of sculptural volume created a materially obtained level of optical irritation.

50 Plaster, destroyed. The title itself refers to the formal innovation which Picasso had introduced in his sculpture *Head of a Woman* (1909).

51 One is reminded in this context of a remark of Picasso's which is reported by Penrose: 'I thought that the curves you see on the surface should continue into the interior. I had the idea of doing them in wire.' ('The Sculpture of Picasso', Museum of Modern Art, New York, 1968, p. 19.)

52 Photo: Kahnweiler.

53 *Cahiers d'Art,* 1950, xxv, pp. 281–82. Picasso invests these works with a playful quality. He interprets them. On this subject, see Douglas Cooper, *Picasso Theatre,* London and New York 1967, and my essay 'Picassos Dramaturgie' in *Bühne und bildende Kunst im 20. Jahrhundert,* Velber, Friedrich, 1968. Picasso's dramaturgical ideas, which are also preserved in two plays, can be traced throughout his work. Interest attaches to a project that was described to Douglas Cooper by Picasso and Kochno: an over-life-size still-life made of meat and vegetables was to be devoured in the course of the dance by performers dressed as flies. The paper model of the guitar referred to can be found in at least four different plastic situations: as an object in its own right; surrounded by seven drawings and *papiers collés* (ill. *Cahiers d'Art,* 1950, p. 281); surrounded by nine drawings and *papiers collés* (ill. *Cahiers d'Art,* 1950, p. 282); and supplemented by collage elements (Z. II, 577; Kahnweiler, 10). The latter appears to have been created after the second and third versions. In the photograph depicting the above-mentioned 'drawing-objects', the collage element which defines the bottle on the right of the fourth composition is affixed to the studio wall. We here apprehend a variability of individual plastic elements which was to become the prerequisite of a series of sculpture-collages subsequent to *The Glass of Absinthe.*

54 Z. II, 115.

55 Z. II, 325–28.

56 Dated 11 April 1912.

57 Barr, p. 90.

58 Paris 1914, Z. II, 838.

59 Picasso first obtained this undulating effect by drawing a comb through wet paint. André Salomon recounts in *La Jeune Sculpture française* (Paris 1919, pp. 12–14) that Picasso inserted wavy hair and a beard in a picture with the aid of a steel comb of the sort decorators use to simulate wood and marble.

60 The composition Z. II, 554, develops a grammalogue for Harlequin.

61 The table recalls *Loaves and Fruit-dish with Fruit on a Table,* 1908, Z. II, 134. It is interesting to note the parallels between the soft technique, which leaves the wood rounded and fluent in form, and the wood reliefs of Hans Arp. The way in which Picasso translates polished glass into wood in *Glass and Die* and *Still-life* has an affinity with Arp's wood reliefs *Forest* (1916), *Clock-tower* (1924) and *Shirt-front and Fork* (1924).

62 *Glass, Knife, Bottle,* Z. II, 430.

63 *Still-life* (p. 53) found its way into the collection of Paul Eluard.

64 Z. II, 848, 849. Bent pieces of sheet metal also occur in Umberto Boccioni's *Horse and Houses, Dynamic Construction of a Gallop* (1912–13) and in Henri Laurens's *Composition* (1914).

65 The Constructivists leave materials intact, their texture in the work being identical with the texture of their intact, polished, shiny surface.

66 Barr, p. 150.

67 Examples of a traced linear framework occur in Z. II, 365. Picasso used rule and compass in a series of sketches in 1915 (Z. II, 864, 865).

68 Cooper, pp. 40–42.

69 These 'space-drawings' seem to have made a deep impression on Giacometti. *Man* (1929) is a sort of cross-section of these anthropomorphic wire constructions, and in *Palace at 4 a.m.* (1932–33) he used Picasso's spatial filigree as the basis of a scene composed of Surrealistic objects and figures. Giacometti's reduction of mass to geometrical drawing, which was in the late 1930s to extend to figures, is foreshadowed here. It follows that his elongation of bodies stemmed less from a psychologically interpretable *amor vacui* than from his intense interest in a new mode of plastic representation.

70 Z. VII, 206.

71 As in numerous other cases, the execution of this head as sculpture followed well after its conception in terms of drawing. A major role was played by material problems such as studio facilities and the need to collaborate with a technician.

72 Z. VII, 151, 161.

73 Z. VII, 206.

74 In a certain sense, this drawing with its overlapping fabric of lines recalls Tatlin's dynamic tower project *Monument to the Third International* (1920) or the constructions of Rodchenko, which create almost solid volumes by means of stratified geometrical drawings.

75 Françoise Levaillant ('La Danse de Picasso et le surréalisme en 1925' in *L'Information d'histoire de l'art,* Paris 1966, no. 5) has examined the typology of the work and drawn attention to the links with Crucifixion and Bacchanalian motifs.

76 The vagueness with which Surrealism was defined at that time is evident from the fact that Breton included André Derain in *Le Surréalisme et la peinture* (Paris 1928).
Picasso's relationship with Surrealism has often been a subject for debate. He was never a member of the Surrealist group. The *Dictionnaire abrégé du surréalisme* (Paris 1938, p. 21) defines Picasso as follows: 'Painter whose work includes Surrealist poems (1935–1938)'. Although Picasso never formally belonged to the Surrealist group, he often contributed to group exhibitions: in 1925, to the first group exhibition at the Galerie Pierre (Paris); in 1930, the group exhibition at the Galerie Goemans (Paris); in 1932, the Surrealist exhibition at the Galerie Julien Levy (New York); in 1936, the exhibition of Surrealist objects at the Galerie Charles Ratton (Paris), and in the same year the survey exhibition 'Fantastic Art Dada Surrealism' at the Museum of Modern Art (New York). The most extreme definition of Picasso as a Surrealist comes from Wallace Fowlie (*Age of Surrealism,* New York 1950, Indianapolis, Indiana University Press 1960). Fowlie writes (p. 159): 'Picasso's career has been a series of revolutionary acts, close in spirit if not in literalness to the revolutionary stimulus of Surrealism.' Again (p. 163): 'Many of Picasso's brief elliptical statements about painting, which have been piously collected and preserved, corroborate much Surrealist doctrine and in many cases have, I suspect, helped to formulate it.' And finally (p. 170): 'All the various articles of Surrealist faith may be exemplified on Picasso: paranoiac-criticism, usually associated with Dalí; the art of dislocation wherein a suprahuman meaning may be found in the work; a psychological intuition which involves both eroticism and violence.'
In Fowlie's definition, Picasso becomes a Surrealist par excellence. Fowlie sees the beginnings of Surrealism in the Cubist phase of Picasso's work. This does, in fact, seem consistent if one chooses to interpret Picasso's formal distortion as psychological expression in the Surrealist sense. It at least seems more consistent than to isolate one aspect of Picasso's output – the biomorphic distortion of the 1920s and 1930s – and pronounce it Surrealist. The Cubist approach which endows Picasso's deformation with a non-literary background must be assumed to underlie his work as a whole.
At the end of the 1920s Picasso turned more towards biomorphic distortion, additionally stimulated, perhaps, by his familiarity with Miró and Tanguy. The underlying principle of the style – freedom of composition itself – was already established in Cubism, however, for it is noticeable that apart from a few motifs (Minotaur, Crucifixion) the thematic content remains the same. If the biomorphic tendency enjoyed precedence within Surrealist painting itself, this was because biomorphic distortion wields a greater psychological impact than geometric distortion. While evolving the language of Cubism, Picasso seems to have wavered temporarily between rounded and angular forms of stylization or deformation. The *Head of a Woman* of 1909 can serve as an example of a 'Cubism' which might have led to a solid biomorphic structure rather than a skeletal one. On this point, I agree with William S. Rubin, who says: 'Picasso's art was ultimately antagonistic to Surrealism since it was almost always set in motion by a motif seen in the real world; the Surrealist vision was discovered, as Breton said, "with the eyes closed"' (*Dada and Surrealist Art,* London and New York 1970, p. 279).

77 A gesture which may very well stem from Picasso's mania for locking things up and living with a huge collection of keys.

78 It is noteworthy that Calder presents a variation on this Picasso theme in a drawing of 1930 (*Couple on the Beach,* Cat. no. 27, Calder Exhibition, Fondation Maeght, 1969). It seems as if some of Calder's stabiles (e.g. *Iguana,* 1968) translate these fully plastic ideas of Picasso into flat plastic silhouettes. In the stabile *The Little Nose* he takes the nose motif – an ascendant, tapering spike – from Picasso's preliminary sketch *Woman Bathing.*

79 The soft liquescent shapes which occur in Dalí's pictures from 1929 onwards appear to take account of these anti-static designs by Picasso.

80 Picasso's interest in ironwork was aroused not only by González but also by the Spaniard Gargallo, who produced iron sculptures from 1911 onwards.

81 Z. VII, 2 and 4; Z. VIII, 85.

82 Z. VII, 179–81.

83 Z. VII, 180.

84 Z. VII, 347, 374, 377.

85 A process which recalls the sand-coated bottle-reliefs of this period.

86 Cf. Z. VII, 276, 277.

87 A similar construction should be placed upon the fact that Picasso had plaster casts made of a large number of sculptures composed of different materials.

88 Masson treated the surfaces of his pictures with sand from 1927 onwards. Even before the First World War, Picasso, Braque and Gris had used sand or ash to thicken paint and give it a granular texture.

89 Kahnweiler, 79, 80, 81 and *Cahiers d'Art* 1935, p. 16.

90 Kahnweiler, 82, 83, 84.

91 Cf. the ritual iron rods of Dogon and Etruscan statuettes.

92 The shape of the pieces of wood from which Picasso carved these figures largely dictated the vertical direction of their movements.

93 Two different versions of this theme are known. A Brassaï photograph taken at Picasso's home in 1934, and used to illustrate Breton's essay 'Picasso dans son élément' (*Minotaure,* No. 1, 1933), shows both works hanging above the fireplace.

94 Reference should here be made to the drawings in the series *An Anatomy* (22 February 1933, ill. *Minotaure,* No. 1, 1933), with their sculptural concentration on spatial values. In these, Picasso develops the drawings made

268

at Cannes and Dinard. The anthropomorphic skeletons of bones and objects adapt themselves to the 'Crucifixion' theme of which a first formal echo can be perceived in *The Dance* (1925). Picasso never made sculptural use of these sketches, but Henry Moore's *Double Figure* (1950) invokes his drawings almost to the letter.

95 25 October 1943.

96 Speaking of *Head of a Woman*, Wilhelm Boeck rightly draws attention to the sculptures in the round on the pediment at Olympia (Boeck, p. 288).

97 Picasso owns two copies of the Venus of Lespugue. Brassaï's notes on a conversation with Picasso on 25 October 1943 contain the following remark: 'In the cupboard there is a copy of the Venus of Lespugue – two copies, in fact: one matches the chipped original and the other is completed, restored.'

98 The figure of the king in *King and Queen* (1952–53) seems to have been directly modelled on Picasso's *Seated Man*.

99 Z. VIII, 257.

100 Geiser, 288.

101 The plaster originals underline this effect because light acts on the plaster much as it does on marble. The treatment is gentler: there is an absence of reflections and areas on which light concentrates in spasms. This favours a slow and steady development of perception. The human eye reacts differently to bronze, being attracted almost automatically by areas which reflect light with greater force. This rhythmicizes the observation even of volumes which are inert from the material point of view.

102 Z. VII, 5, 22.

103 Z. VII, 346.

104 Z. VII, 378.

105 Corrugated paper can, however, assume a more-than-formal role in a different context. Picasso's design for the first issue of the Surrealist review *Minotaure*, 1933, was a collage for which corrugated paper supplied the ground. In association with the Minotaur or Labyrinth theme, the structure of corrugated paper becomes symbolic of a labyrinthine quality, of potential routes running side by side. This is one of the few instances in Picasso's work where we can venture an interpretation of a structure which is – in the Surrealist sense – objective.

106 Z. IX, 91, 92.

107 The Cubist constructions, and six casts of *The Glass of Absinthe,* were painted. Picasso planned to colour *Woman with Pushchair* and *Little Girl Skipping.* The second casts of these works, which had been ordered by the Galerie Leiris, were duly retained by him for this purpose.

108 André Breton remarked in 'Picasso dans son élément' (*Minotaure,* No. 1, 1933): 'If, as has been seen, Picasso the painter does not have the prejudice of colour, it is only to be expected that Picasso the sculptor will not have the prejudice of material.'

109 'Dora owns a veritable "Picasso collection": her numerous portraits, many still-lifes, and a cupboard full of small objects fashioned by Picasso's deft and tireless fingers. A short while ago she very carefully brought out these objects for me to photograph: little birds made of tin capsules, of wood and bones; a thrush fashioned from a piece of wood, a bone worn smooth by the sea and transformed by Picasso into an eagle's head. . . . Little trifles, too, full of wit and humour: a charred fragment of wood painted brown turns into a cigar, a flat bone into a fine-toothed comb – Picasso had painted in every slender tine with enormous care, also a pair of amorous fleas. . . . The many silhouettes cut or simply torn with the fingers from paper or cardboard are a pure delight. . . . He generally used paper napkins or cigarette packets. Among the countless objects are many animals – fish, fox, billy-goat and vulture – as well as satyrs' masks, children's faces and a death's head; there is also a long lady's glove and a remarkable series of dogs.'

110 *Cahiers d'Art,* 'Picasso 1930–1933', p. 70.

111 Picasso used the branch of a tree for these.

112 *Cahiers d'Art,* 1926, p. 180, carried an illustration of this.

113 It was a present from Pierre Loeb.

114 Picasso intended to provide this sculpture with shoes. He told me that he asked Eluard to get him some shoes so that he could add them to the piece: 'He brought me his mother's shoes. But I never put them on.'

115 The tailor's dummy plays an important role in the twentieth-century formal repertoire. The Futurists, as well

as Carrà, De Chirico, Ernst and Schlemmer, have used the 'manikin' motif. Picasso, however, is here experimenting with the contrast between a stereotyped, codified body and a psychologically modified face.

116 Françoise Gilot gives the following description of Picasso at work on *Man with Sheep*: ' "When I begin a series of drawings like that," Pablo explained, "I don't know whether they're going to remain just drawings, or become an etching or a lithograph, or even a sculpture. But when I had finally isolated that figure of the man carrying the sheep in the centre of the frieze, I saw it in relief and then in space, in the round. Then I knew it couldn't be a painting; it *had* to be a sculpture. At that moment I had such a clear picture of it, it came forth just like Athena, fully armed from the brow of Zeus. The conception was a year or two in taking shape, but when I went to work, the sculpture was done almost immediately. I had a man come to make the iron armature. I showed him what proportions to give it, then I let it sit around for about two months without doing anything to it. I kept thinking about it, though. Then I had two large washtubs of clay brought up, and when I finally started to work, I did it all in two afternoons. There was such a heavy mass of clay on the armature, I knew it wouldn't hold together long in that form, so I had it cast in plaster as soon as I could, even before it was completely dry." ' (Françoise Gilot and Carlton Lake, *Life with Picasso,* p. 289–90.)

117 Kahnweiler, p. 139–41.

118 Kahnweiler, p. 157–61.

119 Françoise Gilot (*Life with Picasso,* p. 294) supplies a few details. '. . . he (Picasso) picked up an old wicker waste-basket one morning. "That's just what I need for the goat's rib cage," he said. A day or two later at Madame Ramié's he came across two pottery milk pitchers that hadn't quite panned out. "They're rather peculiar forms for milk pitchers," he said, "but maybe if I knock out their bottoms and break off the handles, they'll be just about right for the goat's teats." '

120 Picasso returned to this relief-like application of drawing in some metal works of later date: in his sheet-iron shapes and in four fruit-bowls (*cat. 560–63*) which the goldsmith François Hugo made in 1967, based on designs dating from 1958 (cf. 'Atelier François Hugo', *Le Point Cardinal* (Paris), November-December 1967).

121 Lionel Prejger has given an account of his collaboration with Picasso in the article 'Picasso découpe le fer' (*L'Œil*, No. 82, October 1961, pp. 28–33). This account does not refer to the previous works of the first phase, which began in 1954. Prejger conveys the misleading impression that he was the first to carry out works of this type with Picasso: 'I am fulfilling a long-cherished dream, in other words, lending durable shape to those little pieces of paper that are scattered here and there' (p. 30). He does, however, supply important particulars about Picasso's working methods: 'It is now that our studio faithfully reconstitutes, in sheet metal of varying thickness, the model sent me by Picasso. Picasso does not take kindly to imperfect workmanship, and sometimes fumes about not working at the forge or the torch himself. If the sculpture is too shiny he decides to paint it, generally in white, and exposes it to full sunlight so that the smallest defects show up; sometimes, again, these sculptures become polychrome or drawn with greasepaint on a ground of matt enamel. Sometimes, too, lines of welding on the sheet metal trace the lines which Picasso has drawn so as to enliven the subject and relieve the shape' (pp. 31–32).

122 'One day, as on other days when I called on Picasso, he was in bed in his room. Facing him near the window was a very large sheet of plywood with an enormous sheet of wrapping-paper affixed to it. On this paper, prior to cutting it out, he had drawn a strange shape which lay spread out like an octopus with motionless tentacles.

'"It's a chair", Picasso told me. "There you have an explanation of Cubism! Imagine a chair run over by a steam-roller, and – well, the result would be more or less like that." ... After cutting along the charcoal lines, Picasso proceeded to bend and crimp the paper in places; the paper vibrated, and the birth of *The Chair* began. Every day, and sometimes several times a day, I took the finished parts to submit them and carry out Picasso's corrections' (Lionel Prejger, op. cit., p. 32).

123 *Europe-Nouvelles*, 13 July 1918.

124 Even Maurice Raynal still had strong reservations about Picasso's sculptural work as late as 1921. He did recognize that Picasso was evidently seeking 'a kind of plastic control' in sculpture, but he applied this only to the early work. For the rest, in his view, 'Picasso has always retained a preference for painting. I should be tempted to believe that he has given up sculpture because this art seems to him to have a specific character of its own which distinguishes it from all other modes of expression of the active capacity for emotion. ... Picasso soon realized, I think, that his sculpture was only a form of painting carried on with sculptural means' (*Picasso,* Munich 1921).

125 Such was the general ignorance of the historical position that in 1931 Hans Hildebrandt could write, in his *Kunst des 19. und 20. Jahrhunderts*: 'The first man entitled to pride himself with having enriched twentieth-century sculpture by novel means is the Ukrainian Alexander Archipenko.' He overlooked the two most important innovators, Picasso and Matisse, entirely.

126 Z. I, p. xxi.

127 Paris 1964.

128 In Kahnweiler's view, as formulated in his essay 'Das Wesen der Bildhauerei', Picasso's Cubist reliefs (which he does not mention) would not count as true sculpture at all, because a relief creates its own 'illusory space'. Kahnweiler formulates this distinction with the sculptures of Hildebrandt in mind; although these are made in the round, they are intended to be seen outlined against a close-up background, and are thus, in Kahnweiler's view, illusory sculpture existing in a space of their own. It is a pity that he never discussed this idea with specific reference to Picasso's Cubist sculpture, because this formulates the issue in unprecedented ways. Kahnweiler writes, still *à propos* of Hildebrandt: 'The relief, we may say, employs the means of sculpture to pursue an end which is close to that of painting. It is quite distinct from sculpture in the round. I try to make this clear by calling the relief three-sided, the sculpture in the round four-sided. What this means will be obvious to everyone. The spectator can look at a relief, built into a wall, from three sides only, left, right and front; but he can look at a sculpture in the round from the back as well. In other words, only sculpture in the round possesses the one essential characteristic of three-dimensionality, of cubicality, which is proper to all bodies in space: the possibility for us to move round it.' (D.-H. Kahnweiler, 'Das Wesen der Bildhauerei', *Feuer* (Weimar), 1, No. 2–3, November-December 1919, pp. 145–46. Reprinted in his *Ästhetische Betrachtungen,* Cologne 1968, pp. 25–35.)

Cubism, on the other hand, seems to have a tendency to abolish just this distinction between three-sidedness and four-sidedness. The distinction can still be made to some extent in the case of early Cubism; seen alongside the paintings, the early Cubist *Head of a Woman* of 1909 maintains its identity as an autonomous form which can be experienced, as they cannot, from four sides. But in the years which followed Picasso found a way of conveying a total knowledge of the object *in a painting*. Painting, which by virtue of its non-'cubical' physical form can show only frontal views of objects, is enriched in Cubism by a knowledge of what Kahnweiler calls 'cubicality' (*das Kubische*). One could make an interesting juxtaposition of the terms 'cubical' and 'Cubist': a Cubist work is one which masters 'cubicality' in pictorial terms. In the paintings of analytical and synthetic Cubism, Picasso affords a representation of structures which carry their own reverse side (that which invites the spectator to walk round them) within themselves. This becomes apparent if we look at the reliefs which Picasso made, in paper, wood and sheet metal, at that period. He restricts himself to representations which abolish the reference to four-sidedness. The real objects he represents are ones which do not have four equally important sides. The musical instruments which are the favourite theme of the Cubist constructions have a reverse side which in itself constitutes only a homogeneous, featureless termination. This can be expressed by a plane surface; and as such it appears in the constructions. Often a two-dimensional repeat of the body of the instrument appears in the background like a shadow.

To sum up: (1) Picasso adopts techniques of representation which imply the intention to translate 'cubicality' into two-dimensional terms. (2) He adopts themes which reduce to a minimum the beholder's impulse to experience them in a cubical (four-sided) way. In the reliefs he employs objects which either facilitate the abandonment of 'four-sidedness', like stringed instruments, or look the same from more than one angle, like glasses, bottles, knives and dice. It was thus the choice of these particular objects which led Picasso to the choice of the relief as a sculptural technique.

Catalogue illustrations

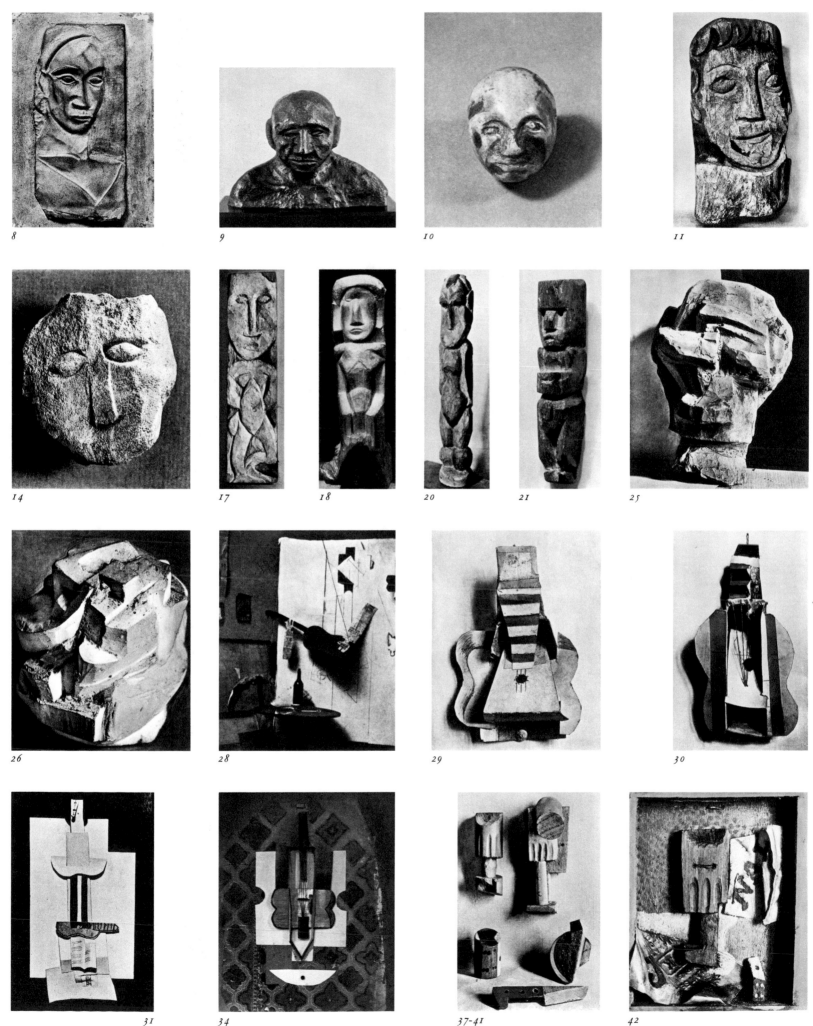

8

9

10

11

14

17

18

20

21

25

26

28

29

30

31

34

37-41

42

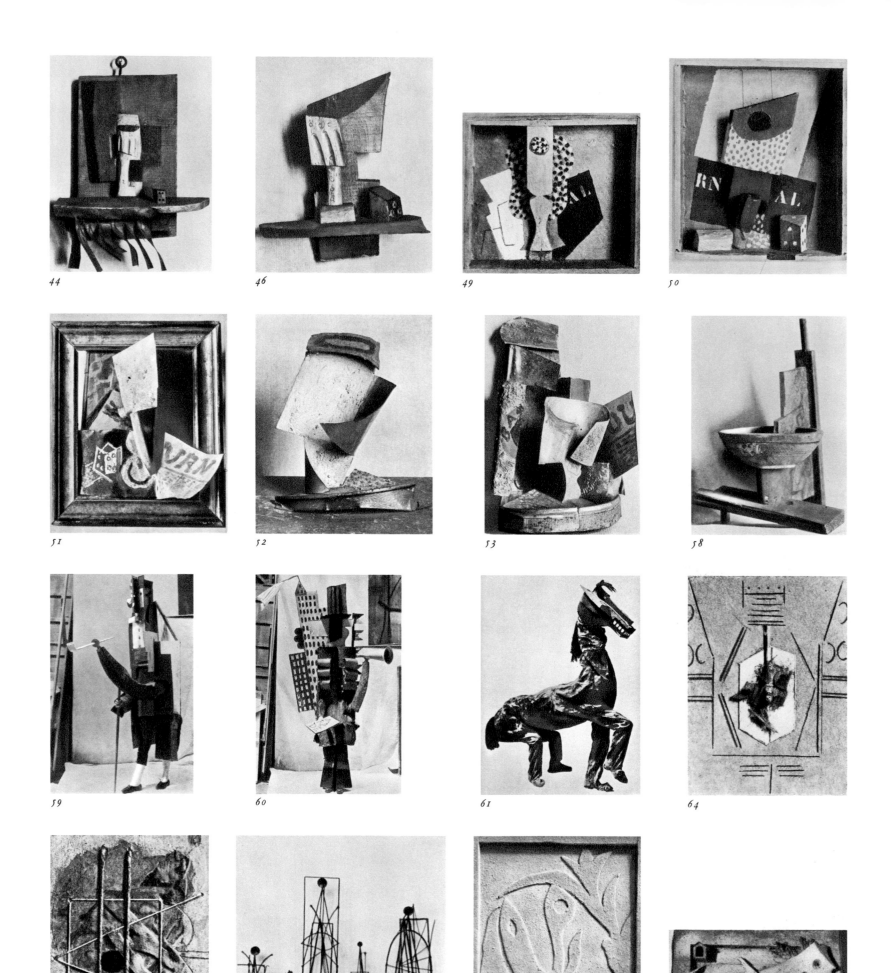

44

46

49

50

51

52

53

58

59

60

61

64

65

70 69 71 68

77

78

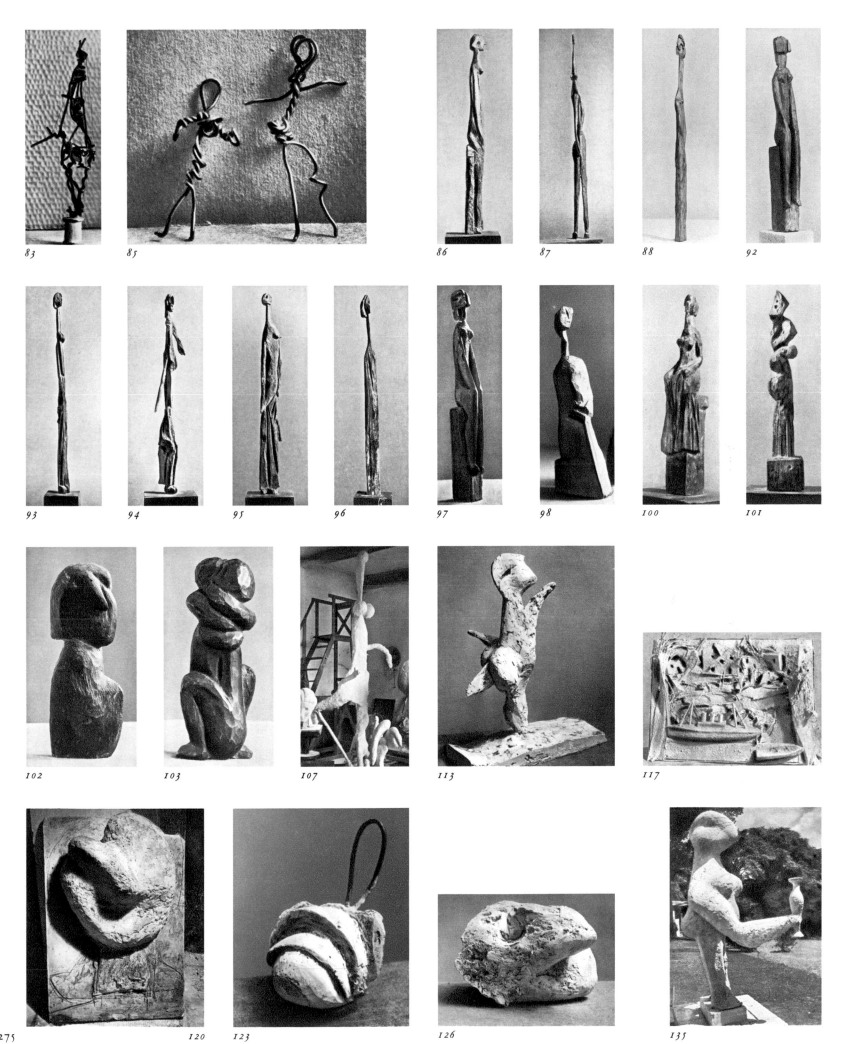

83

85

86

87

88

92

93

94

95

96

97

98

100

101

102

103

107

113

117

275

120

123

126

135

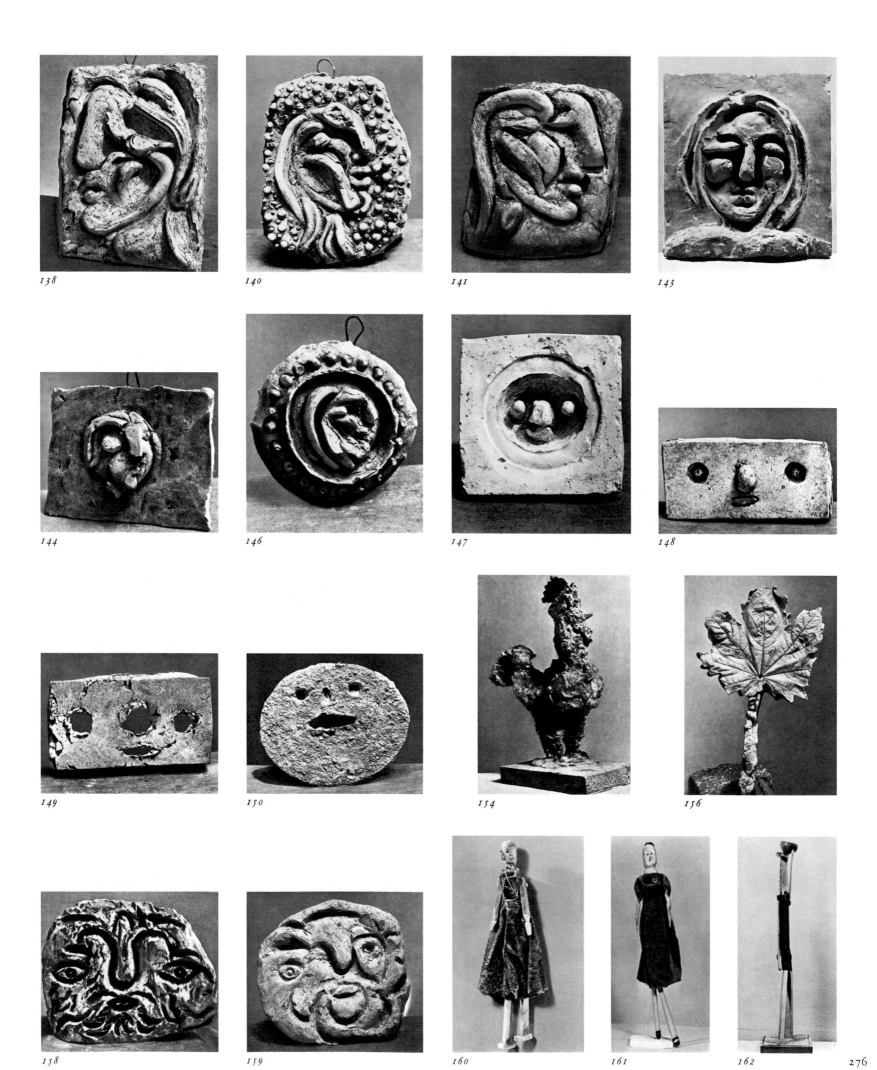

138

140

141

143

144

146

147

148

149

150

154

156

158

159

160

161

162

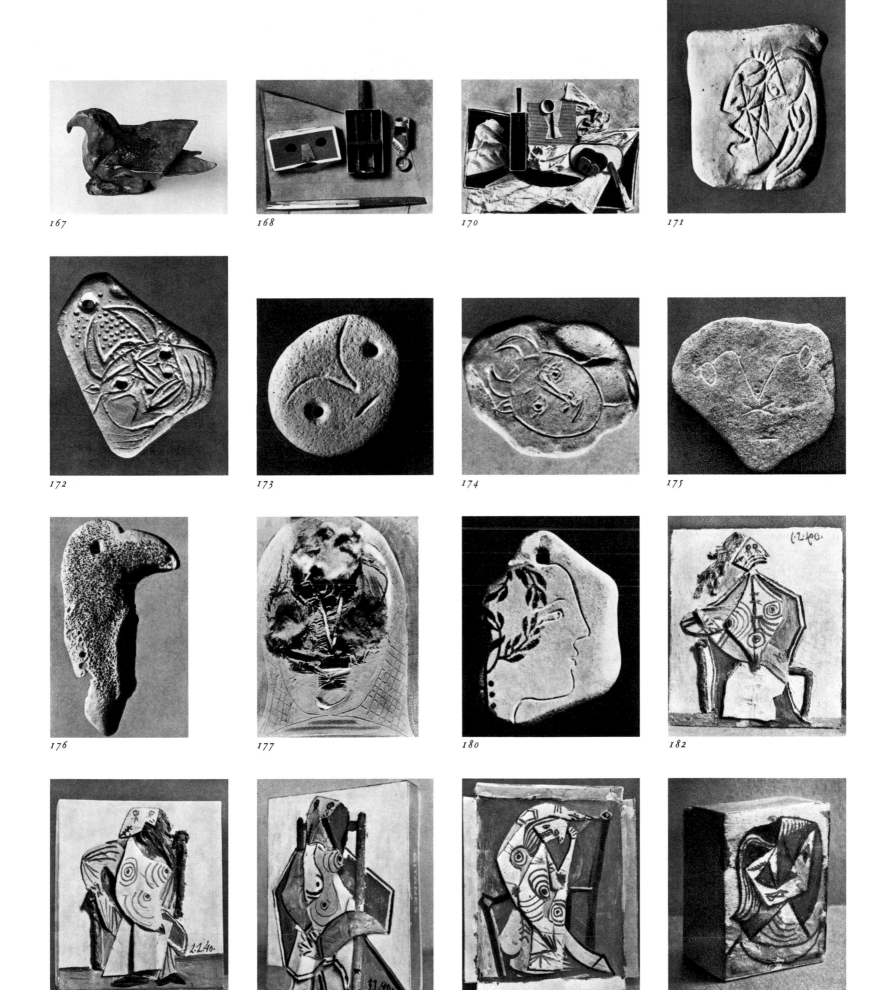

167

168

170

171

172

173

174

175

176

177

180

182

183

184

185

186

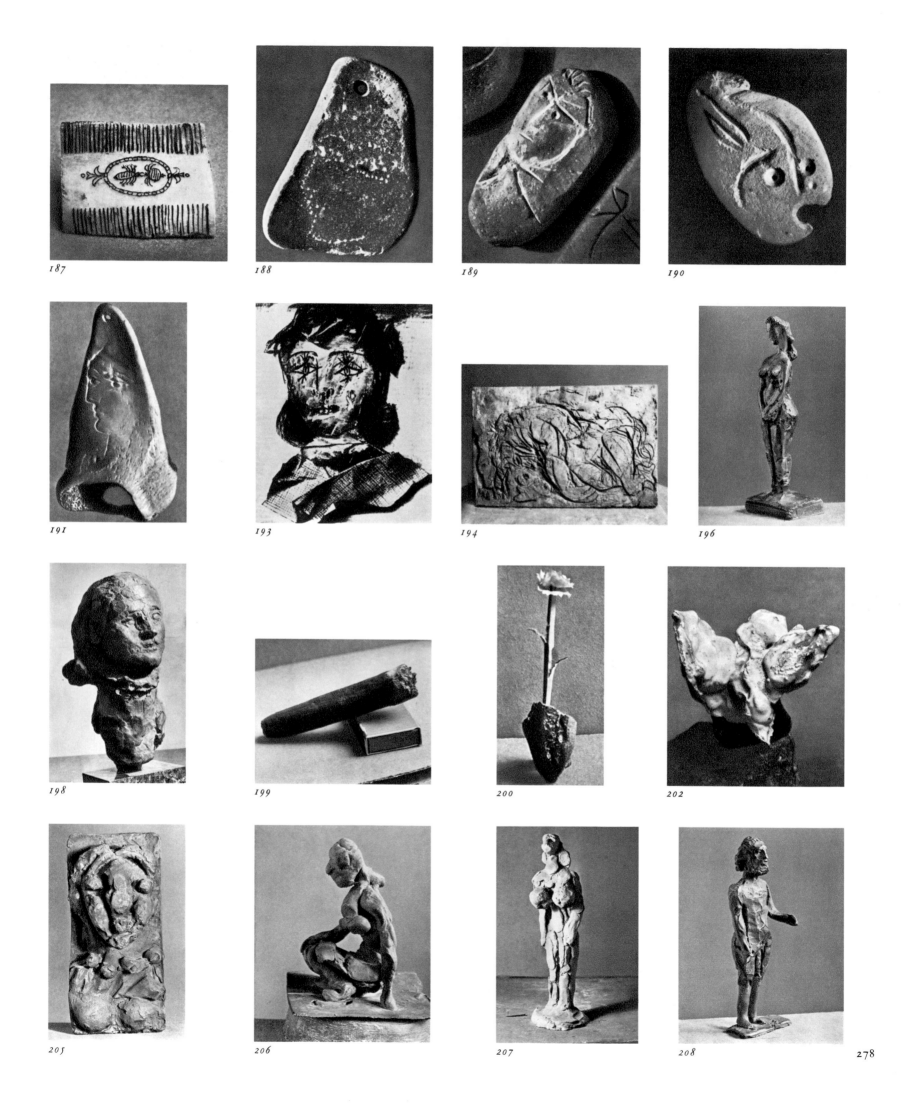

187

188

189

190

191

193

194

196

198

199

200

202

205

206

207

208

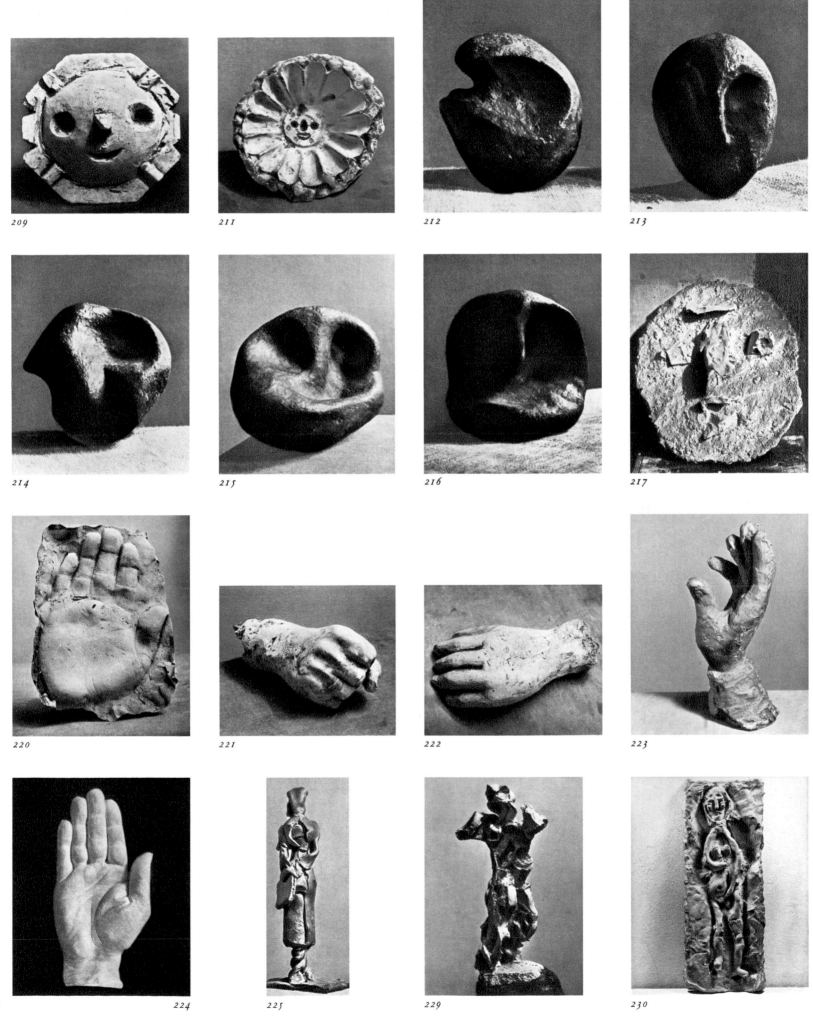

209

211

212

213

214

215

216

217

220

221

222

223

224

225

229

230

231

232

233

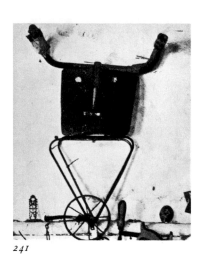

241

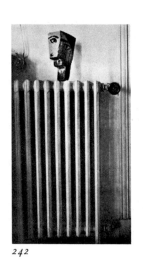

242

243

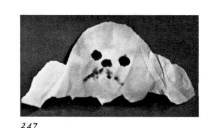

244

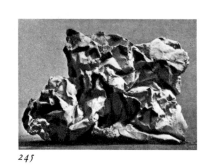

245

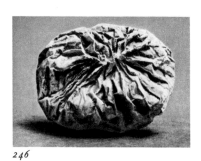

246

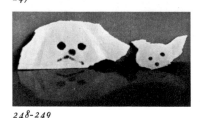

247

250-251

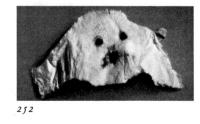

248-249

252

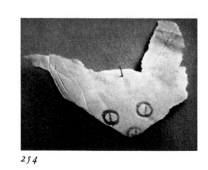

253

254

255

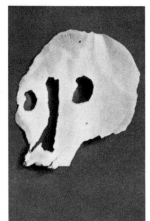

256

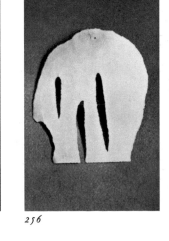

257

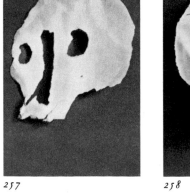

258

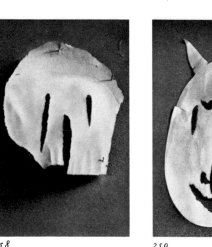

259

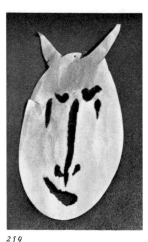

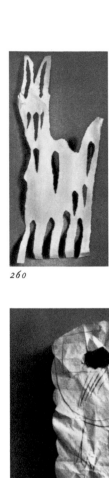

260

261

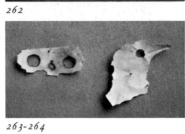

262

263-264

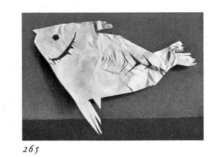

265

266

267

268

269

270

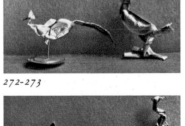
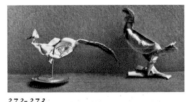

272-273

271

274-275

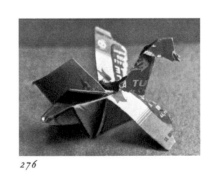

276

277

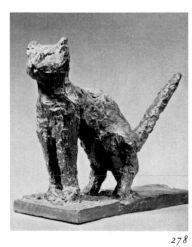

281

278

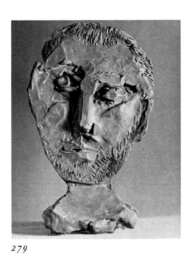

279

281-283

284-285

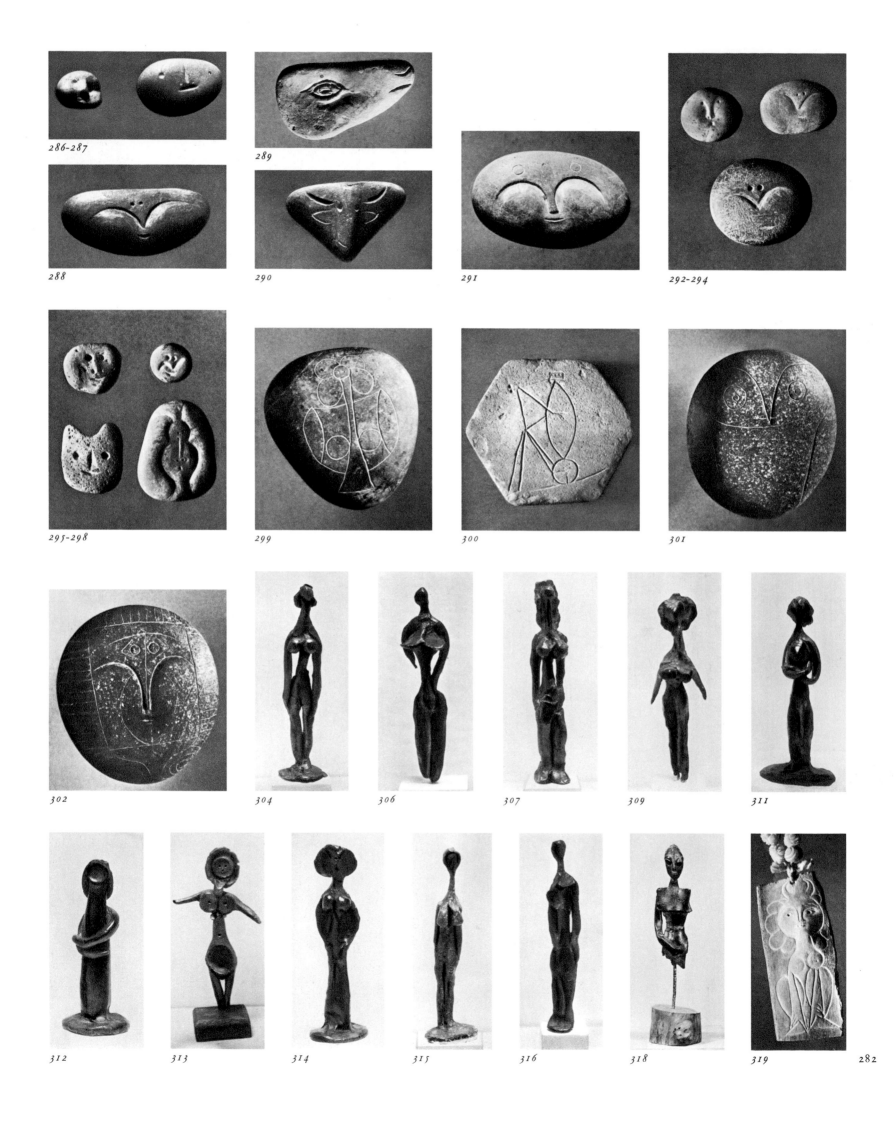

286-287

289

288

290

291

292-294

295-298

299

300

301

302

304

306

307

309

311

312

313

314

315

316

318

319

282

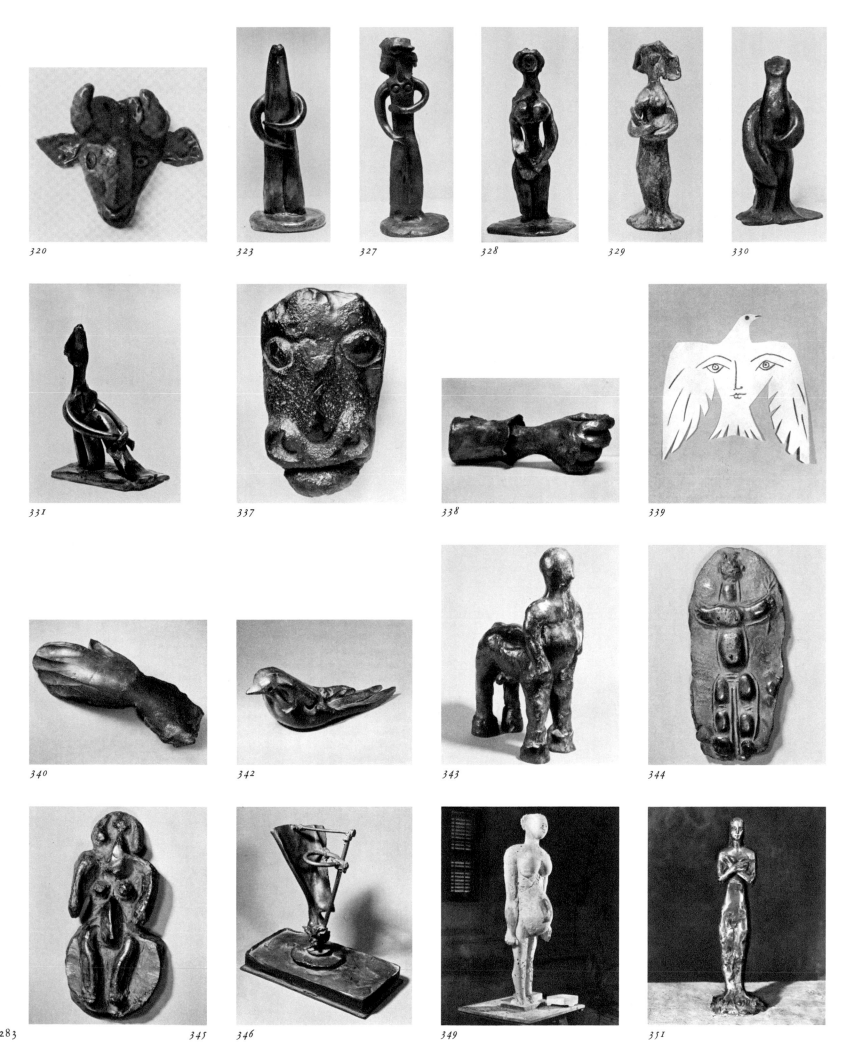

320

323

327

328

329

330

331

337

338

339

340

342

343

344

345

346

349

351

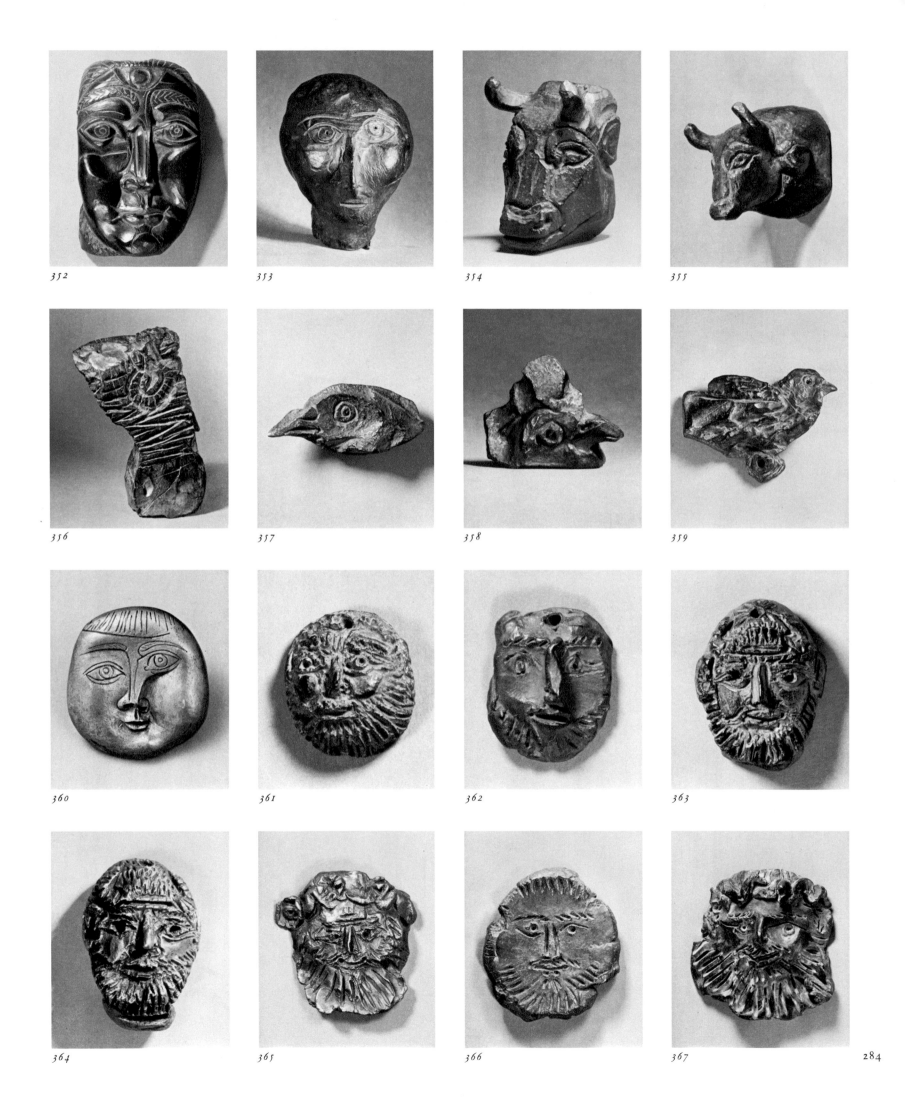

352

353

354

355

356

357

358

359

360

361

362

363

364

365

366

367

284

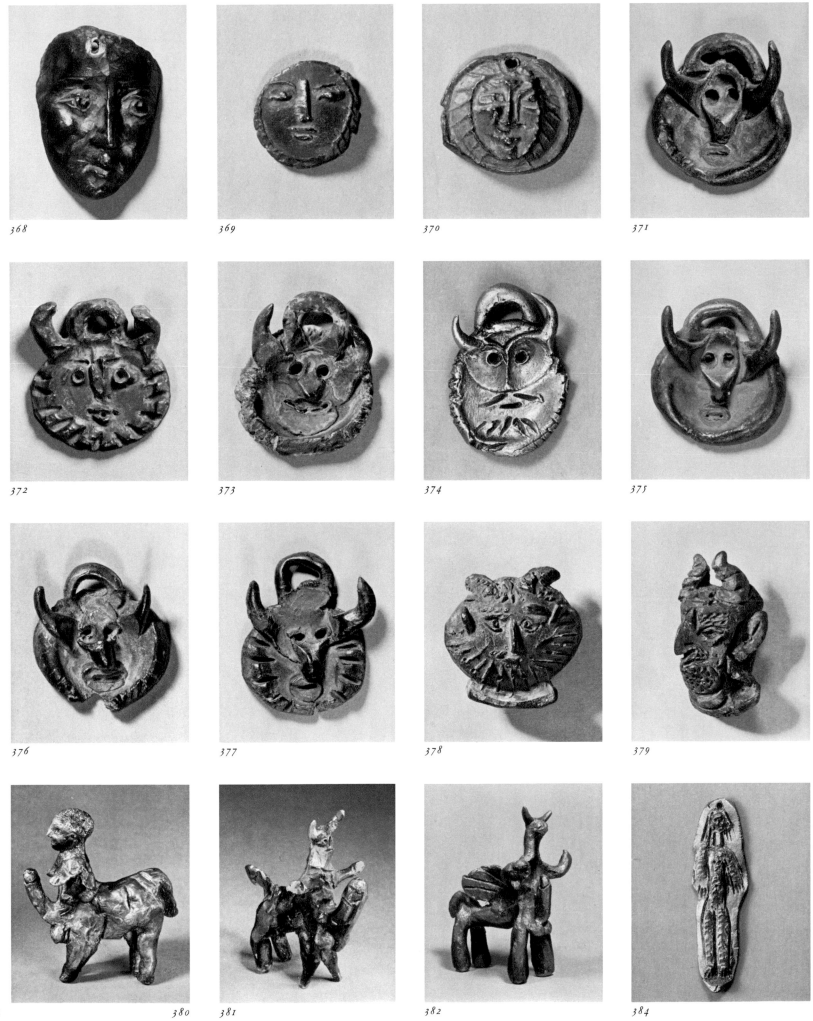

368

369

370

371

372

373

374

375

376

377

378

379

285 380

381

382

384

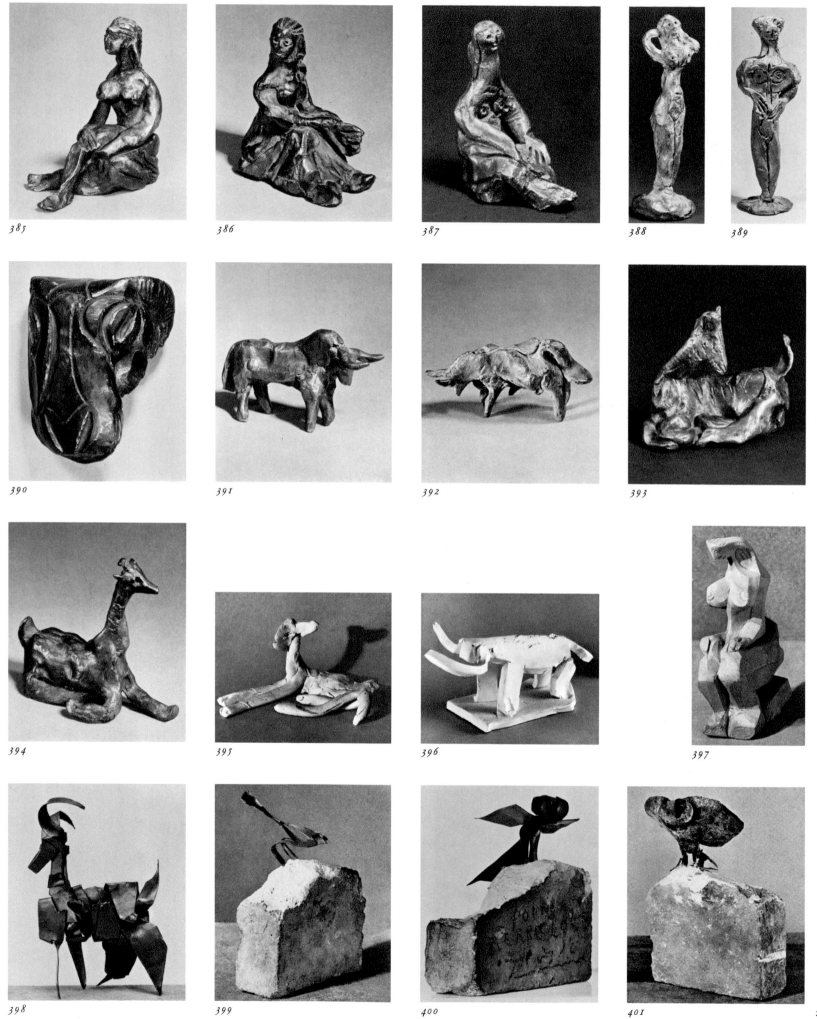

385

386

387

388

389

390

391

392

393

394

395

396

397

398

399

400

401

286

402

405

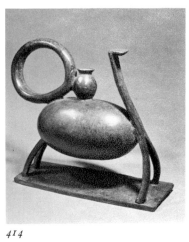

406

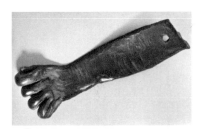

414

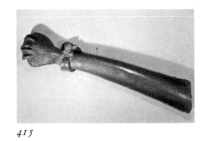

415

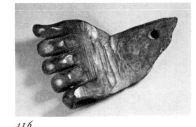

416

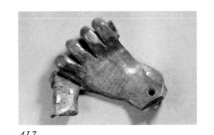

417

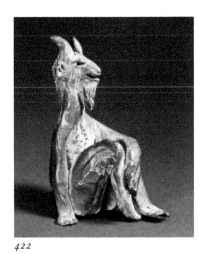

418

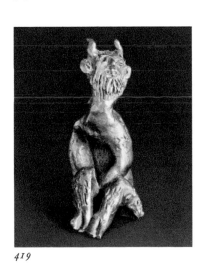

419

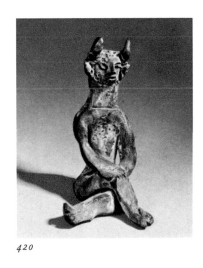

420

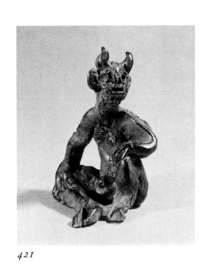

421

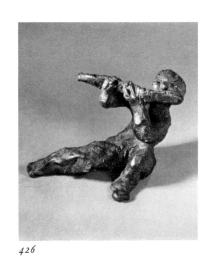

422

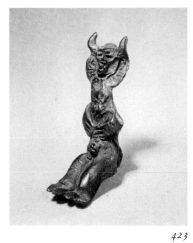

423

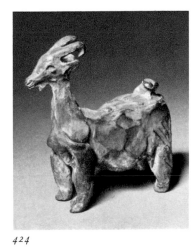

424

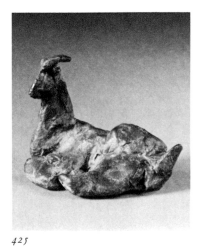

425

426

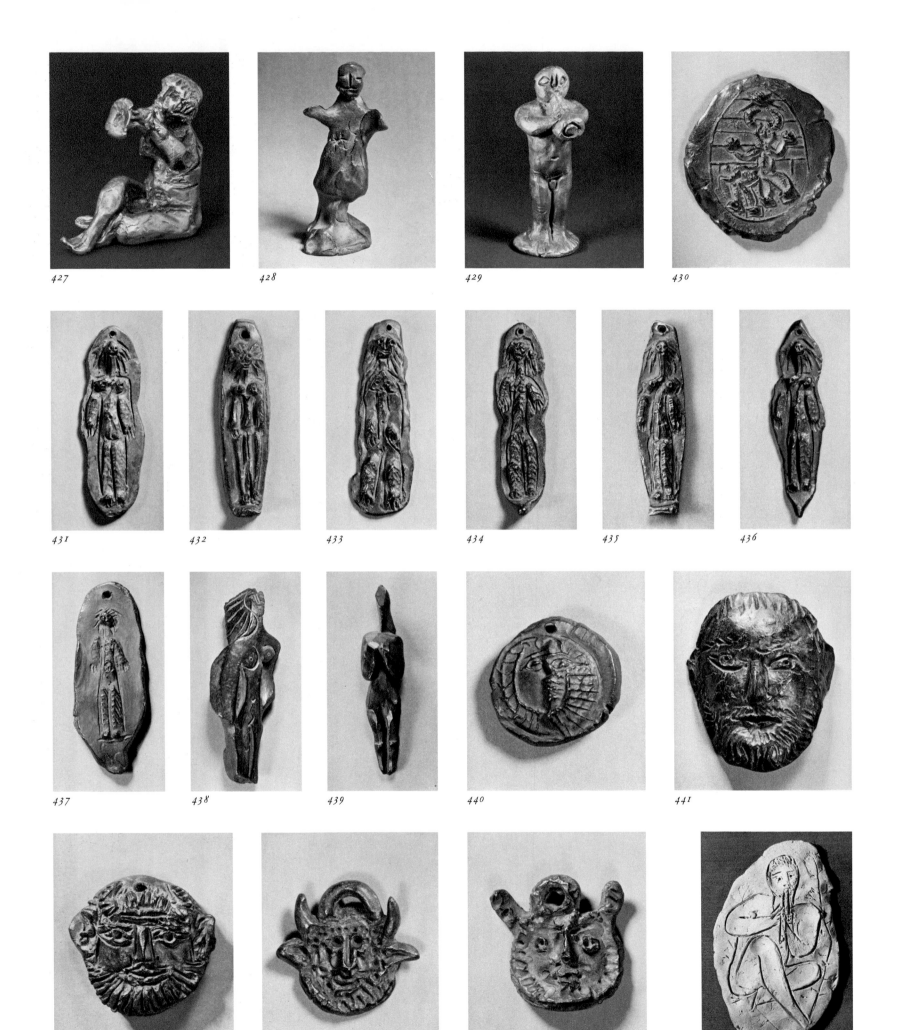

427

428

429

430

431

432

433

434

435

436

437

438

439

440

441

442

443

444

445

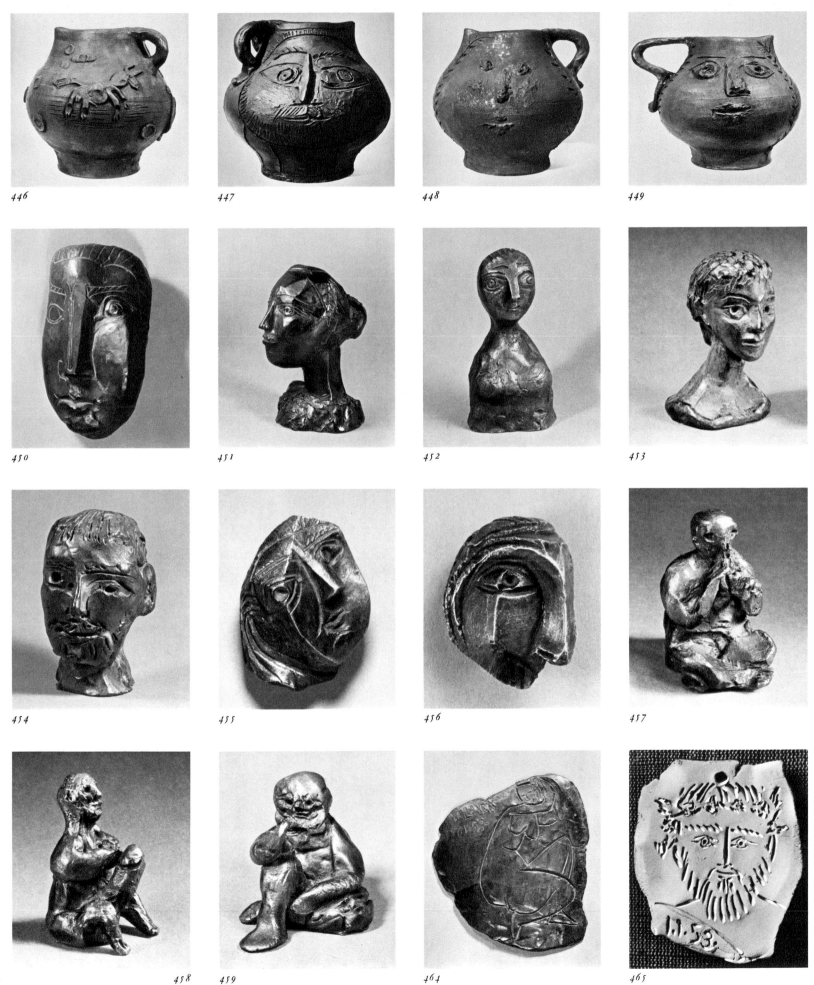

446

447

448

449

450

451

452

453

454

455

456

457

458

459

464

465

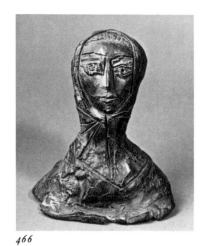

466

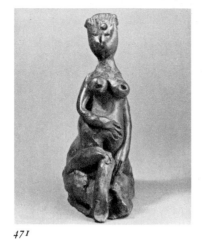

471

473

474

475

476

481-487

490

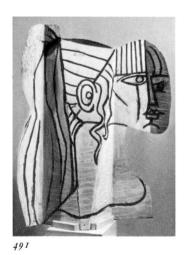

491

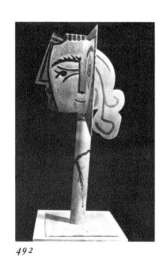

492

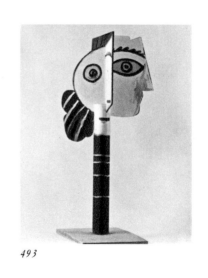

493

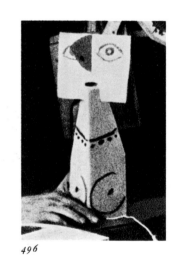

496

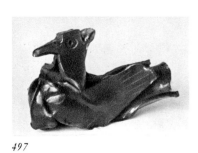

497

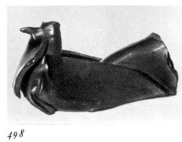

498

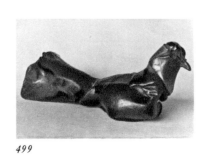

499

500-501

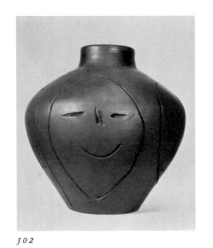

502

510

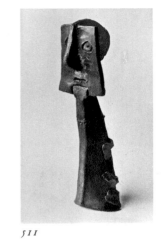

511

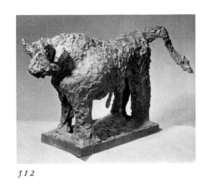

512

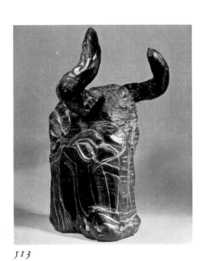

513

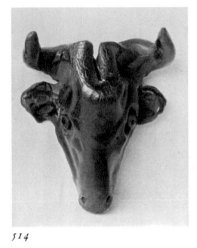

514

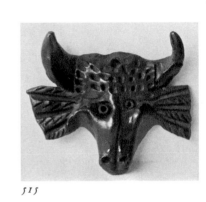

515

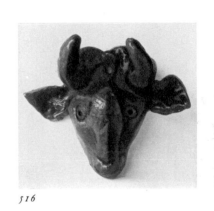

516

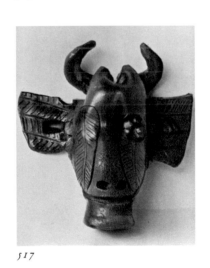

517

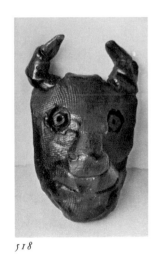

518

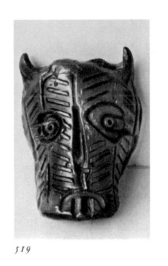

519

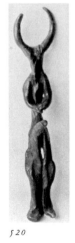

520

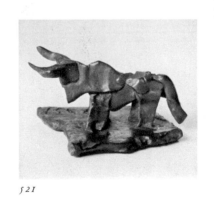

521

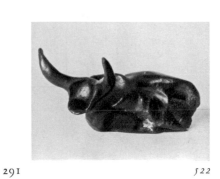

291

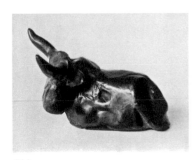

522

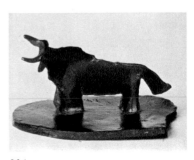

523

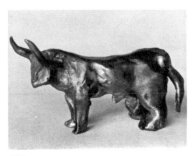

524

525

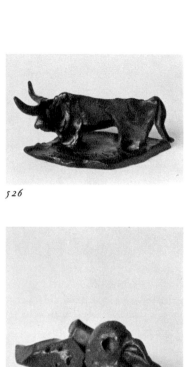

526

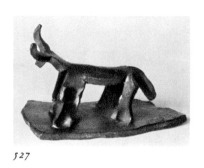

527

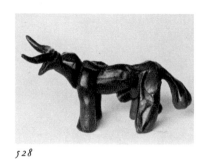

528

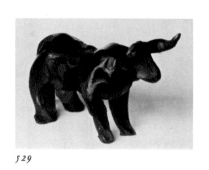

529

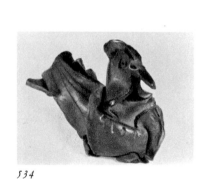

530

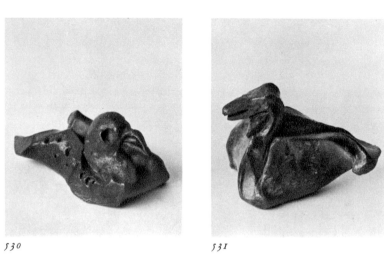

531

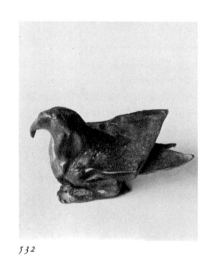

532

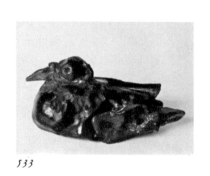

533

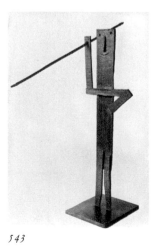

534

535

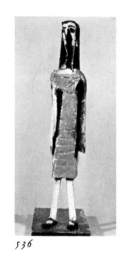

536

540

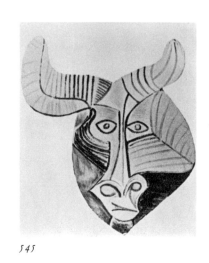

543

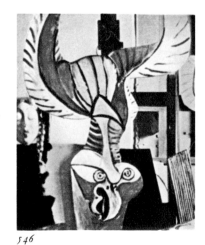

545

546

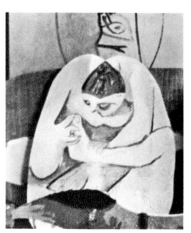

547

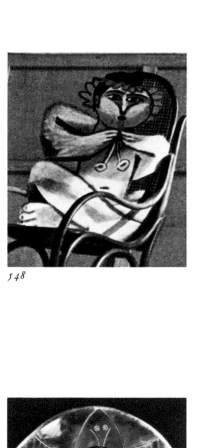

548

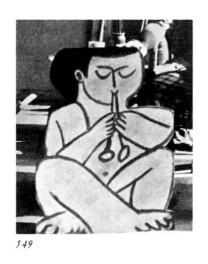

549

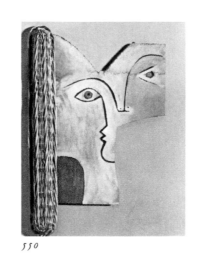

550

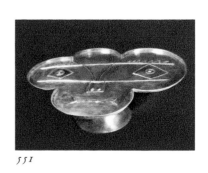

551

552

553

554

555

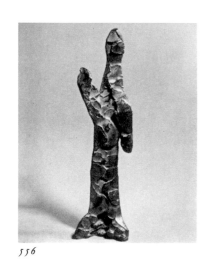

556

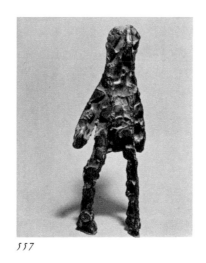

557

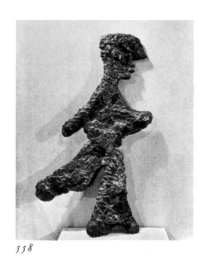

558

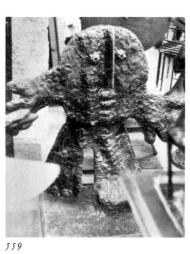

559

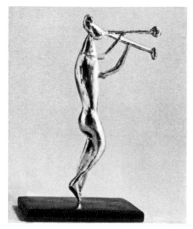

560

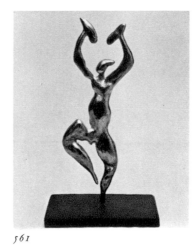

561

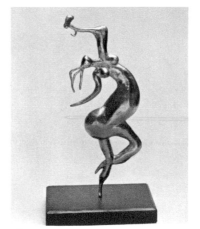

562

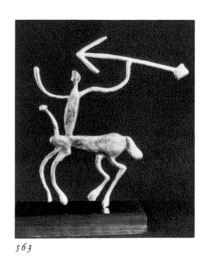

563

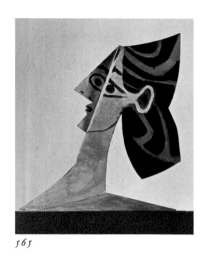

565

566

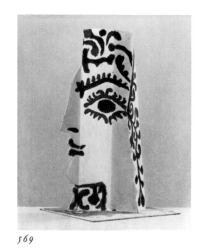

569

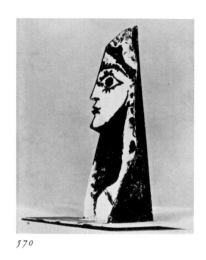

570

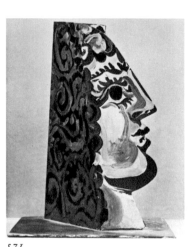

571

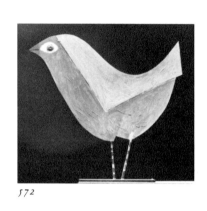

572

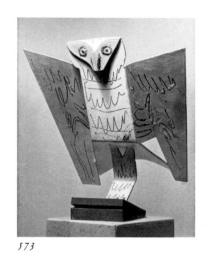

573

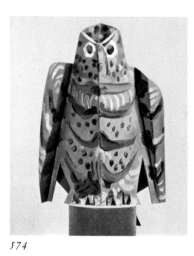

574

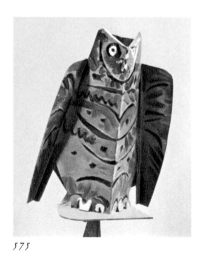

575

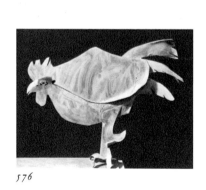

576

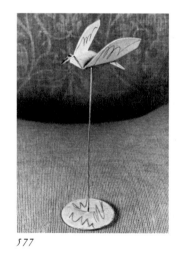

577

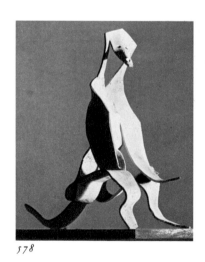

578

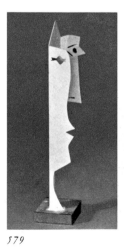

579

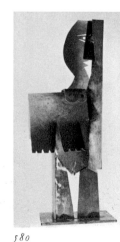

580

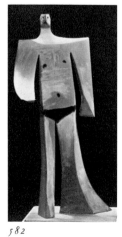

582

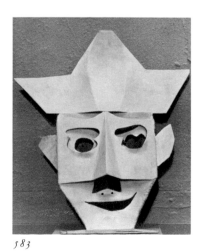

583

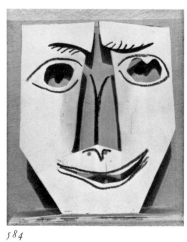

584

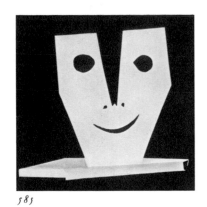

585

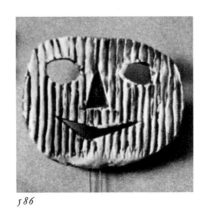

586

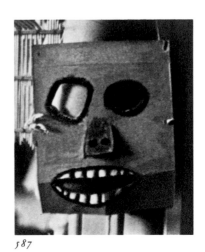

587

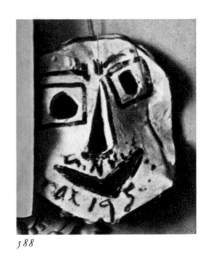

588

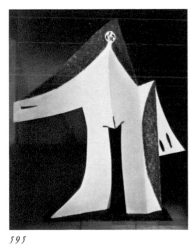

589

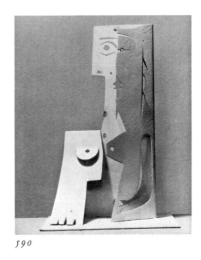

590

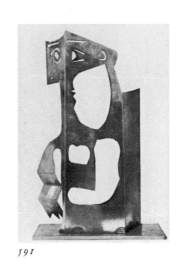

591

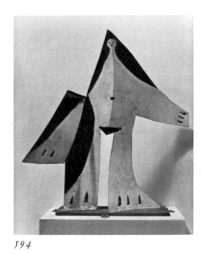

594

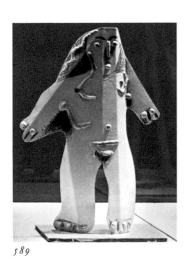

595

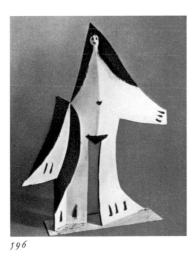

596

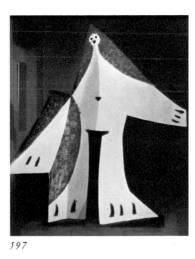

597

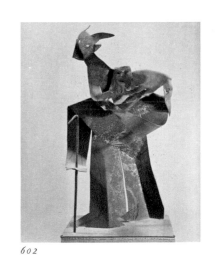

602

295

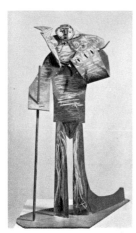

603

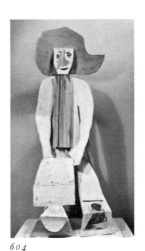

604

607

608-609

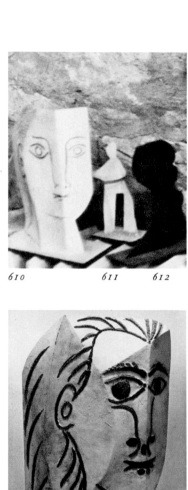

610 611 612

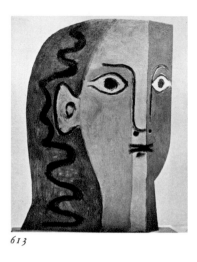

613

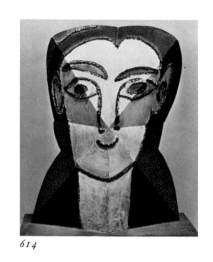

614

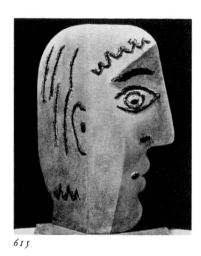

615

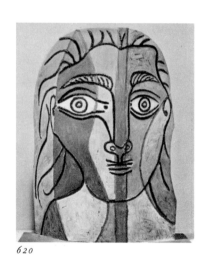

616

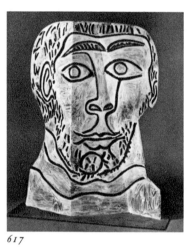

617

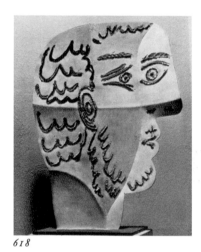

618

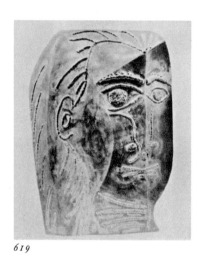

619

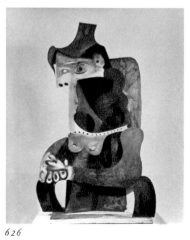

620

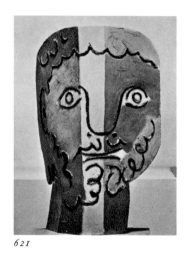

621

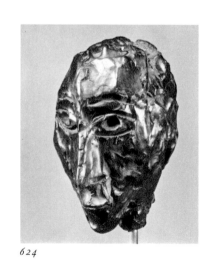

624

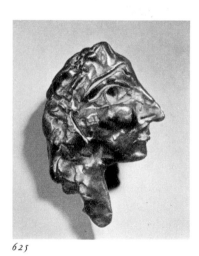

625

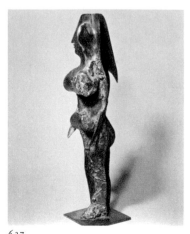

626

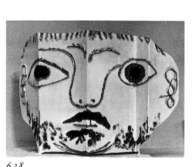

627

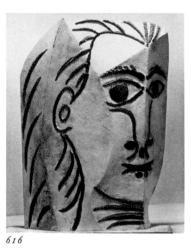

628

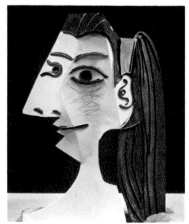

629

296

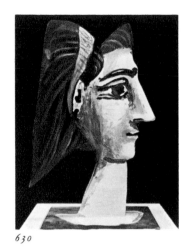

630

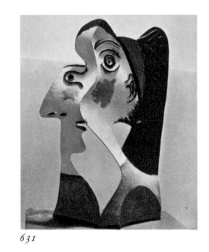

631

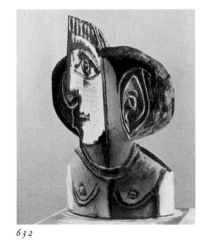

632

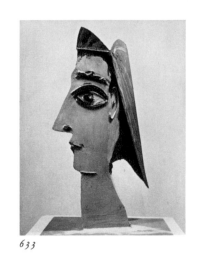

633

634

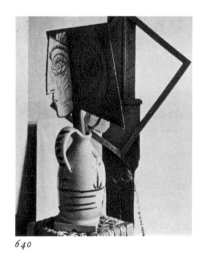

640

641

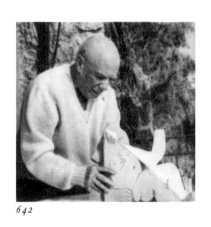

642

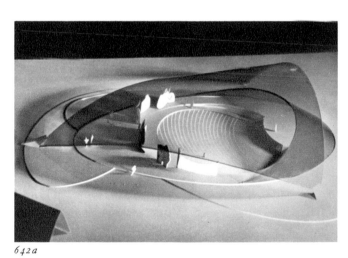

642a

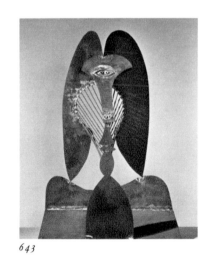

643

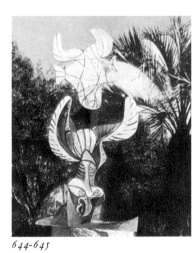

644-645

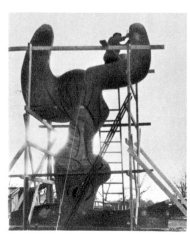

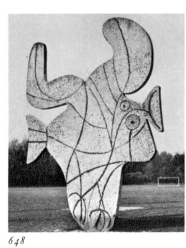

647 648

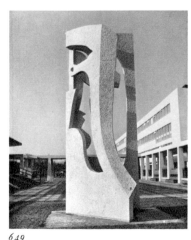

649

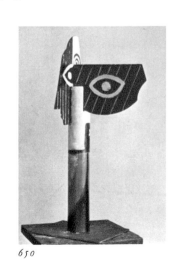

650

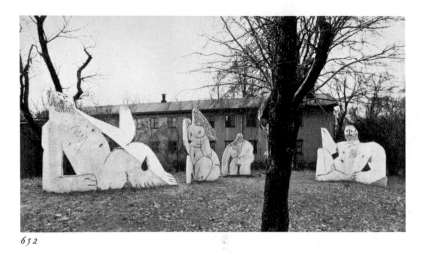

652

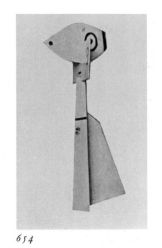

654

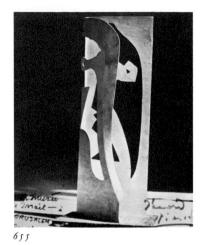

655

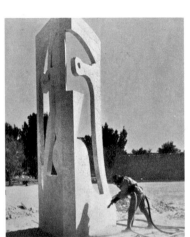

656

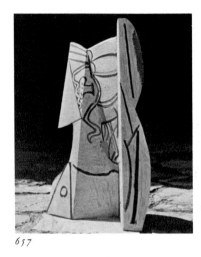

657

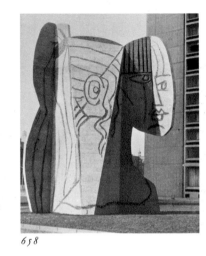

658

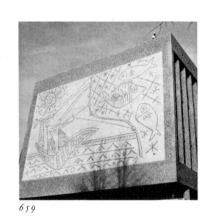

659

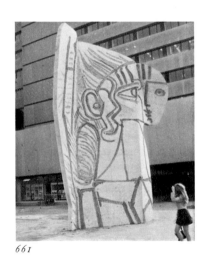

661

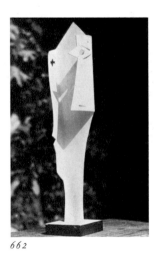

662

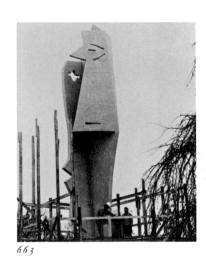

663

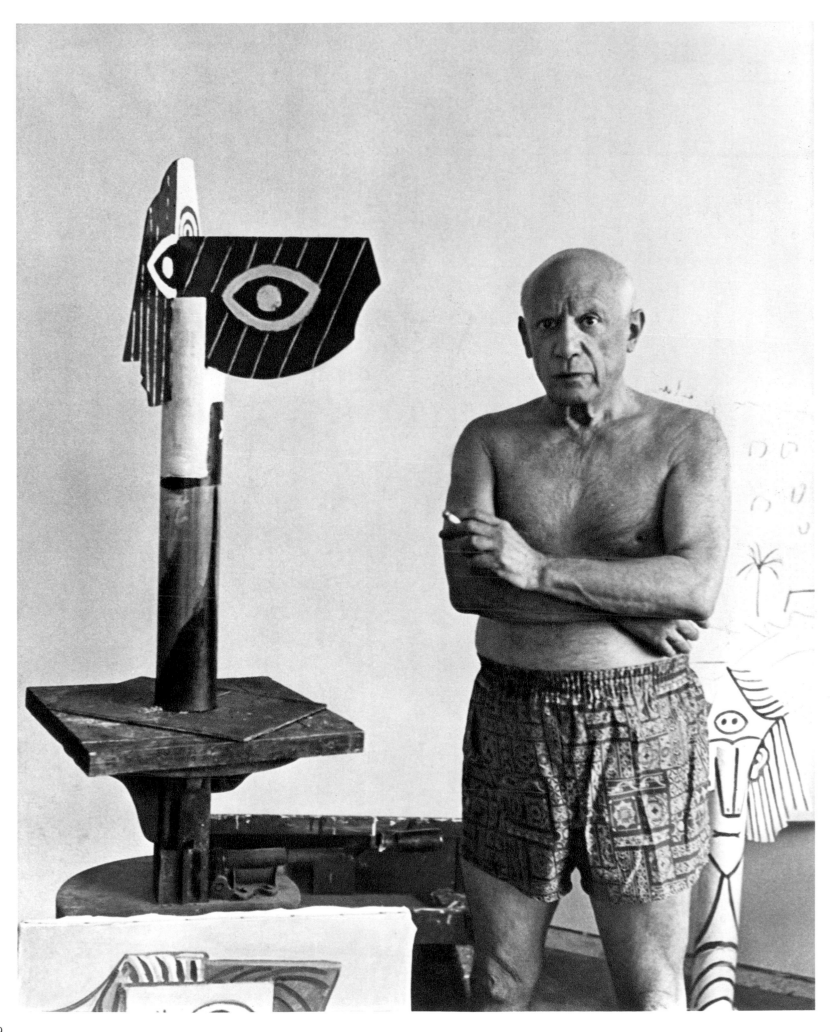

Catalogue

The chronology of Picasso's work given by Kahnweiler (*The Sculptures of Picasso*) and in the catalogues of the various Picasso retrospectives has been modified here in many instances, thanks to the co-operation of the artist and a close study of contemporary photographs and published sources.

I have followed precedent by separating ceramics from sculpture; Kahnweiler deals with ceramics in a separate volume, and the catalogues of the three major exhibitions which have been devoted to Picasso's sculpture (Paris 1966-67, London 1967 and New York 1967) make the same distinction. Consequently, ceramic does not feature here as a sculptural material in its own right, but only in those cases where a ceramic form served as the point of departure for a bronze casting. I have, however chosen six ceramics for reproduction (pp. 186–89, 258) in order to give some idea of the character of this part of Picasso's output. The examples have been chosen for their essentially sculptural formal qualities. Details of these six works will be found at the end of the catalogue; they are numbered *C 1 – C 6*.

The catalogue incorporates all the works that could be identified at the time of compilation. Apart from the records of successive exhibitions, I have made use of numerous photographs in which lost or destroyed works are documented. Further information has been provided by Picasso himself, who gave permission for his own collection to be photographed.

Picasso's collection constitutes a virtually complete record of his activity as a sculptor. He has Artist's Proofs of all the bronzes; and the one-off pieces, such as constructions, assemblages and found objects, are all, with very few exceptions, still in his possession. Where one of these objects has left Picasso's own collection, its ownership is indicated in the catalogue. In due course, I intend to prepare a scholarly *catalogue raisonné,* with exact details of material, edition, format, signature, literature and collections for each piece.

Measurements are given in inches and centimetres (feet and metres for larger works), height first.

1 * Seated Woman · Barcelona 1902
Bronze (original in unfired clay)
5 ½ × 3 ⅛ × 2 ¾ (14 × 8 × 7)
Ill. p. 29

2 Blind Singer · Barcelona 1903
Bronze · 5 ⅛ × 2 ¾ × 3 ⅛ (13 × 7 × 8)
Ill. p. 31

3 Head of Picador with Broken Nose
Barcelona 1903
Bronze · 7 ¼ × 5 ⅛ × 4 ⅜
(18 · 5 × 13 × 11)
Ill. p. 30

4 The Jester · Paris 1905
Bronze (original in wax)
15 ¾ × 13 ¾ (40 × 35)
Ill. p. 35

5 Head of a Woman (Alice Derain)
Paris 1905
Bronze · 10 ⅝ × 10 ⅝ × 5 ½
(27 × 27 × 14)
Ill. pp. 32–33

6 Head of a Woman (Fernande)
Paris 1906
Bronze · 13 ⅜ × 9 ⅞ × 10 ½
(34 × 25 × 26 · 5)
Ill. p. 36

7 Woman Arranging her Hair
Paris 1906
Bronze (original in ceramic)
h. 16 ½ (42)
Ill. p. 37

8 Head of a Woman · Paris 1906
Bronze (original in copper) · 4 ⅞ × 2 ⅜
(12 · 5 × 6)

9 Head of a Man · Paris 1906
Bronze (original in ceramic)
6 ½ × 8 ⅝ (16 · 5 × 22)

10 * Pipe-bowl · Paris 1906
Meerschaum

11 Head of a Woman · Paris 1906–07
Wood · 15 ⅝ × 7 ¼ (39 × 18 · 5)

12 Head of a Woman · Paris 1906–07
Bronze · 4 ¾ × 3 (12 × 7 · 5)
Ill. p. 40

13 Mask · Paris 1907
Bronze · 5 ⅞ × 4 ⅛ (15 × 10 · 5)
Ill. p. 41

14 Head · Paris 1907
Stone · 3 ⅜ × 3 (8 · 5 × 7 · 5)

15 Figure · Paris 1907
Wood · h. 13 (33)
Ill. p. 38

16 Figure · Paris 1907
Painted wood · h. 9 ⅞ (25)
Ill. p. 38

17 Woman · Paris 1907
Painted wood · 12 ⅝ × 3 ¼ (31 · 5 × 8)

18 Standing Man · Paris 1907
Boxwood · h. 13 ¾ (35)

19 Figure · Paris 1907
Painted wood · 32 ¼ × 9 ½ × 8 ½
(82 × 24 × 21 · 5)
Ill. p. 39

20 Standing Man · Paris 1907
Painted wood · h. 14 ½ (37)

21 Doll · Paris 1907
Bronze (original in wood)
8 ⅝ × 2 ⅜ × 2 ⅜ (22 × 6 × 6)

22 Mask of a Woman · Paris 1908
Bronze (original in terracotta)
7 ½ × 6 ¼ (19 × 16)
Ill. p. 44

* Picasso recalls modelling numerous Christmas crib figures in his childhood; many of them foreshadowed this piece (*1*).

* At the same period, Picasso recalls, he made a pipe with two bowls, one for cheap tobacco and one for expensive tobacco.

74 Figure of a Woman · Paris 1930
Iron, with iron last and ball, toys
and string
Temporary modification of 73
Ill. p. 82

75 Construction with Glove
Juan-les-Pins 22 August 1930
Cardboard, plaster and wood on
canvas, coated with sand
10⅝ × 14 (27 × 35 · 5)
Ill. p. 90

76 Relief · Juan-les-Pins 1930
Wood, cardboard and grass, coated
with sand · 10⅝ × 13¾ (27 × 35)
Ill. p. 86

77 Relief · Juan-les-Pins 1930
Wood and cardboard, coated with
sand · 15¾ × 12¾ (40 × 32 · 5)

78 Object with Palm-leaf
Juan-les-Pins 27 August 1930
Wood, cardboard and miscellaneous
objects, coated with sand

79 Head · 1931
Plaster · h. 21½ (55)
Ill. p. 87

80 Head · 1931
Bronze (original in wrought iron)
33 × 15¾ × 14¼ (84 × 40 × 36)
Ill. p. 84

81 Head of a Woman · 1931
Bronze (original in white painted
iron with two colanders)
39⅜ × 14½ × 24 (100 × 37 × 61)
Ill. p. 85

82 Construction · 1931
Flower-pot, roots, feather-duster
and horn
Ill. p. 89

83 Figurine · 1931
Iron wire and spool · h. 12⅝ (32)

84 Figurine · 1931
Iron and iron wire · h. 11 (28)
Ill. p. 88

85 Two Figurines · 1931
Iron wire · h. 1⅝ and 2 (4 and 5)

86* Woman · Boisgeloup 1931
Wood · h. 21⅞ (55 · 5)

87* Woman · Boisgeloup 1931
Wood · h. 17 (43)

88* Woman · Boisgeloup 1931
Wood · h. 20⅛ (51)

89* Woman · Boisgeloup 1931
Wood · h. 12⅜ (31 · 5)
Ill. p. 94

90* Woman · Boisgeloup 1931
Wood · h. 18⅞ (48)
Ill. p. 94

91* Woman · Boisgeloup 1931
Wood · h. 7¾ (19 · 5)
Ill. p. 95

92* Woman · Boisgeloup 1931
Wood · h. 7⅛ (18)

93* Woman · Boisgeloup 1931
Wood · h. 17⅜ (44)

94* Woman · Boisgeloup 1931
Wood · h. 16½ (42)

95* Woman · Boisgeloup 1931
Wood · h. 16½ (42)

96* Woman · Boisgeloup 1931
Wood · h. 17¾ (45)

97* Woman · Boisgeloup 1931
Wood · h. 6¼ (16)

98* Woman · Boisgeloup 1931
Wood · h. 6¾ (17)

99* Woman · Boisgeloup 1931
Wood · h. 6¾ (17)
Ill. p. 96

100* Woman · Boisgeloup 1931
Wood · h. 6¼ (16)

101* Woman · Boisgeloup 1931
Wood · h. 7½ (19)

102 Bust of a Woman · Boisgeloup 1931
Bronze (original in wood) · h. 4 (10)

103 Couple · Boisgeloup 1931
Bronze (original in wood) · h. 4 (10)

104 Seated Woman · Boisgeloup 1931
Bronze
31⅞ × 7⅞ × 7⅞ (81 × 20 × 20)
Ill. p. 107

105 Seated Woman · Boisgeloup 1931
Plaster · h. 11¾ (30)
Ill. p. 105

106 Seated Woman · Boisgeloup 1931
Bronze · h. 16½ (42)
Ill. p. 106

107 The Large Statue · Boisgeloup 1932
Plaster
Fragments in possession of the artist

108 Woman · Boisgeloup 1932
Bronze · 27⅞ × 12⅝ × 15¾
(71 × 32 × 40)
Ill. pp. 110–11

* 86–101 cast in bronze in 1937.

109 Reclining Woman · Boisgeloup 1932
Bronze · 9½ × 27½ × 11¾
(24 × 70 × 30)
Ill. pp. 108–09

110 Head of a Woman · Boisgeloup 1932
Bronze · 27½ × 16⅛ × 14⅛
(70 × 41 × 36)
Ill. p. 113

111 Bust of a Woman · Boisgeloup 1932
Bronze · 25⅛ × 12⅛ × 15 (64 × 31 × 38)
Ill. p. 112

112 Child with Ball · Boisgeloup 1932
Bronze · h. 19 (48)
Ill. p. 126

113 Figure · Boisgeloup 1932
Bronze · h. 15⅜ (39)

114 Woman with Raised Arms
Boisgeloup 1932
Bronze · 13 × 5½ × 5½ (33 × 14 × 14)
Ill. p. 127

115 Figure · Boisgeloup 1932
Bronze · 22⅞ × 11 × 7½ (58 × 28 × 19)
Ill. p. 129

116 Relief · 1932
Matches, thumb-tack, grass, leaf,
butterfly and cloth
Ill. p. 91

117 Relief · 1932
Cloth, grass, cardboard and toy
boat, coated with sand · 9¼ × 12⅞
(23 · 5 × 32 · 5)

118 Relief · 1932
Wood and grass, coated with sand
13 × 9½ (33 × 24)
Ill. p. 92

119 Relief · 1932
Wood and grass, coated with sand
14½ × 10⅝ (36 × 27)
Ill. p. 93

120 Head · Boisgeloup 1932
Plaster · h. 18½ (47)

121 Fragment · Boisgeloup 1932
Plaster · h. 5⅞ (15)
Ill. p. 121

122 Eye · Boisgeloup 1932
Plaster · h. 2 (5)
Ill. p. 120

123 Eye · Boisgeloup 1932
Plaster · h. 4¾ (12)

124 Eye · Boisgeloup 1932
Plaster · h. 2 (5)
Ill. p. 120

125 The Bird · Boisgeloup 1932
Plaster · h. 9⅞ (25)
Ill. p. 121

126 Head · Boisgeloup 1932
Plaster · h. 4¾ (12)

127 Head of a Bull (Heifer's Head)
Boisgeloup 1932
Bronze · 13 × 20⅝ × 21¼
(33 × 52 · 5 × 54)
Ill. p. 130

128 Head of a Woman · Boisgeloup 1932
Bronze · 19⅝ × 12⅜ × 10⅝
(50 × 31 × 27)
Ill. p. 115

129 Head of a Woman · Boisgeloup 1932
Bronze · h. 7⅞ (20)
Ill. p. 123

130 Head of a Woman · Boisgeloup 1932
Bronze · 27⅛ × 23⅝ × 4 (69 × 60 × 10)
Ill. p. 122

131* Bust of a Woman · Boisgeloup 1932
Bronze · 30¾ × 18⅛ × 18⅞
(78 × 46 × 48)
Ill. p. 119

132* Head of a Woman · Boisgeloup 1932
Bronze · 33½ × 14½ × 17⅞
(85 × 37 × 45 · 5)
Ill. pp. 116–17

133 Head of a Woman · Boisgeloup 1932
Bronze · 50⅜ × 22⅞ × 26
(128 × 58 × 66)
Ill. p. 118

134 The Cock · Boisgeloup 1932
Bronze · 26 × 24 × 13 (66 × 61 × 33)
Ill. p. 131

135* Woman with Vase · Boisgeloup 1933
Plaster · h. 7 ft 2½ (222)

136 Helmeted Head (Head of a Warrior)
Boisgeloup 1933
Bronze (original in plaster, metal and
stone) · 47⅝ × 15⅜ × 27⅛
(121 × 39 × 69)
Ill. pp. 132–33

137 Woman Running · Boisgeloup 1933
Bronze · 20½ × 12⅝ × 5½
(52 × 32 × 14)
Ill. p. 128

138 Face · Boisgeloup 1933
Plaster · h. 12⅝ (32)

139 Face · Boisgeloup 1933
Plaster · h. 12⅝ (32)
Ill. p. 124

* The works numbered *131*, *132* and *135*
were cast in cement for the pavilion
of the Spanish Republic at the Paris
World Exhibition in 1937. The cement
casts are now in the Musée Picasso,
Antibes.

140 Face · Boisgeloup 1933
Plaster · h. 4¾ (12)

141 Face · Boisgeloup 1933
Plaster · h. 5⅞ (15)

142 Face · Boisgeloup 1933
Bronze · h. 8¼ (21)
Ill. p. 125

143 Face · Boisgeloup 1933
Bronze · 11 × 9⅞ × 2¾ (28 × 25 × 7)

144 Face · Boisgeloup 1933
Plaster · h. 5⅞ (15)

145 Face · Boisgeloup 1933
Bronze · h. 6¼ (16)
Ill. p. 124

146 Face · Boisgeloup 1933
Plaster · h. 3⅛ (8)

147 Face · Boisgeloup 1933
Plaster · h. 4¾ (12)

148 Face · Boisgeloup 1933
Plaster · h. 4¾ (12)

149 Face · Boisgeloup 1933
Plaster · 4¾ (12)

150 Face · Boisgeloup 1933
Plaster · h. 4¾ (12)

151 Woman · Boisgeloup 1933
Plaster (with imprint of crumpled
paper) · h. 27½ (70)
Ill. p. 134

152 Man · Boisgeloup 1933
Cement (original in plaster with
imprint of corrugated cardboard)
h. 33½ (85)
Ill. p. 138

153 Woman Leaning on her Elbow
Boisgeloup 1933
Bronze (original in plaster with
imprint of crumpled paper and
corrugated cardboard)
24¾ × 16½ × 11 (63 × 47 × 28)
Ill. p. 139

154 Cock · Boisgeloup 1933
Bronze · h. 8⅝ (22)

155 Cock · Boisgeloup 1933
Bronze (original in plaster with
imprint of leaves) · h. 13¾ (35)
Ill. p. 135

156 Leaf · 1934
Plaster · h. 7⅞ (20)

157 Woman with Leaves · 1934
Bronze (original in plaster with
imprint of corrugated cardboard
and leaves) · 15 × 7⅞ × 10⅝

(38 × 20 × 27)
Ill. pp. 136–37

158 Head · 1934
Plaster · h. 17¾ (45)

159 Head · 1934
Plaster · h. 5⅞ (15)

160 Jointed Doll · 1935
Wood and cloth · h. 20⅞ (53)

161 Jointed Doll · 1935
Wood and cloth · h. 14⅛ (36)

162 Woman carrying a Pot · 1935
Wood and metal on cement base
23⅝ × 2 × 4¾ (60 × 5 × 12)

163 Figure · 1935
Wood, metal, string, celluloid and
leather on cement base
24¾ × 3⅛ × 4¾ (63 × 8 × 12)
Ill. p. 150

164 Figure · 1935
Painted wood on cement base
h. 23¼ (59)
Ill. p. 150

165 Figure · 1935
Wood, string, ladle and rakes
44⅛ × 23⅝ × 13¾ (112 × 60 × 35)
Ill. p. 151

166 Figure · 1935
Wood, doll's arm, metal, nails and
string on cement base
13¾ × 5⅞ × 5⅞ (35 × 15 × 15)
Ill. p. 149

167 Bird · 1935
Bronze · h. 10¼ (26)

168 Glass, Bottle and Mask · 1936
Wood and sheet metal

169 Construction with Objects and
Ceramic Tile · 1936
Wood, plaster, metal and
ceramic tile · diameter 10⅝ (27)
Ill. p. 152

170 The Table · 1937
Steel-wool, wooden knife, corrugated
paper, cardboard, piece of
tablecloth and oil on canvas
19¾ × 25½ (50 × 65)

171 Face · 1937
Pebble

172 Head · 1937
Pebble

173 Face · 1937
Pebble

174 Head of a Faun · 1937
Pebble

175 Face · 1937
Pebble · 5 × 4½ (12·5 × 11·5)

176 Head of a Bird · 1937
Bone

177 Relief · 19 March 1938
Wood · 10⅝ × 7½ (27 × 19)

178 Construction · 10 April 1938
Wood and metal on canvas
9⅞ × 10⅝ (25 × 27)
Ill. p. 153

179 Construction with Flower · 5 June 1938
Wood and metal on painted canvas
8¾ × 10⅝ (22·2 × 27)
Ill. p. 153

180 Face · 1938
Fragments of plate

181 Standing Figure · 1939
Bronze · 66⅝ × 19⅝ × 7½
(154 × 50 × 19)
Ill. p. 165

182 Woman · 1 February 1940
Painted and folded cardboard
h. 6¾ (17)

183 Woman · 2 February 1940
Painted and folded cardboard
h. 5⅞ (15)

184 Woman · 3 February 1940
Painted and folded cardboard
h. 5⅞ (15)

185 Woman · 1940
Painted and folded cardboard
h. 5⅞ (15)

186 Head of a Woman · 1940
Match-box · h. 4⅜ (11)

187 Composition · 1940
Bone · l. 2¾ (7)

188 Face · 1940
Pebble

189 Head · 1940
Pebble

190 Fish · 1940
Pebble

191 Head · 1940
Bone

192 Woman · 1940
Bronze · 12⅝ × 6¾ × 6¼
(32 × 17 × 16)
Ill. p. 155

193 Head of a Woman · 1941
Painted paper

194 Bull · 1941
Plaster · h. 11 (28)

195 The Cat · Paris 1941
Bronze · 18¼ × 30¼ × 7½
(46·5 × 77 × 19)
Ill. p. 154

196 Standing Woman · Paris 1941
Bronze · h. 4¾ (12)

197 Head of a Woman · Paris 1941
Bronze · h. 31½ (80)
Ill. pp. 156–57

198 Head of a Woman · Paris 1941 (?)
Bronze

199 Piece of Wood on a Match-box · 1941
l. 5⅛ (13)

200 Piece of Bread and Paper Flower
1941
h. 8⅝ (22)

201 Bird · 1942
Scooter and feather · h. 28⅜ (72)
Ill. p. 160

202 Bird · Paris 1942
Plaster · h. 3⅛ (8)

203 Figure of a Woman · Paris 1942
Plaster · h. 9⅞ (25)
Ill. p. 172

204 excluded

205 Bust of a Woman · Paris 1942
Bronze · h. 9 (23)

206 Crouching Woman · Paris 1942
Bronze · h. 4 (10)

207 Standing Woman · Paris 1942
Unfired clay · h. 8⅞ (22·5)

208 Standing Man · Paris 1942
Bronze · h. 7⅞ (20)

209 Head · Paris 1943
Plaster · h. 5⅞ (15)

210 excluded

211 Head · Paris 1943
Plaster · h. 5⅞ (15)

212 Death's Head · Paris 1943
Bronze · h. 1½ (4)

213 Death's Head · Paris 1943
Bronze · h. 1¼ (3)

214 Death's Head · Paris 1943
Bronze · h. 1½ (4)

215 Death's Head · Paris 1943
Bronze · h. 5⅞ (15)

216 Death's Head · Paris 1943
Bronze · h. 2¾ (7)

217 Head · Paris 1943
Plaster · h. 13¾ (35)

218 Head · Paris 1943
Stone · h. 12⅝ (32)
Ill. p. 171

219 Death's Head · Paris 1943
Casts in bronze and copper
11⅜ × 8⅜ × 10¼ (29 × 22 × 26)
Ill. p. 170

220 Picasso's Hand · Paris 1943
Plaster

221 Picasso's Hand · Paris 1943
Plaster

222 Picasso's Hand
Plaster · l. 14½ (37)

223 Picasso's Hand · Paris 1943
Bronze · h. 9⅞ (25)

224 Picasso's Hand · Paris 1943
Plaster

225 Standing Woman · Paris 1943
Bronze · h. 7⅞ (20)

226 Standing Woman · Paris 1943
Bronze · h. 8⅝ (22)
Ill. p. 158

227 Woman with Raised Arms · Paris 1943
Bronze · h. 8¼ (21)
Ill. p. 159

228 Standing Woman · Paris 1943
Bronze · h. 14⅛ (36)
Ill. p. 158

229 Figure · Paris 1943
Plaster · h. 4¾ (12)

230 Woman · Paris 1943
Bronze · 20⅞ × 7½ (53 × 19)

231 Head of a Woman · Paris 1943
Bronze · h. 3⅛ (8)

232 Head of a Woman · Paris 1943
Bronze · h. 3⅛ (8)

233 Head of a Woman · Paris 1943
Bronze · h. 5⅞ (15)

234 The Reaper · Paris 1943
Bronze (from assemblage with
cake-mould) · 20¼ × 12⅝ × 5½
(51·5 × 32 × 14)
Ill. p. 140

235 Head of a Woman · Paris 1943
Bronze · 23¼ × 17⅜ × 11
(59 × 44 × 28)
Ill. p. 162

236 Woman with Apple · Paris 1943
Bronze (from assemblage of cake-
mould, vase, branch of tree, and
sculptures made at Boisgeloup)
71⅞ × 30¾ × 28 (180 × 78 × 71)
Ill. p. 163

237 The Madame · Paris 1943
Bronze (from assemblage of bricks,
metal fragments, key)
67¾ × 17 × 11¾ (172 × 43 × 30)
Ill. p. 166

238 Woman in Long Dress · Paris 1943
Bronze (from assemblage of dummy
and fragment of Easter Island
sculpture, the latter forming the
left arm) · 63⅜ × 20⅞ × 20⅞
(161 × 53 × 53)
Ill. p. 167

239 The Flowering Watering-can
Paris 1943
Bronze (from assemblage of plaster,
metal and watering-can)
33 × 17⅞ × 15¾ (84 × 43 × 40)
Ill. p. 164

240 Head of a Bull · Paris 1943
Bronze (from assemblage of bicycle
saddle and handlebars)
16½ × 16⅛ × 5⅞ (42 × 41 × 15)
Ill. p. 161

241 Head of a Bull · 1943–44
Assemblage of spade, handlebars,
wheel and metal tubes

242 Head Placed on a Radiator
Paris 1943
Wood · h. 11¾ (30)

243 Composition · Paris 1943
Plaster (cast from corrugated
cardboard) · h. 4¾ (12)

244 Composition · Paris 1943
Plaster (cast from corrugated
cardboard) · h. 3⅛ (8)

245 Fragment · Paris 1943
Plaster (cast from crumpled
paper) · h. 5⅞ (15)

246 Fragment · Paris 1943
Plaster (cast from crumpled
paper) · h. 4¾ (12)

247 Head of a Dog · Paris 1943
Paper · h. 5½ (14)

248 Head of a Dog · Paris 1943
Paper · h. 5½ (14)

249 Head of a Dog · Paris 1943
Paper

250 Head of a Dog · Paris 1943
Paper

251 Head of a Dog · Paris 1943
Paper

252 Head of a Dog · Paris 1943
Paper · h. 5½ (14)

253 Head · Paris 1943
Paper · h. 3½ (9)

254 Head of an Animal · Paris 1943
Paper · h. 3½ (9)

255 Head of a Fox · Paris 1943
Paper · h. 4¾ (12)

256 Death's Head · Paris 1943
Paper · h. 5½ (14)

257 Death's Head · Paris 1943
Paper · h. 4¾ (12)

258 Death's Head · Paris 1943
Paper · h. 5½ (14)

259 Head of a Faun · Paris 1943
Paper · h. 9½ (24)

260 Goat · Paris 1943
Paper · h. 11¾ (30)

261 Glove · Paris 1943
Paper

262 Figurines · Paris 1943
Paper

263 Mask · Paris 1943
Paper

264 Head of a Bird · Paris 1943
Paper

265 Fish · Paris 1943
Paper · h. 5⅛ (13)

266 Composition · Paris 1943
Paper

267 Head in Profile · Paris 1943
Paper · h. 7⅞ (20)

268 Mask · Paris 1943
Paper · h. 7⅞ (20)

269 Bust of a Woman · Paris 1943
Paper · h. 5⅛ (13)

270 Child · Paris 1943
Cigarette-box · h. 5⅛ (13)

271 Bird · Paris 1943
Wood and plaster · l. 4¾ (12)

272 Bird · Paris 1943
Tin · l. 1⅛ (3)

273 Bird · Paris 1943
Tin · l. 1⅛ (3)

274 Bird · Paris 1943
Tin · l. 1⅛ (3)

275 Bird · Paris 1943
Tin · l. 1⅛ (3)

276 Bird · Paris 1943
Match-box · l. 3⅛ (8)

277 Bust of a Woman · Paris 1943
Cardboard · h. 11⅜ (29)

278 The Cat · Paris 1944
Bronze · 14⅛ × 21⅝ × 6⅞
(36 × 55 × 17 · 5)

279 Head of a Man · Paris 1944
Bronze · h. 9⅞ (25)

280 Man with Sheep · Paris 1944
Bronze · 86½ × 30¾ × 28⅜
(220 × 78 × 72)
Ill. pp. 168–69

281 Head of a Faun · 1944–45
Fragment of porcelain

282 Figure · 1944–45
Pebble

283 Head of a Faun · 1944–45
Pebble

284 Face · 1944–45
Pebble

285 Face · 1944–45
Pebble

286 Face · 1944–45
Pebble

287 Face · 1944–45
Pebble

288 Face · 1944–45
Pebble

289 Head of an Animal · 1944–45
Pebble

290 Head of an Animal · 1944–45
Pebble

291 Face · 1944–45
Pebble

292 Face · 1944–45
Pebble

293 Face · 1944–45
Pebble

294 Face · 1944–45
Pebble

295 Face · 1944–45
Pebble

296 Face · 1944–45
Pebble

297 Face · 1944–45
Pebble

298 Figure · 1944–45
Pebble

299 Figure of a Woman · 1944–45
Pebble

300 Figure · 1944–45
Pebble

301 Face · 1944–45
Pebble

302 Face · 1944–45
Pebble

303 Standing Woman · 1945
Bronze · h. 10 (25 · 5)
Ill. p. 181

304 Standing Woman · 1945
Bronze · h. 9⅛ (23)

305 Standing Woman · 1945
Bronze · h. 9⅛ (23)
Ill. p. 181

306 Standing Woman · 1945
Bronze · h. 5½ (14)

307 Standing Woman · 1945
Bronze · h. 10¼ (26)

308 Standing Woman · 1945
Bronze · h. 7⅞ (20)
Ill. p. 181

309 Standing Woman · 1945
Bronze · h. 5⅜ (13 · 5)

310 Standing Woman · 1945
Bronze · h. 7¼ (18 · 5)
Ill. p. 181

311 Standing Woman · 1945
Bronze · h. 7⅞ (20)

312 Standing Woman · 1945
Bronze · h. 7⅞ (20)

313 Standing Woman · 1945
Bronze · h. 5 (12 · 5)

314 Standing Woman · 1945
Bronze · h. 9½ (24)

315 Standing Woman · 1945
Bronze · h. 8½ (21 · 5)

316 Standing Woman · 1945
Bronze · h. 5¾ (14 · 5)

317 Vase Face · 1946
Bronze (original in ceramic)
11 × 4 × 5½ (28 × 10 × 14)
Ill. p. 184

318 Woman · Paris 1946
Bronze on wood base
11 × 3⅜ × 1⅜ (28 × 8 · 5 × 3 · 5)

319 Bust of a Woman · Paris 1946
Bone · h. 3⅛ (8)

320 Head of a Ram · 1947
Bronze (original in ceramic)
8 × 10¼ × 4 (20 × 26 × 10)

321 Vase Woman · 1947
Bronze (original in ceramic)
h. 9⅞ (25)
Ill. p. 182

322 Standing Woman · 1947
Bronze · h. 8¼ (21)
Ill. p. 181

323 Standing Woman · 1947
Bronze · h. 7¾ (19 · 5)

324 Standing Woman · 1947
Bronze · h. 3⅜ (8 · 5)
Ill. p. 181

325 Seated Woman · 1947
Bronze · h. 4⅞ (12 · 5)
Ill. p. 181

326 Standing Woman · 1947
Bronze · h. 6⅞ (17 · 5)
Ill. p. 181

327 Standing Woman · 1947
Bronze · h. 9½ (24)

328 Standing Woman · 1947
Bronze · h. 7¾ (19 · 5)

329 Standing Woman · 1947
Bronze · h. 5⅜ (13 · 5)

330 Standing Woman · 1947
Bronze · h. 3⅜ (8 · 5)

331 Crouching Woman · 1947
Bronze · h. 6½ (16 · 5)

332 Female Form · Vallauris 1948
Bronze (original in ceramic)
37¾ × 10¼ × 7⅞ (96 × 26 × 20)
Ill. p. 185

333 Woman · Vallauris 1948
Bronze · h. 10 (25 · 5)
Ill. p. 190

334 Woman · Vallauris 1948
Bronze · h. 7 (18)
Ill. p. 191

335 Small Pregnant Woman
Vallauris 1948
Bronze · h. 12¾ (32 · 2)
Ill. p. 193

336 The Centaur · Vallauris 1948
Bronze (original in ceramic)
15⅛ × 11¾ × 6¼ (38 · 5 × 30 × 16)
Ill. p. 183

337 Head of an Animal · Vallauris 1948
Bronze · 14⅛ × 9½ × 8¼
(36 × 24 × 21)

338 Hand with Sleeve · 1948
Bronze (original in ceramic)
2¾ × 9⅞ × 4⅜ (7 × 25 × 11)

339 Dove Face · 1948
Cut paper · 7⅞ × 7¾ (20 × 19 · 5)

340 Hand · Vallauris 1949
Bronze · 4 × 10¼ (10 × 26)

341 Head of a Faun · Vallauris 1949
Bronze (original in ceramic)
15¾ × 7⅞ (40 × 27)
Ill. p. 199

342 The Swallow · Vallauris 1949
Bronze · 2½ × 7½ (6 · 5 × 19)

343 Centaur · Vallauris 1949
Bronze · 10⅝ × 6½ (27 × 16 · 5)

344 Woman with Palm · Vallauris 1949
Bronze · 8¾ × 4 (22 · 2 × 10)

345 Woman · Vallauris 1949
Bronze · 9½ × 4⅜ (24 × 11)

346 The Glass · Vallauris 1949
Bronze (from assemblage of plaster
in box, metal and bone)
8⅝ × 8⅝ × 4¾ (22 × 22 × 12)

347 Female Form · Vallauris 1949
Bronze (from assemblage of plaster
and iron bar) · 50 × 14½ × 4
(127 × 37 × 10)
Ill. p. 194

348 Hand · Vallauris 1950
Bronze (original in ceramic)
1¾ × 7⅞ (4 · 5 × 20)
Ill. p. 198

349 The Pregnant Woman
Vallauris 1950
Bronze (first version)

350 The Pregnant Woman
Vallauris 1950–59
Bronze (original in plaster with
ceramic elements) · 43¼ × 11¾ × 13⅜
(110 × 30 × 34)
Ill. pp. 196–97

351 Woman with Arms Crossed
Vallauris 1950 (?)
Bronze

352 Head of a Woman · Vallauris 1950
Bronze · 10½ × 6⅞ × 11¼
(26 · 5 × 17 · 5 × 28 · 5)

353 Head · Vallauris 1950
Bronze · h. 3¼ (8 · 4)

354 Head of a Bull · Vallauris 12 July 1950
Bronze · h. 3½ (9)

355 Head of a Bull · Vallauris 1950
Bronze · 2¼ × 2⅛ (5 · 6 × 5 · 3)

356 Head of a Ram · Vallauris 1950
Bronze · 6¾ × 9½ (17 × 9 · 4)

357 Head of a Bird · Vallauris 1950
Bronze · l. 3½ (8 · 8)

358 Head of a Cock · Vallauris 1950
Bronze · h. 2⅛ (5 · 3)

359 Bird · Vallauris 1950
Bronze · 8⅞ × 2½ (9 · 7 × 6 · 5)

360 Paloma · Vallauris 1950
Bronze · h. 3⅛ (8)

361 Face of a Bearded Man
Vallauris 1950
Bronze · h. 1⅝ (4)

362 Face of a Bearded Man
Vallauris 25 July 1950
Bronze · h. 1⅝ (4 · 2)

363 Face of a Bearded Man
Vallauris 1950
Bronze · h. 2⅜ (6)

364 Face of a Bearded Man
Vallauris 1950
Bronze · h. 2½ (6 · 3)

365 Face of a Bearded Man
Vallauris 1950
Bronze · h. 3 (7 · 5)

366 Face of a Bearded Man
Vallauris 1950
Bronze · h. 3¼ (8 · 4)

367 Face of a Bearded Man
Vallauris 1950
Bronze · h. 3⅛ (7 · 9)

368 Face · Vallauris 2 August 1950
Bronze · h. 2½ (6 · 2)

369 Face · Vallauris 1950
Bronze · h. 1¼ (3)

370 Head of a Woman · Vallauris 1950
Bronze · h. 1⅜ (3 · 4)

371 Head of a Faun · Vallauris 1950
Bronze · h. 2⅛ (5 · 3)

372 Head of a Faun · Vallauris 1950
Bronze · h. 2 (5)

373 Head of a Faun · Vallauris 1950
Bronze · h. 2⅛ (5 · 2)

374 Head of a Faun · Vallauris 1950
Bronze · h. 2¼ (5 · 8)

375 Head of a Faun · Vallauris 1950
Bronze · h. 2⅛ (5 · 2)

376 Head of a Faun · Vallauris 1950
Bronze · h. 1⅞ (4 · 9)

377 Head of a Faun · Vallauris 1950
Bronze · h. 2¾ (7 · 1)

378 Head of a Faun · Vallauris 1950
Bronze · h. 2¼ (5 · 7)

379 Head of a Faun · Vallauris 1950
Bronze · h. 2⅛ (5 · 5)

380 Centaur · Vallauris 1950
Bronze · 3⅝ × 3⅛ (9 · 2 × 8)

381 Priapus · Vallauris 1950
Bronze · 2¾ × 2⅜ (7 × 6)

382 Winged Centaur with Owl
Vallauris 1950
Bronze · 5½ × 4⅜ (14 × 11)

383 Winged Centaur with Owl
Vallauris 1950
Bronze · 5¼ × 4⅜ (13 · 5 × 11)
Ill. p. 192

384 Female Figure · Vallauris 1950
Bronze · h. 3¾ (9 · 6)

385 Seated Woman · Vallauris 1950
Bronze · 4⅜ × 3¾ (11 × 9 · 5)

386 Seated Woman · Vallauris 1950
Bronze · 3¼ × 3 (8 · 2 × 7)

387 Small Seated Woman · Vallauris 1950
Bronze · h. 2¼ × 1⅞ (5 · 8 × 4 · 7)

388 Woman with Raised Arms
Vallauris 1950
Bronze · h. 5½ (14)

389 Standing Woman · Vallauris 1950
Bronze · h. 5 (12 · 5)

390 Head of a Ram
Vallauris 7 September 1950
Bronze · 5⅞ × 4⅜ (15 × 11)

391 Bull · Vallauris 1950
Bronze · 2⅝ × 4¾ (6 · 5 × 12)

392 The Charging Bull · Vallauris 1950
Bronze · 2⅜ × 4¾ (6 × 12)

393 Goat Lying Down · Vallauris 1950
Bronze · 2¼ × 3 (5 · 6 × 7 · 7)

394 Goat with Hoof Drawn Back
Vallauris 1950
Bronze · 3¼ × 4⅛ (8 · 4 × 10 · 4)

395 Small Goat · Vallauris 1950
Wax

396 Seated Woman
Vallauris 14 November 1950
Unfired clay

397 Seated Woman · Vallauris 1950
Clay

398 The Little Goat · Vallauris 1950
Copper cut-out · 4¼ × 3⅛ (11 × 8)
Private collection, Paris

399 Bird · Vallauris 1950
Copper cut-out

400 Owl · Vallauris 1950
Copper cut-out on stone base
h. 1⅝ (4) excluding base
Hanover Gallery, London

401 Owl · Vallauris 1950
Metal cut-out on stone base

402 Owl · Vallauris 1950
Ceramic and copper cut-out
h. 5 (12 · 5)

403 The Owl · Vallauris 1950
Bronze · 14½ × 10¼ × 10¼
(37 × 26 × 26)
Ill. p. 201

404 The Angry Owl · Vallauris 1950
Bronze · 13 × 12⅝ × 13⅜
(33 × 32 × 34)
Ill. p. 200

405 Woman · Vallauris 1950
Bronze · 11 × 4½ (28 × 11 · 5)

406 The Hand · Vallauris 1950
Bronze · 7⅞ × 4¾ (20 × 12)

407 Woman with Pushchair
Vallauris 1950
Bronze (from assemblage of cake-tins,
terracotta, stove-plate and pushchair)
80 × 57 × 23⅝ (203 × 145 × 60)
Ill. p. 211

408 Little Girl Skipping · Vallauris 1950
Bronze (from assemblage of metal
frame, wicker basket, cake-tin,
ceramic elements and plaster)
60¼ × 25⅝ × 24⅜ (153 × 65 × 62)
Ill. pp. 208–09

409 Goat · Vallauris 1950
Bronze (from assemblage of palm-leaf, ceramic flower-pots, wicker basket, metal elements and plaster
47⅝ × 28¾ × 55 (121 × 73 × 140)
Ill. pp. 206–07

410 Goat's Skull and Bottle
Vallauris 1951
Painted bronze (from assemblage of bicycle handlebars, nails, metal, ceramic) · 31½ × 26¾ × 14⅛
(80 × 68 × 36)
Ill. p. 178

411 Head of a Woman · Vallauris 1951
Bronze · 21¼ × 7⅛ × 13¾
(54 × 18 × 35)
Ill. p. 213

412 Head of a Woman · Vallauris 1951
Bronze · 19⅞ × 8⅝ × 14½
(50·5 × 22 × 37)
Ill. p. 212

413 Flowers in a Vase · Vallauris 1951
Bronze (from assemblage of cake-moulds and ceramic)
28¾ × 19¼ × 16½ (73 × 49 × 42)
Ill. p. 204

414 Animal · Vallauris 1951
Bronze (original in ceramic)
10⅝ × 11⅝ (27 × 29·5)

415 Arm · Vallauris 1951
Bronze · l. 22 (56)

416 Hand · Vallauris 1951
Bronze · 5¾ × 3⅜ (14·5 × 8·5)

417 Hand · Vallauris 1951
Bronze · 5½ × 5¼ (14 × 13·5)

418 Hand · Vallauris 1951
Bronze · 9⅝ × 3⅛ (24·5 × 8)

419 Seated Satyr · Vallauris 1951
Bronze · 4 × 3 (10 × 7·7)

420 Seated Satyr · Vallauris 1951
Bronze · 3⅝ × 2⅝ (9·3 × 6·8)

421 Seated Satyr · Vallauris 1951
Bronze · 3⅞ × 3 (9·7 × 7·5)

422 Seated Satyr · Vallauris 1951
Bronze · 3½ × 2½ (8·9 × 6·4)

423 Seated Satyr · Vallauris 1951
Bronze · 3¾ × 1⅞ (9·5 × 4·7)

424 The Goat Gradiva · Vallauris 1951
Bronze · 3 × 2⅝ (7·5 × 6·8)

425 Goat Lying Down · Vallauris 1951
Bronze · 1⅝ × 2⅛ (4·2 × 5·3)

426 Seated Musician · Vallauris 1951
Bronze · 4¼ × 4 (10·8 × 10)

427 Seated Musician · Vallauris 1951
Bronze · 3 × 2¾ (7·5 × 7)

428 Figure with Open Arms
Vallauris 1951
Bronze · h. 4 (10·2)

429 The Standing Musician
Vallauris 1951
Bronze · 5⅛ (13)

430 Centaur · Vallauris 1951
Bas-relief, bronze · 5⅛ × 4⅝
(13·2 × 11·7)

431 Female Figure · Vallauris 1951
Bronze · h. 3½ (8·8)

432 Female Figure · Vallauris 1951
Bronze · h. 8⅝ (9·2)

433 Female Figure · Vallauris 1951
Bronze · h. 3⅜ (8·7)

434 Female Figure · Vallauris 1951
Bronze · h. 3¾ (9·4)

435 Female Figure · Vallauris 1951
Bronze · h. 3½ (9)

436 Female Figure · Vallauris 1951
Bronze · h. 3⅞ (9·7)

437 Female Figure · Vallauris 1951
Bronze · h. 4½ (11·5)

438 Nude Woman · Vallauris 1951–52
Bronze · h. 4⅞ (12·5)

439 Woman · Vallauris 1951–52
Bronze · h. 4⅜ (11)

440 Head of a Woman · Vallauris 1951
Bronze · h. 1½ (3·7)

441 Face of a Bearded Man
Vallauris 1951
Bronze · h. 4 (10·2)

442 Face of a Bearded Man
Vallauris 1951
Bronze · h. 2⅛ (5·4)

443 Head of a Faun · Vallauris 1951
Bronze · h. 1⅝ (4)

444 Head of a Faun · Vallauris 1951
Bronze · h. 2 (5)

445 Seated Musician · Vallauris 1951
Clay

446 Pot with Centaur (Head of a Faun on Reverse) · Vallauris 22 August 1952
Bronze · h. 12 (30·5)

447 Pot with Whiskered Man (Face on Reverse) · Vallauris 23 August 1952
Bronze · h. 12⅝ (32)

448 Pot with Two Faces
Vallauris 24 August 1952
Bronze · h. 12¼ (31)

449 Pot with Faces and Branches
Vallauris 24 August 1952
Bronze · h. 11¾ (30)

450 Face of a Woman · Vallauris 1952
Bronze · 9 × 4¾ (22·8 × 12)

451 Head of Woman with Chignon
Vallauris 1952
Bronze · h. 5⅞ (15)

452 Bust of a Woman
Vallauris 31 December 1952
Bronze · h. 5⅞ (15)

453 Head of a Young Woman
Vallauris 1952
Bronze · 2¼ × 1½ (5·8 × 4)

454 Head of a Bearded Man
Vallauris 1952
Bronze · h. 4⅜ (11)

455 Head of a Woman · Vallauris 1952
Bronze · h. 2⅝ (6·6)

456 Head of a Woman · Vallauris 1952
Bronze · h. 2½ (6·3)

457 Small Seated Musician
Vallauris 1952
Bronze · 2⅛ × 1⅝ (5·4 × 4·3)

458 Priapus · Vallauris 1952
Bronze · 2 × 1¼ (5 × 3·1)

459 Seated Old Man · Vallauris 1952
Bronze · 2 × 2⅜ (4·9 × 6)

460 Jug and Figs · Vallauris 1952
Painted bronze · h. 11⅜ (29)
Ill. p. 216

461 The Crane · Vallauris 1952
Painted bronze (original in plaster with gas-cock, forks and shovel)
29½ × 11½ × 17 (75 × 29 × 43)
Ill. p. 217

462 Woman Reading · Vallauris 1952
Painted bronze (original in plaster with wood, nails and screws)
6⅛ × 14 (15·5 × 35·5)
Ill. p. 218

463 Baboon and Young · Vallauris 1952
Bronze (original in plaster with metal, ceramic and two toy cars)
21⅝ × 13⅜ × 24⅜ (55 × 34 × 63)
Ill. pp. 214–15

464 Woman Arranging her Hair
Vallauris 1 January 1953
Bronze · 6¾ × 5⅞ (17 × 15)

465 Head of a Bearded Man
Vallauris 1 January 1953
Terracotta · 3½ × 3 (9 × 7 · 5)
Collection Lionel Prejger

466 Woman with Kerchief
Vallauris 4 January 1953
Bronze · h. 6¼ (16)

467 Vase with Flower · Vallauris 1953
Bronze (original in iron and ceramic)
29 × 17¼ × 6 (74 × 44 × 15)
Ill. p. 202

468 Vase and Cake-plate · Vallauris 1953
Bronze (original in ceramic with nails)
h. 33⅜ (85)
Ill. p. 203

469 Face · Vallauris 1953
Bronze (original in ceramic)
10⅝ × 5⅞ (27 × 15)
Ill. p. 220

470 The Bunch of Flowers
Vallauris 1953
Bronze · 23⅝ × 19⅝ × 15⅜
(60 × 50 × 39)
Ill. p. 205

471 Seated Woman · Vallauris 1953
Bronze · 8⅝ × 4⅞ (22 × 12 · 5)

472 Standing Woman · Vallauris 1953
Bronze · 20½ × 4 × 4¾ (52 × 10 × 12)
Ill. p. 195

473 Dove · Vallauris 29 January 1953
Bronze (original in ceramic)
6¾ × 11 × 4¾ (17 × 28 × 12)

474 Dove · Vallauris 14 October 1953
Bronze (original in ceramic)
5½ × 9 × 4⅜ (14 × 23 × 11)

475 The Little Owl · Vallauris 1953
Painted bronze with nails and screws
h. 13 (33)

476 The Little Owl · Vallauris 1953
Painted bronze · h. 10¼ (26)

477 The Angry Owl · Vallauris 1953
Bronze · 10⅝ × 8⅝ × 11 (27 × 22 × 28)
Ill. p. 219

478 Woman Carrying a Child
Vallauris 1953
Painted wood · 69 × 20½ × 13
(175 × 52 × 33)
Ill. p. 229

479 Standing Woman · Vallauris 1953
Painted wood · 35½ × 7¼ × 2½

(90 × 18 · 5 × 6 · 5)
Ill. p. 230

480 Standing Woman · Vallauris 1953
Painted wood · 54 × 17¾ × 6⅞
(137 × 45 × 17 · 5)
Ill. p. 231

481 Dolls · Vallauris c. 1953
-87 Wood

488 Sylvette · Vallauris 1954
Metal cut-out, folded and painted
27⅛ × 17⅜ (69 × 44)
Ill. p. 232

489 Sylvette · Vallauris 1954
Metal cut-out, folded and painted
27½ × 17¼ (70 × 44)
Ill. p. 233

490 Sylvette · Vallauris 1954
Metal cut-out, folded and painted
23¼ × 13 (59 × 33)

491 Sylvette · Vallauris 1954
Metal cut-out, folded and painted
24⅜ × 17⅜ (62 × 44)

492 Head of a Woman · Vallauris 1954
Metal cut-out, painted
30¼ × 10⅜ × 14¼ (77 × 26 · 5 × 36)

493 Head of a Woman · Vallauris 1954
Wood cut-out, painted
31½ × 11 × 13¾ (80 × 28 × 35)

494 Head of a Woman · Vallauris 1954
Metal cut-out, painted
32 × 13½ × 12¾ (81 × 34 · 5 × 32 · 5)
Ill. p. 235

495 Head of a Woman · Vallauris 1954
Metal cut-out, painted
34¼ × 10¾ × 10¾ (87 × 27 · 5 × 27 · 5)
Ill. p. 234

496 Bust of a Woman · Vallauris c. 1954
Painted cardboard

497 Pigeon · Vallauris 1954
Bronze (original in ceramic)
5 × 10½ (12 · 5 × 26)

498 Pigeon · Vallauris 1954
Bronze (original in ceramic)
5 × 10½ (12 · 5 × 26)

499 Pigeon · Vallauris 1954
Bronze (original in ceramic)
5⅛ × 12¼ (13 × 31)

500 Figures for Clouzot's Film
-01 'Le Mystère Picasso' · Nice 1955
Painted wood
Destroyed

502 Vase with Three Heads · 13 May 1955
Bronze · h. 17¼ (44)

503 The Woman Diver
(The Bathers series)
Cannes 1956
Bronze (original in wood)
h. 8ft 8 (264)
Ill. p. 237, extreme left

504 Man with Clasped Hands
(The Bathers series) · Cannes 1956
Bronze (original in wood)
h. 7ft (214)
Ill. p. 237, second left

505 The Fountain-Man
(The Bathers series) · Cannes 1956
Bronze (original in wood)
h. 7ft 5½ (227)
Ill. p. 237, third left

506 Child (The Bathers series)
Cannes 1956
Bronze (original in wood)
h. 4ft 5 (136)
Ill. p. 237, third right

507 Woman with Outstretched Arms
(The Bathers series) · Cannes 1956
Bronze (original in wood)
h. 6 ft 2½ (198)
Ill. p. 237, second right

508 The Young Man (The Bathers series)
Cannes 1956
Bronze (original in wood)
h. 5ft 9 (176)
Ill. p. 237, extreme right

509 Young Man · 1956
Bronze (original in wood)
31½ × 16⅛ × 9 (80 × 41 × 23)
Ill. p. 238

510 Wall in the Government Palace, Oslo
1956
Betongravure (engraving on
concrete), from three designs by
Picasso, executed by Carl Nesjar

511 Woman with Necklace · Cannes 1957
Bronze · 14¼ × 3½ × 5½
(36 × 9 × 14)

512 The Bull · 1957
Bronze · 15¾ × 26 × 8½
(40 × 66 × 21 · 5)

513 Head of a Bull · 1957
Bronze (original in ceramic)
14½ × 7⅞ × 7⅛ (37 × 20 × 18)

514 Bucranium · 1957
Bronze · 4½ × 4⅛ (11 · 5 × 10 · 5)

515 Small Animal Head with Large Ears
1957
Bronze · 4¾ × 5½ (12 × 14)

516 Head of a Horned Animal · 1957
Bronze · 8⅝ × 11 (22 × 28)

517 Large Head with Large Ears · 1957
Bronze · 11⅜ × 11¼ (29 × 28 · 5)

518 Mask with Large Horns · 1957
Bronze · 5⅞ × 3¾ (15 × 9 · 5)

519 Mask with Small Horns · 1957
Bronze · 5½ × 4 (14 × 10)

520 The Faun with Large Horns · 1957
Bronze · h. 7½ (19)

521 Bull on Plaque · 1957
Bronze · 2⅜ × 4¾ (6 × 12)

522 Lying Bull · 1957
Bronze · 2⅜ × 4½ (6 × 11 · 5)

523 Lying Bull · 1957
Bronze · 2⅝ × 4¼ (6 · 5 × 10 · 5)

524 Large Bull on Plaque · 1957
Bronze · 3¾ × 7½ (9 · 5 × 19)

525 Bull · 1957
Bronze · 3 × 5¼ (7 · 5 × 13 · 5)

526 Bull · 1957
Bronze · 2½ × 5⅞ (6 · 5 × 15)

527 Bull · 1957
Bronze · 4⅜ × 7½ (11 × 19)

528 Bull · 1957
Bronze · 3½ × 6½ (9 × 16 · 5)

529 Bull · 1957
Bronze · 3½ × 5 (9 × 12 · 5)

530 The Sleeping Dove · 1957
Bronze · 1¼ × 2⅝ (3 × 6 · 5)

531 The Roosting Dove · 1957
Bronze · 1¾ × 2¾ (4 · 5 × 7)

532 Dove · 1957
Bronze

533 Dove · 1957
Bronze · 2⅜ × 4¾ (6 × 12)

534 Dove · 1957
Bronze · 6 × 9⅞ × 4¼ (15 × 25 × 11)

535 La Larga (The Long One) · 1957
Plaster · 4½ × 15⅜ (11 · 5 × 39)

536 Little Girl · 1957–58
Painted bronze · 17 × 4½ × 8¾
(43 × 11 · 5 × 22 · 3)

537 Bather Playing · Cannes 1958
Bronze (original in plaster, wood
and iron) · 44½ × 18⅛ × 17¾
(113 × 46 × 45)
Ill. p. 243

538 Man · Cannes 1958
Wood · 46¾ × 29½ × 11¾

(119 × 75 × 30)
Ill. p. 241

539 Head · Cannes 1958
Bronze (original in wood with metal
dish and buttons) · 20 × 8½ × 6⅛
(51 × 21 · 5 × 15 · 5)
Ill. p. 240

540 Standing Figure · 1958
Bronze · h. 13 (33)

541 Man · 20 July 1958
Bronze (original in wood)
22½ × 5⅛ × 5½ (57 × 13 × 14)
Ill. p. 238

542 Figure · 1958
Wood · 53⅛ × 9½ (135 × 24)
Ill. p. 239

543 Man with Javelin · Cannes 1958
Bronze (original in wood)
48½ × 25⅛ × 3⅛ (123 × 35 × 86)

544 Figure · Cannes 1958
Bronze (original in wood with forks
and spoon) · 48⅜ × 18½ × 7⅛
(123 × 47 × 18)
Ill. p. 239

545 Head of a Bull · Cannes 29 April 1958
Painted cardboard cut-out · 33½ × 25
(85 × 63 · 5)

546 Bull · Cannes 1958
Painted cardboard cut-out

547 Crouching Woman · Cannes 1958
Painted cardboard cut-out

548 Two Fauns · Cannes 1958
-49 Painted cardboard cut-out

550 Head of a Fair-Haired Woman
1958–59
Wood and wicker · 32¼ × 21¼ × 2⅜
(82 × 54 × 6)

551 Trefoil-shaped Fruit-bowl · 1958–67
Silver · 7 × 32½ × 18¾
(18 × 57 × 47 · 5)

552 Oval Fruit-bowl · 1958–67
Silver · 6⅞ × 24 × 16⅛
(17 · 5 × 61 × 41)

553 Fruit-bowl with Fish · 1958–67
Silver · 5⅛ × 21¼ × 18⅛
(13 × 54 × 46)

554 Round Fruit-bowl · 1958–67
Silver · 6¾ × 20½ × 19¼
(17 × 52 × 49)

555 Arm · 1959
Bronze · h. 23 (58 · 5)

556 Figure · 1960
Bronze · 10 × 2¾ (25 · 5 × 7)

557 Child · 1960
Bronze · 10½ × 3¾ (26 · 5 × 9 · 5)

558 Man Running · Cannes 1960
Bronze · 46 × 25⅛ × 3⅛
(117 × 64 × 8)

559 Figure · 1960
Bronze

560 Flute-player · 1960–67
23-carat gold · 5⅞ × 2 (15 × 5)

561 Cymbal-player · 1960–67
23-carat gold · 5⅞ × 1¾ (15 × 4 · 5)

562 Bacchante · 1960–67
23-carat gold · 5⅜ × 2 (13 · 5 × 5)

563 Centaur · 1961–67
23-carat gold · 4¾ × 4⅛ (12 × 10 · 5)

564 The Sparrowhawk · Cannes 1960
Metal cut-out · 11⅜ × 5½ × 3⅛
(29 × 14 × 8)
Ill. p. 246

565 Head of a Woman · Cannes 1960
Metal cut-out, folded and painted
13¾ × 9⅞ (35 × 25)

566 Mural engravings · 1960–61
-68 Betongravure (concrete engraving),
executed by Carl Nesjar from designs
by Picasso · Exterior wall 14 × 197ft
(4 · 25 × 60 m); two interior walls
(not illustrated) 10 × 36ft (3 × 11 m)
Colegio de los Arquitectos, Barcelona

569 The Spanish Lady · Cannes 1961
Metal cut-out, folded and painted
11 × 5⅞ (28 × 15)

570 The Spanish Lady · Cannes 1961
Metal cut-out, folded and painted
6¾ × 4¼ (17 × 11)

571 The Spanish Lady · Cannes 1961
Metal cut-out, folded and painted
8¼ × 5⅞ (21 × 15)

572 Bird · Cannes 1961
Metal cut-out, folded and painted
15 × 16⅛ (38 × 41)

573 Owl · Cannes 1961
Metal cut-out, folded and painted
9⅞ × 9⅝ (25 × 24 · 5)

574 Owl · Cannes 1961
Metal cut-out, folded and painted
15 × 7⅛ (38 × 18)

575 Owl · Cannes 1961
Metal cut-out, folded and painted
16⅛ × 6⅝ (41 × 17)

576 The Cock · Cannes 1961
Metal cut-out, folded and painted
8⅝ × 10⅝ × 3 (22 × 27 × 7·5)

577 Bird · Cannes 1961
Metal cut-out, folded and painted
Collection Lionel Prejger

578 The Little Monkey · Cannes 1961
Metal cut-out, folded and painted
6¾ × 4¼ (17 × 11)

579 Head · Cannes 1961
Metal cut-out, folded and painted
12⅛ × 2 × 2¾ (31 × 5 × 7)

580 Standing Woman · Cannes 1961
Metal cut-out, folded and painted
17⅛ × 6½ (43·5 × 16·5)

581 Standing Woman · Cannes 1961
Metal cut-out, folded and painted
17 × 8⅝ (43 × 22)
Ill. p. 251

582 Bather · Cannes 1961
Metal cut-out, folded and painted
20⅛ × 6⅞ × 8¼ (51 × 17·5 × 21)

583 Clown · Cannes 1961
Metal cut-out, folded and painted
12¼ × 10⅝ × 4¾ (31 × 27 × 12)

584 Head · Cannes 1961
Metal cut-out, folded and painted
6⅝ × 5½ (17 × 14)

585 The Mask · Cannes 1961
Metal cut-out, folded and painted
6⅝ × 5½ (17 × 14)

586 Mask · 1961
Corrugated cardboard cut-out

587 Mask · 1961
Cardboard cut-out, painted

588 Mask · 1961
Cardboard cut-out, painted

589 Woman with Outstretched Arms
Cannes 1961
Metal cut-out, folded and painted
11 × 7½ (28 × 19)

590 Bust of a Woman · Cannes 1961
Metal cut-out, folded and painted
12⅞ × 6½ (32 × 16·5)

591 Woman · Cannes 1961
Metal cut-out, folded and painted
11¾ × 6⅞ (30 × 17·5)

592 The Chair · Cannes 1961
Metal cut-out, folded and painted
43¾ × 29⅛ × 23⅝ (111 × 74 × 60)
Ill. p. 247

593 Woman with Arm Raised
Cannes 1961
Metal cut-out, folded and painted
13⅜ × 4 (34 × 10)
Ill p. 250

594 Small Woman with Outstretched Arms
Cannes 1961
Metal cut-out, folded and painted
14½ × 14½ × 2 (37 × 37 × 5)

595 Woman with Outstretched Arms
Cannes 1961
Metal cut-out, folded and painted
72 × 67¾ (183 × 172)

596 Woman with Outstretched Arms
Cannes 1961
Metal cut-out, folded and painted
72 × 67¾ × 31½ (183 × 172 × 80)

597 Woman with Outstretched Arms
Cannes 1961
Metal cut-out, folded and painted
70 × 67 (178 × 170)
Maquette for 639

598 Woman with Wooden Bowl
Cannes 1961
Metal cut-out, folded and painted
44⅞ × 25¼ (114 × 64)
Ill. p. 252

599 Woman with Child · Cannes 1961
Metal cut-out, folded and painted
50¾ × 21⅝ (129 × 55)
Ill. p. 253

600 Woman and Child · Cannes 1961
Metal cut-out, folded and painted
17¼ × 6⅞ (44 × 17·5)
Ill. p. 249

601 Woman and Child · Cannes 1961
Metal cut-out, folded and painted
17¼ × 6⅞ (44 × 17·5)
Ill. p. 248

602 Man with Sheep · Cannes 1961
Metal cut-out, folded and painted
17¼ × 13¾ (44 × 35)

603 Man with Sheep · Cannes 1961
Metal cut-out, folded and painted
20⅞ × 11 (53 × 28)

604 Pierrot · Cannes 1961
Metal cut-out, folded and painted
53⅛ × 20½ × 18⅞ (135 × 52 × 48)

605 Football Player · Cannes 1961
Metal cut-out, folded and painted

22½ × 18⅞ (57 × 48)
Ill. p. 255

606 Football Player · Cannes 1961
Metal cut-out, folded and painted
23¼ × 19¼ (59 × 49)
Ill. p. 254

607 Figure · Cannes 1961
Metal cut-out, folded and painted
Maquette for 649

608 Woman with Outstretched Arms
Cannes 1961
Metal cut-out

609 Small Man · Cannes 1961
Metal cut-out

610 Head of a Woman · Cannes 1961
Metal cut-out

611 Small Man · Cannes 1961
Metal cut-out

612 Animal · Cannes 1961
Metal cut-out

613 Head of a Woman · Cannes 1961
Metal cut-out, folded and painted
11 × 7⅞ × 1¼ (28 × 20 × 3)

614 Head of a Woman · Cannes 1961
Metal cut-out, folded and painted
8⅝ × 6¾ × 3⅛ (22 × 17 × 8)

615 Head of a Man · Cannes 1961
Metal cut-out, folded and painted
11 × 7½ (28 × 19)

616 Head of a Woman · Cannes 1961
Metal cut-out, folded and painted
15 × 11¾ (38 × 30)

617 Head of a Bearded Man · Cannes 1961
Metal cut-out, folded and painted
31½ × 24⅜ (80 × 62)

618 Head of a Bearded Man · Cannes 1961
Metal cut-out, folded and painted
16⅛ × 11¾ (41 × 30)

619 Head of a Woman · Cannes 1961
Metal cut-out, folded and painted
h. 15 (38)

620 Head of a Woman · Cannes 1961
Metal cut-out, folded and painted
31½ × 21⅝ (80 × 55)

621 Head of a Bearded Man · Cannes 1961
Metal cut-out, folded and painted
15 × 9⅝ × 3⅜ (38 × 24·5 × 8·5)

622 Man with Staff · Cannes 1961
Bronze (original in plaster and metal)
15 × 9½ × 8¼ (38 × 24 × 21)
Ill. p. 245

623 Musician · Cannes 1961
Bronze (original in plaster and metal)
17¾ × 4¾ × 6¼ (45 × 12 × 16)
Ill. p. 244

624 Head of a Woman · Cannes 1961
Bronze · 10⅝ × 5⅞ × 9 (27 × 15 × 23)

625 Face of a Woman · Cannes 1961
Bronze · 6⅝ × 4⅜ (16 · 8 × 11)

626 Woman with Hat · 1961 (painted 1963)
Metal cut-out, folded and painted
49½ × 28¾ (126 × 73)

627 Woman · Mougins 1962
Bronze (original in plaster and metal)
12¾ × 3½ (32 · 5 × 9)

628 Head of Man with Moustache
Mougins 1962
Metal cut-out, folded and painted
11¾ × 17 (30 × 43)

629 Jacqueline with Green Ribbon
Mougins 1962
Metal cut-out, folded and painted
20½ × 11½ (52 × 29)

630 Head of a Woman · Mougins 1962
Metal cut-out, folded and painted
19⅝ × 11¾ (50 × 30)

631 Head of a Woman · Mougins 1962
Metal cut-out, folded and painted
12⅝ × 7⅞ (32 × 20)

632 Bust of a Woman · Mougins 1962
Metal cut-out, folded and painted
17¾ × 14¼ (45 × 36)

633 Head of a Woman · Mougins 1962
Metal cut-out, folded and painted
19⅝ × 11¾ (50 × 30)

634 Head of a Woman · Mougins 1962
Metal cut-out, folded and painted
19⅝ × 15¾ (50 × 40)

635 Head of a Woman · Mougins 1962
Metal cut-out, folded and painted
9⅞ × 7⅛ (25 × 18)
Ill. p. 225

636 Head of a Woman · Mougins 1962
Metal cut-out, folded and painted
19⅝ × 19⅝ × 11¾ (50 × 50 × 30)
Ill. p. 259

637 Head of a Woman · Mougins 1962
Metal cut-out, folded and painted
12⅝ × 10 (32 × 25 · 5)
Ill. p. 257

638 Head of a Woman · Mougins 1962
Metal cut-out, folded and painted
20½ × 10⅞ × 7 (52 × 15 × 18)
Ill. p. 256

639 Woman with Outstretched Arms
1962
Betongravure (concrete engraving),
executed by Carl Nesjar from designs
by Picasso; cement and pebbles
h. 19ft 8 (6 m)
Grounds of residence of
D.-H. Kahnweiler,
Chalo-Saint-Mars (Essonne)
Ill. p. 264

640 Woman · Mougins 1962
Painted cardboard cut-out and
ceramic vase

641 Mural engraving · 1963
Betongravure (concrete engraving),
executed by Carl Nesjar from designs
by Picasso; white cement and crushed
black basalt · 14 × 82ft 3 (4 · 25 × 25 m)
Château de Castille (Gard), property
of Douglas Cooper

642 Le Déjeuner sur l'herbe · 1963
Cardboard cut-out, folded and painted
Maquette for 652

642a Cut out figures · Paris 1963
Used in a joint project for a concert-
hall and theatre by Picasso,
L. A. Johannessen and Carl Nesjar,
at 'Le Mur Vivant' exhibition,
Grand Palais, Paris

643 Maquette for Chicago Civic Center
Sculpture · 1964
Welded steel · 41¼ × 27½ × 19
(105 × 70 × 48)
See also 653
The Art Institute of Chicago, Gift of
Pablo Picasso

644 Two Cut-out Figures · 1964
–45 Painted wood
Maquettes for 646–48

646 Cut-out Figure · 1964
Concrete · h. 11ft 6 (3 · 5 m)
Moderna Museet, Stockholm
Ill. p. 262

647 Cut-out Figure · 1965
Concrete · h. 11ft 6 (3 · 5 m)
Oslo

648 Cut-out Figure · 1965
Concrete · h. 16ft 6 (5 m)
Vondelpark, Amsterdam

649 The Profiles · 1965
White cement and white crushed
granite · h. 13ft (4 m)
Lycée Sud, Marseilles
Maquette for 656

650 Head of a Woman · 1965
Painted metal
Maquette for 651

651 Head of a Woman · 1965
Concrete · h. 49ft (15 m)
Lake Vänern, Kristinehamn, Sweden
Ill. p. 263

652 Le Déjeuner sur l'herbe · 1965/66
Four 'folding sculptures', white
cement and crushed granite
h. 10–13ft (3–4 m)
Moderna Museet, Stockholm

653 Chicago Civic Center Sculpture
1966
Welded steel · h. 65ft 9 (20 m)
Civic Center, Chicago, Ill.
Ill. pp. 260–61

654 Sculpture (Barcarès) · 1966
Concrete · h. 82ft 3 (25 m)

655 Maquette for Israel Museum Sculpture
1967
See also 656

656 Israel Museum Sculpture · 1967
White cement and light-coloured
pebbles · h. 19ft (5 · 8 m)

657 Sylvette · 1968
Metal cut-out, folded
Maquette for 658

658 Folded Sculpture · 1968
White cement and crushed black
granite · 34ft 10 (10 · 5 m)
New York University, New York

659 Mural Engravings · 1969
–60 End wall 26ft 11 × 42ft 8
(8 · 2 × 13 m); wall in entrance hall
(not illustrated) 9ft 10 × 9ft 10
(3 × 3 m)
Government Building, Oslo

661 Folded Sculpture (Sylvette) · 1970
White cement and crushed black
granite · h. 27ft 11 (8 · 5 m)
Bouwcentrum, Rotterdam

662 Maquette for Halmstad Sculpture
1970
See also 663

663 Halmstad Sculpture · 1970–71
White cement and crushed black
granite · h. 49ft 2 (15 m)
Figaro Park, Halmstad, Sweden

664 Polychrome Sculpture · 1971
Painted concrete · h. 16ft 5 (5 m)
Princeton University, Princeton, N.J.
Not illustrated

C 1 Woman with Hands Hidden · 1949
Ceramic, wheel-thrown, modelled and
slip-painted · 18½ × 5⅞ × 3½
(47 × 15 × 9)
Ill. p. 187

C 2 Centaur · 1950
Ceramic sculpture composed of wheel-
thrown parts, wax-resist decoration
17 × 9⅞ × 5½ (43 × 25 × 14)
Ill. p. 186

C 3 Dove with Eggs · 1953
Ceramic, modelled from clay scraps,
slip-painted · 5½ × 8⅝ × 7⅞
(14 × 22 × 20)
Ill. p. 188

C 4 Large Bird · 14 February 1961
Two-handled vase · Ceramic, wheel-
thrown, incised and slip-painted
23¼ × 16⅛ × 17¼ (59 × 41 × 44)
Ill. p. 189

C 5 Face · 12 July 1962
Fragment of hollow brick, slip-
painted and heightened with black
enamel · 8⅝ × 6¼ × 3⅛ (22 × 16 × 8)
Ill. p. 258

C 6 Head of a Woman · 12 July 1962
Fragment of hollow brick, slip-
painted · 8⅝ × 4¾ × 3⅛ (22 × 12 × 8)
Ill. p. 258

Chronology

1881 Birth of Pablo Ruiz Picasso (25 October) at Málaga on the Mediterranean coast of Spain. The eldest child of José Ruiz Blasco, a painter of Basque descent, and María Picasso López of Andalusia. His father teaches drawing at the San Telmo school of arts and crafts, Málaga.

1891 The family moves to La Coruña (Galicia). Pablo begins to draw and paint. Receives tuition in his father's painting class at the Instituto Da Guarda.

1895 José Ruiz Blasco takes up a post at the La Llotja art school in Barcelona. Pablo attends the same school after brilliantly passing the entrance examination for the advanced course in drawing and painting from life. In the summer, he visits Madrid, where he sees the Prado for the first time.

1896 First studio on the Calle de la Plata in Barcelona.

1897 Picasso's painting *Science and Charity* is shown at the Madrid national art exhibition and receives an honourable mention. He joins the circle of artists centred on the bar Els Quatre Gats and adorns its walls with twenty-five full-length portraits of his friends. These include the painters Carlos Casagemas, Isidro Nonell and Sebastián Sunyer, and the sculptors Manolo and Julio González. Picasso holds his first small exhibition at Els Quatre Gats. Accepted by the Academia de San Carlos, Madrid, in the autumn.

1898 Picasso contracts scarlet fever, leaves the academy and returns to Barcelona. Lengthy convalescence in the house of his friend Pallares at Horta de Ebro (now Horta de San Juan).

1899 Returns to Barcelona in April and takes a studio in the Calle de Escudillers Blancs. His painting *Aragonese Customs* wins prizes in Madrid and Málaga. Becomes friendly with the writer Jaime Sabartés, later his secretary.

1900 The periodical *Joventud,* heavily influenced by German Art Nouveau (*Jugendstil*), publishes Picasso's first illustrations. In the autumn, he visits Paris for the first time, accompanied by his friend Casagemas. Works there in the studio of his compatriot Nonell. The art dealer Berthe Weill buys three of his sketches. He returns to Barcelona in December.

1901 Picasso goes to Madrid early in February, and there, jointly with the writer Francisco de Asis Soler, founds the periodical *Arte joven,* which becomes the forum of the younger artists and writers. In this, for the first time, he signs his illustrations and other drawings with his mother's surname, Picasso. The magazine closes after a few issues. Back in Barcelona, Picasso exhibits pastels at the Salón Parés, and gets an enthusiastic review in the journal *Pel y ploma* from Miguel Utrillo. At the end of May he returns to Paris and takes a studio in the Boulevard de Clichy. The art dealer Ambroise Vollard mounts a joint exhibition of Picasso and Iturrino; Picasso contributes paintings which already point in the direction of the Blue Period. The critics react favourably, and enthusiastic visitors to the exhibition include the French writer and painter Max Jacob, who soon becomes one of Picasso's closest friends. The end of the year sees him producing the first typical works of the Blue Period.

1902 Back to Barcelona in January. Picasso models *Seated Woman* (p. 29), his first known sculpture, a small and extremely compact work executed in bronze. In April, an exhibition at Berthe Weill's gallery in Paris. Picasso returns to Paris in October, and with Max Jacob rents a room in the Boulevard Voltaire.

1903 Two smallish sculptures, *Blind Singer* and *Head of Picador with Broken Nose* (pp. 30–31), are produced in Barcelona. Both masks display an expressive solemnity which invites comparison with the Blue Period in Picasso's work as a painter. Commemorative exhibition of Gauguin in Paris.

1904 Picasso settles in Paris and rents the studio formerly occupied by the Spanish sculptor Paco Durio in the Bateau-Lavoir in the rue Ravignan, a studio house where he remains until 1909. Among its inmates are the poet André Salmon and the painter Kees van Dongen, later to be joined by Juan Gris. It becomes a major meeting-place for the younger artists; among Picasso's visitors are Alfred Jarry, Maurice Raynal and Max Jacob, later joined by Derain, Matisse, Braque, Apollinaire, Marie Laurencin, Gertrude and Leo Stein, Daniel-Henry Kahnweiler and Wilhelm Uhde. He meets Fernande Olivier.

1905 Beginning of the Rose Period. Large-scale figurative paintings illustrate the world of the mountebank and showman. In the field of sculpture, *The Jester* (p. 35), an alienated portrait of Max Jacob, modifies the theme of transformation. A second sculpture produced in the same year, *Head of a Woman* (pp. 32–33), is based on the features of Alice Derain. Picasso etches the series entitled *The Tightrope Walkers*. Trip to Holland in the summer. Exhibition by the Fauves at the Salon d'Automne. Collectors of modern art begin to show an interest in Picasso. Leo and Gertrude Stein and the Russian Sergey Shchukin acquire pictures by him. Friendship with Apollinaire, who publishes an article on Picasso in his review, *La Plume*.

1906 Picasso's artistic interest in psychological expression wanes. The sculpture *Woman Arranging her Hair* (p. 37), originally a ceramic, adopts a physical gesture as its motif. There follows the sculpture *Head of a Woman (Fernande)*, the first apart from *Woman Arranging her Hair* to be carried out on a large scale (p. 37).
Picasso spends the summer with Fernande Olivier in the Spanish mountain village of Gosol. Juan Gris visits Paris for some weeks and rents a studio in the Bateau-Lavoir. At the Steins', Picasso meets Matisse. Work on the bronze *Head of a Woman* (p. 36). The year 1906 also, in all probability, witnessed Picasso's discovery of Iberian and African sculpture, which clearly influenced the relief *Head of a Woman* (*cat. 8*).

1907 In the winter 1906–07 Picasso produces the bronzes *Head of a Woman* and *Mask* (pp. 40–41), both of which fit into the so-called Negro Period. Picasso works on a series of woodcarvings in which echoes of primitive art are clearly detectable. In the spring he tackles *Les Demoiselles d'Avignon*, the large painting of female nudes which displays the first stirrings of Cubism. In April, Kahnweiler opens his gallery in the rue Vignon, where Picasso meets Braque and Derain. Major commemorative exhibition of Cézanne in Paris.

1908 Picasso holds the celebrated studio banquet in honour of Henri (Douanier) Rousseau. At La Ville des Bois, his summer abode, he paints his first Cubist still-lifes. Braque, preoccupied with similar problems, shows his early Cubist works at Kahnweiler's gallery in November, after having five works rejected for the Salon d'Automne. In *Gil Blas* for 14 November, the critic Louis Vauxcelles pokes fun at Braque's *'bizarreries cubiques'* – and Cubism has a name. Picasso models *Seated Woman* (p. 44) and *Mask of a Woman*.

1909 *Head of a Woman* (pp. 42–43), Picasso's only purely Cubist sculpture, is destined to influence the Cubist sculpture of Gris, Laurens, Archipenko and Lipchitz and the works of the Futurists. Together with Braque, he evolves the formal gamut of analytical Cubism. Spends the summer at Horta de Ebro painting Cubist landscapes; meanwhile Braque is working at L'Estaque. In October, returns to Paris, moving into a new studio in the Boulevard de Clichy. First exhibition in Germany at the Galerie Thannhauser in Munich, under the auspices of the Neue Künstlervereinigung München.

1910 Summer at Cadaquès, in Catalonia, with Derain. Second exhibition held by the Neue Künstlervereinigung München, again including works by Picasso. He works on etchings for *Saint-Matorel* by Max Jacob, which Kahnweiler brings out in the following year.

1911 Picasso spends the summer with Braque and Manolo at Céret in the Pyrenees. The Photo-Secession Gallery, New York, shows Picasso's work in the USA for the first time.

1912 Picasso produces his first *papiers collés*. Meets and lives with 'Eva' (Marcelle Humbert), with whom he travels to Avignon, and (in May) to Céret, and finally to Sorgues (Vaucluse), where he stays until October. Braque is also there. Transition to synthetic Cubism. Instead of reducing real objects to abstract particles of form, he often makes the material itself his subject. Stronger coloration. Back in Paris, moves to Boulevard Raspail. Contributes to exhibitions of the Sonderbund and Der Blaue Reiter in Cologne and Munich. First Picasso exhibition in London, at the Stafford Gallery; exhibition at the Galerías Dalmau in Barcelona.

1913 Studio in the rue Schoelcher. In 1912–13 Picasso embarks on a series of constructions in high and low relief, montages composed of the most diverse materials – paper, cardboard, wood, sheet-metal, string and wire – which he continues into the 1920s (pp. 57–68). Exhibitions at the Sezession, Berlin, and at Thannhauser's in Munich. Contributes to the Armory Show in New York. A summer get-together at Céret with Braque, Manolo, Gris and Max Jacob. Death of Picasso's father in Barcelona. Vollard produces an edition of *The Tightrope Walkers*.

1914 Picasso models *The Glass of Absinthe* (p. 49), six variously painted casts of a wax original, the first cycle of variations in his entire sculptural work. *The Glass of Absinthe* marks an important step in the development of modern sculpture. By incorporating a found object – the spoon – Picasso here brings about a confrontation between an excerpt from reality and a fictive object (the represented glass).
Summer at Avignon with Braque and Gris. Cubist pictures notable for their firm, discrete planes of colour: the Crystal Period. Illustrations for *Le Siège de Jérusalem* by Max Jacob. Outbreak of First World War. Braque and Derain are conscripted; Apollinaire volunteers.

1915 Moves to rue Victor-Hugo, Montrouge. Death of Eva.

1917 Diaghilev enlists Picasso as costume- and stage-designer for the ballet *Parade*. Joint work with the Ballets Russes company in Rome. Picasso meets the dancer Olga Koklova, later his wife, and Igor Stravinsky. Trips to Florence, Pompeii and Naples. On 18 May, first performance of *Parade* in Paris. Libretto by Jean Cocteau, music by Erik Satie, choreography by Léonide Massine. Among the characters are the French and American *Managers*, squeezed by Picasso into grotesque Cubist tubes (*cat. 59–60*). Debussy, a member of the first-night audience, reacts to the figures' entrance by shouting: 'Go away, you're too ugly!' Apollinaire's programme notes pay tribute to the new unity between music, dance and sculptural form. 'This new unity ... invests *Parade* with an element of Surrealism.' Summer in Barcelona and Madrid.

1918 Picasso marries Olga Koklova. Apartment in the rue La Boétie. Summer at Biarritz. Since Kahnweiler has had to give his gallery up and spend the war in Switzerland, Paul Rosenberg becomes Picasso's dealer.

1919 Working for the Ballets Russes, Picasso designs scenery and costumes for *The Three-cornered Hat,* a Spanish ballet with music by Manuel de Falla and choreography by Massine. Summer at Saint-Raphaël, on the Côte d'Azur. Back in Paris, Picasso meets Joan Miró.

1920 First paintings of the Neoclassical Period. Designs for the Diaghilev ballet *Pulcinelle,* with music by Stravinsky and choreography by Massine. Summer at Juan-les-Pins.

1921 Pablo, Picasso's eldest son, is born. Picasso continues his work for Diaghilev. He produces sets for the Spanish ballet *Cuadro Flamenco,* Andalusian dances choreographed by Massine. At Fontainebleau in summer, he paints *Three Musicians,* a product of synthetic Cubism, in two versions. Monumental neoclassical female nudes.

1922 Scenery and masks for Cocteau's drama *Antigone.* Summer at Dinard (Brittany).

1923 Summer at Cap d'Antibes. First meeting with André Breton. Paints the neoclassical *Harlequins*.

1924 In paintings, the Neoclassical Period draws to a close, and Picasso embarks on the great still-lifes of 1924–25. Decor and costumes for the ballet *Mercure,* scenario by Etienne de Beaumont, music by Satie, choreography by Massine. Picasso's *constructions scéniques* dominate the stage. These are

mechanically operated and move in concert with the dancers, reducing them to a secondary function. In the same year Picasso uses *Women Surprised Beside the Sea,* a painting of 1922, as a basis for the design of the curtain for *Le Train bleu,* a Cocteau/Milhaud ballet with designs by Henri Laurens. Picasso spends the summer at Juan-les-Pins. In Paris, André Breton publishes the first Surrealist Manifesto and the first issue of *La Révolution surréaliste.*

1925 Spring in Monte Carlo, summer at Juan-les-Pins. Picasso takes part, together with De Chirico, Arp, Ernst, Klee, Miró and others, in the first Surrealist exhibition at the Galerie Pierre, Paris. Picasso paints the figurative composition *Three Dancers.* Here, in the field of painting, we see the first moves towards doughily worked figures, a novel feature which assumes great importance in Picasso's sculpture in years to come.

1928 In *Head* (p. 80), Picasso for the first time executes in wire one of those 'space drawings' (Kahnweiler) which convey plastic volume by means of linear structures alone. Two more wire sculptures follow (pp. 78–79). Soft and lumpy shapes create a relationship between the bronze-cast *Figure* (p. 77) and the painting *Three Dancers* of 1925. Summer at Dinard; the 'Dinard period' paintings are mostly small and in vivid colours.

1929 González initiates Picasso into the techniques of wrought ironwork and welding. The result is a series of iron sculptures: *Woman in Garden* (1929–30, p. 81), *Head of a Woman* and *Head* (1930, pp. 84–85), *Figure of a Woman* (1930, pp. 82–83). Summer at Dinard.

1930 Summer at Juan-les-Pins, where Picasso begins a series of material reliefs (pp. 86, 91–93), which he will continue in 1932.

1931 Buys Château de Boisgeloup, near Gisors (Eure), and installs a big sculpture studio (p. 13). Picasso carves several female figures of narrow, elongated proportions, which will be cast in bronze in 1937. Skira publishes Ovid's *Metamorphoses* and Vollard publishes Balzac's *Le Chef-d'œuvre inconnu,* both with illustrations by Picasso.

1932 A big Picasso retrospective at the Paris gallery of Georges Petit in June–July includes seven sculptures. The same year sees a second retrospective at the Kunsthaus, Zürich. Publication of the first volume of Christian Zervos's *catalogue raisonné.* A series of over-life-size *Heads* (pp. 115–19). Busts and figures of his new model Marie-Thérèse Walter, who is to be the mother of his daughter Maya. Full, bulbous shapes characterize these figures (pp. 108–113).

1933 Visits to Cannes and Barcelona. Publication of the first volume of Bernhard Geiser's *catalogue raisonné* of his graphic work. Picasso produces etchings on the theme *The Sculptor's Studio.* In 1932–33, he produces a series of reliefs of heads (pp. 122–25), and in 1933 a series of major sculptures (pp. 128, 132–35, 138–39, *cat. 135*).

1934 A journey through Spain (Irún, San Sebastián, Madrid, El Escorial and Barcelona) inspires a series of bullfight scenes. Picasso illustrates the *Lysistrata* of Aristophanes. *Woman with Leaves* signals a reversion to textured surfaces (pp. 136–37). His marriage to Olga breaks up.

1935 Poems by Picasso appear in *Cahiers d'Art* with commentaries by André Breton and Jaime Sabartés. Sabartés becomes his secretary. Birth of daughter Maya. Picasso etches the series *Minotauromachia,* one of his greatest works. At Gosol he assembles numerous figures and dolls, mostly made of wood and dressed in other materials.

1936 Summer at Juan-les-Pins and Mougins with Dora Maar. Touring exhibition in Barcelona, Bilbao and Madrid. Outbreak of Spanish Civil War. The Republicans appoint Picasso director of the Prado in Madrid. The relief *Construction with Objects and Ceramic Tile* (p. 152) differs from the comparable works of 1930 and 1932 in lacking the coating of sand, and thus emphasizing the nature of the materials.

1937 Picasso's political commitment is reflected in his work. He etches *Dream and Lie of Franco* (with text). The Republic commissions a mural for the Spanish Pavilion at the Paris World Exhibition. His theme is the German bombing of the Basque city of Guernica on 28 April. *Woman with Vase* (*cat. 135*) and the 1932 *Bust of a Woman* and *Head of a Woman* (pp. 116–17, 119) are displayed outside the pavilion. Studio in the rue des Grands-Augustins in which he paints *Guernica.* First incised pebbles and bones (*cat. 171–176*). Completion of the Vollard Suite, a series of one hundred etchings commissioned in 1930 by Vollard.

1939 Major Picasso exhibition at the Museum of Modern Art in New York. Exhibition at the Galerie Rosenberg in Paris. Picasso's mother dies in Barcelona. Summer at Antibes. Outbreak of Second World War. Picasso initially withdraws to Royan near Bordeaux.

1940 Back in Paris despite the German occupation. The Germans ban the showing of Picasso's work. Summer at Royan.

1941 Picasso writes the play *Le Désir attrapé par la queue,* which is performed at the home of Louise and Michel Leiris (who take part together with Jean-Paul Sartre, Simone de Beauvoir and Albert Camus).

1943 In Paris during the war, Picasso produces a series of large-scale sculptures, repeatedly working with ready-made materials. *Head of a Bull, Woman with Apple* and *The Madame* (pp. 161, 163, 166) all embody found objects. A tailor's dummy becomes the basis of *Woman in Long Dress* (p. 167). The *Death's Head* theme occurs simultaneously in Picasso's painting, graphic work and sculpture (p. 170). May 1943, first meeting with Françoise Gilot.

1944 After the liberation of Paris on 25 August, Picasso contributes forty-seven pictures and five sculptures to the Salon d'Automne. He joins the Communist Party. Drawings from the year 1942 pave the way for *Man with Sheep* (pp. 168–69), an almost classical bronze innocent of deformation, a cast of which is to be erected in the marketplace at Vallauris in 1951.

1945 In 1945 and 1947, Picasso models a series of small sculptures in bronze (p. 181). Late summer at Golfe-Juan. Works on the technique of lithography at the Paris studio of Fernand Mourlot. Curtain for the ballet *Le Rendez-vous* with music by Kosma and scenario by Jacques Prévert, choreographed by Roland Petit and performed by the Ballets des Champs-Elysées.

1946 Spends most of the year on the Côte d'Azur, at Antibes, Ménerbes and Golfe-Juan, with Françoise Gilot. First light-hearted essays in the art of ceramics at the Madoura pottery, Vallauris. At the Musée Grimaldi, Antibes, Picasso paints a series of pictures which he later donates to the museum. He starts to lithograph the first illustrations and ornaments for Pierre Reverdy's *Le Chant des morts,* which appears in 1948. Alfred H. Barr publishes the monograph *Picasso: Fifty Years of his Art.*

1947 At Suzanne and Georges Ramié's Madoura pottery, Picasso begins to take a systematic interest in the potter's technique. Works produced in the ensuing years include *Woman with Hands Hidden* and *Centaur* (pp. 186–87). Owl, dove and anthropomorphic vase are recurrent motifs. In addition to producing ceramics, Picasso returns to the series of small bronze sculptures begun in 1945 (p. 181). The unique piece *Vase Face* (p. 184) is based on a functional ceramic shape. Birth of Picasso's son Claude.

1948 On 24 August Picasso is awarded the *Médaille de la Reconnaissance française;* on the next day he goes off to Wroclaw for the World Peace Congress. He buys La Galloise, a villa at Vallauris, and transfers his studio to an abandoned scent factory there. Big exhibition of ceramics at the Maison de la Pensée Française, Paris. Publication of *Vingt poèmes* by Góngora with aquatints by Picasso.

1949 Curt Valentin shows works by Picasso at the Buchholz Gallery, New York. Among them are the small bronzes of 1945 and 1947. Publication of the first work on Picasso's sculptures: *The Sculptures of Picasso* by Daniel-Henry Kahnweiler, with photographs by Brassaï. The existing catalogues are supplemented by the first volume of *Picasso lithographe* by Fernand Mourlot. Alain Resnais makes the film *Guernica,* based on works by Picasso, with commentary by Paul Eluard. Picasso illustrates Mérimée's *Carmen* and Goll's *Elégie d'Iphétonga.* Visits Rome and Florence. Birth of Picasso's daughter Paloma.

1950 Picasso receives the honorary citizenship of Vallauris. He attends a World Peace Congress in England, and works by him are shown at the Venice Biennale. Etchings and lithographs for *Corps perdu* by Aimé Césaire and *De mémoire d'homme* by Tristan Tzara. He paints *Massacre in Korea;* using ceramic forms, he models *The Pregnant Woman* (pp. 196–97). Other large works incorporating found objects: *Goat, Little Girl Skipping, Woman with Pushchair* (pp. 206–09, 211).

1951 Picasso moves from his flat in the rue La Boétie to the rue Gay-Lussac; he keeps his studio in the rue des Grands-Augustins. Attends World Peace Congress in Italy. Exhibition of drawings

and 43 sculptures by Picasso at the Maison de la Pensée Française in Paris. In the sculpture *Goat's Skull and Bottle* (p. 178), Picasso employs, for the first time, surfaces which overlap each other differently according to the angle of sight, thus foreshadowing the 'folding sculptures' of the 1950s.

1952 *War and Peace* murals in a chapel at Vallauris.

1953 Picasso produces variations on the 'Vase with Flowers' theme of 1943–44. *The Flowering Watering-can* (1943) was succeeded in 1951 by *Flowers in Vase* (p. 204) and in 1953 by three more vase pieces (pp. 202-03, 205). Other works produced in this year include some flat, board-like female figures in painted wood (pp. 229-31). Exhibitions in Rome, Milan, Lyon and São Paulo. He parts from Françoise Gilot.

1954 Thin folded sheet metal joins wood as material for Picasso's next sculptures, the heads and busts of Sylvette and Jacqueline Roque (pp. 232–35). These are 'folding' sculptures, composed of a number of deployed surfaces. He now lives with Jacqueline Roque. He draws the 180 sheets which comprise the cycle *Painter and Model*. Summer at Collioure and Perpignan (Pyrenees). Gives up the flat in the rue Gay-Lussac.

1955 Spring at Vallauris. Picasso acquires La Californie, a villa above Cannes. Death of his wife Olga. Touring exhibition in Munich, Cologne and Hamburg. Clouzot makes the film *Le Mystère Picasso* with the artist's co-operation.

1956 Picasso's series of planar sculptures continues with *The Bathers* (p. 237), cast in bronze. He meets the Norwegian painter Carl Nesjar, who later executes Picasso's designs in concrete.

1957 Fifty-eight variations on *The Maids of Honour* (*Las Meninas*) by Velázquez, their treatment coloured by *The Bathers*. Exhibition at the Museum of Modern Art, New York, to commemorate the artist's seventy-fifth birthday. The New York retrospective shows a total of forty-two bronzes. The same exhibition is augmented in Philadelphia by seventy-five ceramics.

1958 Picasso marries Jacqueline Roque and buys the Château de Vauvenargues, near Aix-en-Provence. Exhibition of ceramics at the Maison de la Pensée Française, mural for Unesco, both in Paris. Assemblages (pp. 238-41, 243).

1959 A bronze head of Dora Maar is erected in a small square beside the church of Saint-Germain-des-Prés as a memorial to Apollinaire.

1960 Picasso designs a frieze sixty metres long for the facade of the Colegio de los Arquitectos in Barcelona, using Nesjar's 'betongravure' technique.

1961 Settles on his property at Mougins, Notre-Dame-de-Vie (p.16). Collaborates with Lionel Prejger, who, using folded cardboard models by Picasso, cuts thin sheet metal to produce fairly large sculptures, including the series *Woman and Child* (pp. 248–49, 253), *The Chair* (p. 247) and *Footballers* (pp. 254–55).

1962 Nesjar executes a female figure nearly twenty feet high, in concrete, from a design by Picasso. The sculpture (p. 264) is erected on Kahnweiler's estate at Chalo-Saint-Mars (Essonne). Jaime Sabartés bequeaths his Picasso collection to the city of Barcelona. *Rape of the Sabine Women,* a painting after Jacques-Louis David. Beginning of the painted sheet-metal series of heads of women (pp. 256–59).

1963 Relief in concrete (Picasso/Nesjar), eighty-two feet long, for Douglas Cooper at the Château de Castille near Avignon. Fernand Mourlot publishes the fourth volume of the catalogue *Picasso lithographe*.

1965 A number of works in concrete with Nesjar: *The Profiles* (thirteen feet high, for the Lycée Sud, Marseille), *Head of a Woman* (erected beside Lake Vänern at Kristinehamn, Sweden, forty-nine feet high), *Le Déjeuner sur l'herbe* (monumental group, Moderna Museet, Stockholm). The American firm of architects Skidmore, Owings and Merrill invite Picasso to design a monument for the new Civic Center in Chicago. The result is an iron sculpture over sixty-five feet high (pp. 260–61), based on a 1962 *Head of a Woman* (p. 256).

1966 'Hommage à Pablo Picasso', a three-part exhibition held in Paris to commemorate the artist's eighty-fifth birthday. In addition to a large number of drawings, 187 sculptures and 116 ceramics are exhibited at the Petit Palais. The Galerie Jeanne Bucher assembles an exhibition on the theme 'Picasso and Concrete' (also seen in London and in Switzerland).

1967 London's Tate Gallery exhibits 203 pieces of sculpture in addition to

graphic works; and New York's Museum of Modern Art goes on to present a retrospective comprising 204 sculptures and 32 ceramics.

1968 Picasso produces 347 etchings on the following themes: 'Painter and Model', 'The Lovers', 'Circus', 'Bullfight', 'Antiquity'. Publication of the second volume of Bernhard Geiser's catalogue *Picasso peintre-graveur*. Georges Bloch publishes *Picasso*, a catalogue covering the graphic work of 1904–67, and produced in connection with the Zürich exhibition 'Pablo Picasso – Das graphische Werk'. Death of Picasso's friend and secretary Jaime Sabartés. In memory of Sabartés the artist presents the city of Barcelona with 58 pictures, among them the complete suite of variations on Velázquez's *The Maids of Honour*.

1970 Picasso presents the city of Barcelona with a large collection of youthful works. The collection is displayed in Barcelona's Museo Pablo Picasso, opened on 18 December. May–September, an exhibition of paintings and drawings at Avignon.

1971 In honor of his ninetieth birthday, The Louvre gives Picasso a retrospective in the Grande Galerie, the first time a living artist is so honored. The Pushkin Museum, Moscow, and the Hermitage, Leningrad, lend 25 paintings to this exhibition. Picasso's latest drawings are exhibited at the Galerie Louise Leiris, Paris.

Bibliography

MONOGRAPHS

Barr, Alfred H., Jr. *Picasso: Fifty Years of His Art*. New York, The Museum of Modern Art, 1946. 3rd edn with additions, New York, Arno Press, 1966.

Boeck, Wilhelm. *Picasso*. Stuttgart, Kohlhammer, 1955. Preface by Jaime Sabartés, chronology, bibliography. English edn, *Picasso,* London, Thames and Hudson, and New York, Harry N. Abrams, 1955.

Champris, Pierre de. *Picasso: ombre et soleil*. Paris, Gallimard, 1960.

Cooper, Douglas. *Picasso Theatre*. London, Weidenfeld and Nicolson, and New York, Harry N. Abrams, 1967.

Duncan, Douglas D. *Picasso's Picassos*. London, Macmillan, and New York, Harper, 1961.

Elgar, Frank, and Robert Maillard. *Picasso*. New York, Frederick A. Praeger, 1956. Bibliography.

Gieure, Maurice. *Initiation à l'œuvre de Picasso*. Paris, Editions des Deux Mondes, 1951.

Maillard, Robert. *See* Elgar.

Merli, Joan. *Picasso, el artista y la obra de nuestro tiempo*. Buenos Aires, El Ateneo, 1942. 2nd edn, Buenos Aires, Poseidon, 1948.

Parmelin, Hélène. *Picasso sur la place*. Paris, Juilliard, 1959.

Penrose, Roland. *Portrait of Picasso*. London and Bradford, Percy Lund, Humphries & Co., 1956.

Penrose, Roland. *Picasso: His Life and Work*. London, Victor Gollancz, 1958, new edn, Penguin Books, 1970.

Penrose, Roland, and Edward Quinn. *Picasso, Works and Days*. Garden City, N.Y., Doubleday, 1964. Text by Roland Penrose, photographs by Edward Quinn.

Picasso, Pablo. *Worte und Gedanken von Pablo Picasso*. Basle, Editions Beyeler, 1967/68. Preface by Alfred H. Barr, Jr., pictorial documentation by Roland Penrose.

Stein, Gertrude. *Picasso*. London, Batsford, 1938.

Vallentin, Antonina. *Pablo Picasso*. Cologne and Berlin, Kiepenheuer & Witsch, 1958.

CATALOGUES OF PICASSO'S WORK

Bloch, Georges. *Pablo Picasso: Catalogue of the Graphic Work 1904–67*. Berne, Kornfeld & Klipstein, 1968. Text English, French, German. Preface by René Wehrli.

Geiser, Bernhard. *Picasso peintre-graveur. Catalogue illustré de l'œuvre gravé et lithographié, 1899–1931*. Berne, published by the author, 1933. Reprinted 1955.

Geiser, Bernhard. *Picasso peintre-graveur. Catalogue illustré de l'œuvre gravé et des monotypes, 1932–1934*. Berne, Kornfeld & Klipstein, 1968.

Mourlot, Fernand. *Picasso lithographe*. Monte Carlo, André Sauret, Editions du Livre, 1949–64. Four vols. Preface by Jaime Sabartés.

Zervos, Christian. *Pablo Picasso: Œuvres*. Paris, Cahiers d'Art, 1932. Twenty vols to date.

GENERAL REFERENCES: SCULPTURE

Architectural Review, The (London), March 1968, pp. 209 ff.: 'Sculpture on the streets'.

Argan, Giulio Carlo. 'Cubismo e surrealismo nella scultura di Picasso'. *Letteratura* (Rome), I, no. 4, 1953, pp. 11–16.

Argan, Giulio Carlo. *Scultura di Picasso*. Venice, Alfieri, 1953. Text Italian, English.

Art Digest (New York), 1 March 1952, p. 16: 'Half-century survey of sculpture, oils, drawings and ceramics. Exhibition Curt Valentin Gallery'.

Art Journal, The (New York), Fall 1967, p. 86: 'Retrospective of Picasso's sculpture at the Museum of Modern Art'.

Art News (New York), May 1960, p. 11: 'Bronzes at Janis'.

Arts (New York), November 1967, p. 51: 'Sculpture of Picasso'.

Ashton, Dore. 'Sculptures de Picasso'. *XXᵉ siècle* (Paris), June 1968, pp. 25–40.

Breton, André. 'Picasso dans son élément'. *Minotaure* (Paris), no. 1, 1933, pp. 8–29. Photographs by Brassaï.

Burlington Magazine (London), June 1955, p. 188: 'Exhibition of drawings and bronzes at the Marlborough Gallery'.

Burlington Magazine (London), July 1967, p. 430 f.: 'Exhibition of Picasso sculpture at the Tate Gallery'.

Chevalier, Denys. 'Propos autour d'une sculpture de Picasso'. *Arts de France* (Paris), no. 8, 1946, 77 ff.

Elsen, Albert. 'The many faces of Picasso's sculpture'. *Art International* (Lugano), Summer 1969, pp. 24–34.

Elytis, Odysseus. 'Equivalences chez Picasso'. *Verve* (Paris), vii, no. 25/26, 1951, pp. 28–29. English translation in *Picasso at Vallauris*, New York, Reynal and Company, 1959.

Frigerio, S. 'Les 85 ans de Picasso à Paris'. *Aujourd'hui* (Boulogne-sur-Seine), January 1967.

Gaffe, René. 'Sculpteur, Picasso?'. *Artes* (Antwerp), series 2, no. 3/4, 1947/48, p. 36 f.

Giedion-Welcker, Carola. *Moderne Plastik – Elemente der Wirklichkeit, Masse und Auflockerung*. Zürich, Girsberger, 1937. Biographies, Bibliography. Editions in German and English.

Giedion-Welcker, Carola. *Plastik des 20. Jahrhunderts – Volumen- und Raumgestaltung*. Stuttgart, Gerd Hatje, 1955, pp. xii f., xviii f., 18, 20, 40 f., 57, 80, 84 f., 155, 180, 236, 242 f. English edn, *Contemporary Sculpture. An Evolution in Volume and Space*, New York, George Wittenborn, 1955. Biographies, bibliography.

Gischia, Léon, and Védrès, Nicole. *La Sculpture en France depuis Rodin*. Paris, Editions du Seuil, 1945, pp. 146 ff.

Golding, John. *Cubism: A History and an Analysis, 1907–1914*. London, Faber & Faber, and New York, George Wittenborn, 1959, pp. 81 ff.

González, Julio. 'Picasso sculpteur. Exposition des sculptures récentes de Picasso: Galerie "Cahiers d'Art"'. *Cahiers d'Art* (Paris), xi, 6/7, 1936, pp. 189 ff.

Gowing, Lawrence. 'Object lesson in object love: a great survey of Picasso sculptures at the Museum of Modern Art'. *Art News* (New York), October 1967, pp. 24–27.

Gueguen, Pierre. 'La Sculpture cubiste'. *Art d'Aujourd'hui* (Paris), no. 3/4, 1953, pp. 50–58.

Hahn, Otto. 'The Picasso Enigma'. *Art and Artists* (London), February 1967, pp. 20–25.

Henze, Anton. 'Neue Plastiken von Picasso'. *Das Kunstwerk* (Baden-Baden), March 1960, pp. 17 ff.

Hofmann, Werner. *Die Plastik des 20. Jahrhunderts*. Frankfurt am Main, Fischer-Bücherei, 1958, 146 ff.

Hotaling, E. 'Rally round the Picasso, boys! Sculpture in Chicago's Civic Center plaza'. *Art News* (New York), January 1970, pp. 46 f., 72 f.

Hunter, Sam. *Picasso. Cubism to the Present*. New York, Harry N. Abrams, 1957.

Jouffroy, Alain. 'Ceramics and Small Sculptures by Painters'. *Graphis* (Zürich), May/June 1957, pp. 236–39. Text, English, French, German.

Kahnweiler, Daniel-Henry. *Les Sculptures de Picasso*. Paris, Editions du Chêne, 1948. Photographs by Brassaï. English edn, *The Sculptures of Picasso*, London, Rodney Phillips, 1949.

Laporte, Paul M. 'The Man with the Lamb'. *Art Journal* (New York), Spring 1962, pp. 144–50.

Laughton, Bruce. 'Picasso'. *Arts Review* (London), 10 June 1967, p. 199.

Leymarie, Jean. 'Hommage à Picasso: expositions au Grand Palais et au Petit Palais'. *La Revue du Louvre et des Musées de France* (Paris), xvi, no. 6, 1966, pp. 291–316.

Lieberman, William S. *The Sculptor's Studio: Etchings by Picasso*. New York, The Museum of Modern Art, 1952.

Melville, Robert. 'Picasso: Sculpture, Ceramics, Graphic Work'. *The Architectural Review* (London), September 1967, pp. 215–218.

Penrose, Roland. 'Espaço e volume na escultura contemporânea'. *Cóloquio* (Lisbon), February 1960, pp. 1–8.

Penrose, Roland, *Picasso*. New York, Universe Books ('Universe Sculpture Series'), 1961. Biography, Bibliography.

Penrose, Roland. *Picasso: Sculptures*. Paris, Fernand Hazan ('Petite encyclopédie de l'art'), 1965, English edn, New York, Tudor ('Little Art Library', 72), 1965.

Penrose, Roland. 'A monumental sculpture by Picasso in Chicago'. *Institute of Contemporary Arts Bulletin* (London), November 1966, p. 14 f.

Porter, Fairfield. 'Picasso also as a sculptor'. *Art News* (New York), March 1952, p. 26.

Prampolini, Enrico. *Picasso scultore*. Rome, Libreria Fratelli Bocca ('Anticipazioni', 2, 'Serie Arti'), 1943.

Prejger, Lionel. 'Picasso découpe le fer'. *L'Œil* (Paris), October 1961, pp. 28–33.

Progressive Architecture (New York), November 1966, p. 66: 'The Chicago Picasso'.

Read, Herbert. *The Art of Sculpture*. New York, Pantheon Books ('Bollingen Series'), 1956, p. 111.

Read, Herbert. *A Concise History of Modern Sculpture,* London, Thames and Hudson, and New York, Frederick A. Praeger, 1964, *passim*. Reprinted 1966.

Riedl, Peter Anselm. '"Masque d'homme", ein Frühwerk Pablo Picassos'. *Jahrbuch der Hamburger Kunstsammlungen,* vii, 1962, pp. 83–92.

Ritchie, Andrew Carnduff. *Sculpture of the Twentieth Century*. New York, The Museum of Modern Art, 1952, pp. 25–28, 29, 31 f., 231.

Rosenblum, Robert. *Cubism and Twentieth-Century Art*. London, Thames and Hudson, and New York, Harry N. Abrams, 1960.

Salles, Georges A. 'Les Baigneurs de Picasso'. *Quadrum* (Brussels), no. 5, 1958, pp. 4–10.

Seuphor, Michel. *The Sculpture of this Century,* New York, George Braziller, 1960.

Spies, Werner. 'Picasso – Gespräch in Mougins'. *Frankfurter Allgemeine Zeitung* (Frankfurt am Main), 9 January 1971.

Sweeney, James J. 'Picasso and Iberian Sculpture'. *Art Bulletin* (New York), September 1941, pp. 191–98.

Sylvester, David. 'Picasso lithographs and bronzes at the Hanover Gallery'. *Burlington Magazine* (London), July 1949, p. 205.

Trier, Eduard. *Moderne Plastik*. Frankfurt am Main, Büchergilde Gutenberg, 1955, p. 37 f.

Védrès, Nicole. *See* Gischia.

Verdet, André. *L'Homme au mouton de Pablo Picasso*. Paris, Falaize, 1950.

Verdet, André. *Faunes et nymphes de Pablo Picasso*. Geneva, Pierre Cailler ('Peintres et sculpteurs d'hier et d'aujourd'hui', 25), 1952.

Verdet, André. *La Chèvre de Picasso*. Paris, Editions de Beaune, 1952.

Veronesi, Giulia. 'Sculture di Picasso'. *Emporium* (Bergamo), April 1951, pp. 146–53.

Watt, A. 'Exhibition of drawings, oils and bronzes at Buchholz'. *Art News* (New York), March 1949, p. 42.

Zervos, Christian. 'Sculptures des peintres d'aujourd'hui'. *Cahiers d'Art* (Paris), iii, no. 7, 1928, pp. 276–89.

Zervos, Christian. 'Projets de Picasso pour un monument'. *Cahiers d'Art* (Paris), iv, no. 8/9, 1929, pp. 342 ff.

Zervos, Christian. 'L'Homme à l'agneau de Picasso'. *Cahiers d'Art* (Paris), xx/xxi, 1945/46, pp. 84–112.

GENERAL REFERENCES: CERAMICS

Art Digest (New York), 1 March 1952, p. 16: 'Half-century survey of sculpture, oils, drawings and ceramics, exhibition, Curt Valentin Gallery'.

Ballardini, Gaetano. 'Picasso a Faenza'. *Faenza* (Faenza), xxxvi, no. 3, 1950, p. 47 f.

Batigne, Renée. *Une visite à Vallauris: Guide illustré*. Vallauris, Editions du Musée de Vallauris, 1950. Preface by Georges A. Salles; also 'Extraits de l'ouvrage céramique de Picasso' by Madoura (Georges and Suzanne Ramié).

Bouret, Jean. 'Picasso potier'. *Arts* (Paris), 26 November 1948.

Cahiers d'Art (Paris), xxiii, no. 1, 1948: articles by Madoura, Sabartés, Zenos (q. v.); 446 illustrations.

Cassou, Jean. 'Les poteries de Picasso'. *Art et décoration* (Paris), no. 12, 1949, pp. 13–21.

Champigneulle, Bernard. 'Picasso: poteries nouvelles'. *Art et décoration* (Paris), November 1958, pp. 23 ff.

Craft Horizons (New York), x, no. 2, 1950, pp. 10–13: 'Picasso as potter'.

Domus (Milan), no. 226, 1948, pp. 24 ff.: 'Picasso convertirà alla ceramica'.

Du (Zürich), October 1953, pp. 46–50: 'Picassos Keramik'.

Esprit (Paris), February 1949, p. 290: 'Les Poteries de Picasso'.

Gheerbrant, B. 'Picasso: "pâtes blanches"'. *Graphis* (Zürich), May/June 1957, pp. 240–243, 277 ff. Text English, French, German.

Golfieri, Ennio. 'Le ceramiche di Picasso al Museo di Faenza'. *Bollettino d'Arte* (Rome), January/March 1952, pp. 21–25.

Grand, P. M. 'Céramiques de peintres'. *Art et décoration* (Paris), no. 30, 1952, pp. 4–7.

Illustrated London News (London), 25 November 1950, p. 879: 'Picasso's archaic style; pottery illustrations'.

Jouffroy, Alain. See page 323.

Kahnweiler, Daniel-Henry. *Picasso: Keramik*. Hanover, Fackelträger-Verlag Schmidt-Kuster, 1957. Text English, French, German. Revised edn (German only), 1970.

Levy, Mervyn. 'The Pure Joy: Picasso Ceramics, Arts Council'. *Art News and Review* (London), 11 May 1957, p. 6.

Madoura (Georges and Suzanne Ramié). 'Picasso céramiste'. *Cahiers d'Art* (Paris), xxiii, no. 1, 1948, pp. 74–80.

Melville, Robert. See page 323.

Moutard-Uldry, Renée. 'Les Poteries de Picasso'. *Art et Industrie* (Paris), no. 14, 1949, pp. 43 ff.

Moutard-Uldry, Renée. 'Vallauris: Picasso et les potiers précolombiens'. *Arts* (Paris), 7–13 September 1955.

Moutard-Uldry, Renée. 'La Renaissance de la céramique à Vallauris'. *Cahiers de la Céramique et des Arts du Feu* (Sèvres), June 1956, p. 21–29.

Newton, Eric. 'Picasso as potter'. *Art News and Review* (London), 2 October 1954.

Nielsen, Jais. 'Picassos keramik'. *Dansk Kunsthaandvaerk* (Copenhagen), June 1950, pp. 101–05.

Ouvaliev, Dora. 'Picasso's pottery'. *Art News and Review* (London), 26 March 1949, p. 26 f.

Ramié, Georges and Suzanne. *Céramiques de Picasso*. Geneva, Albert Skira, 1948. English edn, New York, Skira, 1955. Extracts in *Craft Horizons* (New York), Summer 1950, pp. 10–13.

Reichardt, Jasia. 'Picasso ceramics at Grosvenor Gallery'. *Apollo* (London), January 1961, p. 18.

Röthel, Hans K. 'Töpferarbeiten von Pablo Picasso'. *Die Kunst und das schöne Heim* (Munich), April 1949, pp. 15–18.

Sabartés, Jaime. 'Picasso à Vallauris'. *Cahiers d'Art* (Paris), xxiii, no. 1, 1948, pp. 81 ff.

Sabartés, Jaime. *Picasso ceramista*. Milan, All'Insegna del Pesce d'Oro, 1953.

Tallon, W. J. 'An art critic looks at Picasso's pottery'. *Design* (Columbus, Ohio), November 1949, pp. 17, 21, 24.

Toesca, Maurice. 'Picasso, céramiste'. *Age nouveau* (Paris), February 1949, p. 100.

Vallier, Dora. 'Picasso: nouvelles céramiques'. *XXe Siècle* (Paris), December 1963, pp. 113–16.

Valsecchi, Marco. 'Le ceramiche di Picasso'. *Biennale di Venezia* (Venice), April/June 1953, pp. 31–35.

Veronesi, Giulia. 'Le ceramiche di Picasso'. *Emporium* (Bergamo), May 1950, pp. 207–210.

Zervos, Christian. 'Céramiques de Picasso'. *Cahiers d'Art* (Paris), xxxiii, no. 1, 1948, 72 f. Reprinted in English, French and German in *Graphis* (Zürich), v, no. 27, 1949, 260–69, 298, 301 f.

SELECTED EXHIBITION CATALOGUES

Antibes, Musée d'Antibes (Musée Picasso). 'Picasso in Antibes'. 1960. Published by Pantheon Books, New York. Text by Dor de la Souchère, photographs by Marianne Greenwood. 99 works, incl. 2 sculptures, 77 ceramics.

Basle, Galerie Beyeler. 'Picasso. Werke von 1900–1932'. 26 November 1966 – 31 January 1967. 45 works, incl. 3 sculptures. Chronology.

Basle, Galerie Beyeler. 'Picasso. Werke von 1932–1965'. February-April 1967. 61 works, incl. 1 sculpture, 2 ceramics.

Dallas, Museum of Fine Arts, and Fort Worth, Art Center. 'Picasso: Two Concurrent Retrospective Exhibitions'. 8 February – 26 March 1967. Text by Douglas Cooper, chronology, bibliography. 312 works, incl. 8 sculptures, in Dallas; drawings, watercolours and pastels in Fort Worth.

Düsseldorf, Kunstverein. 'Pablo Picasso: Keramik aus der Manufaktur Madoura'. 5 December 1961–21 January 1962. Preface by Karl-Heinz Hering, introduction by André Verdet, 'Keramik' ('Céramiques') by Georges Ramié (q.v.). Text French, German.

Faenza, Museo Internazionale delle Ceramiche. '42 ceramiche originali di Pablo Picasso'. 1 August – 15 October 1960. Introduction by Giuseppe Liverani.

Hamburg, Museum für Kunst und Gewerbe. 'Pablo Picasso: Keramik 1947 bis 1961. Mosaiken 1956 bis 1958. Linolschnitte seit 1961. Lithographien 1956 bis 1961. Plakate 1948 bis 1962'. 31 January – 22 March 1964. Extracts from *Picasso – Keramik* by Daniel-Henry Kahnweiler. 143 works, incl. 31 ceramics.

London, Arts Council of Great Britain. 'Picasso in Provence'. November-December 1950. Preface by Philip James. 83 works, incl. 24 bronzes, 21 ceramics.

London, Marlborough Fine Art Ltd. 'Picasso: 63 Drawings 1953–54, 10 Bronzes 1945–1953'. May–June 1955. Introduction by Rebecca West.

London, Redfern Gallery. 'Picasso'. 1960. 342 works: etchings, lithographs, posters, ceramics.

London, Institute of Contemporary Arts. 'Picasso and Concrete: New Techniques and Photographs by Carl Nesjar'. 11 January – 11 February 1967. Introduction by Pierre Gascar. Also shown in Paris (Galerie Jeanne Bucher).

London, Tate Gallery. 'Picasso: Sculpture, Ceramics, Graphic Work'. 9 June – 13 August 1967. Organized by the Arts Council of Great Britain. Introduction by Roland Penrose. Chronology, bibliography. 275 works, incl. 203 sculptures.

Lucerne, Galerie Rosengart. 'Picasso: l'idée pour une sculpture'. July-September 1970. Preface by Roland Penrose. 26 works, incl. 1 sculpture.

Lyon, Musée des Beaux-Arts. 'Picasso: Exposition organisée sous l'égide du Syndicat d'Initiative de Lyon'. 2nd edn, 1953.

Includes: Jean Cassou, 'Picasso et l'Espagne'; René Jullian, 'Humanité de Picasso'; Daniel-Henry Kahnweiler, 'Picasso et le cubisme'; Marcel Michaud, 'Le Savoir-voir'; Christian Zervos, 'L'Arrière-saison de Picasso'. 179 works, incl. 20 sculptures, 10 ceramics.

Lyon, Musée des Beaux-Arts. 'Picasso: gravures, céramiques'. 1962. Preface by D.-H. Kahnweiler. 182 works.

Milan, Palazzo Reale. 'Pablo Picasso'. September – November 1953. Catalogue published by Amilcare Pizzi, Milan, 1953. Introduction by Franco Russoli. Chronology, bibliography. 329 works, incl. 32 sculptures, 41 ceramics.

Munich, Haus der Kunst. 'Picasso 1900–1955'. 25 October – 18 December 1955. Introduction by Maurice Jardot. Detailed chronology, bibliography. 256 works, incl. 35 sculptures, 13 ceramics. Also seen in Cologne and Hamburg.

New York, The Museum of Modern Art. 'Picasso: Forty Years of His Art'. 15 November 1939 – 7 January 1940. Organized in conjunction with the Art Institute of Chicago. Edited by Alfred H. Barr, Jr. 300 works, incl. 4 sculptures. Also seen in Chicago (Art Institute) and elsewhere in the USA.

New York, Buchholz Gallery. 'Pablo Picasso: Recent Work'. 8 March – 2 April 1949. 58 works, incl. 24 bronzes.

New York, Curt Valentin Gallery. 'Pablo Picasso: Paintings, Sculptures, Drawings'. 19 February – 15 March 1952. 56 works, incl. 10 sculptures, 6 ceramics.

New York, Curt Valentin Gallery. 'Pablo Picasso: 1950–1953'. 24 November – 19 December 1953. Includes Paul Eluard, 'Picasso, Good Master of Liberty', translated by Roland Penrose. 65 works, incl. 18 sculptures.

New York, Galerie Chalette. 'Picasso: "The Woman". Paintings, Drawings, Bronzes, Lithographs'. 16 April – 19 May 1956. 32 works, incl. 5 bronzes.

New York, Fine Arts Associates. 'Picasso: Sculptures'. 15 January – 9 February 1957. 26 works. Includes extracts from *The Sculptures of Picasso* by D.-H. Kahnweiler (q.v.).

New York, The Museum of Modern Art. 'Picasso: 75th Anniversary Exhibition'. 22 May – 8 September 1957. Edited by Alfred H. Barr, Jr. 295 works, incl. 45 sculptures, 2 ceramics. See Philadelphia (Museum of Art). Also seen in Chicago.

New York, Cooper Union Museum. 'Ceramics by Picasso'. 28 March – 10 May 1958. 92 works.

New York, Fine Arts Associates. 'Picasso: The Bathers'. 10 February – 7 March 1959. Includes extracts from 'Les Baigneurs de Picasso' by Georges A. Salles (q.v.). Also seen in Boston (Museum of Fine Arts).

New York, Sidney Janis Gallery. 'Picasso, 1881– : His Blue Period (1900–1905). Collection of Pastels, Water-colours and Drawings. Also, the Complete Set of Small Bronzes of Female Figures 1945–47'. 25 April – 21 May, 1960.

New York, Otto Gerson Gallery. 'Picasso: An American Tribute'. 25 April – 12 May 1962. Catalogue published by Public Education Association, New York, edited by John Richardson.

New York, The Museum of Modern Art. 'The Sculpture of Picasso'. 11 October 1967 – 1 January 1968. Preface by Monroe Wheeler, text by Roland Penrose, chronology, bibliography. 284 works, incl. 204 sculptures, 32 ceramics.

Oslo, Kunstnerns Hus. 'Picasso, Malerier, Tegninger, Grafik, Skulptur, Keramik'. 1956. Text by Reidar Revold, chronology, bibliography.

Paris, Galerie Georges Petit. 'Exposition Picasso'. 16 June – 30 July 1932. 236 works, incl. 7 sculptures.

Paris, Société du Salon d'Automne. 'Catalogue des ouvrages de peinture, sculpture, dessin, gravure, architecture et art décoratif exposés au Palais des Beaux-Arts de la Ville de Paris'. 6 October – 5 November 1944. 79 works by Picasso, incl. 5 sculptures.

Paris, Maison de la Pensée Française. 'Picasso: sculptures, dessins, 1950–1951'. 1951. Text by Aragon. 43 sculptures.

Paris, Maison de la Pensée Française. 'Picasso: cent cinquante céramiques originales'. 8 March – 30 June 1958. Text by Georges and Suzanne Ramié, 'La Terre et le feu de Picasso' by Hélène Parmelin.

Paris, Galerie Jeanne Bucher. 'Picasso et le béton'. November 1966. Texts by Pierre Gascar, Daniel Gervis, Georges Patrix, Michel Ragon. Photographs by Carl Nesjar. Also shown in London (Institute of Contemporay Arts), Le Havre (Maison de la Culture) and St. Gallen (Kunstmuseum).

Paris, Grand Palais and Petit Palais. 'Hommage à Pablo Picasso'. November 1966 – February 1967. Chronology, bibliography. 508 works, incl. 187 sculptures (at Petit Palais).

Philadelphia, Museum of Art. 'Picasso: A Loan Exhibition of His Paintings, Drawings, Sculptures, Ceramics, Prints, and Illustrated Books'. 8 January – 23 February, 1958. Preface by Henry Clifford. 573 works, incl. 46 sculptures, 75 ceramics. Enlarged version of New York exhibition (The Museum of Modern Art); see above.

Rome, Galleria Nazionale d'Arte Moderna. 'Mostra di Pablo Picasso'. 1 May – 5 July 1953. Edited by Lionello Venturi, Eugenio Battisti and Nello Ponente, introduction by Lionello Venturi, chronology, bibliography. 246 works. incl. 32 sculptures, 39 ceramics.

Rotterdam, Museum Boymans. 'Picasso ceramiek'. July 1957. 74 works.

St. Gallen, Kunstmuseum. 'Picasso und der Beton'. 9 April – 21 May 1967. Introduction by Pierre Gascar, text by Daniel Gervis. Text German, French.

Stockholm, Nationalmuseum. 'Picasso i Kiruna'. September 1965. Text by Carl Nordenfalk, chronology. 101 works, all ceramics.

Toronto, Art Gallery of Ontario. 'Picasso and Man'. 11 January – 16 February 1964. Catalogue by Jean Sutherland Boggs, includes: John Golding, 'Picasso, the Demoiselles d'Avignon and Cubism'; Robert Rosenblum, 'Picasso as a Surrealist'; Jean Sutherland Boggs, 'Picasso, the early years'; Evan H. Turner, 'Picasso since 1937'; chronology, bibliography. 276 works, incl. 8 sculptures. Also shown in Montreal (Museum of Fine Arts).

Vallauris, Galerie Madoura. 'Picasso: 20 ans de céramiques chez Madoura, 1946–1966'. July 1966. Introduction by Georges and Suzanne Ramié. 120 works, all ceramics.

Washington, D.C., Gallery of Modern Art. 'Picasso since 1945'. 30 June – 4 September 1966. Preface by Eleanor Green. 97 works, incl. 11 sculptures, 6 ceramics.

Index

PHOTOGRAPHIC ACKNOWLEDGMENTS

The references in roman type are to page numbers; those in *italic type* are to catalogue illustrations

The Art Institute of Chicago 297 (*643*)
Atelier Municipal de Reprographie, Marseille 297 (*649*)
The Baltimore Museum of Art 30
Berggruen & Cie, Paris 49
Galerie Claude Bernard, Paris 32, 33
Galerie Beyeler, Basle 35
Brassaï, Paris 13, 14 (above), 38, 39, 41, 43, 77, 78, 81, 82, 86–89, 91–93, 94 (left), 96, 105–109, 111, 115–121, 123–128, 134–138, 155, 158–160, 168, 170, 172, 274 (*68–71, 77*), 275 (*83, 85–87, 93–98, 100–103, 107, 113, 117, 120, 123, 126*), 276 (*138, 140, 141, 144, 146–150, 154, 156, 158, 159*), 277 (*182–186*), 278 (*187, 194, 196, 198–200, 202, 205–208*), 279 (*209, 211–217, 220 225, 229*), 280 (*231–233, 242–259*), 281 (*260–277, 279, 281–285*), 282 (*286–302, 319*)
Bulloz, Paris 36
Chevojon, Paris 14 (below), 84, 85, 112, 113, 130, 132, 156, 157, 161–163, 167, 171, 200, 203–205, 213, 215, 217, 281 (*278*)
Jean Dubout, Paris 80
David Douglas Duncan, Castellaras 260, 261
Giraudon, Paris 237
J. J. de Goede, Amsterdam 297 (*648*)
John Hedgecoe, London 29, 58, 66, 165, 166, 211, 243, 249, 251, 294 (*565, 578*)
Jacqueline Hyde, Paris 293 (*551–554, 560–563*)
Galerie Louise Leiris, Paris 40, 44, 60, 61, 154, 164, 182, 184, 190–193, 195–199, 202, 208, 209, 212, 214, 216, 220, 225, 239 (right), 244, 245, 273 (*8, 10, 21, 34*), 277 (*167, 175*), 282 (*304, 306, 307, 309, 311–316*), 283 (*323, 327–331, 337–340, 342–346*), 284 (*352–367*), 285 (*368–382, 384*), 286 (*385–394, 398*), 287 (*402, 405, 406, 414–426*), 288 (*427–444*), 289 (*446–459, 464*), 290 (*466, 471, 473–476, 497–499*), 291 (*502, 511–525*), 292 (*526–533, 535, 540, 543*), 293 (*555–558*), 295 (*595–597*), 296 (*624, 625, 627*)
Dora Maar, Paris 275 (*135*), 277 (*171–174, 176*), 278 (*188–191*)

Henri Mardyks, Paris 31, 62, 64, 67, 68, 83, 90, 149, 150 (right), 152, 153, 183, 187, 189, 201, 219, 223, 229, 238 (right), 241, 246, 254, 255, 258, 286 (*396*)
The Museum of Modern Art, New York (Soichi Sunami) 42, 185
Carl Nesjar, Oslo 15 (above), 262, 263, 291 (*510*), 294 (*566*), 297 (*642, 642a, 644–645, 647, 650*), 298 (*654–659, 661–663*), 299
Le Point Cardinal, Paris 293 (*551–554, 560–563*)
Edward Quinn, Nice 280 (*241*), 290 (*496, 500–501*), 293 (*548, 549*), 295 (*586–588*), 297 (*640*)
Service de Documentation Photographique de la Réunion des Musées Nationaux, Paris 57, 63, 65, 94 (right), 95, 110, 129, 139, 150 (left), 151, 186, 188, 194, 207, 234, 235, 239 (left), 247, 248, 250, 252, 253, 256, 257, 259, 275 (*88, 92*), 276 (*143, 161, 162*), 279 (*230*), 282 (*318*), 290 (*490–493*), 292 (*534, 536*), 293 (*550*), 294 (*569–576, 582–584*), 295 (*589, 590, 594, 602–604*), 296 (*613–616, 618, 620, 621, 626, 628, 629*), 297 (*630–634*)
Werner Spies, Paris 15 (below), 16, 264, 293 (*559*), 295 (*607–609*), 296 (*610–612*)
Charles Uht, New York 37
Marc Vaux, Paris 131, 206
John Webb, London 53, 59, 79, 169, 177, 181, 218, 230–233, 238 (left), 240, 276 (*160*), 286 (*400*), 294 (*579*), 296 (*617*)
Etienne Bertrand Weill, Paris 122, 133, 140

Special thanks are due to the Galerie Louise Leiris, Paris, for supplying photographic material and documentary information
Printed in Switzerland by Héliographia SA, Lausanne
Colour blocks supplied by Denz Clichés AG, Berne
Paper supplied by Papierfabriken Landquart
Bound in Switzerland by Mayer & Soutter, Lausanne

Sandburg College
Learning Resource Center
Galesburg, Ill. 61401